TELEVISION STUDIES

**Edited by
Toby Miller**

Associate Editor
Andrew Lockett

 Publishing

First published in 2002 by the
British Film Institute
21 Stephen Street, London W1T 1LN

The British Film Institute is the UK national agency with responsibility for
encouraging the arts of film and television and conserving them in the
national interest.

© British Film Institute 2002
Cover design: Squid Inc.
Cover Image: *Buffy the Vampire Slayer* (Joss Whedon, USA, 1997–); Sarah Michelle Gellar as Buffy Summers

Set by Fakenham Photosetting, Norfolk
Printed by St Edmundsbury Press, Bury St Edmunds, United Kingdom

British Library Cataloguing-in-Publication Data
A catalogue record for this book is available from the British Library
ISBN 0–85170–895–1 (pbk)
ISBN 0–85170–894–3 (hbk)

TELEVISION STUDIES

Contents

(Grey box case studies are indicated in brackets)

GENDER

RACE

Preface

TOBY MILLER

'When I went to university, television was something you watched to get away from study. Now, ho ho ho, you can get a degree for being a couch potato. There can be no more telling sign of the general decline in academic standards that has plagued the Western world. Studying television is right up there alongside an upsurge in ludicrous rules of speech that restrict freedom of thought and the rejection of our philosophical and political foundations.' Discuss.

This might be an exam question from across the kitchen table, workplace or newspaper room (see numerous over-anxious denunciations of cultural studies in *The New York Times* and *The Guardian* over the past decade, for example). The 'exam' represents a serious set of concerns amongst family members, colleagues and intellectuals. They fear that devoting time to understanding popular-culture icons such as television abjures the historic mission of the university to elevate its students and the public more generally, in either a technical or a moral sense.

But as this book should make clear, very serious-minded people have been thinking about television for years, and they have done so for all sorts of reasons – to make money, to govern populations, to provide entertainment, to protest, to alert, and so on. After TV's role during the US war in Vietnam, the Watergate hearings, Tiananmen Square protests, Clinton's impeachment and 11 September, can anyone seriously argue against seeking to understand how and why television and its audiences make meaning? Of course, people can and do object, and one aim of this book is to convince doubting siblings, peers, and hegemons of the need for television studies.

But the principal goal is to open up the field of thinking about television to students and show them how it can be analysed and changed. These two aims must be linked. We now have at our disposal a powerful array of tools for comprehending how television functions, who controls it, how it makes meaning and what audiences do with the result. More needs to be done in all those areas, needless to say, and the contributions that follow offer powerful agendas for future work. But there is an urgent need as well for informed activism by television audiences. We face a point in history when censorship through both governmental regulation and commercial practice is immensely strong. At the same time, democratic influences on television have dramatically diminished because of neo-liberal opposition to popularly elected representatives overseeing the media, not to mention the related slings and arrows that have gutted public television.

The ensuing diminution in comprehensive coverage of major and minor political events (whether they be to do with childcare or military deployment) is leaving a gigantic deficit across the globe that is the tragic and senseless co-efficient of contemporary capitalism. If there are to be more Tiananmens and fewer 11 Septembers, the viewers of today and tomorrow must have a wide range of pleasurable, smart, progressive TV programmes to look at, learn from, and influence. To make that happen, audiences need to understand the institutional, textual and political aspects of television. I hope that this book can play a small part in making that possible.

ACKNOWLEDGMENTS

My chief thanks go to Andrew Lockett and Ann Simmonds. Andrew did so much to bring this project to fruition that it made sense for him to become its Associate Editor. I also wish to thank Andrew for involving me in the wider project that will eventually be the multi-volume *Television Book*. For her part, Ann was an extremely efficient and cheerful point person between the editor, the authors and the press. Thanks are also due to all those at the BFI and elsewhere whose invisible, unnamed labor made this into a book. Finally, I wish to record my appreciation for the contributors' work. They have written clearly, pointedly and intelligently.

Notes on Contributors

Nick Couldry lectures in Media and Communications in Media in the Department of Sociology at the London School of Economics and Political Science, where he is also Director of the Master's Programme in Media and Communications Regulation. He is the author of three books: *The Place of Media Power: Pilgrims and Witnesses of the Media Age* (Routledge, 2000), *Inside Culture: Reimagining the Method of Cultural Studies* (Sage, 2000) and *Media Rituals: A Critical Approach* (Routledge, 2002).

Stuart Cunningham is Professor and Director of the Creative Industries Research and Applications Centre, Queensland University of Technology. He co-edited (with John Sinclair) *Floating Lives: The Media and Asian Diasporas* (Rowman & Littlefield, 2001), (with John Sinclair and Elizabeth Jacka) *New Patterns in Global Television: Peripheral Vision* (Oxford University Press, 1996), (with Graeme Turner) *The Australian TV Book* (Allen & Unwin, 2000) and *The Media and Communications in Austr*alia (third edition, Allen & Unwin, 2002). He has worked on two commissioned international studies of 'borderless' education between 1997 and 2000.

Michael Curtin is Professor of Communication Arts at the University of Wisconsin-Madison. His books include *Redeeming the Wasteland: Television Documentary and Cold War Politics* (Rutgers, 1995), *Making and Selling Culture* (co-editor; Wesleyan, 1996) and *The Revolution Wasn't Televised: Sixties Television and Social Conflict* (co-editor; Routledge, 1997). He is currently writing a book about the globalisation of Chinese film and television and, with Paul McDonald, co-editing a book series for the British Film Institute called 'International Screen Industries'.

Julie D'Acci is a Professor of Media and Critical Studies at the University of Wisconsin-Madison. She is the author of *Defining Women: The Case of Cagney and Lacey*, co-editor of *Feminist Television Criticism: A Reader*, and author of various articles on the media. She writes on television, cultural studies, gender and methodology.

Mara Einstein is an Assistant Professor of Media Studies at Queens College, City University of New York. In 2003 she will be an adjunct at New York University's Stern School of Business having just completed a book provisionally entitled *Prime Time Power and Politics: Diversity, Fin-syn and the FCC*, which will be published by Lawrence Erlbaum Associates. Prior to becoming an academic she spent twenty years in the media including stints at NBC, MTV Networks and a number of advertising agencies.

John Nguyet Erni is Associate Professor in the Department of English and Communication at the City University of Hong Kong. He is the author of *Unstable Frontiers: Technomedicine and the Cultural Politics of 'Curing' AIDS* (University of Minnesota Press, 1994), editor of a special issue entitled 'Becoming (Postcolonial) Hong Kong' for *Cultural Studies* (2001), and co-edited two new volumes *International Cultural Studies* and *Asian Media Studies*, (both forthcoming from Blackwell). His work focuses on gender and sexual politics, and media studies.

Terry Flew is a Senior Lecturer and Discipline Head of Media Communication, Queensland University of Technology. He is the author of *New Media Technologies: An Introduction* (Oxford University Press, 2002) and his current research interests include the impact of digital and online media technologies, media policy and citizenship, globalisation and the future of media policy, and the future development of educational media technology in the context of convergence and the development of digital media and lifelong learning.

Kelly Gates teaches media studies at the Institute of Communications Research, University of Illinois at Urbana-Champaign. Her current research examines the development of automated surveillance and identification technology, namely facial recognition, focusing on the social and political issues involved in implementing these systems. She has recently published 'Wanted Dead or Digitized: Facial Recognition Technology and Privacy' in *Television and New Media* (May 2002).

Marie Gillespie is Senior Lecturer in Sociology at the Open University. Her most recent research on diaspora literary and media cultures has been undertaken as part of the Economic and Social Research Council's Transnational Communities Programme (www.transcomm.ox.ac.uk –

axial writing project). She has published a book and numerous articles on media, migration and cultural transnationalism.

Faye Ginsburg is Director of the Center for Media, Culture, and History and the David Kriser Professor of Anthropology at New York University. Her research builds on a strong interest in social movements, cultural activism, and the place of media in contemporary cultural worlds. Her latest book is *Media Worlds: Anthropology on New Terrain* (California, 2002), edited with Lila Abu-Lughod and Brian Larkin. In the next year, she will be curating a major film exhibition at the Museum of Modern Art entitled *First Nations/First Features*. Her book on indigenous media, *Mediating Culture*, is forthcoming.

Nitin Govil is a doctoral candidate in the Department of Cinema Studies at New York University. His dissertation project, 'Something to Declare', is a study of the recent history of Hollywood in India. A co-author of *Global Hollywood* (BFI, 2001), he has also written and published work on television and broadband technology, science fiction and the city, in-flight entertainment, and intellectual property and media piracy.

Ann Gray teaches Cultural Studies at the University of Birmingham and is editor of the *European Journal of Cultural Studies*. She has researched the domestic use of media and new entertainment technologies and has written extensively on audience issues. Her most recent publication, *Research Practice for Cultural Studies* (Sage, 2002) addresses questions of interdisciplinary research methods.

Alison Griffiths is an Assistant Professor of Communication Studies at Baruch College, City University of New York, where she teaches media studies and documentary film and television. She is the author of *Wondrous Difference: Cinema, Anthropology, and Turn-of-the-Century Visual Culture* (Columbia University Press, 2001) and has published widely on pre-cinema, early cinema, and on television audiences.

John Hartley is Professor and Dean of the Faculty of Creative Industries, Queensland University of Technology, Australia. Previously he was Head of the School of Journalism, Media and Cultural Studies at the University of Wales, Cardiff. He is author of many books and articles on TV studies going back to the 1970s (*Reading Television*, with John Fiske [Routledge, 1978]). His most recent books are *Uses of Television* (Routledge, 1999) and *The Indigenous Public Sphere: The Reporting and Reception of Aboriginal Issues in the Australian Media* (with Alan McKee, Oxford University Press, 2000).

Heather Hendershot is an Assistant Professor of Media Studies at Queens College/City University of New York. She is the author of *Saturday Morning Censors: Television Regulation before the V-Chip* (Duke University Press, 1998) and the forthcoming *Shaking the World for Jesus: Media and Conservative Evangelical Culture* (University of Chicago Press).

Annette Hill is Reader in Communication at the Centre for Communication and Information Studies, University of Westminster. She is the author of *Shocking Entertainment: Viewer Response to Violent Movies* (University of Luton Press, 1997), and is the co-author (with David Gauntlett) of *TV Living: Television, Culture and Everyday Life* (Routledge, 1999). She is also the editor of *Framework: the Journal of Cinema and Media* (www.frameworkonline.com), and the co-editor, with Robert C. Allen, of the forthcoming *TV Studies Reader* for Routledge (2003). Her new book *Real TV* is to be published by Routledge in 2003.

Sara Gwenllian Jones is Lecturer in Television and Digital Media at Cardiff University. Her published work includes articles in *Screen*, *Continuum* and *Television and New Media*. She is co-editor of *Intensities: the Journal of Cult Media* and is currently writing a book about cult television and working on a documentary project about tribal peoples and their worlds.

Douglas Kellner is George Kneller Chair in the Philosophy of Education at University of California, Los Angeles, and is author of many books on social theory, politics, history, and culture, including *Camera Politica: The Politics and Ideology of Contemporary Hollywood Film* (co-authored with Michael Ryan), *Television and the Crisis of Democracy*, *The Persian Gulf TV War*, and *The Postmodern Turn* (with Steven Best). He has just published a book on the 2000 presidential election, *Grand Theft 2000: Media Spectacle and the Theft of an Election*, and *The Postmodern Adventure. Science, Technology, and Cultural Studies at the Third Millennium* (co-authored with Steve Best). Forthcoming books include *Media Spectacle and September 11: Terror War, and the New Barbarism*.

Marie Leger is an MD/PhD student at the University of Illinois in the Institute of Communications Research. She is currently writing her PhD thesis, which examines

globalisation and pharmaceutical clinical trials, with a case study of HIV/AIDS research in Mexico.

Justin Lewis is Professor of Communication and Cultural Industries at the University of Wales, Cardiff. He has written several books about media and culture. His particular interests are media influence, cultural policy and the ideological role of media in contemporary societies. His most recent book, *Constructing Public Opinion: How Elites Do What they Like and Why We Seem to Go Along With It*, is an analysis of the media and public opinion, published by Columbia University Press (2001).

Andrew Lockett is Head of BFI Publishing at the British Film Institute, London. His connections with film, television and media and cultural studies publishing date back to 1985 and he has worked for Croom Helm, Routledge and Oxford University Press on many projects including the 'Oxford Television Studies' series.

Anna McCarthy teaches in the Department of Cinema Studies, New York University. She is the author of *Ambient Television: Visual Culture and Public Space* (Duke University Press, 2001). Her current research traces the history of television sponsorship as a form of political activism in the postwar United States.

Dan McGee is an MD/PhD candidate in the Institute of Communicatons Research and College of Medicine at the University of Illinois at Urbana-Champaign. McGee's media research focuses on the construction of infectious disease threats, particularly emerging infectious diseases and bioterrorism, in the mass media and scientific community. His clinical work is in emergency medicine and urban disaster preparedness.

Alan McKee teaches television studies at the University of Queensland. His most recent book is *Australian Television: A Genealogy of Great Moments* (Oxford University Press, 2001). He is currently researching the production and consumption of pornography in Australia, and David E. Kelley's philosophical writings on happiness.

Eric K. W. Ma is Associate Professor of Communication at the Chinese University of Hong Kong. He is the author of *Culture, Politics and Television in Hong Kong* (Routledge, 1999). His papers appear in *Social Text, Positions, Cultural Studies, International Journal of Cultural Studies*, and *Inter-Asia Cultural Studies*. He has also published eight popular books in Chinese on the popular culture of Hong Kong.

Eileen Meehan is an Associate Professor in the Department of Media Arts at the University of Arizona. She has been honored with the Dallas Smythe Award by the Union for Democratic Communication and the Garry Carruthers Chair in Honors at the University of New Mexico, 2002–03. She is co-editor with Ellen Riordan of *Sex and Money: Feminism and Political Economy in Media Studies* and with Janet Wasko and Mark Phillips of *Dazzled by Disney? The Global Disney Audiences Project*.

Michael Morgan is Professor and Chair in the Department of Communication at the University of Massachusetts/Amherst. He recently edited *Against the Mainstream: The Selected Works of George Gerbner* (Lang, 2002) and co-authored *Television and its Viewers: Cultivation Theory and Research* (with James Shanahan, Cambridge, 1999).

Horace Newcomb is Director of the Peabody Awards Program and Lambdin Kay Distinguished Professor at the University of Georgia. He is editor of the Museum of Broadcast Communications' *Encyclopedia of Television*, of six editions of *Television: The Critical View*, and author of numerous works on television.

Laurie Ouellette is Assistant Professor of Media Studies at Queens College, City University of New York. She is the author of *Viewers Like You? How Public TV Failed the People* (Columbia University Press, 2002).

Lisa Parks is Associate Professor of Film Studies at University of California, Santa Barbara. She is the author of *Cultures in Orbit: Satellites and Television* (Duke University Press), and co-editor of *Planet TV: A Global Television Reader* (New York University Press) and *Red Noise: Buffy the Vampire Slayer and Television Studies* (Duke University Press). She has also published essays in *Screen, Television and New Media, Convergence*, and *Social Identities*.

Dr Lorna Roth is Associate Professor and Chairperson at the Department of Communication Studies, Concordia University in Montréal, Québec, Canada. Dr Roth has been involved in broadcasting policy development and analysis, and has consulted with First Peoples and multicultural/multiracial groups since the late 70s. She has recently completed a book called *Something New in the Air: The Emergence and Development of First Peoples Television Broadcasting in Canada*, and is currently working on another book entitled *The Colour-Balance Project: Race and Visual Representation*.

Andy Ruddock lectures in Media and Cultural Studies at Liverpool John Moores University. He has taught in the United States and New Zealand, and is the author of *Understanding Audiences* (Sage, 2000).

Ellen Seiter is Professor of Communication at the University of California, San Diego. She is the author of *Television and New Media Audiences* (Oxford, 1999) and is working on a new book about children and the digital divide.

Annabelle Sreberny is Professor and ex-Director of the Centre for Mass Communication Research at the University of Leicester. Her books on international communication and globalisation include *Small Media, Big Revolution* (1985), *Globalization, Communication and Transnational Civil Society* (1996); and *Media in Global Context* (1997). Her recent work has focused on the Iranian diaspora; minority media; and journalism and trauma post-9/11 (in *Journalism After September 11th*, 2002).

Thomas Streeter is an Associate Professor of Sociology at the University of Vermont. Some recent publications include 'Notes Towards a Political History of the Internet 1950–1983' in *Media International Australia*; 'Blue Skies and Strange Bedfellows: The Discourse of Cable TV' in Lynn Spigel and Michael Curtin (eds), *The Revolution Wasn't Televised: Sixties Television and Social Conflict* (Routledge, 1997); and *Selling the Air: A Critique of the Policy of Commercial Broadcasting in the United States* (University of Chicago Press, 1996).

Gerald Sussman is Professor of Urban Studies and Communications at Portland State University. He is the author or co-editor of three books on information and communications technology, including *Communication, Technology and Politics in the Information Age* (Sage, 1997).

Lora Taub is an Assistant Professor in the Department of Communication at Muhlenberg College, in Allentown, Pennsylvania. Her research focuses on the role of communication technologies in the commodification of education. Recently, her chapter co-authored with Dan Schiller, 'Networking the North American Higher Education Industry', was published in *Continental Order? Integrating North America for Cybercapitalism*, edited by V. Mosco and D. Schiller (Rowan & Littlefield, 2001).

Graeme Turner is a Professor of Cultural Studies and Director of the Centre for Critical and Cultural Studies at the University of Queensland, Brisbane, Australia. He has published widely on media and cultural studies topics. His most recent publications include (with Stuart Cunningham) *The Australian TV Book* (Allen & Unwin, 2000) and (with Frances Bonner and David Marshall) *Fame Games: The Production of Celebrity in Australia* (Cambridge University Press, 2000).

Angharad N. Valdivia is a Research Associate Professor at the Institute of Communications Research at the University of Illinois. She is the author of *A Latina in the Land of Hollywood* (Arizona University Press, 2000) and editor of the forthcoming *Blackwell Companion to Media Studies* and co-editor of *Geographies of Latinidad*. Her research focuses on transnational multiculturalist feminist issues with a special emphasis on Latinas in popular culture.

INTRODUCTION

A scholarly book about the study of television published thirty years ago would have focused on two topics: engineering and panic. At that time, TV was understood along twin axes. The first of these, the engineering axis, was driven by technocratic questions – where and how could TV 'happen', in terms of a country's electronic spectrum and its economic power? The second axis, the panic axis, was driven by moral and social anxieties – what would TV 'do' to its viewers, in terms of a country's behavioural norms and its political stability? These axes shared what Wilbur Schramm, the doyen of reactionary media analysts of the cold-war era, referred to as the dominant *ethos* of 'communication research in the United States . . . quantitative, rather than speculative' (Schramm, 1973, p. 4). This was in contradistinction to more populist, qualitative theorists of the day like Marshall McLuhan, who argued for intense differentiation between the media. Whereas radio, he said, was a 'hot medium', because it contained a vast array of data that led the audience in a definite direction that was explicitly defined, TV was 'cool', as it left so much up to the viewer to sort out (McLuhan, 1974, p. 31).

John Downing has criticised both these traditions of media research because '[p]olitics and power . . . are often missing, presumed dead' (1996). The absence of politics and power in the study of television is no longer sustainable. Ways of knowing television have changed as well, as the spread of TV beyond its sites of origin has called into question theories derived from a small number of developed nations (Curran and Park, 2000). While the spectrum is still important (through issues of access to cable, satellite, the Internet and electricity), television is now much more available, and in many more forms, than it was in 1970.

Technological issues are more clearly tied to capital than was the case then, as governments are no longer the principal agents of either technical development or televisual delivery. Once the province of state-owned national broadcasters and perhaps a few commercial stations or networks, other than in the US, television now transcends national borders and governmental domination. The engineering requirement is still there – most public policy is undertaken by technocrats in the service of capital – as is the social-scientific impulse to measure the 'good and evil' of TV's impact on its audience. Similarly, the moral panic about what television 'does' to people continues, but in a

different way, given the proliferation of channels and the advent of DVD, the Internet and video games. Nowadays, the anxiety is not only about a passive adoption of violent tendencies. It also addresses the risk of audiences enacting their fantasies with interactive technology preparatory to the real world.

Television studies has developed in a number of ways. Horace Newcomb (1994) has isolated four influences. The first is literary studies, a practice of textual criticism that transferred its concerns from high culture towards entertainment, driven by the desire for relevant, demotic politics that would address hitherto demonised forms of pleasure. This was a US-based tendency, starting in the late 1960s. At the same time, a second key influence was forming in Europe, as cultural studies displaced its left-Leavisite evaluative approach to the popular with an embrace of cultural anthropology, semiotics and Western Marxism, and proceeded to look at ideology instead of ethics. Third came an engagement with the Frankfurt School of critical theory, which was incorporated into US sociology and communications. Finally, film studies provided a site for both old-style evaluative models and psychoanalytic fancies about the audience that were at variance with mainstream ego-psychological effects studies. Newcomb asserts that feminism influenced all these approaches, via the 'recognition of gendered distinctions' in programming and viewing (Newcomb, 1994, pp. 4–7).

The intellectual genealogy of television studies is formidable and very interdisciplinary. Consider the emergence of encoding/decoding as a model of producer–audience relations mediated through TV content. It arose from Umberto Eco's 1965 consultancy for the Italian broadcaster RAI (Eco, 1972), and Harold Garfinkel's 1967 critique of the 'cultural dope' paradigm that assumed audiences lacked an active role in making meaning from the programmes they were offered (Garfinkel, 1992). A list of the foundational books of TV studies would include volumes by Raymond Williams (1962 and 1974) on the nexus of humanities and social-sciences approaches; Herbert I. Schiller (1969) and Armand Mattelart (1976) on the cultural imperialism threat posed by imports; Edward Buscombe (1975) on sport and television; James Curran, Michael Gurevitch and Janet Woollacott's (1977) reader of comparative approaches; Horace Newcomb (1974) and John Fiske and John Hartley

(1978) on the literary method of interpreting TV texts; Manuel Alvarado and Edward Buscombe's (1978) production ethnography of a TV crime series; Richard Dyer et al. (1980) and Robert C. Allen (1985) on soap opera; and David Morley (1980) on the active audience (also see L. R. Beltran and E. Fox, 1980; Tony Bennett et al., 1981; G. Cesareo, 1974; E. Ann Kaplan, 1983). Surveying this literature clarifies that the field emerged from a need to address monopoly capital, cultural imperialism, conditions of production, textual meaning, gendered aesthetic hierarchies, audience interpretation, and pleasure. In other words, critical TV studies has been at once both scholarly and politically committed.

The field has shown immense development in the last few years, marked by such breakthroughs as studies of audiences through the lenses of race and gender (Dines and Humez, 1995; Jhally and Lewis, 1992), omnibus volumes covering the global reach of the medium (Newcomb, 1997; Smith, 1998), decades of successful feminist theory (Brunsdon et al., 1997), challenges to the Eurocentrism of much research (Goonasekera and Lee, 1998), global production histories (Moran, 1998; O'Donnell, 1999), and the advent of cultural-historical approaches (Haralovich and Rabinovitz, 1999), along with an array of scholarly professional bodies, where academia mavens line up to be seen and heard.

This success is a matter of due pride and recognition. Today, television studies provokes its own moral panics among conservative opponents, who express anxieties that curricular changes 'such as the replacement of Shakespeare [British playwright] with *Neighbours* [Australian soap opera]' will diminish civilisation, addling it with 'populism and immediacy' (Turner, 2000, p. 4) rather than complexity and deliberation.

Neighbours – moral panics, curricular changes and television studies (see Turner, 2000)

Despite its success in emerging as a field of consequence, there are severe lacunae in critical TV studies. Psychological effects methods and neo-classical economic models are largely excluded from this genealogy – and they are the favoured domain of powerful conservatives like Schramm and his successors. TV studies needs to enter the lists on these topics as well. The psy-complexes (psychoanalysis, psychology, psychotherapy, psychiatry and psycho-pharmacology) are clearly dominant in public discourse on the media, as measured by academic funding, policy anxiety, moral panics and everyday meta-discourse (for a classic example, see Comstock and Scharrer, 1999). The psy-complexes pose such hardy perennials as: does television rot your brain/educate you/make men violent/incite sexual desire? Effects research remains crucial to limiting what viewers are permitted to see. It is a tool for encouraging concerns with social disorder to be levelled at texts of popular culture, rather than such issues as the availability of weaponry, the norms of straight white masculinity, the rule of capitalism, and the role of the state as an embodiment of supposedly legitimate violence.

On the economic side, media policy is dominated by neo-liberalism, with neo-classical economists saying there should be no governmental barriers to the exchange of programmes and no state subvention of entertainment – the market as a site of magic. This position is opposed by advocates of national-cultural institutions, such as public broadcasting. These critics argue that local audiences should be exposed to locally produced material, rather than programmes that are screened because they are cheap imports (see Noam and Millonzi, 1993). Neo-classical economic discourse is also of great moment in such areas as cross-sectoral ownership, anti-union activity, control of distribution, hidden public subsidies, the rhetoric of technological determinism, and the new international division of cultural labour. Public understanding of these topics is governed by economists, business journalists, corporate lobbyists and agents of the state. Research is needed that addresses this hegemony, via a critical engagement with the analytic, financial and governmental power of the psy-complexes and neo-liberalism. That might provide counter-discourses. Such work can draw on what I see as the strengths of our field: close reading, ethnography, historicisation and political economy. Of course, there have been noble attempts of this sort already: Bob Hodge and David Tripp's *Children and Television* (1986), Richard Maxwell's *The Spectacle of Democracy* (1995), Thomas Streeter's *Selling the Air* (1996), Stuart Cunningham and Elizabeth Jacka's *Australian Television and International Mediascapes* (1996), and David Buckingham et al.'s

Children's Television in Britain (1999) are important works that engage the twin monsters of knowing TV. However, they have not received sufficient follow-up or prominence.

An evolving, contested domain that draws from the humanities, the social sciences and cultural studies, television studies as it is understood in this volume encompasses production and audience ethnography, policy advocacy, political economy, cultural history and textual analysis. This TV studies borrows from and contributes to media studies, mass communication, critical race theory, communication studies, journalism, public policy, media sociology, critical legal studies, queer theory, science and technology studies, psychology, film studies, economics, cultural studies, feminist theory and Marxism. One common and abiding preoccupation of television studies is to question power and subjectivity in terms of access to the means of communication and representation. This questioning recurs across sites, albeit with due regard to the specificity of the medium's social uptake – the occasionality of culture. By this I refer to the fact that TV is comprised of cultural products that travel through time, space and population. As such, their material properties and practices of circulation must be addressed in a way that blends disciplinary perspectives.

Of course, we are also faced with the claim that television has had its day, that the Internet is the future. That may be. But I suspect that the future will involve a *transformation* of television, rather than its *displacement*. As we have noted, TV started in most countries as a broadcast, national medium, dominated by the state. Since then it has been transformed into a narrowcast, international medium, dominated by commerce – but still called 'television'. A TV-like screen, located in domestic and other *spaces*, and transmitting signs from other *places*, will be the future. It may even be that television as a word comes to take over what we now call 'new media'. In any event, there is intellectual and political value in utilising the knowledge gained from TV studies to assess this transformation and intervene in it. Examples of such scholarship already on the books include volumes from Steven G. Jones (1998), Kevin Robins and Frank Webster (1999) and Wendy Harcourt (1999).

In order to change the field of television and/or new media, we need to address our own strengths and put them to good use against the mainstream's anti-democratic tendencies. To that end, this volume engages both conventional approaches and more radical ones, in the interests of engaging hegemonic perspectives both on their own terms and from outside. *Television Studies* summarises the current state of play in the field, how we got here, and where we need to go. In capsule, suggestive form, it offers both an overview of the current state of knowledge about television and an intervention into that knowledge, opening up new areas. This is, then, a representative, reporting role that is also linked to innovation. In keeping with that mission, the contributions are by experts in the field from five countries.

The book offers four focal points, each with its own section:

• forms of knowledge;
• audiences;
• gender;
• race.

'Forms of Knowledge' looks at key methods of researching television, providing a broad overview of available methodologies and their social implications. 'Audiences' applies these methods to the key public obsession with television – what does it *do* to you? 'Gender' and 'Race' combine the analysis of textual issues about representation with an address of policy and programme initiatives to redress bias and neglect.

Throughout, the basic goal of the book is to encourage its readers to think critically about the social role of television, and familiarise them with its central discourses and institutions. If we are to imbue the medium with progressive cultural politics, we must understand how it is regarded by those in power who favour conservative politics, recognising that the technology is available for socially progressive transformation.

Author's note: My thanks to Marie Leger for her comments.
Toby Miller

FORMS OF KNOWLEDGE

Introduction

In 1974, Horace Newcomb said of television that 'noone seems to know what the medium is'. This difficulty arose, he thought, because TV was 'so much more than art . . . exist[ing] in a perpetual tension between what will sell and what satisfies the multiple needs of producers, actors, writers, directors, and the audience' (p. 1). One might add the state to this list. The means of creating, understanding and policing these various needs have arisen from disciplines such as business administration, psychology, labour organisation, public policy, economics and textual analysis. Newcomb called for a harmonisation of these modes, such that social-science approaches to the audience, and textual approaches to programming, could pay equal and even combined attention to effects on audiences and signification on programming (1974, p. 244). For the most part, this has not happened. This section of *Television Studies* examines such traditions. Perhaps a new generation of scholars will emerge who can reconcile the differences and their separate development. But, as you will see, some of the distinctions derive from political disagreements about the role of research as well as disciplinary ones. Full harmonisation may be unattainable and even undesirable, for the projects of, for example, feminist analysis and neo-classical public policy may simply be at odds.

Toby Miller

Mass Communication Studies

For some time, television has been central to mass communication studies. The cultural primacy of television as a form of mass communications has, understandably, captured a great deal of attention among those interested in the study of mass media. Indeed, it could be argued that this has led to the comparative neglect of other mass media – notably radio, which is often regarded as something of a footnote in discussions of broadcasting. The study of mass communications, however, precedes television, even if some of the questions raised were appropriate to it.

Writing in the early 1960s, Raymond Williams observed that 'there are in fact no masses, there are only ways of seeing people as masses' (Williams, 1963, p. 289). How the masses were seen, he suggested, was partly a function of how the term was understood. In his view, notions such as 'mass culture' or 'mass communication' were judgments rather than mere descriptions. The 'masses' – like the term 'mob' that preceded it – tended to signify 'gullibility, fickleness, herd-prejudice, lowness of taste and habit' (p. 288). If the notion of 'mass communication' no longer carries quite such pejorative inferences, Williams' observation does provide a commentary on the development of mass communication studies.

The idea of 'mass communication' came from the more general notion of 'mass society', an idea developed in response to urbanisation, regional or national forms of citizen organisation (such as the labour movement or professional sports leagues) and the growth of the mass production and consumption of goods. Mass communication was seen as part of this process, as the production of information and culture became organised on an increasingly industrial scale.

By the end of the 19th century, for example, the leading British Sunday newspaper – *Lloyd's Weekly News* – reached a circulation of 1 million (Thompson, 1997). By the 1930s, an established national and regional press in Europe and North America existed alongside burgeoning radio and film industries. The development of television in the late 1940s and 50s created a mass medium *par excellence*, quickly becoming – and remaining – the most ubiquitous cultural industry.

Although written in a pre-television era, Walter Benjamin's essay 'Art in the Age of Mechanical Reproduction' (1935) was one of the more sophisticated attempts to come to terms with the mass production of information and culture. Unlike some of his contemporaries, Benjamin did not see the consumer of mass culture as a simple functionary (Benjamin, 1970). For Benjamin, the citizen was capable of engaging with new forms of communication, while the reproducibility of cultural forms, he argued, might make them a democratic source of insight. He saw film, for example, as a medium with the potential to stimulate *active* audience responses and which might generate, in turn, more sophisticated forms of social

Metropolis (1926) – the 'Masses'

awareness. The problem, for Benjamin, was when mass communication sought to entrance, rather than engage with, the spectator and thereby create what he saw as a fascist aesthetic based on mass compliance. Benjamin's two visions of the audience for mass communication – the active citizen or the passive consumer – would be repeated in various forms at various points in the history of mass communication studies, and it is a dichotomy that remains.

Unlike Benjamin, many social theorists in the first half of the twentieth century, saw the citizenry that emerged from the rise of mass society as shadowy figures, defined only by the commonalities of their physical or cultural environments. Indeed, against the backdrop of fascism and Stalinism in Europe, and amid critiques of the dehumanising nature of mass production (expressed most vividly in films like *Metropolis* or *Modern Times* [1936]), audiences for mass communication were often understood in precisely the terms Raymond Williams described, as intellectually passive and easily manipulated.

This view of the masses, albeit with different inflections, was recognisable in both European Marxism and American sociology. These two important traditions were brought together at Columbia University in the 1940s – perhaps the best-known institutional birthplace of mass communication studies – when mass society theorists at the University's Department of Sociology affiliated with Walter Benjamin's colleagues at the Frankfurt Institute for Social Research (who moved to New York City to escape Hitler's Germany). Benjamin himself was less fortunate, and he died fleeing the Gestapo in 1940. And, it might be said, his more nuanced approach to the relationship between mass cultural forms and audiences was also left behind – at least for a period.

In the 1940s and 50s, as television began to emerge as a dominant medium, mass communications research began to establish itself in the United States, and researchers at Columbia developed what came to be known as the media 'effects' tradition (see p. 11). The effects approach was informed by a concern that the growth of mass media implied increasingly centralised control – whether from government or from private corporate mass media – over culture and information. The use of media in fascist propaganda in Europe and the growth of commercially driven mass entertainment in the United States were seen, by exiles from the Frankfurt School, as different visions of totalitarian forms of media power. At the same time, the market research industry sought to use mass communications research to achieve precisely what some members of the Frankfurt School feared – namely the use of media to push people, *en masse*, to devote increasing income and leisure time towards enormous increases in the consumption of commodities.

Alongside the lingering images of fascist propaganda and the concerns of the Frankfurt School were fears that

have always tended to accompany the widespread use of new media technologies. In particular, mass media were linked with changes in moral value systems, an anxiety that has often been articulated around one of its potentially most extreme manifestations – the idea that images of violence in the mass media would lead to violent behaviour. This fear was particularly pronounced in relation to television, which combined an almost universal reach with the power of the moving image.

The early development of mass communications research was therefore partly a response to a range of social, political and cultural concerns about the impact of mass media. Much of the early 'effects' research in the United States alleviated these fears, and succeeded in diminishing visions of an all-powerful media creating homogeneous mass cultures or manipulated mass publics. The dominant view of this period is that mass communications research found the effects of media to be 'minimal' – mediated or obviated by other influences. In retrospect, this view seems premature – not least because of a growing market research industry that suggested propaganda for commercial ends could be singularly effective (Hovland, 1959). However, the *impact* of the notion of 'minimal media effects' was profound. It not only sanctioned the development of mass media as a force compatible with (rather than antithetical to) democratic culture, but informed a liberal, pluralist philosophy of mass media. This philosophy characterised the role of mass media in capitalist or mixed economies as responding to (rather than shaping) consumer demand, serving different needs in different ways and, therefore, as an essentially benign institution.

The liberal pluralist approach was, in many ways, encapsulated by the 'uses and gratifications' tradition developed in the wake of the notion of 'minimal effects' (see pp. 70–3). A mass cultural form like television had become part of the cultural environment without, apparently, becoming a tool of mass propaganda (although the role of the media in one of the twentieth century's most successful propaganda campaigns – anti-communism – was largely uninterrogated) or causing major upheavals in the social order. Uses and gratifications saw the influence of media in relation to the way it was used to gratify people's needs (such as the need to be entertained or informed) and in relation to people's motivations (such as their interest – or lack thereof – in politics). The concept of the 'mass audience' could no longer be regarded as a passive, undifferentiated entity, but as a series of active sub-groups using media for their own ends. This approach was, in both sociological and psychological terms, more sophisticated than some of the 'effects' studies that preceded it, but it was also

a turn away from investigating the ideological power of mass media. Uses and gratifications was also premised on a functionalist sociological model in which media power was scrutinised much more for its role (or lack thereof) in contributing to deviant behaviour (or for 'dysfunctional' influence) than for its role in reinforcing the status quo.

In terms of reach, concentration of ownership and domination of leisure time, television quickly became the dominant and most influential form of mass communication. And while some of the fears that accompanied the rise of other mass media resurfaced with television, by the 1960s in the United States, the ideological thrust of capitalist consumerism was such that concerns about mass communications – and television in particular – were often understood as a function of consumer power rather than media power. Thus when Federal Communications Commissioner Newton Minow famously described US television as 'a vast wasteland' (see p. 55), his critique was of the debased tastes of the vulgar masses rather than the commercial imperatives of the system (Ouellette, 1999).

By the 1970s, although its institutional presence was still most significant in the United States, the systematic study of mass communication had crossed the Atlantic. The influence of the Frankfurt School began to wane, and the study of mass communications had also become less concerned with questions of culture and more preoccupied with applying sociological and psychological models to mass media. The development of mass communication studies in Britain and the United States, nonetheless, followed different trajectories. In the US, disciplinary barriers and traditions tended to be less rigid, and mass communications research found a home in communication departments (along with the study of interpersonal communication and, in a rather quirky if appropriate gesture towards a more classical tradition, the study of rhetoric). The study of mass communication in Britain was more firmly confined to the margins of the academy, where the social sciences – sociology in particular – were still regarded with some suspicion, and the humanities were firmly reserved for the study of elite culture.

During the 1970s, the study of mass communication and popular culture was caught up in the development of cultural studies in Britain and the increasing influence of continental European theory. If mass communications had, until this point, fallen under the auspices of social-science traditions, it was now bombarded by interest from the humanities. Film was becoming old enough – and apparently respectable enough – to be treated as an art form, while the influence of semiotics and other forms of textual analysis spread quickly from departments of liter-

ature to raise more general questions of meaning. These questions – about culture, ideology and the politics of representation – applied every bit as much to television as they did to the traditional arts. The influence of the humanities was particularly profound outside the United States, where the fledgling tradition of mass communications studies was partly dislodged by a cultural studies approach that combined the social sciences and the humanities in ways that foregrounded questions of power. From this confluence emerged a new creature that is perhaps most commonly identified as 'media studies'.

In the United States, the institutional presence of mass communications research – and communication studies in general – kept the new media/cultural studies approaches (which had their own distinct American forms) on the periphery. The influence of these approaches has been gradual and dispersed: the response of the mass communications research tradition has ranged from interest to deep suspicion and, within a variety of institutional settings, media/cultural studies has been incorporated, accommodated, resisted or ignored. Today, the differences between media or cultural studies and mass communications studies are fluid rather than fixed, a matter of nuance rather than a product of clearly defined boundaries. While both forms devote a great deal of time to the study of television, mass communications is generally seen as more rooted in social-science traditions – such as sociology, political economy or psychology – while media studies has been dominated by textual forms of analysis. Mass communications tends to be more sympathetic towards quantitative methods of analysis, while media/cultural studies is identified with more qualitative methodologies (although the whole question of methodology has been more vigorously pursued under the rubric of mass communications). If there is a defining logic here (and the boundaries here are often rather hazy), it comes from the notion of 'mass' – for while some in the mass communications tradition assume, with Raymond Williams, that 'masses' are analytical constructions (rather than experiential categories), the focus is on the macro rather than the micro.

So, for example, television audience research within the media and cultural studies tradition has tended to be qualitative, often with an emphasis on particular social groups and contexts. Approaches developed within mass communications studies, while they have taken many in the field beyond the notion of 'minimal effects', have tended to explore television's influence on society as a whole. In particular, the emergence of cultivation analysis (which deliberately focuses solely on television as the dominant medium) and agenda-setting research (which has looked at both television and the press) explore ways in which television can create common assumptions and ways of understanding the world – not by overt attempts at persuasion, but simply by privileging *some* kinds of images, representations or facts over others.

Justin Lewis

RECOMMENDED READING

Benjamin, W. (1970), 'The Work of Art in the Age of Mechanical Reproduction', in *Illuminations*, London: Jonathan Cape.

Thompson, John B. (1997), 'Mass Communication and Modern Culture', in T. O'Sullivan and Y. Jewkes (eds), *The Media Studies Reader*, London: Arnold.

Williams, R. (1963), *Culture and Society*, London: Penguin.

The Political Economy of Television

The interplay of social, individual, ideological, popular, structural, institutional and technological forces in industrial societies is a subject that evokes diverse and conflicting interpretations. Conventionally understood, industrialisation and the rise of the mass media in the United States were concurrently part of the emergence of 'mass society', a morphogenesis of serendipitous events, spontaneous technological breakthroughs, shifting cultural frames and individuated genius engaged in the art of nation building and the pursuit of national economic development. As an alternative framework, critical political economy is rooted in the Marxian tradition, that is, one that draws on the works of Marx and his epigone, including those who share some of Marx's core precepts but have taken Marxism in directions its intellectual progenitor did not necessarily contemplate or intend. Political economy asks how the means of accumulating material largesse and political practice co-evolve within a conflictual, class-tiered social structure. Political economy historicises, politicises and foregrounds social change as a continuous dialectical tension between owners and direct producers of material and social wealth. It challenges mainstream approaches to communications studies, as one Marxian writer notes, in 'placing its emphasis on production or supply rather than consumption or demand as the determining moment'(Garnham, 1990, p. 7). Even as political economy is highly critical of capital's relentless commoditising, labour-exploiting and imperialist propensities, it shuns

both crude economism and essentialism on the one hand and idealist eclecticism on the other. Among the many leading contributions to the political economy of media in North America and Western Europe are Gandy (1992), Garnham (1990), Golding and Murdock (1991), Hamelink (1983), McChesney (1993), Mattelart (1991), Mosco (1996), Murdock (1978), Robins (1991), D. Schiller (1988), H. I. Schiller (1981), Smythe (1977), Webster (1995) and Williams (1975).

Enveloped in historical-industrial processes, mass media emerged from a confluence of different factors. These include political initiatives (e.g., property law and entitlement, territorial expansion, state regulation and legitimation), technological means (e.g., railroads, telegraphy, electrical, optical and chemical engineering), capitalist accumulation (e.g., monopolies, an international division of labour, innovations in product and classified advertising) and an underlying material culture emphasising the conquest of nature in the service of capital – which together define the meaning of 'progress'. The economist Alfred Marshall presented the underlying premise as: 'Knowledge is our most powerful engine of production; it allows us to subdue Nature and force her to satisfy our wants' (cited in Perelman, 1998, p. 46). Television, experimentally introduced in the 1920s and mass-circulated in the 50s, became the most effective promotional and ideological instrument of capital. The first postwar quarter-century in the United States was a period of unparalleled material prosperity, and the television industry heavily sold and indulged postponed Depression- and wartime-era gratifications of leisure and consumption.

From the political economy perspective, television (or any technology for that matter) was not invented – in the way that that concept is usually understood. It was neither the genius of an individual nor the collective will of 'society' that brought it to fruition. Rather, as Raymond Williams (1975) explains, television was the outcome of a series of technological developments related to private industrial needs going back to the 19th century and foreseen in experimental photo-telegraphy. The forms and functions of television are not technologically determined so much as commercially, politically and socially constructed. Drawing on the talents of craft and performance labour in a production process that is continually negotiated and renegotiated with capitalist owners, financiers and corporate management, television labour as a whole continually faces technological substitution, cost-reduction threats and industry layoffs. Designed in this context primarily for delivering audiences to advertisers, the 'logic' of the television set is encased in a set of monopolistic legal and industrial precedents, class-dominated prerogatives, and familiar styles of commercial entertainment and modes of state legitimacy that are dedicated to maximising household consumption. In the one-way flows of market- or state-sponsored programming, households are treated as efficient units of goods, services and ideological consumption, with television serving as a utility *par excellence* in the circulation of commodities.

From working-class, ethnic and gender perspectives, American television's portrayals of social conflict bear a heavy textual imprint of white male corporate sponsorship and supremacy. The real-life struggles of working people, generally ignored or ridiculed by commercial television, are represented only slightly more realistically by public broadcasting (PBS). A study done by the City University of New York in 1988–89 found that less than 0.5 per cent of prime-time television addressed the lives and concerns of workers as workers, of which more than two-thirds focused on British workers and a mere twenty minutes per month dealt with American workers (Cohen and Solomon, 1992, p. 19). Few prime-time programmes or news broadcasts consider the structural inequalities and humiliation commonly experienced by workers, women and people of colour.

The bias of network television lies not only in its topical selection and slant but more essentially in its unending commodification of information and culture – 'selling both consumer goods and a "way of life" based on them' (Williams, 1975, p. 41). By the early 1990s, Americans on average were exposed to more than 30,000 television ads per year (Postman and Powers, 1992, p. 122). British sociologist Anthony Giddens sees television, driven by 'giant multinational media corporations . . . [led by] unelected business tycoons', as having undermined democracy by 'destroy[ing] the very public space of dialogue they open up, through a relentless trivialising, and personalising, of political issues' (Giddens, 2000, pp. 96–7). As political culture, television packages programming primarily to promote entertainment values, an elite-defined ideological consensus and political legitimation, with the aid of news formats that give the widest possible coverage to a narrow list of approved topics and reliable 'experts'.

Political advertising, which symbiotically links media to the political and corporate establishment, channels windfall profits to television from well-oiled interest groups. This turns a narrow two-party structure into a kind of money-laundering operation of corporate political action committees to control the selection of candidates and party agendas and purchase the attention of voters. Political advertising is marked by style over substance (simulacra),

customised messages over reasoned arguments, irrational over rational appeals, pre-tested symbolic manipulation of audiences (via polling and voter research), standard media conventions (e.g., news-oriented sound bites), and other propaganda techniques. By 1992, the US national elections ran up costs of $1.6 billion, of which up to three-quarters was spent on television and mail advertising (Strother, 1999, p. 188); by 1996, spending reached $2.2 billion (Abramson, 1997, p. A18). The television industry's monopoly control of the nominally 'public' airwaves helps explain television news' disinterest in campaign finance reform or free airtime for political candidates.

Ideological consensus is also encouraged through increasingly concentrated and interlocked media ownership, occurring at a time when state deregulation was supposed to yield greater competition and consumer choice. Among the more than 25,000 newspaper, magazine, television, book publishing and motion picture outlets found in the United States, the majority are now controlled by some six multimedia Fortune 500 CEOs who manage the country's cultural industries. Almost all of them can be classified as 'economic conservative', according to Ben Bagdikian

Rupert Murdoch – 'economic conservative' and merger mogul

(1997), a former Pulitzer Prize winning journalist, *Washington Post* editor, and professor at the University of California, Berkeley. The big five megamedia conglomerates are AOL Time Warner, News Corporation, Disney, Viacom and Sony.

Since the Reagan administration, the management of television and other media industries have engaged in a frenzy of deeper and wider forms of vertical and horizontal integration, both within broadcasting and across the once separate telecommunications industries, bringing a major consolidation of TV station ownership. The Telecommunications Act of 1996, a Magna Carta for media and telecommunications industries, and the business-oriented Federal Communications Commission have accelerated megamergers among telecommunications, broadcasting, cable and Internet companies, including the $55 billion AT&T takeover of TCI in 1999, respectively the country's largest telecommunications and cable operators, and the more recent $106 billion AOL–Time Warner marriage. The television business, still the most important piece of media real estate, has been greatly amplified in recent years with the advent of digital, multimedia and broadband technologies and a multiplicity of media channels, including those carried by cable, satellite and the Internet, that compete for the advertising dollar.

One of the results of these mergers has been severe layoffs. Rupert Murdoch, owner of Fox Broadcasting Network, among many other media holdings, built his American television empire on the strength of low wages, layoffs and job reclassification (after sacking 5,000 union employees from his London newspapers – see Downing, 1990). In Britain, television employment has been falling drastically. At the British Broadcasting Corporation, the number of jobs dropped by 17 per cent between 1987 and 1993, and at the ITV stations, employment slumped 40 per cent from 1988 to 1993 (see Cornford and Robins, 1998, pp. 203–4). Little attention has been given to the political economic effects of neo-liberalism on media, including declining state support for PBS and public access cable channels.

The US media system is being replicated globally. Aggressive state and corporate initiatives in the early postwar period spread American and British television standards to the rest of the world, the United States being the dominant player in mass-media exports (Tunstall, 1977). A handful of film and television studios, press agencies, government broadcast services, book and magazine publishers, and advertising and public relations firms control the global distribution of mass media and, in effect, what most people read and receive electronically. The American music

television network, MTV, with its high-tech music and electronic image culture, penetrates 215 million homes in seventy-five countries (McPhail, 1993). Atlanta-based Cable News Network International (CNNI), launched in 1980, transmits television news in English and five other languages all over the world, half of its international programming coming directly from its US cable news station, with twenty-eight news bureaux (and 500 radio stations) reaching by the mid-90s some 130 million people. During the Persian Gulf War, the whole world was glued to CNNI's version of events, a measure of influence no world leader could match. At the same time, Reuters Television was supplying television news to more than 400 broadcasters in eighty-five countries, with an audience of some half-billion households (Hamelink, 1994, p. 83).

Television programming is largely centred in Hollywood lots and studios, although 'formatting' has become a new method by which creolised versions of US and Western European programmes are reproduced in other countries – in effect proliferating Hollywood through a variety of 'domestic' vernacular imitations of commercial television under the hegemony of increasingly market-based cultural regulation. Whether or not the imports are of a direct or indirect nature, US television companies, commodity producers and product advertisers stand to be the biggest winners.

The key to the redemption of television is ultimately political. As an institution that links citizen to civil, state and economic society, television cannot be entrusted to motives that serve only profit and that inevitably lead to insatiable commercialism and tabloid excesses. The short-term way to recovery is to adopt strict rules of accountability for the commercial media and guarantee adequate state funding for competitive public media that nurture a vibrant public sphere, and not only via PBS, with opportunities for creative and independent grass-roots alternatives introduced by television and radio performers, writers, directors, producers – and by audiences.

Gerald Sussman

PIERRE BOURDIEU ON TELEVISION NEWS

One of the leading critical European intellectuals, Pierre Bourdieu (1930–2002), a postwar French sociologist trained in the Marxian tradition, first published *On Television* in 1996. The English language translation came out in 1998 (Bourdieu, 1998). Focusing on news journalism, Bourdieu moves beyond the emphasis on ownership concentration in the political economy of media to the less reductionist, more interpretative realm of social and cultural practices. Bourdieu argues that it is within the underlying social and economic *premises* of capitalist media where one finds explanation about why the news is both narrow and shallow in its coverage.

Ownership is not an insignificant factor for Bourdieu, but for him the consequences of concentration are too obvious to even discuss. Indeed, it could be argued that the number of corporate media owners is relatively unimportant, else we would look back to the far less concentrated 1950s and expect to find a far more diverse array of political, social, cultural and ethnic viewpoints represented in the media. Looking at the United States, the opposite is true. Where concentration is actually of more significance is in the transnationalisation of media, a concern that Bourdieu ignores.

Bourdieu offers a number of harsh but astute observations about television, although for seasoned critical observers they are not particularly remarkable or new. He finds that television journalists commonly defer to the industry standard of compressed, disintegrated news coverage and accept its absence of historical and political context and interrelationships of events. Opting for safe reporting and rarely if ever seriously challenging the sacred cows of profit-seeking media (such as the privileged position of commercial advertising and the hegemony of such sources as the *New York Times* and the wire services), their 'professionalism' is compromised by self-censorship, survivalist instincts, conformity – and narcissistically as wielders of symbolic (celebrity) capital. News organisations are thus bound by a big market-manipulated, Nielsen-driven ratings imperative, which, he says, reduces their product to depoliticised, homogenised mediocrity or 'cultural fast food'.

Bourdieu's work is more nuanced in some ways than a lot of recent radical media criticism, but it does not fully dissect how the ratings and commercial system of production actually work. Demographic profiling of viewers reveals not simply how many people watch a programme but what their disposable income and spending habits are, a more important determinant of what appears and remains on the air. He also assumes that viewers are as bored by intelligent programming as the media barons claim. In fact, there is little evidence to support what viewers will or will not watch when creative and culturally attuned production techniques are mixed with informative content.

By restricting his analysis to news and ignoring television's entertainment formats, Bourdieu does not respond to post-modernist readings of the medium, including the

notion that 'active audiences' independently construct ('co-produce') their own individual meanings in what they watch. Bourdieu would probably answer that television is a far more effective instrument of propaganda than post-modernists generally realise and would insist that while audiences are not necessarily victims, the culture of the medium under a corporate capitalist value structure prevents its potential to develop. In contrast to another leading French intellectual, Jean Baudrillard, Bourdieu believes that under the right conditions (democratic socialism) its uses as an instrument of broadly political, educational and cultural value can be recovered or launched.

Gerald Sussman

RECOMMENDED READING

Bourdieu, P. (1998), *On Television*, trans. Priscilla Parkhurst Ferguson, New York: New Press.

Downing, J. (1990), 'The Political Economy of US Television', *Monthly Review*, May, pp. 30–41.

Garnham, N. (1990), *Capitalism and Communication: Global Culture and the Economics of Information*, London: Sage.

Mosco, V. (1996), *The Political Economy of Communication*, Thousand Oaks, CA: Sage.

Schiller, H. I. (1981), *Who Knows: Information in the Age of the Fortune 500*, Norwood, NJ: Ablex.

Sussman, G. (1997), *Communication, Technology, and Politics in the Information Age*, Thousand Oaks, CA: Sage.

Violence and Effects Research

Violence on television has provoked controversy and concern since the medium's earliest days. While there have been some especially intense peaks of sustained attention during the past five decades, the issue has never been far from the eye of parents, teachers, politicians, religious leaders, media activists and researchers. Television quickly inherited the fears that previous generations had expressed about the presumed harmful effects (especially on the young) of media such as movies, pulp fiction, radio and comic books. Yet, even as new media such as video games and the Internet provoke worries about high-tech violence in the 21st century, television's dominant cultural role means that the violence it presents remains a critical focus of public debate. In the interim, it has become a sprawling and unruly topic; the Internet search engine Google.com returns links to 460,000 web pages (as of January 2001) that pertain to the issue.

It is frequently claimed that children see about 10,000 acts of violence per year on television, and that by the time they graduate from high school, they will have witnessed about 40,000 murders. Such figures, promulgated by the American Medical Association and other groups, may or may not be inflated, but content analyses have established that violence is pervasive and nearly inescapable on television. Thirty years of studies by George Gerbner show that, with only minor fluctuations since the 1960s, violence occurs five or six times an hour (about twenty-five times per hour on children's programmes), and that more than half of all major characters are involved in violence. In the 1990s, the National Television Violence Study found violence in about 60 per cent of the nearly 10,000 programmes analysed. Blood, gore and pain are rarely shown. Much violence is committed by 'good', attractive characters, and most violent scenes feature no remorse or penalty. Long-term studies of the portrayal of television violence consistently conclude that television's portrayals of violence are 'remarkably stable' over time. These studies point out that although gruesome violence and bloodshed have been central features of both religious and secular stories for centuries, the sheer quantity of violent images to which people are regularly exposed today is unprecedented. The extension of viewing options by cable, satellite, VCRs and other new technologies has only increased the amount of violence television disseminates, and often its explicitness as well.

Many have asserted that 'thousands of studies' have been carried out on the effects of television violence, and that all but a very small handful of these demonstrate that fictional violence stimulates actual aggression. For example, testifying to the Senate Commerce Committee, the President of the American Academy of Pediatrics stated:

> Since the 1950s, more than 3,500 research studies in the United States and around the world using many investigative methods have examined whether there is an association between exposure to media violence and subsequent violent behavior. All but 18 have shown a positive correlation between media exposure and violent behavior. (Cook, 2000)

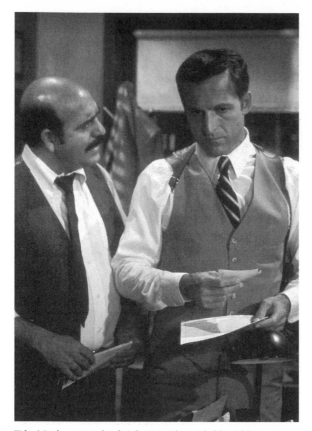

Television's portrayals of violence are 'remarkably stable over time': *Hill Street Blues*

The actual number of studies that have been conducted is much smaller – about 200, at most. The discrepancy is due to the very large number of reviews, summaries, opinion pieces and commentaries on the topic; almost 3,000 articles (not all of which were empirical studies) concerning television violence had been published by 1980 (Murray, 1980), and this reinforces the myth of the 'thousands of studies'. On the other hand, the results of the actual studies do consistently show that exposure to television violence is associated with aggressive behaviour and antisocial consequences.

Researchers studying the effects of television violence on viewers generally focus on one of three hypothetical outcomes:

- exposure to television violence causes people to behave in more violent or aggressive ways;
- exposure to television violence leads people to become desensitised to violence;
- exposure to television violence cultivates the belief that the world is a 'mean and scary place'.

Other potential emotional effects include fright reactions and nightmares, the valorisation of violence as a legitimate means to resolve conflicts (including international disputes), and the expectation that others will resort to violence to solve problems. Nevertheless, most of the research attention and public concern have focused on the first hypothesis above, that television violence breeds real-world violence. Various mechanisms have been proposed for this effect (Josephson, 1995). In the most direct version, some believe that viewers simply imitate the violent acts they see, leading to 'copycat' violence, or that viewers acquire violent behaviour through a process of social learning. Others hold that television violence 'arouses' viewers, and that such excitement leads to the performance of violent acts. Also, witnessing representations of violence might reduce the inhibitions that are normally in place against behaving aggressively, or it may 'trigger' impulsive acts of aggression (a process known as priming). Watching television violence may displace other activities, such as socialising with other children and interacting with adults, that would teach children non-violent ways to solve conflicts. Alternatively, some claim that watching television violence provides a healthy way to release aggressive impulses (through catharsis), although there is no empirical support for this position.

Many controlled experiments were conducted in the 1960s, mostly with subjects ranging from young children to college students. In a typical laboratory study, subjects would be randomly divided into experimental and control groups; the former would be exposed to some violent stimulus (e.g., a violent clip from a film or TV show) and the latter would view some presumably innocuous material (e.g., a travelogue). Subsequent to exposure, some measurement of violent behaviour or aggression would be taken; for example, subjects might be given the opportunity to punch and kick a Bobo doll, or to push a button which they believed would cause someone pain, or to choose among various violent or non-violent conclusions to a narrative, and so on. The difference in the violent actions or inclinations of the two groups is attributed to the specific stimulus to which they were exposed (violent or non-violent), since the random assignment to experimental and control groups could be assumed to eliminate any pre-existing differences between the groups. Many variables were manipulated in later versions of these experiments (e.g., is the violence presented as 'justified' or not, is it presented as 'punished' or not, is the perpetrator attractive, is the violence graphic or sanitised, what happens if subjects are first experimentally frustrated, or exposed to pornography, and so on), but the essential design is the

same in all cases. Virtually all such studies have found that experimental exposure to violent stimuli generates violent responses, despite the range of potential mechanisms at work and and despite the complexity of variables and processes that can and do moderate (enhance or diminish) the effect. In the 1970s, researchers turned increasingly to field studies, to investigate the extent to which the results from experimental studies could also be observed outside the artificial confines of the lab. These studies, typically surveys of adolescents, correlated amount of exposure to television violence (as it occurs 'naturally' in real life, and not as a result of assignment to an experimental or control group) with various measures of aggressive behaviour, including observation of behaviour in schoolyards, self-reports of aggressive tendencies and frequency of getting into fights, or reports from peers and/or teachers. Those who tend to watch more violence on television tend to score higher (i.e., more aggressively) on whatever scale or measure of violent behaviour is used. The strength of this correlation may vary a great deal for different groups (depending on age, class, gender, region, parental relationships, among many others), but it is an extremely consistent finding.

Many other research strategies have been employed. Some studies examined communities before and after the introduction of television, finding increases in both physical and verbal aggression, with no changes in control communities (Williams, 1986). Some 'panel' studies have followed the same people over long periods of time (over twenty years), finding that exposure to media violence in childhood has long-term impacts on aggressive behaviour as an adult (Huesmann and Miller, 1994). A growing number of 'meta-analyses' have been conducted, in which the data from numerous independent investigations are statistically accumulated and compared; these analyses leave no doubt that the existing research establishes a positive association between exposure to televised violence and aggressive behaviour (Comstock and Scharrer, 1999; Hogben, 1998; Paik and Comstock, 1994).

A few scholars claim that the research suffers from methodological flaws that invalidate these conclusions (Fowles, 1999; Gauntlett, 1998). Most disagree; there is a clear consensus among the vast majority of investigators that violence on television does lead to aggressive behaviour, based on the consistent convergence of results over a wide range of research designs. This effect should not be overstated; the research does not suggest that television violence compels otherwise peaceful viewers to brutally rape, assault or murder each other. Yet, it does show a strong and clear link with aggressive behaviour such as pushing, shoving and bullying. Television violence is not the only, or by any means the major, factor in real-world violence and aggression, but its contribution to these behaviours cannot be denied on the basis of the empirical evidence.

Social upheavals and events such as political assassinations, urban unrest, rising crime rates or school shootings inevitably and cyclically place television violence on the front burner of research and policy debate. At these times, public debate over the effects of television violence tends to be polarised between over-simplified extremes. Television's ubiquity and the prominence of its violence lead some to treat it as a convenient scapegoat for actual violence in society. Widely publicised cases of apparent imitation – in which some shocking act of violence seems to have been directly caused by something the perpetrator saw on television – regularly appear in the news, bolstering the 'television-causes-violence' equation in conventional discourse. On the other hand, others point to more serious social problems such as poverty, drugs, the easy availability of guns, and child or spousal abuse, arguing that, in comparison to these, the role of violence on television is trivial and irrelevant. The research evidence calls for a more nuanced view.

It should be noted that the television industry has been able to maintain consistency in its product, despite decades of research, congressional hearings, public pressure from parents, efforts by activists, health organisations and crusaders (from the left and the right) and periodic pronouncements by the Surgeon General (most recently, in January 2001, that 'exposure to violent media plays an important causal role' in youth violence). There is no reason to assume that television in the 21st century will adopt any meaningful changes in the nature and frequency of the violence it presents.

Michael Morgan

RECOMMENDED READING

Comstock, George and Scharrer, Erica (1999), *Television: What's On, Who's Watching and What It Means*, San Diego: Academic Press.

Huston, Aletha C., Donnerstein, Edward, Fairchild, Halford, Feshback, Norman D., Katz, Phyllis A., Murray, John P., Rubenstein, Eli A., Wilcox, Brian L. and Zuckerman, Diana (1992), *Big World, Small Screen: The Role of Television in American Society*, Lincoln, NE: University of Nebraska.

Morgan, Michael (ed.) (2002), *Against the Mainstream: Selected Writings of George Gerbner*, New York: Peter Lang Publishers.

United States Senate Committee on Commerce, Science, and Transportation (2000), *Children's Protection from Violent Programming Act: Report of the Committee on Commerce, Science, and Transportation on S. 876*. Washington: US GPO [online: http://www.purl.access.gpo.gov/GPO/LPS7638].

Ethnography

'Ethnography', in television studies, has been a controversial and often mystifying term. It signifies issues crucial to the development of television, particularly audience, research over twenty-five years, yet its use has often shed more confusion than light. We must distinguish sharply between a loose use of the term 'ethnographic', to describe most qualitative work on audiences, and 'media ethnography' in a more precise sense. While the former is best abandoned, there is much to gain from 'media ethnography' proper, and the dialogue it opens between media research and anthropology (see box, p. 16).

'Ethnography' developed to describe twentieth-century anthropology's classic research form: going to live for an extended period in a strange place, observing life there and returning home to write a book. This practice was championed by Bronislaw Malinowski (for a useful discussion, see Geertz, 1988: chapter 4), rejecting earlier 'armchair anthropology', but its dependence upon colonial privileges has since been thoroughly deconstructed (Clifford and Marcus, 1986). But what has this idea of ethnography got to do with researching the everyday practice of watching television? To understand the potential of ethnography in television studies, we need first to understand the developing logic of audience research.

This moved, in various stages, away from the television text: first, an interest in the various ways audiences interpret any text; second, an interest in the actual contexts where interpretations get made; third, an interest in the connections between watching television as an everyday practice and everything else we do in the home. It is the second and third stages on which we will concentrate, although they were inconceivable without the first and they do not exclude a fourth, quite independent possibility, which is to develop an ethnographic approach to television *production*, also touched on below. That *some* version of ethnography – the detailed observation of living contexts – seemed essential to studying television is hardly surprising.

Many media researchers began in the 1980s investigating the complexities of how television is viewed in the home: notably in the UK, Dorothy Hobson (1980), David Morley (1986), Ann Gray (1992) and Shaun Moores (1996). They generally made no claims to do ethnographic research, for their work involved interviews in people's homes, but not any significant period of observing, let alone living in, people's homes. Important insights emerged about how gender differences structure television watching: not only what programmes men and women choose, but differences in how they talk about television and (in Morley's and Gray's work) the male domination, particularly in working-class homes, of how viewing choice is exercised and the technological interfaces of television (remote control and the VCR).

None of this was strictly ethnographic, although Morley drew closely on media ethnography proper and helped inspire new ethnographic work. Considerable confusion ensued when this qualitative research, and even other work on audience interpretations, was labelled 'ethnographic', by contrast with pure textual analysis and quantitative audience research. 'Ethnographic' became, in the words of US media ethnographer James Lull (1991), a 'buzzword', and this loose usage quickly attracted criticism from those who pointed out that interviewing someone in their home is quite different from ethnographic method as normally understood (Gillespie, 1995; Nightingale, 1996), as well as raising the suspicion of anthropologists. The ethnographer's authority is rather special – it means saying, as James Clifford put it, 'You [the reader] were there, because I [the researcher] was there' (1988) – and could never be easy for television researchers to claim; television viewing after all is paradigmatically done in private.

Nonetheless, there have been a number of major attempts to conduct truly ethnographic television research. First, there were ethnographic research traditions that

Early research on TV in the home: Hobson (1982) on *Crossroads*

developed in the US and elsewhere in the 1980s, and in the UK, in the most complex project of its kind, in the early 1990s.

The earliest ethnographic work was done in the US and its leading exponent was James Lull (1991). He became convinced of the need to study television viewing in its natural domestic setting through researchers spending periods observing in viewers' homes. An important insight gained by Lull was how, quite apart from the interpretative process of watching itself, television entered into the dynamics of the family situation: helping to organise family time and domestic space, providing topics of family conversation, and as a 'medium' through which family rivalries were conducted. Lull's was the broadest study, although other US scholars did valuable work on, for example, television's role in the home's temporal routines and family members' patterns of thought and language (Bryce, 1987; Traudt and Lont, 1987).

There were parallels between this US work and research in other countries, which Lull's edited book *World Families Watch Television* brought to wider attention: for example, Leoncio Barrio's work (1988) on television viewing in Venezuelan homes and Rogge and Jensen's work (1988) on West German viewers. Indeed the international *comparative* dimension is one of the longer-term contributions to media research of this ethnographic work.

The most wide-ranging ethnographic-style media research, however, was conducted in the UK at Brunel University in the late 1980s and early 90s by Roger Silverstone, David Morley, the anthropologist Eric Hirsch and others. This was ambitious in two ways: first, through its combination of methods (not just observations and interviews in the home, but surveys, viewers' time-use diaries and so on); and second, in its definition of what was to be researched – no longer just the place of television in the home, but more generally 'the relationship between private households and public worlds, and the role of communication and information technologies in that relationship' (Silverstone, Hirsch and Morley, 1992). Television was to be studied in its interrelations with other domestic technologies, including the phone and computer, with the home seen as the site where families over time negotiated a role for those technologies in their living routines. The connections with anthropology were more specific here than in any other media ethnography, but unfortunately the research project was not fully published (see, however, Silverstone, 1994). Its problem perhaps was extending the definition of television's 'context' unmanageably wide, but in any case, such an approach to media ethnography was then attacked from many directions.

Before turning to those criticisms, we must remember another, independent, tradition of ethnographic research into television *production*. With roots in the classic 1970s studies of news journalism by Herbert Gans (1980) and others, this broadened to cover not only television documentary (Dornfeld, 1998; Silverstone, 1985), but also television drama production of all sorts from science fiction to soap opera (Tulloch and Alvarado; 1983; Tulloch and Moran, 1986). Such work opens important questions about the cultures of television production, including the practices of textual interpretation and discussion on which they depend, with parallels in research on other forms of cultural production (music, film).

Some of this work (such as Dornfeld's study, 1998, of the US PBS series *Childhood*) comes from the distinct disciplinary area of media anthropology that emerged as anthropology radically revised its aims in the 1980s and 90s (for a useful survey, see Ginsburg, 1999). What we see now, particularly in research on processes of media production (but also at times in relation to media consumption – see Abu-Lughod, 1999) are two disciplinary traditions, media studies and anthropology, competing for the same object: a better qualitative analysis of television in all its aspects. Implications of this are explored from another angle in the box on p. 16.

Reverting to ethnographies of television consumption, one criticism – that such media ethnography was never properly ethnography – applies more fairly to the 1980s work loosely called 'ethnographic'; this criticism has been revived by the anthropologist Lila Abu-Lughod (1999), but takes little account of the methodological sensitivity of media ethnography proper or of the *inherent* difference between researching a largely private domestic practice (television viewing) and the observation of private and *public* cultures classically called 'ethnography'.

The second criticism (made frequently by political economists) – that over-detailed observation of a few homes prevents us studying connections with issues of power and markets – has some validity, but it was exactly such wider connections that the Brunel project was developing. The difficulty of being sensitive both to wider power structures and the inflections of individual voices is still unresolved.

There is, however, a third and deeper problem shared by many media ethnographies with ethnography more widely. Is it plausible to claim that, by studying *one* place in great detail, we can best grasp cultural flows and power processes in a media-saturated culture that works precisely *across and between* all locations? Janice Radway (1988) and Ien Ang

(1996) argued for the artificiality, or even impossibility, of studying in isolation local practices such as domestic television viewing. To answer this, it makes sense to look at how 'ethnography' is being redefined by anthropologists in ways that no longer privilege the immersive study of one place (see box below).

Even so, media ethnography remains alive and well. Marie Gillespie's study (1995) of the media cultures of South Asian youths in Southall, West London, is perhaps the closest media research has come to ethnography in the classic sense. Based not only on observations, interviews and a detailed survey, but also on the experience of teaching in a local school, it covers the range of media culture, from devotional viewing of religious soaps to news and advertisement consumption. Recently, the Danish researcher Thomas Tufte (2000) has published a study of television viewing in poor urban neighbourhoods of Brazil which tells us much about the domestic consumption of telenovelas and, more widely, about how television works within Brazilian discourses of modernity.

From Tufte's work in particular, new connections are opening up with the work of Latin American researchers (such as Jesús Martín-Barbero, 1993) into 'mediation', the processes by which media contents get taken up in the flow of everyday public and private life. At the same time, recent qualitative work into young people's home and school use of new media, without claiming to be 'ethnographic', is providing insights into our increasingly complex media environment (Livingstone and Bovill, 1999).

The future of qualitative work on television is not in doubt, and it has taught us much about television consumption and production. An issue remains about whether 'ethnography' is the best term for describing audience research in its most developed forms. In the fast changing digital media landscape, it is better probably to see television ethnography as one important, but not exclusive, entry-point into the complexity of today's mediated social worlds.

Nick Couldry

MULTI-SITED ETHNOGRAPHY: MADE FOR TELEVISION?

The traditional idea of ethnography within the colonial context was to spend a lot of time in one distant place and bring back home a comprehensive account of what life and culture there was like. This made apparent sense when the places visited were so distant, and when the ethnographer's authority to tell that story was largely unchallenged. None of this holds for contemporary ethnography which, just like contemporary sociology and cultural studies, must address the shared global space of cultural interconnections. As a result, recent anthropology has not only deconstructed the ethnographer's narrative authority, but more recently challenged the very idea that ethnography is about immersion in *one* single place. In a world of complex connections, as George Marcus has argued (1998), ethnography needs to be mobile as well.

A multi-sited ethnography drops the claim that, by staying put in one place and observing it as intensely as possible, you can understand all that goes on there: what of the forces, the power relations, indeed the people, that flow *through* that place? This insight has been developed by Marcus in his own work on the networks of the very rich, but also by other ethnographers of migrant populations, of contemporary work environments, and so on. There is a striking parallel between Marcus' insight and media researchers' insights into the issues raised by ethnographic method: for example, the Brunel University researchers' insistence on studying the home's

insertion in wider communication and economic systems, and Radway (1988) and Ang's (1996) theoretical arguments for the untenability of studying one consumption site in isolation (see above).

This new vision turns an apparent impasse for contemporary ethnographic research into the opening of a much wider field of detailed qualitative work, and it has quite direct consequences for media research in particular.

First, the flow of media images across space is one of the most obvious reasons why multi-sited research is inevitable and necessary. Second, recent years have seen a growing range of qualitative media research that no longer fits satisfactorily onto the spatial template of the home. Marie Gillespie's (1995) work on media-related talk within and outside the home fits as easily into the new ethnographic paradigm as the old. And there is much work that could only fit into a newer multi-sited research paradigm: Nick Couldry's (2000) work on visitors to television-filming locations that have become tourist sites; Joshua Gamson's (1994) work on celebrity watching; and Ellen Seiter's (1999) work on media talk in playgroups.

Media research has already been moving for some time, then, towards an interest in processes of mediation that are stretched across multiple locations, not just the home. Multi-sited work may be one fruitful way of thinking about the future of media ethnography.

Nick Couldry

RECOMMENDED READING

Couldry, Nick (2002), 'Passing Ethnographies: Rethinking the Sites of Agency and Reflexivity', in P. Murphy and M. Kraidy (eds), *Transnational Culture and Media Ethnography*, Luton: University of Luton Press, 2003.

Gillespie, Marie (1995), *Television, Ethnicity and Cultural Change*, London: Routledge.

Marcus, George (1998), 'Ethnography In/Of the World System', in *Ethnography Through Thick and Thin*, Berkeley: University of California Press.

Silverstone, Roger, Hirsch, Eric and Morley, David (1992), 'Information and Communication Technologies and the Moral Economy of the Household', in R. Silverstone and E. Hirsch (eds), *Consuming Technologies*, London: Routledge.

Television and the Frankfurt School

From the classical Frankfurt School perspective, commercial television is a form of what Horkheimer and Adorno and their colleagues called 'the culture industries' (1972). Moving from Nazi Germany to the United States, the Frankfurt School experienced at first hand the rise of a media culture involving film, popular music, radio, television and other forms of mass culture (on the history of the Frankfurt School, see Jay, 1993, and Wiggershaus, 1994). In the United States, where they found themselves in exile, media production was by and large a form of commercial entertainment controlled by big corporations. Thus, the Frankfurt School coined the term 'culture industries' to call attention to the industrialisation and commercialisation of culture under capitalist relations of production. This situation was most marked in the United States which has had little state support of film or television industries. Consequently, to understand the classical Frankfurt School approach to television, one needs to understand their concept of the culture industry.

THE FRANKFURT SCHOOL AND THE CULTURE INDUSTRIES

To a large extent, the Frankfurt School inaugurated critical studies of mass communication and culture, and produced the first critical theory of the cultural industries (see Kellner 1989, 1995 and 1997). During the 1930s, the Frankfurt School developed a critical and transdisciplinary approach to cultural and communications studies, combining critique of political economy of the media, analysis of texts, and audience reception studies of the social and ideological effects of mass culture and communications. They coined the term 'culture industries' to signify the process of the industrialisation of mass-produced culture and the commercial imperatives which drove the system. The critical theorists analysed all mass-mediated cultural artifacts within the context of industrial production, in which the commodities of the culture industries exhibited the same features as other products of mass production: commodification, standardisation and massification. The culture industries had the specific function, however, of providing ideological legitimation of the existing capitalist societies and of integrating individuals into the framework of its social formation.

Key early studies of the culture industries include Adorno's analyses of popular music (1978 [1932], 1941, 1982 and 1989), television (1991) and popular phenomena such as horoscopes (1994); Lowenthal's studies of popular literature and magazines (1981); Herzog's studies of radio soap operas (1941); and the perspectives and critiques of mass culture developed in Horkheimer and Adorno's famous study of the culture industries (1972 and Adorno, 1991). In their theories of the culture industries and critiques of mass culture, the Frankfurt School were among the first to systematically analyse and criticise mass-mediated culture and communications within critical social theory. They were the first social theorists to see the importance of what they called the 'culture industries' in the reproduction of contemporary societies, in which so-called mass culture and communications stand in the centre of leisure activity, are important agents of socialisation, mediators of political reality, and should thus be seen as major institutions of contemporary societies with a variety of economic, political, cultural and social effects.

Furthermore, they investigated the cultural industries in a political context as a form of the integration of the working class into capitalist societies. The Frankfurt School were one of the first neo-Marxian groups to examine the effects of mass culture and the rise of the consumer society on the working classes which were to be the instrument of revolution in the classical Marxian scenario. They also analysed the ways that the culture industries and consumer society were stabilising contemporary capitalism and accordingly sought new strategies for political change, agencies of social transformation, and models for political emancipation that could serve as norms of social critique and goals for political struggle. This project required rethinking the Marxian project and produced many important contributions – as well as some problematical positions.

Victims of European fascism, the Frankfurt School experienced first hand the ways that the Nazis used the instruments of mass culture to produce submission to fascist culture and society. While in exile in the United States, the members of the Frankfurt School came to believe that American 'popular culture' was also highly ideological and worked to promote the interests of American capitalism. Controlled by giant corporations, the culture industries were organised according to the strictures of mass production, churning out products that generated a highly commercial system of culture which in turn sold the values, lifestyles and institutions of American capitalism.

In retrospect, one can see the Frankfurt School work as articulation of a theory of the stage of state and monopoly capitalism which became dominant during the 1930s. This was an era of large organisations, in which the state and giant corporations managed the economy and in which individuals submitted to state and corporate control. This period is often described as 'Fordism' to designate the system of mass production and the homogenising regime of capital which wanted to produce uniform desires, tastes and behaviour. It was thus an era of mass production and consumption characterised by uniformity and homogeneity of needs, thought and behaviour producing a 'mass society' and what the Frankfurt School described as 'the end of the individual'. No longer was individual thought and action the motor of social and cultural progress; instead giant organisations and institutions overpowered individuals. The era corresponds to the staid, ascetic, conformist and conservative world of corporate capitalism that was dominant in the 1950s with its organisation of men and women, its mass consumption and its mass culture.

During this period, mass culture and communication were instrumental in generating the modes of thought and behaviour appropriate to a highly organised and conformist social order. Thus, the Frankfurt School theory of 'the culture industries' articulates a major historical shift to an era in which mass consumption and culture were indispensable to producing a consumer society based on homogeneous needs and desires for mass-produced products and a society based on social organisation and homogeneity. It is culturally the era of highly controlled network radio and television, insipid top-forty pop music, glossy Hollywood films, national magazines and other mass-produced cultural artifacts.

Of course, media culture was never as massified and homogeneous as in the Frankfurt School model and one could argue that the model was flawed even during its time of origin and influence. One could also argue that other models were preferable, such as those of Walter Benjamin (1969), Siegfried Kracauer (1995), Ernst Bloch (1986) and others of the Weimar generation. Yet the original Frankfurt School model of the culture industry did articulate the important social roles of media culture during a specific regime of capital and provided a model, still of use, of a highly commercial and technologically advanced culture that serves the needs of dominant corporate interests and plays a major role in ideological reproduction and in enculturating individuals into the dominant system of needs, thought and behaviour.

THE FRANKFURT SCHOOL AND TELEVISION

In *Dialectic of Enlightenment* (1972), Horkheimer and Adorno anticipate the coming of television in terms of the emergence of a new form of mass culture that would combine sight and sound, image and narrative, in an institution that would embody culture industry mass production and reception. Anticipating that television would be a prototypical artifact of industrialised culture, Adorno and Horkheimer wrote:

> Television aims at a synthesis of radio and film, and is held up only because the interested parties have not yet reached agreement, but its consequences will be quite enormous and promise to intensify the impoverishment of aesthetic matter so drastically, that by tomorrow the thinly veiled identity of all industrial culture products can come triumphantly out into the open, derisively fulfilling the Wagnerian dream of the *Gesamtkunstwerk*, the fusion of all the arts in one work. The alliance of word, image, and music is all the more perfect than in Tristan because the sensuous elements which all approvingly reflect the surface of social reality are in principle embodied in the same technical process, the unity of which becomes its distinctive content. . . .
>
> Television points the way to a development which might easily enough force the Warner Brothers into what would certainly be the unwelcome position of serious musicians and cultural conservatives. (1972, pp. 124, 161)

Following the model of critique of mass culture in *Dialectic of Enlightenment*, a Frankfurt School approach to television would analyse television within the dominant system of cultural production and reception, situating the medium within its institutional and political framework. It would combine study of text and audience with ideology critique and a contextualising analysis of how television texts and audiences are situated within specific social relations and

institutions. The approach combines Marxian critique of political economy with ideology critique, textual analysis and psychoanalytically inspired depth-approaches to audiences and effects.

A striking example of a classic Frankfurt School analysis is found in T. W. Adorno's article 'How to Look at Television' (1991). Adorno opens by stressing the importance of undertaking an examination of the effects of television upon viewers, making using of 'depth-psychological categories' (see box, p. 20). Adorno had previously collaborated with Paul Lazarsfeld on some of the first examinations of the impact of radio and popular music on audiences (see Lazarsfeld, 1941). While working on *The Authoritarian Personality*, Adorno (1969 [1950]) took on a position as director of the scientific branch of the Hacker Foundation in Beverly Hills, a psychoanalytically oriented foundation, and undertook examinations of the socio-psychological roots and impact of mass cultural phenomena, focusing on television in one study (Adorno, 1991) and the astrological column of the *Los Angeles Times* in another (Adorno, 1994).

In view of the general impression that the Frankfurt School make sharp and problematic distinctions between high and low culture, it is interesting that Adorno opens his study with a deconstruction of 'the dichotomy between autonomous art and mass media'. Stressing that their relation is 'highly complex', Adorno claims that distinctions between popular and elite art are a product of historical conditions and should not be exaggerated. After a historical examination of older and recent popular culture, Adorno analyses the 'multilayered structure of contemporary television'. In light of the notion that the Frankfurt School reduces the texts of media culture to ideology, it is interesting that Adorno calls for analysis of the 'various layers of meaning' found in popular television, stressing 'polymorphic meanings' and distinctions between latent and manifest content.

Adorno's examples come from early 1950s TV shows and tend to see these works as highly formulaic and reproducing conformity and adjustment. He criticises stereotyping in television, 'pseudo-realism', and its highly conventional forms and meaning, an approach that accurately captures certain aspects of 1950s television, but which is inadequate to capture the growing complexity of contemporary television. Adorno's approach to 'hidden meanings' is highly interesting, however, and his psychoanalytic and ideological readings of television texts and speculation on their effects is pioneering.

Adorno's study is one of the few concrete studies of television that addresses the sort of text produced by network

television and the audience for its product. While Horkheimer, Adorno, Marcuse, Habermas and other major Frankfurt School theorists mention television in their development of a critical theory of society, or in their comments on contemporary phenomena, they never systematically addressed television production, texts or audiences. Following the Frankfurt School analysis of changes in the nature of socialisation, Herbert Marcuse noted, in *Eros and Civilization* (1955), the decline of the family as the dominant agent of socialisation and the rise of the mass media, like radio and television:

> The repressive organization of the instincts seems to be *collective*, and the ego seems to be prematurely socialized by a whole system of extra-familial agents and agencies. As early as the pre-school level, gangs, radio, and television set the pattern for conformity and rebellion; deviations from the pattern are punished not so much in the family as outside and against the family. The experts of the mass media transmit the required values; they offer the perfect training in efficiency, toughness, personality, dream and romance. With this education, the family can no longer compete. (Marcuse, 1955, p. 97)

Marcuse saw television as part of an apparatus of administration and domination in a one-dimensional society. In his words, 'with the control of information, with the absorption of individuals into mass communication, knowledge is administered and confined. The individual does not really know what is going on; the overpowering machine of entertainment 0unites him with the others in a state of anaesthesia from which all detrimental ideas tend to be excluded' (Marcuse, 1955, p. 104). On this view, television is part of an apparatus of manipulation and societal domination. In *One-Dimensional Man* (1964), Marcuse claimed that the inanities of commercial radio and television confirm his analyses of the individual and the demise of authentic culture and oppositional thought, portraying television as part of an apparatus producing the thought and behaviour needed for the social and cultural reproduction of contemporary capitalist societies.

While the classical Frankfurt School members wrote little on television itself, the critical theory approach strongly influenced critical approaches to mass communication and television within academia and the views of the media of the New Left and others in the aftermath of the 1960s. The anthology *Mass Culture* (Rosenberg and White, 1957) contained Adorno's article on television and many studies influenced by the Frankfurt School approach. Within critical communication research, there were many

T. W. ADORNO

The effect of television cannot be adequately expressed in terms of success or failure, likes or dislikes, approval or disapproval. Rather, an attempt should be made, with the aid of depth-psychological categories and previous knowledge of mass media, to crystallize a number of theoretical concepts by which the potential effect of television – its impact upon various layers of the spectator's personality – could be studied. It seems timely to investigate systematically socio-psychological stimuli typical of televised material both on a descriptive and psychodynamic level, to analyze their presuppositions as well as their total pattern, and to evaluate the effect they are likely to produce . . .

We can change this medium of far-reaching potentialities only if we look at it in the same spirit which we hope will one day be expressed by its imagery.

T. W. Adorno (from 'How to Look at Television' in Adorno, 1991, pp. 136, 151).

criticisms of network television as a capitalist institution, and critics of television and the media such as Herbert Schiller, George Gerbner, Dallas Smythe and others were influenced by the Frankfurt School approach to mass culture, as was C. Wright Mills in an earlier era (see Kellner, 1989, pp. 134ff).

From the perspectives of the New Left, Todd Gitlin wrote 'Sixteen Notes on Television' that contained a critique of television as manipulation with resonances to the Frankfurt School in 1972 and continued to do research and writing that developed in an idiosyncratic US context a Frankfurt School approach to television. A 1987 collection *Watching Television* contained studies by Gitlin and others that exhibited a neo-Frankfurt School approach to television, and many contemporary theorists writing on television have been shaped by their engagement with the Frankfurt School.

Today, it is more fashionable to include moments of Frankfurt School critique of television in one's theory than to simply take a monolithic Frankfurt School approach. It would be a mistake, however, to reject the Frankfurt School *tout court* as reductive, economistic and representative solely of a one-dimensional 'manipulation theory', although these aspects appear in some of their writings, as I have noted. But the systematic thrust of the Frankfurt School approach that studies television and other institutions of media culture in terms of their political economy, text and audience reception of cultural artifacts continues to be of use. Overcoming the divide between a text-based approach to culture and an empiricist social-science-based communication theory, the Frankfurt School sees media culture as a complex multidimensional phenomenon that must be taken seriously and that requires multiple disciplines to capture its importance and complexity. Within the culture industries, television continues to be of central importance and so critical theorists today should seek new approaches to television while building upon the Frankfurt School tradition.

Douglas Kellner

RECOMMENDED READING

Adorno, T. W. (1991), *The Culture Industry*, London: Routledge.

Arato, Andrew and Gebhardt, Eike (eds) (1982), *The Essential Frankfurt School Reader*, New York: Continuum.

Bronner, Stephen and Kellner, Douglas (eds) (1989), *Critical Theory and Society. A Reader*, New York: Routledge.

Gitlin, Todd (1972), 'Sixteen Notes on Television and the Movement', in George White and Charles Newman (eds), *Literature and Revolution*, New York: Holt, Rinehart and Winston.

Kellner, Douglas (1997), 'Critical Theory and British Cultural Studies: The Missed Articulation', in Jim McGuigan (ed.), *Cultural Methodologies*, London: Sage, pp. 12–41.

Media Imperialism

'Media imperialism' is one of the most influential models in international communication. It triggered a significant body of empirical research, considerable theoretical debate and support for international policy interventions about global communications imbalance. However, it is increasingly subject to critique, reflecting a particular moment of international media history that has changed.

1. THE BROADER PARADIGM OF CULTURAL IMPERIALISM

Media imperialism is a subset of the earlier paradigm of 'cultural imperialism' developed by Schiller (1969), part of a broader critique of modernisation, the triumphalist paradigm propounded predominantly by US theorists in the late 1950s and 60s. This 'dominant' model proposed a single global process of modernisation through a unilinear diffusion of Western technologies, social institutions, modes of living and value systems to the eponymous 'Third World' (Sreberny-Mohammadi, 2000 [1991]). Critical dependency theorists saw the process instead as the spread of inegalitarian capitalism from a few core advanced industrial countries to the periphery, the South. The West was supplied with raw materials and cheap labour as well as markets for manufactured goods while the spread of Western influence established an ideological bulwark against the spread of communism.

Schiller's critical analysis described the processes by which a society was brought into the modern world system and how its dominant stratum shaped social institutions to support the values and structures of the dominating centre of the system (1976, p. 9). Here the carriers of Western cultural influence, including communication technologies, are not value-neutral instruments but are imbued with capitalist values, language and business practices, genre forms, etc. Schiller's view was US-centric, with media as central elements in the global expansion of capitalism centred on the US, fuelled by advertising and consumerism. In the context of the cold war, US policy-makers' promotion of the 'free flow of information' – no trade or legal barriers to the production or movement of mediated cultural products – undoubtedly helped the spread of US hegemony in ways consonant with, although not totally driven by, US foreign policy.

2. MEDIA IMPERIALISM

Media imperialism was defined more specifically as 'the process whereby the ownership, structure, distribution or content of the media in any one country are singly or together subject to substantial external pressures from the media interests of any other country or countries without proportionate reciprocation of influence by the country so affected' (Boyd-Barrett, 1977, p. 117). It differentiated four elements: the shape of the communications vehicle; a set of industrial arrangements; a body of values about best practice; and media content (the latter receiving the most research attention). It highlighted issues around 'cultural invasion' and the more general imbalance of power resources. Essentially the model argued that world patterns of communication flow, both in density and direction, mirrored the system of domination in the international economic and political order – the control by the West over the Rest.

3. EMPIRICAL RESEARCH

The paradigm of media/cultural imperialism suggested a critical route into international television research, particularly in relation to content. The 'one-way street' of television traffic from the West to the Rest was mapped by Nordenstreng and Varis (1974). Katz and Wedell (1977) showed that Third World broadcasting organisations were modelled on those of their mother empires. Others map the ongoing transnational processes of conglomeratisation and the increasing vertical and horizontal linkages of media corporations (Bagdikian, 2000; Herman and McChesney, 1997; News International website).

These models took the global dynamics of media production and diffusion seriously and posed important questions about cultural homogenisation, about the diffusion of values such as consumerism and individualism and about the possible impacts of Western media product on indigenous cultures in the South (Hamelink, 1983).

4. CRITIQUES OF MEDIA IMPERIALISM

'Media imperialism' was problematic from the beginning and by 2001 appears ossified. An argument with some validity for some countries at a certain period of time became the dominant critical paradigm, operating as a form of political correctness which turned its critics into 'apologists for the USA'; by the late 1980s, when the global television and other media industries really changed shape, the critical paradigm had itself become the orthodoxy (Sinclair et al., 1996, pp. 5–6).

While the prime mover sets the model, other media players 'catch up', begin to produce their own content and rework genres to fit their cultural habits. Already in the 1970s, Tunstall (1977) argued that Latin America's high level of television imports in the 1960s was a transitional

phase while nationally based television systems were being established.

Television only became a truly global and popular medium in the 1990s with the expansion of global satellite systems and development of infrastructure. Thus media could not have had the strong effects imputed both by 'media imperialism' and by modernisation theorists (Lerner, 1958) because the televisual media actually didn't reach most people in the South until the satellite expansion of the late 1980s.

The earlier cultural legacies of imperialism – the spread of Christianity, training in and use of European languages, establishment of systems of schooling and higher education, and spread of administrative cultures – have had more enduring and far-reaching effects as carriers of Eurocentric modernisation to the South than has the subsequent arrival of electronic media (Bitterli 1989; Sreberny-Mohammadi, 1997).

Television is only one element of contemporary cultural production and flow, which also includes the fashion and design industries, music and film, consumer durables and global tourism. Media can support processes of economic transformation, and television content diffuses images of the goods, lifestyles and attitudes that are increasingly commodified and available for consumption in the capitalist market.

Second, 'media imperialism' was propounded in comparative media scarcity and newly established broadcasting structures in the South. In 2002, there are powerful cultural industries in the South. Globo in Brazil and Televisa in Mexico produce telenovelas; a multimedia complex near Cairo produces Islamic soap operas, which come from Turkey also. Indian Zee TV is a powerful independent newscaster while Qatar's Al-Jazeera is revolutionising factual programming in the Arab world.

The old metaphors of 'one-way flow' down the 'one-way street' from the West to the Rest are challenged by more diverse production, demanding new metaphors like the 'patchwork quilt' (Tracey, 1988). Southern media exports into the West have been dubbed 'reverse imperialism'. Many of the new media mogul empires are not based in the West and Asian corporations and entrepreneurs (Sony, Masushita) have bought up segments of Western media.

Third, 'media imperialism' implied direct unmediated effects of television programming on audiences, turning them into Americanised consumers. It ignored the particularities of local cultures and their meaning systems as well as other processes of modernisation (shifts in material production, migration and tourism, political institutionalisa-

Qatar's *Al-Jazeera* – from the Rest *to* the West

tion and democratisation) that often operate alongside media development.

The 'active audience' approach within media studies requires a rethinking of international effects. Analyses of the negotiation of meanings around US-produced programmes such as *Dallas* by 'foreign' audiences show different audience viewing strategies, including the imposition of local interpretive frames on 'foreign' media product (Liebes and Katz, 1990). Audiences prefer locally made mediated culture when available (Sepstrup and Goonasekura, 1994).

A single global product doesn't always work across cultural divides and media production needs to be tailored for specific linguistically bounded, cultural markets. The mantra is 'think global, produce local' as regional linguistic-cultural markets are growing in economic significance as the 'cultural discount' of local cultural preference kicks in (Hoskins and McFadyen, 1991).

Fourth, the nature and definition of television genres in the South has been most engaged around the debate as to whether Latin American telenovelas constitute a new form of television, inflected with socially developmental themes, or are simply soap operas with commercial promotional messages. Anthropologists analysing the rise of the Islamic soap opera (Abu-Lughod, 1993) suggest that Southern media texts are neither 'simply' copies of Western texts nor totally novel genres. Textual give and take, multiple sources of inspiration and derivation in media content, needs to be taken seriously, and attention paid to how forms evolve over time, both within developed television industries like the US and UK and in 'younger' media systems. For example, Zee TV is not identical to MTV, although it also shows music video.

Fifth, autocratic, sometimes religious, regimes of the Middle East and South-East Asia use the rhetoric of 'media

imperialism' and the 'protection of indigenous culture' to prevent internal change and demands for democratisation, constructing the 'outside' as a rapacious predator against the feminised, vulnerable nation. Yet, in numerous countries – Indonesia, Nigeria, Kuwait, Brazil – secular intellectuals, ethnic groups and women are struggling for greater political openness and basic human rights as well as a media environment which facilitates the construction of an inclusive national public sphere; sometimes the transnational space can promote solidarity for such struggles.

Media imperialism's focus on Western dominance over transnational media institutions and the market has precluded serious analysis of national processes, particularly the complex class formations in the South and the role of states in media regulation. In Latin America, repressive military juntas have used media as key institutions of authoritarian government (Waisbord, 2000) while in rapidly modernising South-East Asian economies the ruling elites have aligned with global corporate interests, often against their own populations. As popular movements for democratisation and equality have grown inside such regimes, it has prompted greater analytic focus on the relations between transnational processes, national politics and media control, and how states and markets interact within different political and economic formations.

5. GLOBALISATION

The debates around cultural/media imperialism prefigure theorisation around globalisation: the collapse of space and time through communications technologies; the commodification of social life; the significance of cultural flows. But globalisation also suggests the collapse of the older, single-centred hegemony into a more disorganised post-Fordist set of global production processes (Lasch and Urry, 1994); a more decentred and unstable political and cultural environment; and a variety of resistances to Western modernity with the rise of primordial religious and ethnic loyalties. The interpenetration of the global and local actually produces multiple formations of modernity.

'Cultural imperialism' tended to see cultures as singular, somewhat frozen, nationally bounded entities, with 'American' television impacting on 'Iran', for example. There is increased awareness of the loosening of the hyphen in the nation-state and that 'national culture' is better seen as a site of contest. National identity may be practised daily through a variety of symbolic forms and organisational routines, but its actual content may be more fluid and disputed than ever.

Globalisation highlights the manner in which pressures to modernise are being met with particular local orienta-

tions and practices. It can still be argued that Western values lie hidden behind a seemingly neutral 'universal' and abstract set of processes, but the precise way these are encountered, understood and dealt with varies from country to country, and even within regions, like Latin America or the Arab world. More particularism, more case studies, more comparison is required.

The real collapse of the three worlds of development has left a conceptual lacuna. Rather than such totalising models we need regional frames that take cultural specificities, local structures and political values seriously. Globalisation has exacerbated economic disparities among – but also within – countries and has not ended political repression. Contemporary 'flows' include massive movements of capital and of people, so others are no longer 'there' but 'here' and building transnational communities through various kinds of diasporic media.

6. CONCLUSION

Media imperialism framed the NWICO (New World Information and Communication Order) debates of the 1970s within UNESCO (United Nations Educational, Scientific and Cultural Organisation) and the Non-Aligned Movement, until the US, the UK and Singapore left UNESCO in 1984–85 (Galtung and Vincent, 1992). The MacBride Commission's final report, *Many Voices, One World* (UNESCO, 1980), challenged the prevailing idea of 'free flow of information' which privileged Western hegemony and cultural diffusion and turned the South into mere consumers of Western news-values, entertainment and advertising images. Instead it proposed the important qualification of a 'free and balanced' flow, which was adopted as UNESCO policy, although precise criteria to measure 'balance', particularly in news content, were never formulated. While UNESCO had funded many landmark studies in critical international communication research, from the mid-1980s it moved towards a liberal position focused more on freedom/democratisation than on balance/flow.

The debates about global media inequality and concern about the logics of conglomeratisation and the threats to local cultures continue at the fora of the MacBride Round Tables, the demand for a People's Communication Charter and in the activities of the Cultural Environment Movement. However, while the debates in the 1970s involved Third World policy-makers, the critical voices are now mainly Western academics, while Southern politicians are involved with policy-making about deregulation, digitalisation and media convergence.

For television, the enduring cultural legacy of the US

lies in the diffusion of a commercial model with entertainment content used to attract audiences who are sold to advertisers (Sinclair et al., 1996, p. 9). While this is still not a universal model – some states still control broadcasting, and others maintain public service – commercial pressures, and availability of multiple forms of media distribution/reception such as satellite and cable, mean the globalisation of capitalism and the manufacture of mediated culture are in the ascendant. A focus on media diffusion obscures a far wider concern around a generic mass production of culture that is now flourishing globally.

Annabelle Sreberny

RECOMMENDED READING

Hoskins, C. and McFadyen, S. (1991), 'The US Competitive Advantage in the Global Television Market: Is it Sustainable in the New Broadcasting Environment?', *Canadian Journal of Communication*, vol. 16, no. 2, pp. 207–24.

Schiller, Herbert (1976), *Communication and Cultural Domination*, White Plains: International Arts and Sciences Press.

Sreberny-Mohammadi, A. (1997), 'The Many Cultural Faces of Imperialism', in, P. Golding and P. Harris (eds), *Beyond Cultural Imperialism*, London: Sage.

Tunstall, Jeremy (1977), *The Media are American*, New York: Columbia University Press.

Cultural Studies and Television

What is Cultural Studies? A shorthand definition might be, the study of *popular* culture, particularly *contemporary* culture from a *critical-theoretical* perspective. In the 80s and early 90s this critical perspective was one guided largely by a triumvirate of terms: class, gender and ethnicity. 'Theory' was at the heart of the Cultural Studies project. 'Theory' opposed itself in a structural way to suspect 'empirical' work that purported to be a 'theory-less' politically neutral discourse. According to the critics of empirical work (and there were many) it was in practice deemed reactionary or at best passively supportive of an established and discredited social and political order. Behind 'Theory' lay a Marxist materialist orientation (see Turner, 1996). But there are problems with this formulation now and not just with Marxism post-1989 and the rapid decline of communism. Cultural Studies is now rather less about popular culture than the relations of all sorts of cul-

ture to the social order. It can also be profoundly historical in orientation. And its politics are rather less clear cut. Sarah Berry and Toby Miller (2002) in an overview website describe the field as such: 'Cultural studies is concerned with subjectivity and power – how human subjects are formed and experience their lives in cultural and social space.'

Subjectivity (a suspect category in traditional Althusserian Marxist analysis) is now closer to the centre of the field. Politics becomes a lot more personal even as the power of institutions in the world (say multinational media corporations) in key respects loom ever larger over the individual.

What has this to do with TV Studies? Pretty much everything. And if Cultural Studies and TV Studies are not the proverbial twins separated at birth it is fair to conclude they emerged around the same time, were brought up together, share many of the same values and often get mistaken for each other by friend and foe alike. Both TV Studies and Cultural Studies draw from literary textual traditions, from sociology and mass communication and from the diverse sources of contemporary theory – feminist theory, structuralism, post-structuralism, postcolonial studies, queer theory and Marxist critical thought. Charlotte Brunsdon (1998) concludes that it is 'difficult to separate the development of TV Studies from that of cultural studies'. The evidence is compelling.

After Richard Hoggart (no particular friend to television, see Hoggart, 1958) key writings in what was termed British Cultural Studies (see Turner, 1996) were very frequently on television. These include Stuart Hall's highly influential 'Encoding and Decoding' (Hall, 1980); Raymond Williams' early works on television and communications (1975); Brunsdon and Morley on *Nationwide* (1978), Fiske's empowered audiences work (Fiske, 1987) and the rise of feminist and black perspectives (Spigel, 1992; D'Acci, 1994; and especially Bobo and Seiter, 1997) and more recently the work discussed by Erni, p. 56. If 'Cultural Studies is an interdisciplinary field where certain concerns and methods have converged' (Turner, 1996, p. 11), then TV Studies is a *primary* instance of those interests converging.

Of course it needs to be said that whilst Cultural Studies traditions of the UK, US and, of course, other countries have diverged (maybe sprawled to be more accurate), an emphasis on cultural politics remains. (See the introduction in Hartley and Pearson, 2000, for an account of transatlantic interaction in the field) In virtually all incarnations Cultural Studies is a form of academic writing that tends to be *critical* of the social order of postmodern capi-

talism and seeks to argue for a transformation to a more inclusive, egalitarian if not necessarily socialist order. And it is this assumed leftist perspective that TV Studies has largely shared albeit with only a very few dissenting voices (e.g. Collins, 1993, 1999). This shared heritage between Cultural Studies and TV Studies has a number of features that reconnect with its history and debates over the social and political order. They could be categorized under the following headings:

- Cultural and Institutional Status
- The 'True' Text
- Populism, Elitism and Political Economy
- Audiences

For much of the 80s and 90s Cultural Studies and Television Studies suffered (in the UK particularly) under the lash of media opprobrium dismissing both areas as indulgent, intellectually vacuous and of no use to wider society. Lusted (1998) could still claim 'Among elite groups (in the UK at least) television in general falls into the category of low culture or perhaps even "despised culture".' Such nervousness still persists (perhaps less in the wider population and media elites than in the university academy) and continues to politicise debates over media and cultural education. Against a background where student enrolments inexorably rose in media and Cultural Studies, the actual institutional strength appeared for a long time to be with the opposition. Cultural Studies and TV Studies found themselves insinuated into the margins of other curricula, appended to existing faculties or programmes or smuggled through in media studies or mass communication studies, both of which could be cited by university administrators as practical or vocational areas of growth potential. The institutional fragmentation that results is still a weakness in the field with still only relatively few dedicated Cultural or TV Studies departments (as against a plethora of programmes or modules), few shared spaces for discussion and debate, a low-ish level of *regular* academic conferences and fewer established academic journals than desirable, affect both Cultural Studies and Television Studies. But the twins do have differences.

Brunsdon (1998) identified two prerequisites for the development of the Anglophone discipline of TV Studies. Her first: 'that television be regarded as worthy of study' is a battle Cultural Studies has and is still fighting outside its own (relatively few) departmental corridors as a *discipline* if not necessarily as an approach (e.g. It is reported that the foundational Centre for Contemporary Cultural Studies at the University of Birmingham is to close). Her second that

TV Studies be granted 'conceptually some autonomy and specificity as a medium' is a condition that Cultural Studies, without any frontiers imposed by a specific cluster of broadcasting technologies, or form of reception, or presumed (and it is usually only ever presumed) habitual viewing habit, cannot and can never fulfill.

Cultural Studies is not about any one 'object' as such (see above Berry and Miller, 2002) so much as about relations between people and power, technologies and subjectivities. A key task for Cultural Studies from the beginning has been methodological clarity. Determinants such as gender, class and ethnicity form angles of approach rather than defined objects with established disciplinary protocols. Is that true for TV Studies too? In many ways it is. Gender, ethnicity and the nature of audiences loom a lot larger in TV Studies discourse than specific programmes (e.g. *Dallas, Nationwide, Star Trek, Big Brother*) which sometimes usefully serve to organize debates and provide a focus for discussing these broad categories. But is the 'text' or the focus of much recent TV Studies really the construct that is the 'audience' or 'audiences'? Is it race? Or should it be gender ? Or theorisations of one or all of these? There is no obvious answer but the working through or 'thick' descriptions of particular texts (see Miller, 1997, for a good example) does have utility for staging discussions which might otherwise be dispersed across a myriad of particular instances or special theoretical interests. So it is, that Hartley in this volume (pp. 29–33) foresees textual analysis becoming a 'guide technique' within a wider field of interactivity, one that might need to address institutions such as network channels and production companies, generic histories, media critics and of course audiences. Television texts therefore have the ability to offer a common point of departure or public space for debate as there are a few programmes with significant analysis appeal like *Big Brother* or *Buffy the Vampire Slayer* where several theoretical interests converge. These are less readily found in Cultural Studies.

Nothing is so particular to TV Studies and Cultural Studies as the vexed debates over populism and elitism which form part of a wider public discourse in the UK mainstream press and other media. Television figures very prominently in this 'debate' in which accusations of dumbing down on the one hand are exchanged for charges of elitism on the other and which is often really another argument about the merits of public versus private broadcasting (see Ouellette, p. 53) conducted by proxy. The debate has wide and deep roots in the UK as a result of its unique public sector television culture founded under Lord Reith. John Corner (2001) reflects a consensus position that char-

acterises resulting industry 'protocols' in the UK that are organised around so-called duties and pleasures thus :

> a genuine impulse to foster excellence, widen accessibility, and discourage exploitation with, on the other hand metropolitan, class-based taste preferences shot through with disdain for the 'ordinary' and sometimes hankering after 'standards' with a punitive schoolmasterly zeal'.

If televisual duties are favoured by elitists and pleasure is championed by the populists it is still true that the criticism implied by Corner of elitist British TV mandarins is widely accepted and in some areas very deeply felt, by for instance, Lusted (1998) who explicitly relates it to issues of class and his own social background. So it is also that even when TV Studies academics come to discuss their own work and choice of material for discussion they can seem almost equally uncomfortable whether they are asserting a right to analyse light entertainment (Lusted, 1998) as they can be making a case for discussing a category as heavy as 'serious TV Drama' (Caughie, 2000). This is therefore a seemingly unique British debate about class. In the US the inflection is different (see Ouellette, p. 53) but it seems endemic to Cultural Studies and TV Studies that debates around these poles are always ongoing and reflect continuing anxieties about status: cultural, personal, social and institutional.

In Cultural Studies the fighting has been fierce and has been played out between a variety of antagonists starting most conspicuously with the work of John Fiske (1987a, 1987b) and the debate staged between Garnham (1998) and Grossberg (1998). Television again appeared centre-stage when Fiske argued that traditional media analysis greatly underestimated the power of audiences to shape meaning and the positive dimension of commercially sponsored popular entertainment:

> I would argue that television's political effectivity and its progressive potential lie rather in its ability to devolve the power to make meanings rather than in any alternative meanings it may offer (p. 73).

Or if you like TV might be capitalist poison but if consumed properly could be the nectar of subcultural empowerment. Fiske's work offered the promise that many critics seized upon that audiences could position themselves in relation to dominant popular culture in a separate – as he called it – 'cultural economy' that could occasionally make commercial interests dance to the tune of 'resistance'. His work his been fiercely criticised but has set an agenda for much subsequent debate (for and against) in TV and

Cultural Studies with its stress on the active agency of consumers and interest groups; its optimism about resistance to oppression through consumption and its reprocessing of cultural forms; and its sense of a more dynamic and uncertain ideological environment.

Critiques of such 'populism' were led by McGuigan (1992), Garnham (1998) and most devastatingly perhaps Morris (1990). Political economy criticisms of the Fiskeian brand of culture studies centred on the charge that the mechanics of production and institutions and economy have been set aside and that his distinction between 'cultural economy' and a 'financial economy' (taken in part from Michel De Certeau) was naïve and ignored the real politics and economics of cultural production for easy cheerleading of the 'popular'. For the defence Grossberg argued that old-style Marxist determinism (thanks to the Frankfurt School particularly) had blinded Garnham – the subject of his attack – to the subtleties of the situation and to the operations of society and culture in general. (The advent of new media seems to have added some credence to that view.) And yet again whilst traditional political economy can be attacked for the blind pessimism of characterising the consumer or TV viewer as always victim or dupe, then more recent work in Cultural Policy studies (see Streeter, 1996) and that outlined by Cunningham and Flew in this volume, pp.50–6) re-examines the position of the viewer and the issue of the 'Consumer' interest in more contextual terms than the earlier more theoretical debates were inclined to do. So it remains that in theory and practice awkward issues around cultural value (populism and elitism again) remain a focus of concern on all sides in the search for meaning amongst television audiences.

There is no question that the last decade has seen a hugely increased interest in television audiences. John Caughie has described John Fiske's role as dramatising a more general 'desperation' in TV Studies 'to identify and identify with viewers' (2002) and a desire for academics to present themselves as hip and cool or simply as ordinary and as engaged as real fans (see McKee pp. 69). Work around audiences that has, in the tradition of Fiske, emphasised audience empowerment, has struggled to get beyond, on the one hand, an assertion of the validity of specific audiences and their 'power to be different', and on the other, the truism Morris enunciates in her critique that:

> people of modern mediated societies are complex and contradictory, mass cultural texts are complex and contradictory, therefore people use them to produce complex and contradictory culture.

And there are problems, as many in this volume have pointed out, in representing such a collectivity. Audiences differ – and as social individuals they do so in such profound, subtle and various ways that a danger exists that as the canvas of diversity broadens the relevance of most research to any specific student or researcher might well diminish ('narrowcasting' writ large – and very narrow – in academic writing and publishing). Indeed such is the Cultural Studies commitment to the empowering refrain of diversity and to the upholding of the interests of audiences (we are all individuals), that powerful structures of organising cultural life (the stock market, government, the celebrity production machine) can be lost to view. The problem is compounded by the relative lack of work in the area of production ethnography (see Couldry, p. 15) This entails a lack of reliable data and market research (or simply professional lore) readily accessible to those with the greatest vested interests in knowing about audiences: the producers. Altman (1999) has very usefully theorised in the area of film studies the reciprocal and interconnected 'games' that audiences and producers (both acting in their own ways as critics) undertake in order to organise their viewing and production practices around genres for purposes of pleasure and profit respectively. This suggests a useful line of enquiry but would necessitate greater research access to TV production lots and boardrooms to be convincing. Work ongoing on the interface between television and new media in progress on the one hand and on the sets of particular programmes on the other offers a little hope that this nexus may be addressed more fully in the near future.

Andrew Lockett

RECOMMENDED READING

Brunsdon, Charlotte, D'Acci, Julie and Spigel, Lynn (eds) (1997), *Feminist Television Criticism: A Reader*, Oxford: Oxford University Press.

Brunsdon, Charlotte (1998), 'What's the Television of Television Studies?' in Geraghty, Christine and Lusted, David (eds), *The Television Studies Book*, London: Edward Arnold.

Kellner, Douglas (1997), 'Critical Theory and British Cultural Studies: The Missed Articulation', in Jim McGuigan (ed.), *Cultural Methodologies*, London: Sage, pp. 12–41.

Morley, David (1992), *Television, Audiences and Cultural Studies*, London: Routledge.

Morris, Meaghan (1990), 'Banality in Cultural Studies' in Patricia Mellencamp (ed.), *The Logics of Television: Essays in Cultural Criticism*, Bloomington: Indiana University Press/London: BFI Publishing.

Storey, John (ed.) (1998), 'Part Seven: The Politics of the Popular' in *Cultural Theory and Popular Culture: A Reader*, Harlow: Longman.

Turner, Graeme (1996), *British Cultural Studies: An Introduction*, London: Routledge.

Popular Television Criticism

The role of the journalistic television critic is a peculiar one. Unlike counterparts who write about theatre, there is little sense that his or her opinions, analyses, commentaries or informative essays will have a direct effect on the object of consideration (though this generalisation bears further discussion below). And unlike those journalists who comment on film, there is little sense that the work addresses a readership that, at least in part, is knowledgeable about certain histories, techniques or continuing topics that exist within what might be termed a 'discourse' surrounding cinematic practices.

Rather, the television critic generally writes from a realistic perspective that every reader considers him or herself the critic's equal. After all, television remains, to a great extent, an unworthy topic. Or, put another way, it is a topic worthy only of opinion, not of critical discussion in which the tutored (or even the merely professionally 'assigned') author writes with greater authority than that afforded the viewer who pressed thumb to remote-control device the night before and skimmed through dozens of scenes, clips, words, performances, representations, modes of address, sound bites, bytes, actions and, occasionally, complete 'texts'. In short, what can or should the journalistic critic say to his or her 'audience' that will somehow enhance or intensify the experience when that audience becomes the audience for television again? What lessons are offered in the critic's evaluations? What special skills are imparted to viewers already extremely sophisticated, who are instructed by the medium itself, with its built-in museum of reruns and 'archival channels', channels inflected with the ironic, almost 'analytical' perspectives often offered by 'critics'? How does the work of the journalistic critic contribute to the ongoing industrial, social, cultural nexus we know as 'television' in a manner that accepts the mantle of the thoughtful, public role afforded criticism of other expressive forms? Stated differently, more forcefully and, one hopes, without cynicism – what difference does journalistic television criticism make?

To be sure, it could be strongly argued that contemporary literary, theatre, film, art and dance criticism faces the same struggle. Corporate involvement, some would say control, in the arena of expressive culture has dampened the force of critics dealing with all these genres and media. Yet television, perhaps because it continues to shape-shift even as some critics seem to gain perspective, remains particularly immune to critical discussion, and this is no new thing. Perhaps, in fact, it could also be argued that journalistic criticism of all the arts and entertainment categories has 'descended' to the fate of television criticism. That 'fate', however, is grounded in a truly fascinating problem of definitions. The most difficult problem facing the journalistic television critic is what 'television' to write about.

The problem is succinctly captured by one of the most successful and prominent critics in US journalism history, Lawrence Laurent, for many years the television critic for the *Washington Post*. His essay, 'Wanted: The Complete Television Critic' (1962), appeared in *The Eighth Art*, a volume edited by Robert Lewis Shayon, himself the long-time TV critic for *The Saturday Review*. In Laurent's view:

> This complete television critic begins with a respect and a love for the excitement and the impact of the combination of sight and sound – pictures which can be viewed and words which can be heard, by millions of people at one time. This complete critic must be something of an electronics engineer, an expert on our governmental processes, and an aesthetician. He must have a grasp of advertising and marketing principles. He should be able

to evaluate all of the art forms; to comprehend each of the messages conveyed, on every subject under the sun, through television. And there is more.

> He must be absolutely incorruptible, a firmly anchored man of objectivity in a stormy world of special interests and pressure groups. At the same time he should stand above the boiling turmoil while he plunges into every controversy as a social critic and guardian of standards. While being both aloof and involved, he must battle for the right, as his judgment and instincts guide him toward that right.

Heavy burden, this. But Laurent spoke for a generation of critics who recognised that television was changing, or at least offering changing perspectives on, much of social and cultural life. John Crosby at the *New York Post*, Jack Gould at the *New York Times*, Shayon at *The Saturday Review* – these and others wrote to and for the public. Any item might focus, as Laurent suggests, on the content or presentation of a particular television programme, on social issues swirling about the medium, on shifts in industrial relations, on personalities, or on governmental involvement with the medium.

To some extent these and a handful of other influential authors were read by those who controlled and developed television. But the swift and unstoppable social uptake of TV in the 1950s, even into the 1960s, made any real effectivity on the part of the critics all but impossible. Moreover, in smaller, local newspapers, the 'television column' was

Critics encouraging the creative community – *All in the Family* and *The Waltons*

often handed off to the newest staff member. Columns were frequently composed from the increasingly substantial press packets that arrived in the mail to accompany new programmes. Junkets were provided for writers whose papers could afford to send them to Los Angeles or New York. For some academic observers, journalistic television criticism was – and could be – nothing more than an extension of the industry itself, collusive or complicit in the spread of a corrupting mass culture.

In the US there were of course moments when critics seemed to play a somewhat different role. Responses to programmes such as *All in the Family* encouraged both the 'creative community' in Hollywood and the executive officers there and in New York. Critical approval sometimes assisted in enabling controversial programmes, or programmes considered to be 'quality television', to stay on the air. This was partially the case with television offerings such as *The Waltons* or *Cagney and Lacey*. Rarely could criticism 'kill' a show unless negative reviews were accompanied by low ratings. Negative criticism could never lead to cancellation of programmes with high ratings. Critics such as Norman Mark at the *Chicago Tribune* and Ron Powers at the *Chicago Sun Times*, Gary Deeb at several papers, Les Brown at *Variety* and later the short-lived magazine *Channels* clearly recognised the role of the critic as more prominent, as attended to both by their readers and the industry.

By the early 1980s, however, a new perspective was emerging, led not so much by critics, but by critical recognition that television itself had perhaps achieved a different social status. Admiration for programmes such as *Hill Street Blues* appeared in conjunction with widespread positive audience response. *Hill Street Blues* and, more tellingly, programmes such as *St Elsewhere* were considered 'quality' work that marked a 'new era' in television content. These programmes also engaged controversial subject matter, broke certain taboos of language and behaviour, and appealed to specific, often 'upscale' audiences desired by advertisers. In this context, television itself became more 'respectable' and criticism of it more involved, nuanced, considered. The necessities outlined by Laurent remained, and critics still faced the daunting task of writing about everything from cable technology to Federal Communications Commission (FCC) rulings. But their approaches to matters aesthetic, political and moral were couched in a renewed sense that their subjects were crucial to public consideration.

This continues to be the case at present, but that sense of public consideration is fundamentally altered by the increased numbers of television distribution channels. In one way, this simply means the critic's task is expanded. Writers such as Bill Carter at the *New York Times*, Tom Shales at the *Washington Post*, and Howard Rosenberg at the *Los Angeles Times* must focus their 500- or 600-word columns on topics chosen from a massive array of possibilities – whether these are programmes, people or problems.

The issue, then, much the same but greatly intensified, is how to define the daily topic, address a knowledgeable public, approach an indifferent industry, and do so within highly restricted space. The very best television critics are those whose work stands in its consistency, work that develops over time so that the daily reader can be assured that appraisal of a programme will be on familiar, even if contested, grounds, that a perspective on the industries at large will be informative, and that judgments of moral, ethical and political issues will express vision and integrity.

Lawrence Laurent's admonitions remain. The task of the journalistic television critic is amazingly significant. With relatively few exceptions, the task demands and deserves better than it has received.

Horace Newcomb

RECOMMENDED READING

Arlen, Michael J. (1969), *The Living Room War*, New York: Viking.

Arlen, Michael J. (1981), *Camera Age: Essays on Television*, New York: Farrar, Straus, Giroux.

Laurent, Lawrence (1962), 'Wanted: The Complete Television Critic', in Robert Lewis Shayon (ed.), *The Eighth Art*, New York: Holt, Rinehart and Winston.

Seldes, Gilbert (1956), *The Public Arts*, New York: Simon and Schuster.

Shayon, Robert Lewis (1971), *Open to Criticism*, Boston: Beacon Press.

Watson, Mary Ann (1985), 'Television Criticism in the Popular Press', *Critical Studies in Mass Communication*, March.

Textual Analysis

Textual analysis in television studies has had a chequered history. Some of the earliest work (e.g. Hoggart, 1960) appeared in a 'books and politics' tradition dubbed 'superannuated' by Tom Wolfe in his own 1969 essay on Marshall McLuhan. Wolfe identified a 'literary-intellectual mode' originating in Regency England, where 'literati . . . excited by the French Revolution' would 'pass judgement in a learned way on two subjects: books and poli-

tics'. This survived into contemporary times in the same format: 'books and moral protest, by gentlemen-amateurs, in the British polite-essay form' (Wolfe, 1969).

Even as Wolfe was pensioning it off, prematurely as it transpired, the literary essay was joined by a more systematic and rigorous form of analysis originating separately in France (Ferdinand de Saussure, Roland Barthes, Christian Metz) and Eastern Europe (Valentin Volosinov, Roman Jacobson, Yuri Lotman). In the USA the semiotic philosophy of C. S. Pierce linked the tradition of 'speech communication' with that of 'mass communication'. Semiotics held out the hope that the study of textual features might emerge as a science, even to the extent of finding a scientific basis for 'moral protest'.

Semiotic 'demystification' of popular culture proliferated in the wake of Barthes' polemical studies of soap powder and wrestling. After publishing the first semiotic inquiry into television, Umberto Eco even attempted a 'textual analysis' of modernity (Eco, 1972; 1987). Construing movies as a language, Metz took film studies from fun to philosophy. The journal *Screen* was influential in applying aspects of French semiotics, Russian formalism, psychoanalytic theory and Marxism to film and television. Brunsdon and Morley (1978) published an 'ideological analysis' of a television programme combining semiotic and Marxist techniques. Fiske and Hartley (1978) published the first book-length semiotic study of television. Meaghan Morris (1988) brought semiotics, the literary essay and feminism together in studies of both film and TV. Linguists like Gunther Kress and Theo van Leeuwen were active in analysing television 'grammar' (1996). Text-based TV analysis seemed assured.

But eventually semiotics declined, certainly as the cutting edge of TV analysis. Fewer claims were made on behalf of the method itself, and fewer detailed performances of it were published. With the abandonment of hope that it might put 'ideological analysis' on a scientific footing, textual analysis as a whole came under a cloud. In the words of Lynn Spigel, the 'rhetorical tradition of criticism' is 'a practice that, for whatever reasons, seems to have been oddly displaced in television studies' (Spigel, 2000, p. 414; see also Spigel, 1997). These varying fortunes may be traced to:

* *Changing circumstances.* Television as a cultural form changed, most importantly from broadcast (mass medium) to post-broadcast (narrowcast and interactive) forms. As a result, there were periods when 'content' – the 'text' of television – loomed large as a focus of public attention, and other times when structural, technological or policy aspects drove the agenda.

* *Contested purposes.* A hotly contested question has been over the purpose of television studies as such. The principal point of difference was between those for whom TV was an object of policy, in which economic, technological, 'industry' and regulatory issues would be to the fore, and those for whom TV was a part of culture for general populations, where content, programming and audience studies were emphasised.

* *Disciplinary and theoretical differences.* Textual analysis devolved from the humanities. It was criticised by commentators trained in the social sciences. One bone of contention was methodological. Textual analysis was criticised for not using scientific methods of investigation that relied upon quantitative, generalisable findings (Morrison, 1998). The other bone was theoretical. While social-science approaches to media largely remained fixed in a modernist, realist, technological paradigm, textual analysis explored post-modernism, indeterminacy and subjectivity (see Philo and Miller, 1998). The chalk criticised the cheese.

* *The bottom line.* The analysis of single texts could come cheap – it might be accomplished by one critic (or grad student), a VCR, and lots of time and thought. Both of the latter were reckoned abundant, and therefore not costed. It suited the resource base of non-traditional institutions of higher education in which media studies took root. Social-science research was more expensive, relying on large databases or sampling techniques, number-crunching programs and teams of research assistants. Textual analysis nevertheless made very good *teaching* material, attractive to students who were themselves interested in the programmes analysed, and attractive to publishers for use in introductory textbooks. Social-science research, for its part, was underwritten by research funding agencies, and was less interested in publics than in publication for specialists and policy-makers. Instead of 'textual' analysis, it evolved 'content' analysis; something that can't be done well in classrooms.

In such circumstances textual analysis was never a neutral component of what Elihu Katz called a 'multidisciplinary armamentarium' at the disposal of the analyst (Katz, 2000, p. 129). Instead, its use often signalled a commitment to disciplinary, theoretical, cultural and historical positions that may well have determined what a given piece of textual analysis was taken to 'mean', no matter what it 'said'.

TV studies got going when *broadcast* television reigned supreme. At that time, textual analysis seemed handy. The important questions about television were to do with its

social reach and cultural impact. A thriving trade was done by those who wanted to investigate its 'effects' on individual (psychology) or social (sociology) behaviour. But at the same time it was clear that 'texts', reaching millions of people at one time, increasingly across national as well as internal demographic boundaries, were interesting in their own right. What was their appeal? What values did they convey? By what devices – visual, verbal, 'filmic' or 'behavioural' – might they actually achieve the effects claimed for them?

Textual analysis became one of the first players in the field of popular cultural studies (Fiske and Hartley, 1978; Hall and Whannel, 1964; Newcomb, 1974). It could not predict what individual viewers might make of any given show or sequence, but it did begin to elaborate both the technical attributes of the 'television text' and the issues that needed to be discussed (Williams, 1974). In other words, it was not a scientific method with falsifiable hypotheses, testable observations and generalisable, predictive results. It was instead a genre of discourse in which observers who were also participants in the cultural processes under investigation could talk about questions of power, subjectivity, identity and conflict in the non-canonical context of everyday life, popular culture and widespread dissent from the official cultures and politics of the day (Brunsdon, D'Acci and Spigel, 1997; Gray, 1995).

Textual analysis was accessible to non-specialists. It was a useful pedagogic and persuasive tool. It could be used to talk about universal themes in the social imaginary, both 'public' (politics, war, news) and 'private' (sexuality, identity, drama). But at the same time it focused on very specific features that could be isolated and discussed. Linking the universal with the all-too-particular became quite an art form in itself. Analysts looked at editing techniques in news programmes for evidence of political conflict (Birmingham, Glasgow), or at dialogue patterns in soap opera to illustrate gender politics (feminism), or even at visual components of drama shows to uncover the structure of desire in the human psyche (*Screen*, psychoanalysis). Textual analysis seemed an appropriate means to investigate the meanings of some diffuse but influential concepts: subjectivity, culture, power.

At a more demotic level, textual analysis of television could continue to do what 'practical criticism' of literary texts had attempted in an earlier age. With the democratisation of higher education, those interested in the democratisation of individual consciousness could use classroom versions of textual analysis to encourage 'critical literacy'. They could take *The Beverly Hillbillies* and teach students about ideology; use *Dallas* to think about capitalism; do

Teaching about ideology – *The Beverly Hillbillies*

race and *The Cosby Show*, class and *Boys from the Blackstuff*, gender and soap opera. At more advanced levels, concepts like hegemony or *différance* could be introduced by reference to *News at Ten*.

The idea was to 'train' aspects of citizenship – critical, self-reflexive engagement with the structures and processes of modern, associated life – in people whose own social background excluded them from established governmental circles. That same 'establishment' was held responsible for taking advanced countries in the wrong direction – 'capitalism' was far from universally admired in Europe; the Vietnam war provoked fundamental doubts about the 'military industrial complex' in the US. At the same time, counter-cultural consciousness-raising was finding politics in the minutiae of everyday life, and expanding the domain of culture to include activities and aspirations well outside the envelope of the 'normal'.

At a time of 'strong' states and cold war adversarialism on one side, and 'sex, drugs and rock-'n'-roll' on the other, the investigation of popular subjectivity was urgent. This made television an unusually apposite object of study. There it was, the epicentre of the 'normal', but it dealt in dreams and death, aspirations and assassinations. It was the chosen pastime of the 'mass' population, but it avoided class politics. It brought the world to the home, but

reduced that world to the contents of the fridge and the bathroom cabinet. It was somehow caught up in both hope and rage (Gitlin, 1987).

The difference between the universal and the inconsequential, high theory and low entertainment, world politics and suburban cleanliness, the sublime and the gorblimey – the very bathos of this mismatch between television itself and the ambitions of textual analysis – was a sure sign that something important was at stake. Those who found the gap between rhetoric and reality to be irritating or risible were in danger of throwing the 'baby' of democratisation out with the 'bath-water' of banality. Textual analysis held out some hope of understanding what theories of manipulation, subliminal persuasion and ideological bias or distortion had failed to address. It could tease out how pleasures mixed with power, emotion with reason, information with ideology, in the very tissue of sense-making, without either ascribing the whole system to evil state or corporate intentions, or blaming the populace for not being as smart as sourpuss professors.

Such ambitions drove textual analysis of television. But there were problems. These were:

- *Projection* – a danger that textual analysts projected their own prejudices and priorities onto the texts they were analysing, and thence onto the populations that made up the audience for those texts (see Sinfield, 1994). Put another way, what can straight, middle-aged, white professional academics from favoured suburbs in rich countries say about the young, gay, poor, or people of colour? Three alternatives were preferred by critics of free-floating textualism:
 1. *science* – the use of representative sampling to remove personal preference;
 2. *identity* politics – the promotion of self-representation by subject positions;
 3. *policy* – 'useful' cultural policy studies, rather than 'universal' intellectual pronouncements (Bennett, 1998).
- *Populism* – analysis of popular culture was criticised for 'celebrating' it rather than criticising it. Analysts such as John Fiske were berated for taking popularity as a *value* rather than a problem. 'The people' were to be emancipated from their culture, not congratulated for it, because it was a bad object made by commercial monopolies and class supremacists for their own benefit, against the real interests of the end user (Philo and Miller, 1998). Cultural populists were said to 'disempower' and 'depoliticise' the very domain of cultural

politics they purported to champion (McGuigan, 1992). It was all revel, no rebel.

- *Pessimism* – pessimists of the left dwelt on the 'power' of structures and institutions over the people, not on the agency of individuals (Schiller, 1996). Pessimists of the right lamented the 'decline' in traditional values. Neither side saw *positive* 'effects' of TV (see Hartley, 1999a). Textual analysis was berated for missing 'structural determinants', while concentrating on superficial and illusory flim-flam.
- *Post-modernism* – textual analysis took seriously, and worked through, issues of scepticism, doubt, relativism, multiple realities and indeterminacy, not only in the circulation of imaginative meanings via TV but also in the 'construction' of truth and reality as such. It was both witness to and an example of the strange disappearance of textual 'value' within analytic discourse, and simultaneously the rise of the 'self' of the analyst in its place. This got right up the noses of the realists (Windschuttle, 1998).

In the context of these disciplinary vicissitudes, textual analysis of television has evolved its own 'armamentarium' for investigating the social production of meaning. An emergent trend saw it combine with historical research, investigating the 'archive' of popular culture. An exemplary contemporary exponent of the 'history of looking' in television studies is Lynn Spigel. The same approach can also take the form of a sort of cultural journalism that dives into the actual *stuff* of everyday semiosis to see what's going on. In both cases the 'object of study' is the extra-textual relation between 'addresser' and 'addressee' in modern, mass, anonymous, public communications, as much as distinctive textual features; however, such features can be analysed in their own right, within and across individual 'texts'.

The means chosen for such work have involved significant interdisciplinary borrowings. Methods adopted are heterogeneous, including:

- close critical reading of audiovisual texts, derived from the traditions of literary critical reading;
- semiotic analysis derived from Saussurian/Barthesian linguistic structuralism and Russian Formalism (Lotman, 1990; Volosinov, 1973);
- analysis of visual images (still and moving) derived from art criticism and film studies (*Screen*);
- cultural analysis derived from 'Birmingham' cultural studies (Hall and Whannel, 1964; Hoggart, 1960) and from Raymond Williams (ideology/hegemony analysis);

- social-structural analysis, derived from Marxist sociology and political economy of the media (content analysis);
- feminist criticism (Brunsdon, D'Acci and Spigel, 1997);
- historical investigation of popular media forms (Sconce, 2000; Spigel, 2001).

The interweaving of these disparate disciplinary and discursive strands became characteristic of contemporary television studies. An excellent model of how mixing different modes of inquiry could produce an original study of a familiar textual object was Toby Miller's book on *The Avengers* (Miller, 1997).

However, times changed again, with the advent of digital and interactive television formats. With more customisation, 'mass' broadcasting was under attrition, reducing the times when whole communities might use a television presentation to think about the human condition (the moon landings), a dramatic sensation (who shot JR?) or a national shock (OJ Simpson). With narrowcast pay channels and commercially available archives like TiVo, viewers could disrupt the traditional organisation of television around time-rituals imposed by programmers. With the digital web-cams, television's 'readers' could become 'writers', extending its literacy in ways that may yet profoundly affect its textual form. Certainly, textual analysis of television entered the 'post-broadcast' era contending with circumstances in which:

- the 'text' kept morphing;
- methodological fashions and passions turned again;
- a crisis of legitimacy continued to challenge what was understood to be knowledge, disciplinary or otherwise, and who got to do the understanding;
- public life was ever more textualised, as government, education and media converged and integrated;
- readers became writers in the literacy of audiovisual production (Hartley, 1999b).

All in all, questions of power, ideology, citizenship and 'mass' cultural politics may decline in importance as television, like culture at large, turns into a service industry. Perhaps television will no longer be treated as a national cultural weathervane, but only as an 'application' within consumer-driven technological infrastructure and connectivity. As part of the 'content' or 'creative industries', television may move beyond the broadcast era's obsession with control and 'effect'-minimisation, and towards the new economy's devotion to networks, interactivity, partnership and DIY culture. Then textual analysis may be most useful as a 'guide' technique (see Spigel, 1997, and 'Popular Television Criticism', p. 27–9, for discussion of television reviewing in the press) or emerge as an epistolary form (e.g. blogging) within the repertoire of electronic communication. Watch this space.

John Hartley

RECOMMENDED READING

Brunsdon, Charlotte, D'Acci, Julie and Spigel, Lynn (eds) (1997), *Feminist Television Criticism*, Oxford: Oxford University Press.

Eco, Umberto (1987), *Travels in Hyperreality*, London: Picador.

Gray, Herman (1995), *Watching Race: Television and the Struggle for 'Blackness'*, Minneapolis: Minnesota University Press.

Hartley, John (1999), *Uses of Television*, London: Routledge.

Lotman, Yuri (1990), *The Universe of the Mind: A Semiotic Theory of Culture*, Bloomington: Indiana University Press.

The Avengers – a familiar textual object

New Technologies

Imagine today's favourite consumer electronics fantasy: replacing the old television set is a gigantic high-definition screen of striking image and sound quality offering home entertainment, web browsing, e-mail, videoconferencing, DVD, CD, movies on demand, and the latest in video-game playing. In addition, the system might offer controls for the so-called 'smart' home, household budgeting, movies on demand and surveillance of the baby's nursery. New technologies are normally presented by the consumer electronics industry as a natural and direct response to the needs and desires of television viewers (Caldwell, 2000, p. 8). Although the electronics manufacturers are one of the most easily accessible sources of information about new technologies, through press releases, advertising and trade shows, and are the primary source of information for most journalists on the topic, unfortunately they are most unreliable. We can expect exaggerated claims for ease of use, inflated predications of how likely it is that widespread adoption will occur, and a failure to report technical glitches or incompatibilities, or the failure of new product launches.

It is wrong to conceive of new technologies as either a simple response to consumer demand or as a direct march towards improved image and sound quality of ever-greater verisimilitude. New technologies are not made available as soon as science and engineering 'invents' them. Some technologies that might be technically feasible are never developed at all because they are not seen to have a strong market potential. Others are developed despite known problems for consumers because they are seen to be potentially lucrative to manufacturers and media content providers, or because big players own the patents. Deciding factors such as the potential for new technologies to increase advertising capacity, to expand existing markets, to fit into planned obsolescence schemes, or to be priced attractively are given first – and often exclusive – priority.

Besides the relationship between manufacturers, broadcasters and consumers, new technologies are implicated in policies protecting economic interests and the global competition for markets. One case in point is High Definition Television (HDTV), which was technically feasible for decades but has been somewhat stuck with compatibility and interoperability problems. These problems have their historical roots in the different television standards (NTSC, PAL) established half a century earlier, with NTSC (National Television Standards Committee) dominant in North America and incompatible with PAL (Phase Alternate Line), the European standard. The desired number of lines of resolution was contested – since it would be easier if the number were a multiple of the earlier system. HDTV has only recently became feasible in part because of the availability of cheap factory workers in Mexican maquiladoras – a direct result of NAFTA (the North American Free Trade Agreement). Thus trade agreements, manufacturing agreements, professional licences and global markets are also implicated in the 'development' of the new technology of High Definition Television.

Since its widespread and rapid adoption as a domestic technology in the 1950s, broadcast television has weathered the introduction of several significant technological 'add-ons': remote controls, cable, video games and the videocassette recorder. Each of these played a role in altering television form, and each was predicted to have potentially devastating effects on viewership of commercial television by reducing the amount of time spent viewing commercials. Channel surfing with the remote control led to shortening of programme segments, and the introduction of a wide variety of trailers, promos and eye-catching effects hoping to hold the viewer's attention on a single channel. Video-game playing on the television set became widespread in the 1980s and its popularity is very high, especially with adolescents and young males. Video-game playing certainly helped spur on the tendency for homes to have multiple television sets and, in many households, for each family member to have his or her own television set to watch or play games or tapes on. The VCR was originally predicted to be used primarily for time-shifting of programmes, so that viewers could fast-forward through commercials. Instead, viewing habits remained substantially the same *vis-à-vis* broadcast television, and instead the VCR – whose rapid adoption outpaced even that of the first television sets – has come to be used primarily as a means for viewing movies on video. The machine's capacity to be programmed to tape on a particular schedule has involved a level of mastery that continues to elude many VCR users, but three-year-olds can learn to put in a VHS tape and push the play or record button.

Cable posed a significant threat to broadcast networks, and was probably responsible for a complete economic reorganisation of the US television industry, as Fox, Warner Bros. and other 'networks' gained significantly in prime-time audience share. Similarly, the spread of satellite television in Europe took a serious toll on viewership of the traditional public service broadcasters in these countries. However, after the initial adjustment to the exponential increase in the number of channels, viewers tended to limit themselves to a handful of channels. Cable penetration in the US is still stuck at about two-thirds of US homes and

computer ownership at around 50 per cent. While cable brought on the end of the network era, it has not entirely replaced broadcast, mass-media offerings. Satellite television became the standard for expanded television offerings in Europe and Asia and is an important form among elites – but its numbers, too, are limited and it has not replaced the viewing of local land transmissions, although it has hugely increased the viewership for MTV and ESPN. Despite the ability to carry hundreds of channels on the new digital cable and the much-touted possibilities for niche programming, there is surprisingly little diversity of material available – the offerings are still restricted to familiar genres, reruns and subscription movies – and programmers jockey frantically for position in the single digits: no programmers wish to be located in the high tier of numbers, so-called 'digital Siberia'.

COMPUTERS AND TELEVISION SETS

The technologies of broadcast television and of computers are becoming increasingly intertwined – in terms of the box – as computers with television tuners and video-stream capabilities become more commonplace. Television sets and computer terminals will certainly merge, cohabit, coexist in the next century. As the Internet develops from a research-oriented tool of elites to a commercial mass medium, resemblances between websites and television programming increase. Commercial content providers seek ways to reproduce popular genres from broadcast radio and television on the World Wide Web. The only 'killer apps' so far are business news, sports and pornography. Each of these male-dominated genres has also been an enormous profit-maker for television. The much-publicised presence of pornography on the Internet also parallels the spectacular success of that genre on home video.

Despite these overlapping contents, the television industry has felt severely threatened by Internet and e-mail as a competitor for viewers' leisure time. Television companies have sought to join with new media to cushion themselves against predictions that old entertainment media are dead, or will not be enough for the Net generation, or that people are decreasing consumption of traditional media and spending more time online and some new hybrid form of data plus entertainment will be taking over. Concerned to hang on to their diminishing and dispersed audience, broadcasters have promoted tie-ins between programmes and the Web, with a proliferation of contests, chatrooms, live interviews with stars web cast. Hardware and software manufacturers are scrambling to secure the market for sales to non-computer owners of devices that will convert the plain old television set to an Internet browser, or win

the battle between the high-definition TV sets favoured by the electronics industry and the digital television/monitors favoured by the computer industry.

As a result of the conglomeration of media companies (cable, television, film, telephone, publishing) we can expect television producers to continue their keen interest in the Internet to cross-promote movies, television programmes, music and books. The television industry is also scrambling to establish a stake in the future 'Internet appliance', the machine and the delivery system, through reserving space on digital TV channels, set-top-box leasing or the development of navigational guides for digital TV. Microsoft has been avidly pursuing strategies to position itself as the supplier of software for cable set-top boxes with the intention of choking off competitors. The television industry is also anxious to prepare for the time when the Internet will deliver video (something not technically efficient in the current system but possible when broadband access is established).

DIGITAL MEDIA AND PRODUCTION PRACTICES

Less apparent, but equally significant, has been the impact of new technologies on how television professionals work. Digitisation of media radically changed production equipment and working practices in the video and television industry. 'Production practices' refers to the unit organisation, division of labour, performance of work and processes of specialisation involved in conceptualising and planning TV productions (pre-production), shooting the actual scenes, and editing, sound mixing, titling and special effects (post-production). The switch to digital media has affected all three parts of the production process, but had its most significant impact on post-production.

As in other businesses, television production utilises a wide range of software for script generation (programs which assist writers in keeping to the prescribed length, introducing plot points at the appropriate moment – such as before a commercial break – and maintaining character consistency across episodes). Budgeting, production planning and scheduling have also been affected by dedicated software for tasks related to pre-production planning. In the shooting phase, digital video has replaced analogue video in many contexts, although many television programmes, especially high-profile, 'quality' shows are still shot on film, to be edited later in digital format, and analogue equipment is still widely used for 'live' broadcast transmission. While digital cameras introduce certain requirements of their own, such as special lighting to compensate for the tendency for digital images to look flat with

cartoonish colours, they have not significantly changed the way crews work to capture images, or the numbers of people involved in production.

The post-production phase is where the impact of digital video has been most dramatic. For the television/video producer, digital media introduce remarkable efficiencies. The most significant advantage of the technology is that there is no generational loss in signal reproduction – the material can be copied or transmitted an indefinite number of times without any degradation of quality. By contrast, analogue video was fragile, deteriorated rapidly when copied and was time-consuming to edit due to delays for fast-forwarding and rewinding. Non-linear editing (working with computers to manipulate digital media) makes possible instant access to any frame of the stored video – editors can move from one section of a video to another with the click of a mouse. Special effects, transitions and layering of images that formerly required days of work on optical printers are now available in seconds – thus the proliferation of elaborate station IDs, title sequences, trick shots and computer graphics on broadcast television. Frame-accurate editing, re-editing, rapid cutting with extremely short shots, and special effects can all be quickly accomplished in digital video. The material can be stored and accessed easily, there is a far greater capacity for storage in small spaces, and hundreds of differently edited versions of the same material can be carried out rapidly. Even more dramatic are the possibilities for transmission of the digital media over broadband technologies: this allows for post-production to take place at different locations simultaneously. An editor in Mexico could work for a director in the US, with a Korean sound specialist, and the material can be 'shared' through a digital media storage facility at a fourth location.

Overall, new digital technologies have worked to increase the hiring of freelance personnel, many of whom work from their homes or studios and 'telecommute'. In the long run, digitisation of post-production work favours contract labour and weakens the possibilities for organising labour unions. It has also worked in favour of decentralising US television production, dispersing it from Los Angeles – digitalisation thus facilitates the movement of production to regions with cheaper labour forces around the world, such as the preponderance of animation work performed in Asia.

CONCLUSION

Many technological utopianists had hoped that the digital revolution would unleash independent producers. With analogue production, even those who had their own cam-

eras, for example, would have to pay exorbitant rates to 'online' their final production at a studio. Non-linear editing systems have become quite reasonable, so it is now possible, for the first time in the history of independent film or video, for producers to own the entire means of production – from pre-production through post-production. When video-streaming capability increases on the Web it could be seen as a new, alternative distribution outlet to broadcast or cable television. As Robert McChesney put it, 'Long ago – back in the Internet's ancient history, like 1994 or 1995 – some Internet enthusiasts were so captivated by the technology's powers they regarded "cyberspace" as the end of corporate for-profit communication. . . . That was then' (1997, p. 33). Such projections – like those for Portapak video or public access television – overlook important factors which continue to give established media companies a vast advantage over independent producers. The style of production that audiences are accustomed to reflects a level of investment on the set, at the time of shooting, which is largely unaffected by digital technologies. While some reality shows have popularised a pared-down look, television still aspires to production values that require large crews, intensive specialisation in preparing elements of what is to be photographed, and elaborate equipment set-ups.

TV sets and video cassette recorders are cheap, plentiful and work forever. The humble half-inch tape is still a remarkably sturdy and standardised form of storage for video. Television scholars must be prepared to protest the drastic cuts in funding for public television and for independent productions in the name of investment in the new digital era. While computers are still costly and difficult to maintain, television sets and VCRs are to be found in nearly every home and school and library. Television and video will continue to be vastly more accessible than computer communications for a very long time – and probably a better investment for a democratic society. For aggrieved communities whose second-rate access to media technologies and whose representational exclusion from the mass media have long and relatively unchanging histories, the push towards digital media threatens to exacerbate economic hardship and a widening class divide. As historian David Noble reminds us: 'Technological revolutions are not the same as social revolutions and are more likely, in our times, to be the opposite. But the two do have this in common: they do not simply happen but must be made to happen' (1984, p. 195). New technologies only become available when powerful economic interests decide to make them so, and their accurate assessment requires care and scepticism.

Ellen Seiter

RECOMMENDED READING

Caldwell, John Thornton (ed.) (2000), *Electronic Media and Technoculture*, New Brunswick: Rutgers University Press.

Harries, Dan (ed.) (2002), *The New Media Book*, London: BFI Publishing.

Schiller, Daniel (1999), *Digital Capitalism*, Cambridge, MA: MIT Press.

Seiter, Ellen (1999), *Television and New Media Audiences*, Oxford and New York: Oxford University Press.

Silverstone, R. and Hirsch, E. (eds) (1992), *Consuming Technologies: Media and Information in Domestic Spaces*, London: Routledge.

Television Marketing

Marketing and research for television are unlike that for other product categories. Standard marketing practices are based on the four Ps – product, price, place and promotion. When it comes to television marketing, only the last P counts. The reason for promotion's pre-eminence is simple. In television, marketing can only affect the TV product, price and place indirectly through promotion.

Television marketing is unique in one other respect. The product being sold to viewers – television programming – influences what we think and talk about by presenting some ideas and withholding others. Watching television, specifically commercials, motivates us to purchase one product over another. Commercials, print ads and other types of television marketing persuade us to spend more and more time in front of the television screen. Watching television is not for the benefit of the audience, but rather benefits networks and advertisers, who pay substantial sums for large audiences.

Television's product *is* the audience, which marketing seeks to alter in terms of size and demographics. Marketers can determine prices paid by advertisers, but only through the promotional work of building audiences – the advertiser passes these costs on to the consumer in the price of goods and services. (In Britain, consumers pay a licence fee for their television, but the government sets this fee without direct influence of market logic pricing.) Marketing affects place, or the availability of TV programming, only to the extent that it raises awareness of existing programmes and the channels on which these are distributed. Promotion, therefore, is the heart and soul of television marketing. Advertising, sweepstakes, sponsor tie-ins and on-air promotion are the tools a television marketer uses to sell the product.

Promoting *Frasier* – urban situation comedy or family programme?

Television marketers address three key constituencies in their promotional work – consumers (or viewers), advertisers and affiliates. Promotion can also be aimed at corporate shareholders and the government, but these are viewed as less important than the other three.

Consumers are targeted with advertising messages about television programming through on-air promotion or via off-air purchased advertising. Most shows are promoted on the network itself with commercials known as on-air promos. These messages can be either general tune-in messages or they can be episodic. Tune-in messages tell the viewer when and where to see the show: '*ER*, tonight at ten. Only on NBC.' Episodic messages tell more specifically what that night's episode is going to be: 'Tonight on *ER*, Dr Greene will have to make the decision of a lifetime. Watch this exciting all-new episode.' Shows may also be promoted differently to different parts of the country or different target audiences. For example, *Frasier* was promoted as an urban situation comedy in most US markets. However, in many markets, particularly in the more conservative markets in the southern United States, the show was promoted as a family programme. The promos were cut to focus more specifically on the relationship between Frasier, his father and his brother in order to appeal to that more conservative audience. This attention to regional variations

can be extended globally as marketers track local differences in taste, tradition, attitudes and behaviour in order to promote programmes in narrative terms that are familiar and appealing to local audiences. This practice applies obviously to the promotion of imported programming but also to promotion within particular national settings where a good deal of difference may separate regional cultures as well as urban and rural audiences.

In addition to on-air promotion, television networks use off-network paid advertising to promote tune-in. Advertising will usually be in the form of print (obvious places are viewing guides like *TV Guide* and general entertainment publications like *Entertainment Weekly*), radio, billboards and some television. Television tends to be limited in the US because competitors put restrictions on what other networks can say on their air. For example, ABC can mention a show on a competitive channel, but they can not mention the time and day that the show will air.

Networks (broadcast or cable) use consumer promotions in addition to advertising. These are sweepstakes or contests that allow the viewer to win a chance to see a taping of a favourite show or get tickets to a special event like the MTV Video Music Awards or the Soap Opera Digest Awards. These sweepstakes are created to provide more marketing opportunities for sponsors (advertisers). Sweepstakes are a way to give multiple advertisers additional promotion through both on- and off-air exposure using advertising, point-of-purchase displays, premium items and on-air promos.

In contrast to consumer promotion, marketers will target affiliates and advertisers through direct business-to-business or trade promotions. These trade campaigns use a combination of advertising, special events and one-on-one selling.

Strategies differ between marketing broadcast networks to affiliates and marketing cable networks to local cable systems (their affiliate equivalent). Broadcast affiliates are local stations under long-term contracts with a broadcast network. Marketing, in this case, is usually done to make the stations feel good about their affiliation and tends to be done on a sporadic basis. For cable networks, however, marketing to cable operators can be very intensive. For example, if a cable network is just being launched, it needs to gain access to viewers. The only way it can do this is by getting picked up by the local cable system. The network must demonstrate its advantages over all the other new alternatives being presented. This is particularly difficult in the current television marketplace, because the owners of the cable systems – usually large multinational conglomerates – also own the majority of the cable networks. These companies tend to give carriage preference to those networks that they own rather than independent networks, which they might have to pay for. More established cable networks still need to promote themselves to cable affiliates in order to keep from being dropped from a system. The best way that they can do this is by promoting their local advertising sales capabilities. Local advertising is money that goes into the cable operators' pockets. If the marketers can demonstrate that the cable system will make money by having their network on the system, they are more likely to be retained by the operator.

Marketing to advertisers tends to be more consistent than marketing to affiliates. Advertisers are constantly kept aware of changes in standing between networks and any major movement that may occur in the ratings on a particular show or in a particular 'daypart' (time periods during the day that are programmed to appeal to different audiences). These dayparts are early morning (*Today*, *CBS Early Show*, *GMA*), daytime (soap operas, talk shows), prime time (8–11 p.m.), late night (*The Tonight Show*, *The Late Show*, *Nightline*), teens or children's programming, news and sports. These different demographics suggest different advertisers to target. For example, when television marketers want to promote their daytime soap operas over the competition they begin their campaign in trade press advertising and follow up with a one-on-one sales call. Since it is assumed that the daytime audience is primarily women, marketers hype the programme to companies whose products are aimed at women. The objective is to win the advertiser's business away from a competing network.

This brings us to ratings – the be-all and end-all of television marketing. Eyeballs, not programming, are what television marketers sell. Nielsen Media Research calculates the television ratings. Audiences are determined through the use of People Meters. In the US, these boxes sit on top of the television sets of 5,000 households from where they electronically send information back to Nielsen about who is watching what programme. There have been complaints about Nielsen ratings because they only record viewing in the home. They do not take into account viewing in places like college dormitories (a site for serious soap opera viewing) or bars (the bastion of sports viewing). Even so, television networks (and advertisers) are dependent on these numbers for determining advertising prices.

Pricing for advertising is based on estimates by the network. The key factors that determine the price that advertisers will pay for commercials are ratings and the marketplace. The money an advertiser will pay for a commercial is based on the rating multiplied by the CPM (cost per thousand) of a certain demographic. For example, if the CPM for women aged 18 to 49 is six dollars and a show

delivers 5 million women, then the cost for a commercial on that show for that advertiser is $30,000 ($6 x 5,000). Therefore, it is easy to see that if the audience increases, the advertising rate increases accordingly.

It is instructive to look at an example. The average prime-time household CPM for the US networks in 1998 was estimated to be US$11.85. For comparison, daytime CPMs were US$4.25 and late night CPMs were US$9.60. Therefore, it was more expensive for an advertiser to reach an audience during prime time than it was at other times during the day. These numbers, however, were household numbers and advertisers rarely purchase households. They purchase specific demographics. Many advertisers want to reach women between the ages of 18 and 49. In 1998, this demographic had a CPM during prime time of US$26.25. Because it is a more specialised audience than households, it commands a higher price. Even more expensive was the male 18 to 34 audience with a CPM of US$57.50. This is because men, particularly young men, watch less television and are more difficult to reach.

This example demonstrates how pernicious television ratings are. The underlying message is that one group of people is more valuable than another. Women are more valuable than old people, and men are more valuable than women. Therefore, networks need to create programming that will attract these audiences in significant numbers. Programming like *Temptation Island* or *Baywatch* takes precedence over *Masterpiece Theatre* or the nightly news. This is not only because the audience is younger, but also because they have more money to spend. Young audiences tend to have more discretionary income versus older people who are on a fixed income. Young people are just beginning to establish their brand preferences, while older audiences have long ago determined what laundry detergent they will buy or the type of car they like to drive. Therefore, in the pursuit of wealth and youth, the television landscape becomes littered with adolescent themes and programmes that appeal to the lowest common denominator.

Mara Einstein

DISNEY/ABC'S YELLOW CAMPAIGN: 'TV, SO GOOD, THEY NAMED A FROZEN MEAL AFTER IT'

When a broadcast network is in last place, it is more likely to take chances. This was true when Disney's ABC network launched *Who Wants to be a Millionaire?*, a prime-time game show. It was also true in 1997, when the same network launched its 'TV is Good' campaign, which became known as the yellow campaign.

This advertising campaign was created by Chiat/Day, the same advertising agency behind the '1984' Macintosh ad. The campaign got its name from using slogans printed in black type on a yellow background. While the campaign promoted individual shows, the most controversial ads urged television viewing as an end in itself – usually a first-place marketer's strategy – with such irreverent lines as:

- 'If TV's so bad for you, why is there one in every hospital room?'
- 'Life is short. Watch TV.'
- 'It's a beautiful day, what are you doing outside?'
- 'Before TV, two World Wars. After TV, zero.'
- 'Hello, it's free.'
- 'TV, so good, they named a frozen meal after it.'

ABC had the most diverse programme line-up and the broadest demographics of any network at the time, but it lacked a coherent marketing identity. With 210 affiliates wanting a more cohesive look and feel, especially in a cable universe with over fifty channels in every home, ABC faced a serious branding problem. The solution came in moronic non sequiturs printed on a yellow background. The irreverent language and sardonic tone play into people's love-hate relationship with television. That is, while people watch a lot of television, if you probe them about their television viewing habits they get defensive about it. The language, therefore, supports viewers' belief about their television viewing – TV is good, and now I have a way to justify it.

The campaign consisted initially of print ads, outdoor advertising, on-air promos and even ads on coffee cups and bananas. There were promos entitled 'Great innovations in television', depicting comic renditions of television inventions. Another series of promos, entitled 'ABC Cheap Cinema Theatre', recreated popular movies in thirty seconds using stick figure drawings and the tagline, 'Classic movies inexpensively recreated so you can spend more time watching TV.'

The very simple design – black type on a yellow background – proved to be effective in creating an identity for ABC and was still in use four years later, appearing throughout the broadcast day. It gave the network an immediately recognisable image – a difficult task in a multi-channel television market.

Mara Einstein

RECOMMENDED READING

Berger, Arthur A. (2000), *Ads, Fads, and Consumer Culture: Advertising's Impact on American Character and Society*, Lanham, MD: Rowan & Littlefield.

Eastman, Susan T. and Klein, Robert A. (1991), *Promotion and Marketing for Broadcasting and Cable*, Prospect Heights, IL: Waveland Press.

Twitchell, James B. (1996), *Adcult USA: The Triumph of Advertising in American Culture*, New York: Columbia University Press.

Online Resources

www.adage.com (Leading trade publication for the advertising industry)

www.adbusters.org (An anti-advertising publication)

www.broadcastingcable.com (The weekly trade publication for the television industry)

Television and the Law

The institution of television involves a great deal of legal activity. The TV industry does not create things one can hold in the hand but rather relationships: relations between copyright holders, producers, consumers, networks, stations, advertisers, audiences, etc. And those relations exist only through a dense web of constantly shifting regulatory structures and legal contracts embodied in legal documents, every line of which has been closely examined by at least two lawyers. Every executive in the television business deals with lawyers and legal issues on a regular basis.

Yet this steady hum of essential legal activity so familiar to industry executives is not what we see represented on our TV screens. The courtroom dramas that fill the airwaves focus instead on crime, personal conflicts like divorce and family, and popular ethical dilemmas involving personal behaviour like drug testing. The disparity between the law behind and in front of the camera can be understood in terms of the central social division that forms the context of contemporary television and which television itself reinforces: the divide between, on the one hand, the 'public' world of work, economic exchange and production, and on the other, the 'private' world of personal life, domesticity and consumption. To oversimplify: behind the camera, law is about business; in front of the camera, it is about personal life.

To understand the behind-the-camera side of television law, one has to understand the regulated character of tele-vision. With very few exceptions, broadcasting the world over has relied on government regulation for its very existence. There are many reasons for this. Most of the radio spectrum is used for strategic, point-to-point purposes, particularly military purposes, so the use of radio waves for broadcasting exists against a backdrop of hierarchical institutions strongly interested in rigid control. And it may be the case that the technology of radio itself necessitates an enforceable framework for regulating channels and technical standards of transmission to prevent interference. Whether or not broadcast regulation is really made necessary by the technological characteristics of the medium has long been a favourite debating point. See, for example, Rand (1967), Smythe (1952) and Coase (1959). With the interesting but marginal exception of pirate radio, however, it nonetheless remains the case that all significant television systems in the world have existed within intricate relations with the state.

But at least as important as these factors is the fact that large, capital-intensive industries prefer a certain amount of predictability in the field of economic competition. As William Paley, founder of the US commercial broadcast network CBS, once said, 'sudden revolutionary twists and turns in our planning for the future must be avoided. Capital can adjust itself to orderly progress. It always does. But it retreats in the face of chaos' (Paley, 1971 [1938]). Whether or not law provides justice, then, it provides order of a kind perceived as necessary for conducting business. This is not to imply that the businesses involved in television don't compete with each other; they do, often ferociously. But for the game of economic competition to begin, some legally complex underlying rules and structures have to be developed beforehand. For that purpose, legal and government regulation of television has proven to be quite useful, and in a certain sense necessary. In the US, where the broadcast industry is often described as a minimally regulated, *laissez-faire* institution, it is worth recounting that most of what regulation does exist has come at the behest of corporate forces within the broadcast industry.

Taken together, these factors have generated four overlapping terrains of television law. One is the regulation of frequencies and technological standards. Here there are both international regulatory bodies, particularly the International Telecommunication Union (ITU), and national bodies such as the US Federal Communications Commission (FCC), which together make rules that govern the character and use of satellite and terrestrial radio channels, and technological standards for transmission and

reception (like the PAL, NTSC and SECAM standards for television). Though typically shrouded behind the complexities of electrical engineering, debates over technological standards are nonetheless highly political. For any given standard, there are winners and losers. Setting any technological standard thus typically involves bitter battles between competing industrial and national interests. (The still unresolved question of standards for High Definition Television, or HDTV, is a classic example.) It's generally a safe bet that any standard that emerges victorious from such battles is probably not the technologically *best* standard, but a technologically *adequate* one that had the most politically powerful forces behind it.

A second terrain of television law falls under the broad rubric of intellectual property (IP), which is also created and enforced both on national and international levels (particularly by the World Intellectual Property Organisation, or WIPO). Patents and copyrights essentially create not ownership of a 'thing' but temporary monopolies that allow the holder to *prevent others* from copying a creative work (copyright) or using a process (patents). IP does not last forever; it typically becomes free for the taking, or part of the 'public domain', after a specified period of time. These temporary monopolies are thought to be justified insofar as they encourage the creation of new works and inventions. Many of the early twentieth-century corporate empires that had such an influence over the development of television (e.g., RCA, AT&T, GE, Westinghouse, Philips, Siemens) were built on top of patent libraries, and still today a portion of the cost of television technologies goes for the intellectual property embedded in the microchips, circuits and processes that make TVs work.

However, more recently the era of media convergence has brought copyright to the forefront in media policy. Copyright is no longer something used simply to protect a writer's or artist's works; it is now central to corporate strategy. As corporate oligopolies have lost control over hardware because of the proliferation of channels with satellites, VCRs, cable and computers, they have shifted attention towards control over software, and sought to use expanded intellectual property rights to ensure that control. During the 1980s, both media and computer software corporations, then, began to pursue a new strategy that emphasises the process of cornering and cultivating huge libraries of old films, programmes and similar software. Those could then be integrated with product licensing campaigns and media tie-ins, and continuously recycled through the ever-growing variety of communication channels. Scott Sassa, the executive often credited with the suc-

cess of the Fox TV network in the 1980s and later president of NBC Television, described his secret to success as making sure that 'every copyright that starts out anywhere in the system gets leveraged every which way imaginable' (Kline, 1995). This kind of corporate strategy in turn has an increasing effect on television content: scripts, characters and plots are frequently created with an eye towards their potential for long-term licensing and tie-ins; a popular novel is written with film rights and sequels in mind, or a children's story is written with characters that can be easily licensed as toys and spun off as cartoon series.

While corporate strategy has generated an interest in raising the barriers against copying, technology has simultaneously made it easier to copy media material, and therein lies much of the controversy in the topic. Each new technology with copying capabilities – e.g., VCRs, dual-cassette audiotape decks, digital audio tape (DAT), MP3 digital audio, and digital video – has been greeted by a furious effort on the part of media corporations to use a mixture of law and technology to restrict its use for copying content. The resolution of these controversies is less simple than it might seem at first, because the proper boundaries of intellectual property are not self-evident. At some point, too much protection for intellectual property can restrict the circulation of new works and ideas, and thus stifle the innovation that is the law's principal justification; the Hollywood film industry tried to prevent the wide distribution of videocassette players, for example, but when the US courts decided against them in the *Betamax* decision, videotapes eventually became a major source of industry revenue. Furthermore, intellectual property is a strange beast; it does not easily fit the standard image of property. It is ephemeral, and one can sell it and not have any less of it than before; it is what economists call a 'public good'. And it is highly divisible; the rights for a particular programme, say, can be divided into first broadcast, rebroadcast, videotape, trademarks, teleplay, treatment, musical, digital rights, and others, and each of these rights can be bought and sold separately. Because of all these factors, current struggles over the terms of IP law tend to be at once complex and strangely metaphysical.

A third terrain of television law falls under the heading of content regulation, the direct and indirect regulation of television content by government. In developing nations particularly, and in most nations to some degree, television is viewed as an instrument of economic development and national integration. The national governments of the world, as a result, have sought to shape the content of their informational and entertainment programming so as to support these goals. In many nations,

WLBT: RACE, LAW, POLITICS AND TV

The US government has the theoretical power to take away a television station's licence to broadcast – an effective death sentence for a station – on content grounds. Significantly, however, it has fully used that power only once in the history of the medium: against WLBT in Jackson, Mississippi, in 1971, following a protracted legal battle. In the 1950s and early 1960s, this white-owned and operated television station used its airwaves to support the segregation of whites from African-Americans. National newscasts about the civil rights movement were censored, segregationist views were openly espoused, and no African-Americans (who made up half of Jackson's population) were allowed any airtime on the station. White and African-American civil rights activists at the time were eager to find ways to get their views expressed in this powerful new medium. At the time, the FCC had a policy called 'fairness doctrine', which said that for stations to meet the 'public interest' requirement that is a condition of their government-issued licence, they should make a good faith effort in their news coverage to report controversial issues of public importance in a balanced, 'fair' way that gave attention to the competing points of view. With the help of a Washington, DC-based activist group, elaborate information was gathered to demonstrate the (obvious) bias of the station,

and a claim against the station's licence was filed, eventually leading to licence revocation.

Competing interpretations of this case demonstrate the political divisions that shape debates about the proper relations between law, government and industry. Some argue that this is a case of 'good government', of the proper and valuable use of government regulation to further democracy and racial equality. Many economic conservatives might counter that this is an example of unnecessary government interference, at least in the present multi-channel environment; rather than involving government bureaucrats in judging the appropriateness of programme content, it would be better to turn the problem over to the 'marketplace of ideas' by, for example, increasing media outlets and encouraging economic competition. Classen's study of the case (forthcoming), however, adds another dimension to the discussion: neither point of view, he shows, does full justice to the complexities of racial politics at the time. The only way the FCC could be convinced to hear the case at all, for example, was by shoe-horning a social and political struggle around race relations into legal categories like 'the consumer'. A richer sense of justice, he hints, might require a complete rethinking of the legal and regulatory apparatus of television altogether.

Thomas Streeter

this has led to state-owned or state-controlled broadcast systems that either directly fund particular kinds of programming or censor them after the fact so as to support various national ideals and economic agendas. In liberal developed nations where legal regulation of media is framed within traditions of business autonomy and free speech, such concerns tend to be expressed in more limited ways, generally through moral concerns (e.g., restrictions on sex and violence in programming), concerns about media coverage of legal and political issues (e.g., cameras in courtrooms, regulation of political advertising) and vague guidelines about promoting things like 'the public interest'. Even the US commercial television industry, which often promotes itself as the world's most 'free', is subject to legal regulations on all three of these counts.

Content regulation regularly leads to protestations of 'censorship', and indeed there are instances the world over of governments using their influence over television content to promote their power and hide their misdeeds. Yet the fact remains that television is a large institution and embodies a concentration of power; it is a collective, rather than personal, means of expression. As a result, even in nations where TV is in principle fairly well insulated from direct government control over content, making manifest the ideal of free speech becomes a murky enterprise. Is using government regulation to require diversity in programming a use of government to promote free speech or a form of government censorship? When a powerful TV network refuses to give airtime to minority or dissident views, is that the exercise of free speech or an act of censorship? Much ink has been spilled trying to resolve such dilemmas.

A fourth terrain of television law concerns what might be called 'private censorship' – that is, private agreements and legal relations outside of government that influence content and behaviour. In liberal developed democracies, the function of programme censorship that elsewhere is handled by government agencies is largely handled in-house; the US commercial television networks, for example, typically have 'programme practices departments' that engage in systematic and thorough censorship of scripts for television series, typically to ensure that scripts are morally 'appropriate' – or at least safely inoffensive – for mainstream audiences (and, some might argue, advertisers).

The McLibel case – politics, the media and the law

Industry segments also frequently engage in what is called 'self-regulation', where television advertisers or similar groups formally or informally agree to follow specific content guidelines so as to fend off public ire and/or direct government regulations. Hard liquor advertisements are largely banned from broadcast television in the US by such agreements, for example. The form of private censorship of most concern to broadcast executives, however, is probably libel law, which gives individuals and corporations the power to sue media organisations for false and defamatory attacks on 'character'. While typically involving personal issues, libel cases can stray in a political direction, as in the case of Westmoreland v. CBS in the US and McDonald's v. David Morris and Helen Steel (two Greenpeace activists) in Britain.

In sum, the institution of television should be viewed as something not merely constrained by, but constituted in, a set of legal relationships. The tools of television, even the boxes in our living rooms, are to an important degree legal constructs. A TV set itself is made practical, made into a practice, by its internal organisation in concert with the elaborate social relations that make broadcasting possible, including everything from government regulation of the spectrum to a consumer economy. Those relations, in turn, centrally involve law and politics, that is, lawyers, judges, legislators, and a polity interpreting, making, changing and enforcing laws and regulations that enable and shape both the equipment of broadcasting and the institutions that make the equipment come alive.

Thomas Streeter

RECOMMENDED READING

Aufderheide, Patricia (1999), *Communications Policy and the Public Interest: The Telecommunications Act of 1996*, New York: Guilford.

Boyle, James (1996), *Shamans, Software and Spleens: Law and the Construction of the Information Society*, Cambridge, MA: Harvard University Press.

Collins, Richard (1990), *Television: Policy and Culture*, Boston: Unwin Hyman.

Collins, Ronald K. L. and Skover, David M. (1990), 'The First Amendment in an Age of Paratroopers', *Texas Law Review*, vol. 68, no. 6.

Price, Monroe E. (1995), *Television, the Public Sphere, and National Identity*, Oxford University Press.

Ó Siochrú, Seán and Girard, Bruce with Mahan, Amy (2002), *Global Media Governance: A Beginner's Guide*, Boston: Rowan and Littlefield.

Globalisation

The very mention of globalisation can spark heated debate regarding the origins, implications and definition of the concept. Discussions about globalisation of television are no less animated and complex, yet we can nevertheless identify three perspectives from which to approach the topic: institutional, historical and intellectual.

Institutionally, one can discern significant changes in the medium over the course of its history. Originally, television, like radio before it, emerged as a quintessentially national medium. In almost every country, the state played an active role in its deployment, hoping that television would serve purposes of national integration, social development, public enlightenment and popular entertainment. Using their power to grant broadcasting licences and therefore limit the number of national network broadcasters, governments carefully controlled access to the airwaves either by creating public service broadcast systems that served the interests of the state or by licensing domestic commercial broadcasters who pledged to serve the national interest. In fact, with the exception of the Western hemisphere, most nations around the world opted for public service television during early years of the medium. In countries like France, the government organised powerful, centralised television networks that focused on the promotion of national culture, while in poorer countries like India and

China, television was mobilised to address pressing concerns related to economic and social development. Whether a commercial or public service, audiences in most countries had few channels to choose from during this classical era of national network television and broadcasters consequently placed their first priority on serving a mass audience.

During the 1980s, however, television institutions began to change dramatically. For example, economic reversals in Europe put great pressure on the budgets of public service broadcasters as government subsidies and licence revenues began to decline. Attempts to justify increased public expenditures to support these beleaguered institutions were met with challenges from groups who traditionally were marginalised by national networks. Women's organisations, labour unions, peace groups, environmental advocates, and ethnic and regional political movements all criticised state broadcast institutions for focusing on mass audiences and failing to represent a diverse range of perspectives.

This crisis of legitimacy came at the very moment when transnational entrepreneurs with access to new sources of capital began to develop satellite/cable services that fell outside the domain of national broadcast regulation. Business leaders supported these initiatives since they would expand the availability of advertising time and diminish government control over the airwaves. The resulting commercial channels initially targeted two groups: transnational niche viewers (e.g., business executives, sports enthusiasts and music video fans) and subnational niche groups who were not being served by public broadcasters (e.g., regional, local or ethnic audiences). Similar trends emerged outside of Europe and, in response, a new generation of corporate moguls – such as Rupert Murdoch (News Corp.), Ted Turner (CNN) and Akio Morita (Sony) – aspired to build media empires that realised global synergies through horizontal and vertical integration. These new corporations aim to serve a wide variety of mass and niche markets in both information and entertainment. Although national audiences continue to play an important role in their calculations, these firms increasingly strategise about transnational and subnational audiences, hoping to find new markets and potential synergies among their diverse operations.

This 'neo-network era' of multiple channels and flexible corporate structures has also engendered new local services, such as Zee TV in India and Phoenix TV in China, as well as global satellite networks that adapt their content for local and regional audiences. For instance, MTV now operates eight different services in Asia alone,

offering various mixes of global, regional and local programming. Thus, globalisation has paradoxically fostered the production and promotion of transnational media products as well as niche products aimed at subnational audiences. Media conglomerates are flexibly structured to accommodate both strategies. The scale and competitive power of these organisations have seriously undermined public broadcasting in some countries, such as Italy. But in other countries, like India, competition with satellite TV has encouraged India's Doordarshan to improve programme quality, conduct systematic audience research and diversify its services, targeting new channels at local and niche viewers, many of whom were previously marginalised by the national mass medium. Nevertheless large segments of the Indian population remain on the margins of the TV revolution, since both commercial and public services now pay increasing attention to middle-class audiences that are of primary interest to advertisers. The globalisation of television can in large part be defined by these changes in media institutions, audience configurations and textual practices. Yet it is also part of a broader historical transformation that has been going on for at least 500 years, beginning with the European voyages of discovery and conquest.

Globalisation refers to a historical process of structural and cultural change. It refers on the one hand to the increasing speed and density of interactions among people and institutions around the world – e.g., the dynamic interdependence of global financial markets, the transnational division of labour, the interlocking system of nation-states, the establishment of supranational institutions, and the interconnection of communication and transportation systems. On the other hand, it also refers to changing modes of consciousness, whereby people increasingly think and talk about the world as an entity. Sociologist Roland Robertson suggests that rather than the world just being itself, we increasingly imagine the world being 'for itself' (Schiller, 1971). We speak of global order, human rights and world ecology as shared experiences and collective projects. We reflect upon information from near and far and we often deliberate as if we have a stake in both domains. Not everyone joins in these conversations and certainly all voices are not equal, but these discussions nevertheless span greater terrain and include more people than ever before and the outcomes of these interactions often have effects that transcend national boundaries. Furthermore, our experience of the everyday local environment has been fundamentally transformed by our increasing awareness of a global ecumene.

All of the trends outlined above have accelerated in the

last 150 years with the help of communication technologies like the telegraph, telephone, radio, cinema, television and computer. Moreover, the development and deployment of these technologies have been linked to specific historical projects – European expansion and colonisation, cold war struggle between the superpowers and, most recently, neo-liberal, supranational capitalism. This last project is most centrally concerned with trade liberalisation and countries around the world are being pressed to eliminate import barriers on goods and services, as well as cultural products. Consequently, no society today can confidently say that it stands outside the field of global financial markets and transnational corporate operations. A similar observation might be made about popular culture and television.

Intellectual debates about transnational flows of popular culture predate the emergence of global TV by almost a century. As early as the 1920s, national broadcast systems, such as the BBC, were put in place as a bulwark against foreign media influences, particularly Hollywood films and US popular music. Throughout the twentieth century, preserving and promoting national culture over the airwaves was characterised as a key component of national sovereignty in Europe, Latin America, and especially in the newly independent states of the post-colonial world, such as Ghana, Pakistan and Indonesia. Herbert I. Schiller (1971), Dallas Smythe (1981) and Armand Mattelart (1984) were especially strong critics of US TV exports, claiming that they played an important role in sustaining an international structure of economic and political domination. They contended that the huge flood of media messages exported from the core industrialised countries specifically served the interests of a Western ruling class by squeezing out authentic local voices and instead promoting a culture of consumption that sustains the profitability of capitalist enterprise. This media imperialism thesis emerged in the 1960s and prevailed through the end of the 1980s. Although many scholars still adhere to its central tenets, others have commented upon significant changes in television institutions, audiences and programmes since the 1980s.

Joseph Straubhaar (1991) questions the emphasis on Western dominance of TV schedules around the world. Even though Hollywood continues to be the world's dominant exporter of television programmes, most US shows are shown in off-peak hours with the heart of prime time reserved for local productions. Moreover, scholars point to the increasing amount of television trade within particular regions of the world and note that when audiences tune to a foreign programme, they generally prefer a show

that is more culturally relevant. In Venezuela, for example, viewers are most likely to prefer a show imported from a regional producer like Mexico's Televisa rather than a Hollywood production. Likewise, Taiwanese audiences seem to prefer Japanese or Hong Kong serial dramas over Western fare. In recent years, programme flows from core countries to the periphery have been displaced by more complicated patterns of distribution.

Such arguments are supported by the work of cultural studies researchers like David Morley (1995), Ien Ang (1996), Marie Gillespie (1995) and James Lull (1991) who have shown how audiences make unanticipated uses of television programming, often reworking the meanings of transnational texts to accommodate the circumstances of their local social context. Their findings raise questions about the presumed ideological effects of Hollywood television programmes as they circulate around the world. Rather than simply absorbing US capitalist ideology, 'active audiences' fashion meanings and identities that are hybrid and complex. Investigations of the institutional practices of media organisations in this new global environment find that, contrary to widespread anxieties about cultural homogenisation, television services increasingly are pressed to develop diverse offerings that are adapted to the needs and interests of local audiences. As television services multiply in number and compete for audiences, they develop both niche and mass products that adapt globalised stylistic elements to local themes and concerns. Even global conglomerates are often compelled to localise their services in order to attract the attention of viewers.

The media imperialism thesis has been challenged on other accounts as well. Critical studies of nationalism delineate the historical and contested qualities of modern nation-states, showing how power relations *within* countries are often as exploitative as power relations *between* countries. Consequently, the media imperialism thesis, which takes the sovereignty of the nation-state as a given, may rush too quickly to the defence of countries whose internal politics deserve greater scrutiny. National media systems have often been as insensitive to the interests of minority groups. In India, for example, Doordarshan, the national media monopoly, provided few benefits to Tamil or Telugu or Muslim populations prior to the introduction of satellite TV competitors (Mankekar, 1999). Indeed, pressures of globalisation unexpectedly opened the door to new services, new voices and new contexts for public deliberation.

Finally, although the media imperialism thesis claims that 'authentic' local cultures are disappearing under the avalanche of global popular culture, recent research in the

humanities and social sciences, and especially in the field of anthropology, questions the prior existence of pure or authentic cultures. Even before the advent of modern media, cultures were always in flux and often shaped, albeit more slowly, by outside influences. Rather than portraying local culture as an integrated, organic way of life, recent scholarship suggests that it is more productive to understand culture as a dynamic site of social contest and interaction. Careful attention must be paid to the diverse local contexts into which television has insinuated itself.

These challenges to the media imperialism thesis have formed the foundation of globalisation studies of television and they have opened the door to new critical perspectives. John Tomlinson (1999) suggests, for example, that a critique of global capitalist modernity is perhaps a more salient analytical project for television scholars. Still alert to questions of power and dominance, Tomlinson shows how television transforms an individual's experience of everyday life by fostering an awareness of social forces stretching far beyond one's immediate context. The medium does not instrumentally shape or homogenise human consciousness; rather it alters the ways in which we reflect upon our environment and the quotidian choices that we make. Tomlinson contends that this 'glocal' of consciousness may, in turn, lay the foundations for nascent transnational political movements around issues such as labour, ecology and human rights.

Similarly, Ien Ang (1996) advocates television research that explores the global/local dynamics of the medium, arguing that the very indeterminacy of communication processes in a world of media conglomerates is perhaps the central question that researchers must address. The play of power in global television is to be found in the ways that media conglomerates attempt to set structural limits on the production and circulation of meaning and contrarily on the ways in which viewers both comply with and defy these semiotic limits. This play of power requires an understanding of both industries and audiences, as well as the diverse social contexts in which the contest over meaning arises.

Michael Curtin

RECOMMENDED READING

Ang, Ien (1996), *Living Room Wars: Rethinking Media Audiences for a Postmodern World*, London: Routledge.

Miller, Toby, Maxwell, Richard, Govil, Nitin and McMurria, John (2001), *Global Hollywood*, London: BFI Publishing.

Morley, David and Robins, Kevin (1995), *Spaces of Identity: Global Media, Electronic Landscapes and Cultural Boundaries*, London: Routledge.

Schiller, Herbert I. (1971), *Mass Communications and American Empire*, New York: Beacon Press.

Straubhaar, Joseph (1991), 'Beyond Media Imperialism: Asymmetrical Interdependence and Cultural Proximity', *Critical Studies in Mass Communication*, vol. 8, pp. 1–11.

Tomlinson, John (1999), *Globalization and Culture*, Chicago: University of Chicago Press.

Television Production and Distribution

Today's television is produced by a combination of public service and commercial broadcasting networks/channels; by one-off production companies financed by public or private money; and by production studios affiliated with major transnational conglomerates making film, television and video for the local and international market. Mostly, live or 'event' material as well as news and current affairs, game shows and infotainment genres are produced locally for local markets; mostly, too, drama and comedy series and serials are produced locally for an international market. Increasingly, however, consumers tune to programmes produced by an industry which eschews localism in favour of an explicitly international form of television: US-styled drama and movies, soap opera, popular music and sport.

Historically, the US has dominated the trade in television, exports of US programming playing a substantial role in the development of national television services and markets throughout the world. This is a major area of international trade, and has spawned a disciplinary interest in the political economy of the media industries. A critical tradition, which developed in the 1970s, was concerned about the inequities resulting from this trade in mass-media culture. It analysed the consequential differences in access to information (see 'Media Imperialism', p. 21), as well as the likely ideological effects of US domi-

nance of cultural consumption in other countries (see Mattelart, 1979).

However, more recently, it has become clear that dependence on American programming diminishes as the local or national service matures and more local programming is developed (Mattelart et al., 1984). Changes in the environment within which 'world television' is now produced and consumed may also have affected US dominance. The spread of satellite and cable television has opened up new markets as well as expanding the number of channels available to a large proportion of developed world consumers. This in turn has increased the demand for programming. The US dominance of programming as new services developed effectively established the US model of entertainment-based programming as the international norm. Nevertheless, pay television has developed new niches for specific genres of programming that were not viable on such a scale through free-to-air networks: documentary, music, home shopping and news.

Two opportunities emerge from this development. One is that some smaller television production industries – those of Mexico, Hong Kong and Australia, for instance – have been able to achieve export success for their products as substitutes for American programming. In the case of Australia, producing in English provides the industry with access to the largest language market and the maintenance of high production standards makes them a suitable substitute for American programming (see Cunningham and Jacka, 1996, Part Two). Second, the development of satellite delivery has enabled the construction of regional zones or markets. In the case of Latin America, the sharing of a language (Spanish, in this instance) as well as a geographic zone has assisted in the development of local production industries with the capacity to export their programmes to the same language communities in the United States and Europe (Sinclair, 1999). A marked feature of the last decade has been the development of these geo-linguistic zones as significant components of the international market for television production.

While the US may still dominate international television production and distribution, that dominance has declined through the 1990s as a larger number of smaller players have begun to achieve some success in exporting their programming. Furthermore, in most Western countries with developed commercial television services, locally produced programming is still preferred by audiences where it is available.

TELEVISION PRODUCTION IN THE 1990s

Over the 1990s, the global patterns of television production have become more complicated. Commercial television has progressively displaced public service television. This trend has enhanced television's shift from information to entertainment, and it has also been accompanied by a broadly deregulatory response to the convergence of media industries – the weakening distinctions between the mass media, telephony and information technology. A consequence has been the loosening of restrictions on international trade in programming and the transnational supply of services. There are now large satellite networks serving most of the developed world – Star TV in Asia and the Middle East, BSkyB in Europe, and CNN almost everywhere. While this may seem only to further entrench the US hegemony, it has also increased the amount of television exported from Europe and South America. It is now relevant to seek an answer to the highly contemporary question of 'Who produces our television?'

A partial answer to this question is, of course, national public service broadcasters and nationally based commercial producers. Much local programming continues to be developed within the national or regional market for consumption by those living in that market. Increasingly, however, the economics of the industry force television producers to seek international markets for their products. It is now quite common for 'quality' drama, in particular, to be the product of co-production deals between national public service networks, or between nationally based commercial producers and large transnational distributors. The aim of these co-production deals is to maximise export opportunities by integrating the production into more than one distribution and exhibition network.

The development of transnational production and distribution networks is another feature of the 1990s. Media production of all kinds is now dominated by a small number of transnational conglomerates with diversified interests which might include broadcast television, feature film, cable and satellite, publishing, software, video and computer games, newspaper and other print media, amusement parks, professional sport and retailing. Examples of such transnational conglomerates include Rupert Murdoch's News Corporation Ltd (holdings in newspapers, in broadcast, satellite and cable television, film and television production, book publishing and professional sports); AOL Time Warner (international magazines, book publishing, recorded music, film and television production, cable/satellite and terrestrial television channels and networks, theme parks and retailing); and Disney (film and television production, ter-

restrial and cable television networks, recorded music, news-papers and magazines, book publishing, amusement parks and retailing) (Herman and McChesney, 1997, Chapter 3).

These conglomerates are geographically diversified, and no longer simply US-based firms with international interests. While some may have originated in the US (News Ltd originated in Australia), their operations are now transnational. News Ltd owns Star TV, the major satellite network in Asia and the Middle East, as well as the European satellite network BSkyB; AOL Time Warner owns the largest cinema network in the world, with over 1,000 screens outside the US, and growing; Disney has theme parks in France and Japan as well as substantial investments in European and Scandinavian television. As the market for media products has internationalised, the conglomerates are in the best possible position to exploit the opportunities for cross-selling and cross-promotion between the various parts of the organisation and around the globe.

As a result, the transnational media conglomerate is now the dominant influence on the production and distribution of television. This dominance is neither total nor uncontested. Nor does transnational distribution necessarily mean the homogenisation of programming. The experience of Murdoch's Star network in Asia, which attempted to schedule the same programming for all of its markets but ended up having to 'localise' in response to cultural differences, demonstrates the limitations of 'world television'. As pointed out earlier, all developed markets prefer local material and there has been no diminution of either local content or the ratings for local programming which can be traceable to the dominance of offshore providers.

By no means all successful programming comes from the US or from the large transnational media companies. In the UK, the BBC has long been a significant exporter of quality television and the development of its satellite news service builds on that reputation. Other, more peripheral, industries have also been able to develop international markets for their programming. There is a strong international demand for Latin American soap operas and telenovelas, for instance, or Japanese animation or Australian domestic soaps. In some cases, the success of original programme concepts within a small or peripheral market can generate copies in other markets, reversing the American dominance of formats and genres. The Netherlands' invention of the format for *Big Brother*, copied in many other countries, is an example of this.

THE PRODUCTION CULTURE OF TELEVISION

There is another angle of inspection onto this topic. While it is conventional to talk about television production from the point of view of political economy, it is important to acknowledge that such large contextual factors may not inevitably or directly determine the character of the actual texts the television industry produces. Attempts to understand the process of production itself – how creative decisions are reached within production companies, how programming strategies by the large networks affect decisions at the level of the individual producer and distributor – have revealed how contingent it is. While the structure of the production industry may indeed overdetermine many decisions, it is difficult to map this structure onto the extraordinary range of texts it produces. Essentially, this is because the texts are produced by specific cultural systems as well as an industrial structure.

There have been very useful attempts to examine such cultural systems. The most celebrated is Todd Gitlin's *Inside Prime Time* (1994), first published in 1984, which uses participant observation and interviews with production and network personnel to construct a quasi-ethnography of the commercial television industry in the United States. Unsatisfied by the industry's continual recourse to the myths of intuition and instinct as a means of explaining production strategies and creative decisions, Gitlin attempts to unravel the system of unspoken values and cultural preferences which structure the working of American commercial television. Critical of the networks' conservatism, but sympathetic to the commercial pressures which produce it, Gitlin's book remains our major source of information about how commercial television is actually produced.

A similarly observational method informs Philip Schlesinger's *Putting 'Reality' Together: BBC News* (1987), and this study again provides us with insight into the contingency and unpredictability of live television. A different approach, based more on textual analysis, is the collection of essays edited by Feuer, Kerr and Vahimagi (1984) which examines the output of the MTM production company – effectively, looking at the production company as an *auteur*. Alvarado and Buscombe's study (1978) was devoted to the production of a single British private eye series, *Hazell*, while Tulloch and Moran's (1986) examination of the Australian 'quality' soap opera *A Country Practice* observed the programme's audiences as well as the production company. Most recently, Barry Dornfeld (1998) investigated the production process in a documentary series for which he was the researcher. There is now a long-standing and sophisticated tradition of research that examines the specificity of the cultures implicated in the production and distribution of television.

Graeme Turner

EXPORTING AUSTRALIAN SOAP

Australian television has a long history of locally produced serial drama. The soap opera form has been the most commercially successful in the domestic market, and has gradually infected long-running drama series with continuing storylines and developing relationships. Soap opera has also been the most successful export with *Neighbours* and *Home and Away* in the UK, and *The Flying Doctors* in the Netherlands, the most outstanding examples.

At the beginning of the 1990s, *Neighbours* and *Home and Away* were among the most popular programmes in the UK, and were both being screened twice a day, five days a week. More British airtime was taken up by these two programmes (fifteen hours a week) than by the total of imported US drama (five hours a week) (Cunningham and Jacka, 1996, pp. 130–8). There are textual elements which may explain *Neighbours'*

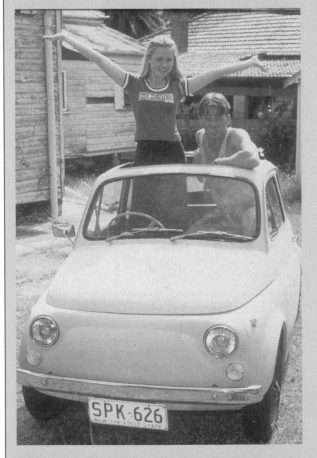

appeal to the British audience – the location, lifestyle and a national context just foreign enough to be both exotic and familiar. However, there are industrial factors as well. *Neighbours* was an appropriate choice for a BBC management eager to present a slightly more commercial and youth-oriented image to its audience, but reluctant to wholly embrace American programming as a means of doing so. Screening the same episode at different times on the same day to reach different market segments was a scheduling tactic employed for the first time by the BBC with *Neighbours* and repeated by ITV with *Home and Away*. The success of *Home and Away* was directly related to *Neighbours'* popularity. The perfect vehicle for ITV to challenge *Neighbours'* market dominance, *Home and Away* – another youth-oriented Australian soap, but this time set by the beach – also established itself as among the most popular programmes on British television through the 1990s.

The colonial relation between Australia and Britain enhanced Australia's same-language advantage as an exporter of television into Britain, and these programmes have not had the same success in other markets. *Neighbours* failed dismally in the US, for instance. However, there are other cases where industry- or country-specific reasons have played a role in Australian exports establishing themselves in a foreign market. *The Flying Doctors*, for instance, was voted the favourite imported programme by Dutch television viewers in 1992, in part because its values appear to so perfectly coincide with those of the social-democratic public broadcaster VARA (Cunningham and Jacka, 1996, pp. 147, 162–7).

Graeme Turner

Australian successes in the UK and the Netherlands – *Home and Away* and *The Flying Doctors*

RECOMMENDED READING

Gitlin, T. (1994), *Inside Prime Time* (rev. edn), London: Routledge.

Herman, E. S. and McChesney, R. W. (1997), *The Global Media: The New Missionaries of Global Capitalism*, London: Cassell.

Mattelart, A. (1979), *Multinational Corporations and the Control of Culture: The Ideological Apparatuses of Imperialism*, Sussex: Harvester.

Policy

Studying television policy is important because TV is both a vastly pervasive popular entertainment medium as well as being perceived as a key to influence and commercial success in the information age. In their systematic study of ownership strategies of the biggest players in the ECI (entertainment-communications-information) industries in the 1990s, Herman and McChesney (1997) show how virtually all have moved to acquire or consolidate holdings in television. Strategically, television bridges, partakes in or provides a major platform for significant elements across the continuum of entertainment (cinema, music, computer gaming), information (journalism, news) and communications (carriage of signals, satellites, broadband cable, Internet) and thus stands at the centre of the convergent ECI complex, the most dynamic growth sector of the information age. It will always be at, or close to, the centre of powerful players' corporate and political strategies and state responses to them.

WHERE DOES THE POLICY APPROACH SIT IN TELEVISION STUDIES?

The significance of the policy approach in media, communications and cultural studies was brought into stronger focus by the 'cultural policy debate' in the 1990s. Tony Bennett (1992) argued that culture could be understood as an 'intrinsically governmental' area of social activity, tied to the development of citizens in modern societies, through the role played by bureaucratic and pedagogical institutions such as schools and public museums. As a result, Bennett proposed, the study of cultural policy would need to move from being an 'optional add-on' to cultural studies, and instead become 'central to the definition and constitution of culture' (Bennett, 1992, p. 397). For Bennett and Stuart Cunningham, another leading cultural policy theorist, this implied a need for media and cultural studies to move from blanket denunciations of the dominant

political and cultural order, to what Cunningham described as 'a more subtle and context-sensitive grasp of the strategic nature of policy discourse in negotiating piecemeal, ongoing reform in democratic societies' (Cunningham, 1992, pp. 53–5)

The policy approach in media and communication studies draws on critical conflict models derived from neo-Marxist political economy, as well as the fields of public administration, policy studies, politics and government. Its approach to policy is largely derived from elite theory in political science, and it is also strongly engaged with applied neo-classical economics. Most of the explanatory power and the dynamic tensions in the policy approach can be sheeted home to straddling these traditions, which can see students studying technical policy handbooks through to racy critiques of unbridled deal-making and the power of media tycoons.

Media and communications studies has always possessed an interest in questions of policy. That interest has often been grounded in normative assessments of what policy should do, and radical critiques of its actual practice. Such normative assumptions might include: independence of media outlets; broad community access to media; diversity of media content; objectivity of media content (especially in the area of news); promotion of social solidarity and cohesion; cultural pluralism; and the promotion of quality media (see McQuail, 1998). This end of the spectrum is grounded in *neo-Marxist political economy*, which has for the most part explored questions of policy in order to demonstrate the complicity between governments and regulatory agencies with the dominant economic interests in the media, as part of a larger project of establishing the functional (if at times contradictory) role of the state in the management and reproduction of capitalist societies and economies. (A comprehensive overview of the political economy approach to media is developed by Mosco, 1995.)

Neo-Marxist political economy has tended to downplay the role of human agency in change, in preference to a focus on underlying structures that constrain human action and the functionality of these structures in supporting dominant economic interests. Nevertheless, there is also a more popular strain of political economy that focuses on human agency and the contingencies of the policy process. It stresses the ways in which normative goals of media policy can be subverted by the power of media moguls; much current political economy focuses on how convergence and the growth of new media is consolidating mogul power rather than diluting it (e.g., McChesney and Herman, 1999; Tunstall and Palmer, 1991).

Cultural policy studies marks out a 'centrist', social-

democratic attempt to connect political economy and achievable change. This is a politics of bureaucratic reform borrowing, for theoretical support, more from American elite theory rather than the European neo-Marxist theories. Against the traditions of the Marxist left, it argues that real political and social change is possible in liberal-capitalist societies, but that one condition for intellectuals to more effectively achieve such goals was to learn the 'language' of decision-making agents and to participate in policy formation. Policy advocates (Bennett, 1992; Cunningham, 1992) contested the Marxist *cipher image* of public policy (Dunleavy and O'Leary, 1987), where policy is seen as largely the reflection of outcomes achieved through elite bargaining among powerful agents outside of the policy process. By contrast, it was believed that an ability to influence the more 'mundane' technical, administrative and organisational aspects of policy formation would make a significant political difference.

The critical tradition of media and cultural studies, that sees questions of policy as largely subordinate to understanding the main game of how economic and political power interact in capitalist societies, has been under challenge from other sources. 'Third way' political thought, associated in particular with the Blair Labour government in the UK and the policy settings of the first Clinton administration in the US, argued that social democracy should no longer be seen as an inadequate halfway-house between liberal capitalism and socialism, but rather as the best way to reconcile the core principles of the political left – such as a belief in equality, participatory democracy and social justice – with the challenges of globalisation, cultural pluralism and an increased assertion of the rights of the individual (e.g., Giddens, 1998). In a similar vein, Richard Collins and Christina Murroni (1996) have criticised left thinking on the media for its tendency to promote 'paternalist corporatism' and the industry status quo, at a time when technological change, resurgent industry competition and the development of new products more tailored to individual consumer requirements point to a need to seek new forms of synthesis between the promotion of dynamic competition and elevation of the principles of social and economic justice.

Highly normative approaches to policy assessment are not the preserve of the political left. Neo-liberal and conservative 'think-tanks' adopt a purist neo-classical economic position on the pitfalls of state intervention and the virtues of markets. They programmatically seek to limit the role of government to maximising deregulation, guaranteeing competitive conditions and providing minimum safety-net-style social regulation. In these approaches, ambitious public-sector-led initiatives for cultural and industry development are held to be market distorting, inefficient and, in budgetary terms, unsustainable.

CHALLENGES FOR POLICY STUDIES

The centrality of television in the ECI complex makes policy, state subvention and regulation a highly volatile but increasingly important feature of state action. We will focus on two major, related challenges for television policy which will inevitably inform its study in years to come.

Policy from nation-building to services industries

First, there is the tendency for media and communications to be folded into a 'services industries' approach to regulation and policy. Much convergence talk has the television set becoming a prime vehicle for the delivery or carriage of services. Banking, home security and shopping are some of the everyday services which types of interactive television might deliver. However, for the media (and especially media content) to be considered *as* part of the service industries takes the convergence tendency to a new level. For most of television's history, media content and the conditions under which it is produced and disseminated have typically been treated as issues for cultural and social policy in a predominantly nation-building policy framework. They have been treated as 'not just another business' in terms of their carriage of content critical to citizenship, the information base necessary for a functioning democracy and as the primary vehicles for cultural expression within the nation.

In the emerging services industries model, media content is treated less as an exception ('not just another business') but as a fundamental, yet everyday, part of the social fabric. Rather than television's traditional sectoral bedfellows cinema, the performing arts, literature and multimedia, it is seen as more related to telecommunications, e-commerce, banking and financial services, and education. For theorist John Hartley, television has a 'permanent' and 'general', rather than specific and formal, educational role (1999, p. 140) in the manners, attitudes and assumptions necessary for citizenly participation in communities. '[C]ontemporary popular media as guides to choice, or guides to the attitudes that inform choices' (p. 143) underpin Hartley's allied claim for television's pre-eminent role in promoting 'Do-it-yourself' (DIY) citizenship.

The model carries dangers. It subjects all television systems to a normative, globalising perspective and thus weakens the cultural case for national regulation and financial support. Its widespread adoption would see the tri-

umph of a US regulatory model, where competition is the main policy lever and consumer protection rather than cultural development is the social dividend. However, there are also possible advantages. Hitherto marginal programming could be significantly upgraded in a services industries model. Programming produced for and by regional interests might be as fundamental as the guarantee of a basic telephone connection to all regardless of location. The need for programming inclusive of demographics such as youth and children might be as fundamental as free and compulsory schooling. Moves in various jurisdictions, including the EU and Canada, to give greater weighting to regional, infotainment, youth and children's programming signal a shift in priority of content regulation to include these alongside a continuing emphasis upon drama and social documentary. While the latter advance core cultural objectives such as quality, innovation and cultural expression, the former warrant greater consideration in a services industries model of media content regulation in terms of their contribution to diversity, representation, access and equity (Goldsmith et al., 2001).

The services industries model is strongly linked to the trend we will now consider, because the pulling of media and communication into the domain of supranational trade policy and away from nationally specific cultural policy relies on it being folded into a generic bundle of services industries.

'Supranational' policy

While the engine rooms of media policy development remain at a national level, and this will continue into the foreseeable future, it would be naive not to take cognisance of the impacts on media and communications policy of the transnational corporate and the supranational sectors.

Canadian communications theorist Marc Raboy (2001) sketches a general typology of the global policy 'map' comprising five levels of supranational influence and activity. First, there are global organisations, encompassing bodies that have traditionally been part of the United Nations family, such as the International Telecommunications Union (ITU), United Nations Educational, Scientific and Cultural Organisation (UNESCO), and newer ones such as the World Trade Organisation (WTO) supervising the implementation of the General Agreement on Trade in Services (GATS). This sector has been strongly marked by a power shift in recent decades from organisations dedicated to communication and cultural issues, such as UNESCO or the ITU, to those focusing on commercial or trade issues, such as the World Intellectual Property Organisation (WIPO) and the WTO.

Second in Raboy's account, there are multilateral exclusive 'clubs', such as the Organisation for Economic Co-operation and Development (OECD) and the G8 (the eight major industrialised nations), which collectively exercise enough economic clout to influence the globe without having to deal directly with lesser economies politically. More streamlined, and thus more efficient, than more cumbersome global organisations like the WTO, these clubs can at the same time afford to put forward a more generous public discourse while promoting specific projects, including major ones in communications (such as the 1995 Global Information Infrastructure).

Third, there are regional multi-state groupings, the most important of which are the European Union (EU) and the North American Free Trade Association (NAFTA), but also including the Association of South East Asian Nations (ASEAN) and the Asia Pacific Economic Cooperation (APEC). The EU has played a balanced role in advancing cultural and human communicational issues with economic and trade issues. Its 1997 protocol on public broadcasting stands as the only actual example of a transnational media policy that aims to supersede economic imperatives.

Fourth, large corporates have organised themselves to achieve representation in official fora. No longer merely restricted to lobbying, transnational corporations and their associations are increasingly present at the tables where policy decisions are made. Groups such as the Global Business Dialogue for e-commerce and the Global Information Infrastructure Commission, speaking for the forty or so largest corporations in the information technology sector, have become a powerful force in setting the global communication policy agenda, especially with respect to Internet, e-commerce and new media issues.

Finally, media issues are becoming – like the environment – an important rallying point of grass-roots transnational community mobilisation. Global associations such

Transnational community mobilisation – the WTO Seattle meeting

as AMARC (community radio), Vidéazimut (video), the Association for Progressive Communication (Internet users) and Computer Professionals for Social Responsibility now represent alternative media producers worldwide, while the media mainstream was targeted well and alternative media used effectively by such groups in their dramatic interventions in the WTO meeting to initiate the Millennium Round in Seattle in 2000.

The emergence of supranational policy-making raises a number of serious issues. First, there is the question of whether these bodies are unaccountable to their respective national citizenries, erode national sovereignty and intensify what Anthony Giddens has referred to as the 'democratic deficit' in modern liberal democracies (1998, p. 71). Second, as we have noted, the split between media as a form of nationally based self-expression and as a component of global services industries is intensified. A final issue is the subordination of national policy-making institutions to global agreements as part of a strategy to extend the United States' economic domination of global audiovisual markets, and its capacity to extend global cultural hegemony through the exercise of 'soft power'. It is around these rallying points and often within groupings such as those mentioned in the penultimate paragraph that policy-minded intellectuals might join with movement activists to influence change.

Stuart Cunningham and Terry Flew

RECOMMENDED READING

Bennett, T. (1992), 'Useful Culture', *Cultural Studies*, vol. 6, no. 3, pp. 395–408.

Cunningham, S. (1992), *Framing Culture: Criticism and Policy in Australia*, Sydney: Allen & Unwin.

Mosco, V. (1995), *The Political Economy of Communication*, Thousand Oaks: Sage.

Raboy, M. (2001), 'Introduction: Media Policy in the New Communication Environment', in Marc Raboy (ed.), *Global Media Policy in the New Millennium*, Luton: University of Luton Press.

Public versus Private

In 1983, political economist Nicholas Garnham analysed 'Public Service versus the Market' for the British journal *Screen* (Garnham, 1983). At stake, he proposed, were two ways of organising television – one in apparent decline, the other gaining currency at the hands of deregulation, Conservative governments and the much-heralded promise of 'choice' surrounding advertising-financed television channels in the UK and commercial cable and satellite services worldwide. Against these shifts, Garnham defended the democratic value of public service broadcasting – in theory if not always in actual practice.

Garnham acknowledged the paternalistic origins of the British Broadcasting Corporation (BBC), founded on an interpretation of the common good in which an 'enlightened political and cultural elite imposed its tastes and views of the world by means of the "brute force of monopoly" upon a public whose views and tastes were not to be trusted' (Garnham, 1983, p. 22). Still, he said, state-owned institutions like the BBC, which is funded with licence fees rather than advertising, represented an important gain over commercial television and the commodification of public life it represented. Garnham advocated the preservation of the public service model on the grounds that it catered to social and cultural goals over profit margins, fostered a non-commercial 'public sphere' accessible to everyone regardless of their socio-economic status, and addressed the people as 'rational beings' rather than consumers of toothpaste, automobiles and potato chips.

Garnham's 1983 article appeared at a juncture when free-marketers were challenging the European public service 'monopolies' in the name of technological progress, market liberalisation and 'consumer sovereignty'. From this vantage point, television should be treated as a commercial business like any other, a stance epitomised in the US by Federal Communications Commission (FCC) Chairman Mark Fowler's characterisation of the medium as a 'toaster with pictures'. A competitive multi-channel marketplace would serve the public interest by giving the people 'what they wanted', assisted by the growing repertoire of programming offered by globalised cable and satellite television industries. Scholars aligned with political economic approaches to media studies rejected these claims, raising questions about the fate of universal service and attention to social minorities, the conflation of private control with consumer choice, the flow of commercial programming from the United States, and the market's tendency to favour the most affluent consumers when left to its own devices. By and large, however, the argument that gained the most currency hinged on commercial television's deleterious cultural impact on democracy. Rejecting the claim the proliferation of private channels was capable of meeting all of society's needs, British political economist Graham Murdock argued that public service broadcasting is 'indispensable to the development of full citizenship in complex societies' (1992, p. 19).

The United States has always had a much weaker com-

mitment to public service broadcasting than Europe, having rejected strong regulation and state-owned broadcasting institutions for minimally regulated private broadcasting from the start. In the 1980s, state involvement in broadcasting was called into question altogether as new technologies brushed up against the 'scarcity' rationale for regulating the airwaves and a deregulatory mindset erased rules governing 'fairness' and cross-ownership. Within this context, scholars drew inspiration from the discussion in Europe to reassess the Public Broadcasting Service (PBS), the marginalised equivalent to the BBC. As the advancement of 'commercial interests by selling goods to consumers' crowded out nominal public interest provisions, Patricia Aufderheide (1991, 2000) and William Hoynes (1994), among others, called for a 'public alternative' to foster the 'creation of a healthy public sphere' (Hoynes, p. 37). In *Public Television for Sale*, Hoynes critiqued PBS for failing to serve this role on account of its quasi-commercialism and reliance on corporate sponsors – limitations that accelerated, he argued, as conservatives attempted to privatise public television throughout the 1980s. Given these shortcomings, Hoynes looked to the fading European public service tradition for an idealistic model of television that could 'transmit the kinds of imagery and information that fundamentally prepare the public for its role in a democracy' (Hoynes, 1994, p. 43).

The issues raised by defenders of public service are as important as ever at an historical juncture when the 'convergence' of digital technologies is again changing the television landscape. Yet, many potent arguments made in the name of democracy have not entirely shed the patronising logic upon which institutions like the BBC and PBS were built. Michael Tracey's 1998 assessment of *The Decline and Fall of Public Service Broadcasting* attempts to do this, but ultimately resorts to a tired critique of the market's relentless attention to the 'basic desires and wishes, but not needs' of the audience (Tracey, 1998, p. 34). Pitting a feminised, low-brow mass culture against an emasculated, enlightened public culture, Tracey condemns commercial television on the grounds that it is essentially 'crass, trivial, shallow, exploitative, and fundamentally distorting of the long-established desire to construct cultural, social, and political practices which are rational, informed, and enriching of the human experience' (p. 34). However well-intended, this patrician spin tends to mistrust the public's judgment as it neglects the new possibilities and limitations of today's fragmented television culture.

Other commentators have treated public service broadcasting with less reverence, noting for example that the partial introduction of commercial television in Britain in the

1950s is what forced the BBC to rethink its uplift mission and attend to popular tastes and desires. In his 1993 *Screen* article 'Public Service versus the Market Ten Years On', Richard Collins took issue with Garnham's essay from a more conservative wing of media studies, adopting some of the same language used by free-marketers to question public service rationales. For Collins, the BBC's history demonstrates that non-commercial television isn't crucial or even essentially democratic: 'It is difficult to reconcile Garnham's claims for the success of public service broadcasting . . . with the dramatic loss of audience experienced by European public service broadcasters when they lost their national monopolies and faced commercial competition,' he argued (Collins, 1993, p. 250).

Cultural studies scholars have challenged the 'obvious' hierarchy between public and private from a more radical perspective by emphasising television's relationship to audiences and everyday life. The difference between political-economic and cultural studies responses to the privatisation of European broadcasting was often a matter of 'different conceptions of social empowerment' says Jim McGuigan (1992). He offers a telling example in the response by Ian Connell, a cultural studies scholar trained at the Birmingham Centre, who cited Dorothy Hobson's research on British female soap opera viewers to make a case for the 'popular usability of commercial television'. For Hobson's women, commercial soap operas allowed for resistance to the gendered constraints of everyday life, whereas Garnham was principally concerned with broadcasting's role in the historically masculine 'public sphere of information and democratic debate' (McGuigan, p. 164).

Ien Ang's 1991 book *Desperately Seeking the Audience* argued that public service television and commercial television are controlling in different ways. Whereas private broadcasters seek to 'win' the audience for advertisers, public broadcasters attempt to guide and shape the populace with social and cultural goals. For Ang, classic public service philosophy is bound to what Michel Foucault called an 'art of effects', geared towards the production of 'quality' citizens (Ang, 1991, p. 103). Private gain was rejected, but so too were the people's ideas about what sorts of programmes were 'good for them', for public service broadcasting traditionally defined was a top-down affair, says Ang (pp. 101–2). Faced with the 'crisis' of the 1980s, however, many European public broadcasters turned to 'principles and methods' associated with the market, including a quest for ratings (p. 103).

In their 1990 *Journal of Communication* article 'Worldwide Challenges to Public Service Broadcasting', Willard Rowland and Michael Tracey draw historical paral-

lels between the BBC's 'abandonment of purity' in the 1950s and its attempt to remain competitive in the new television environment. They worry that institutions like the BBC are 'selling their soul' by booting high culture out of prime time and instead presenting popular programmes with 'no obvious public service broadcasting rationale', including soap operas, talk shows and game shows. While these scholars condemn 'commercialisation' *within* public service broadcasting, Ang sees the issue differently. The turn towards 'commercial strategies' was not entirely

imposed by private broadcasters, she says: it was also the product of unco-operative viewers who proved 'unwilling to submit to such goals' when alternatives became available (Ang, 1991, p. 106).

Cultural studies in the US has said very little about public service broadcasting, largely because PBS occupies a nominal role in the daily lives of most television viewers. Whereas the BBC must remain relevant to the public to justify the collection of licence fees, US public television was created in the late 1960s to provide the prestigious but

PBS: THE 'OASIS' OF THE WASTELAND

The Corporation for Public Broadcasting calls the Public Broadcasting Service (PBS) the 'oasis' of the wasteland, a term that pits 'public service' against popularity. We can learn a great deal about the limitations of US public broadcasting by analysing Federal Communications Commission (FCC) Chairman Newton Minow's infamous 1961 address to the National Association of Broadcasters (Minow, [1961] 1984). During this speech, Minow declared commercial television – then comprised of ABC, NBC and CBS – a 'vast wasteland'. While Minow considered himself a champion of the public interest, his liberal critique of broadcasting skirted the issue of private control. He was much concerned with raising the 'level' of programming. Minow singled out the most popular genres of the early 1960s – situation comedies, soap operas, Westerns, quiz shows – as evidence of malaise. From a cultural studies vantage point, his mistake was to dismiss these popular formats as worthless instead of advocating more creativity and diversity within them. When Minow told commercial broadcasters they must present a 'wider range of choices, more diversity, more alternatives' (p. 212), he meant the *worthier* programmes favoured by the intelligentsia, like legitimate theatre and panel discussions.

Minow insisted that private broadcasters serve the public good, telling executives 'it is not enough to cater to the nation's whims – you must also serve the nation's needs'. True enough. Yet for Minow, the people needed maturation and uplift – a paternalistic premise that cast them as flawed in their constitution as a mass audience. TV was corrosive to the public interest, for 'given a choice between a Western or a symphony, most people will watch the Western' (p. 212). This argument *presumed* the tawdry status of the Western, ascribing correct taste and social responsibility to those who preferred the symphony.

The people's tendency to choose wants over needs was conceived as a discipline problem that could be managed by regulators and broadcasters. Constructing a telling analogy,

Minow argued that if parents and teachers followed 'ratings', children would be spoiled by ice cream and holidays (p. 211). Class and gender were implicit to this troubling portrait of the collective id. The television audience was implicitly filled with stereotypical characters like Joe Six-pack and housewives in curlers bingeing on afternoon soap operas. Commercial broadcasters were not being asked to reform university professors or corporate CEOs; nor did *New York Times* critic Jack Gould mean sophisticated newspaper readers when he opined that the 'mass audience can be childlike; it will generally choose candy over spinach' (quoted in Steiner, 1963, p. 239).

While Minow's plea for upgrades within the commercial system were unrequited, the spectre of the vast wasteland propelled the appearance of PBS on the TV dial, and provided the cultural reference point for its dos and don'ts. Cast as a patch of excellence in a sea of mediocrity, its legitimacy hinged on transforming or ignoring the people it claimed to represent. Bound to a narrow cultivating mission, US public television poses virtually no threat to private broadcasters, and yet it continues to relieve them from public interest duties and burdens.

Instead of always trying to outshine the cable and satellite venues who now focus on upscale programming, PBS should give the commercial broadcasters who enjoy a lucrative monopoly on popular cultural production a run for their money. Freed from advertising constraints and market pressures, PBS might infuse situation comedies, music videos, soap operas, reality programmes, popular news and serial dramas with creativity as well as racial, gender and class diversity. In so doing, it might bridge the public interest and popular culture by treating the people with more respect than the infantilising 'paedocratic' regime John Hartley ascribes to commercial television (1992). Given the tightly-bound niche PBS has always occupied, this prospect unfortunately does not seem very likely.

Laurie Ouellette

poorly rated informational, educational and cultural pro-
grammes commercial broadcasters didn't want to bother
with. The tension between 'public service versus the
market' is complicated by the fact that PBS was created as a
corrective to the popular television claimed by private
broadcasters. Its *raison d'être* was to combat the cultural
shortcomings of the pre-cable 'vast wasteland' with a mix
of public, corporate and viewer funding. Narrowly pigeon-
holed as 'better' television, its claim to public funding has
been challenged by conservatives who claim PBS is elitist
and unnecessary at a time when upscale cable channels like
CNN, Arts & Entertainment, The Learning Channel and
Bravo show similar types of programmes.

Despite two decades of contentious debate, the
European Union has announced a commitment to the
preservation of public service broadcasting and the values
– mandated pluralism, universal service, national cultural
production and informed citizenship – it represents. The
lines between public and private, however, have become
increasingly blurred. The BBC has forged partnerships
with corporate venues like the Discovery Channel and sub-
scription-based news and culture channels. PBS has also
developed strategic relationships with the corporate sector,
including *Reader's Digest* and cable operators. Rather than
experimenting with what Tracey and Rowland deride as
'infotainment', it appears to be carving a predictably edu-
cational digital niche in an attempt to survive the new
media age. Whereas the BBC has been compelled to win
back the popular audience, US public television seems to
be headed in the opposite direction.

Laurie Ouellette

RECOMMENDED READING

Ang, Ien (1991), *Desperately Seeking the Audience*, New York:
 Routledge.
Aufderheide, Patricia (1991) 'Public Television and the Public
 Sphere', *Critical Studies in Mass Communication*, no. 8.
Brants, Kees, Hermes, Joke and van Zoonen, Liesbet (eds)
 (1998), *The Media in Question: Popular Cultures and Public
 Interests*, London: Sage.
Garnham, Nicholas (1983), 'Public Service versus the Market',
 Screen, vol. 24, no. 1, pp. 6–27.
Ouellette, Laurie (2002), *Viewers Like You? How Public
 Television Failed the People*, New York: Columbia University
 Press.
Tracey, Michael (1998), *The Decline and Fall of Public Service
 Broadcasting*, New York: Oxford University Press.

Stereotypes and Representations: International

Outside the US and UK, television studies of biases, stereo-
types and representations of racial and ethnic communi-
ties, gender, sexual minorities, etc. have largely continued
to employ social scientific paradigms, whose chief method
of investigation remains to be content analysis (both qual-
itative and quantitative). Broadly speaking, this inheritance
from the American social psychological research tradition
– dating back to McArthur and Resko's (1975) formative
study of stereotypes on TV commercials over twenty-five
years ago – derives from three interlocking factors: hege-
monic circulation of American social scientific research in
the international setting; relocalisation of many American-
trained media studies researchers to their own countries;
and legitimation of university, industry and activist
research within those countries through adoption of
Western research frameworks, protocols and even liberal
interpretive ideologies. In addition, this pattern of
homogenisation has created relative ease for performing
comparative studies of television stereotypes across conti-
nents (e.g. Browne, 1998; Cheng, 1997; Furnham et al.,
1997; Furnham and Farragher, 2000; Gilly, 1990; Milner
and Collins, 2000).

Social scientific studies of TV stereotypes in the US,
which have taken on the phraseology of 'images that injure',
evoke stereotyping as a moral assault to the pragmatist
intellect. The images that injure, therefore, are conceived of
as the images that caricature, lessen, diminish; in short,
images that simplify. The demeaning of minorities on TV
amounts to the injurious battering of a (presupposed)
cerebral American multiculturalism. This has led to a ten-
dency to study TV stereotypes against the backdrop of a
parade of identity types, giving a semblance of a prosper-
ous multicultural society. In reality though, TV research
often treats them independently of each other. Ethnic
minorities are categorised into five main types (African-
American, Hispanic and Latino American, Asian
American, Native American, and Jewish American), while
the gender system is seen to comprise four main identity
labels (men, women, gay, straight). Typology-making
therefore ensures the repeatability of certain preferred
methodologies, principally content analysis. It seems ironic
in view of the fact that the original stereotype was an object
– a plate called a *flong* – used in the printing process that

facilitated reproduction of the same material. Thus, a stereotype 'imposes a rigid mold on the subject and encourages repeated mechanical usage' (Enteman, 1996, p. 9). In American social scientific research of TV, 'stereotype' is both a subject of study and a kind of proclivity.

Many international TV studies of stereotypes and representations replicate this American tendency. Nonetheless, researchers who examine their own national television deem it significant to embed the stereotypes they find within the historical milieu and political economic machinery of their nations and the media industries in them. Contextualisation serves more than the function of setting the scene for readers who may be unfamiliar with various national media or national political histories; it also emphasises the broader and deeper historical and political conditions that both predate and fuel stereotypical depictions in the media. This is evident in Krishnan and Dighe's (1990) book-length study of the construction of femininity on Indian television. In it, they stress the ideological and psychic demarcation of the public/private split in traditional Indian social structure in order to explain the stereotypical roles of Indian women seen on Doordarshan programmes (the state-owned television system in India). Women are depicted as having careers, but only when their jobs do not disrupt the household and do not challenge the importance of the male. The public/private split thus lays the discursive foundation for a permitted, but circumscribed, mobility of women who appear on television commercials, dramas and news. The same split that relegates women to the private sphere, argue Krishnan and Dighe, also works as a psychological framework for what they call 'women's interiorized inferiority'.

In a similar attempt to contextualise their studies about aspects of gender shown on Malaysian television, Anuar and Wang (1996) situate the stereotypical roles of mothers/wives and seductresses for women, and that of politicians and merchants for men, within the complicated ethnic politics in Malaysia. They compare Malay TV dramas that appeal to the Malay/Bumiputera and Muslim community with locally produced Chinese TV dramas, noting the significance of an almost ethnic-separatist TV world in Malaysia (p. 272). As a result, multi-ethnic casts and settings are rare, and when they exist, in a show such as the popular local sitcom *2 + 1*, the interaction among the different ethnic characters is eclipsed by gender jokes. In this way, Anuar and Wang imply that the stereotypical roles for men and women noted above are employed to preserve ethnic separation, denying an overall sense of 'Malaysian-ness'. The same problem of ethnic division – and conflict – is most visibly treated on TV news in Malaysia. If the image

of 'men of action' typifies a certain gender treatment on Malaysian TV in general, it is utilised specifically in news programmes by male politicians and journalists who stress ethnic division and inter-ethnic antagonism for their own political ends. Stereotypes of gender and ethnic strifes on Malaysian TV, lament Anuar and Wang, deprive the country of its unity.

Debates in the international arena around TV stereotypes have also focused on the effects of cultural nationalism that tend to privilege the elite class's taste for conventional sexist and racist representations. On French television, for instance, rapid privatisation and globalisation in recent years, resulting in a diverse multi-channeled television environment, has replaced state monopoly of television in the earlier de Gaulle years. However, as Kuhn (2000) notes, '[e]conomic liberalization was not synonymous with simple state withdrawal from the field of television policy' (p. 333). Regulatory authorities were established to oversee the new system, dragging the progress for creating more varied representations. Kuhn goes on to suggest that unlike other forms of popular culture in France, television has been slow to reflect women's growing economic power and the diversity of their societal roles. In the same vein, Hargreaves (1997) has also argued that French TV in the 1990s had remained reluctant to reflect the multi-ethnic composition of French society. Televised soccer games, especially in high-intensity (nationalistic) coverage of such events as the World Cup success in 1998, only offer short-lived moments of festive inter-ethnic interaction and inter-class representation on television. Cultural nationalism is kept alive through gatekeeping processes, which lead to a retardation of progress toward representational diversity on television.

The market-led approach in the French television industry, ironically, resuscitated old-fashioned French cultural nationalism due to the establishment of multiple

Festive inter-ethnic interaction on TV – the World Cup Finals in France, 1998

channels, which has resulted in more and more foreign programmes – especially American Anglophone shows – flooding the French television screen. This has fanned a protectionist, national chauvinistic response. Outdated, elitist and conservative stereotypes of women and ethnic and racial minorities seen on French TV today are thus the result of a contradiction between economic liberalisation on the one hand (usually associated with the US) and cultural/nationalist sovereignty on the other. As more and more countries are subjected to the torturedly contradictory imperatives of globalisation, similar observations have also been reported in studies of TV stereotypes from Indonesia (Sunindyo, 1993), Eastern Europe (Reading, 1995), Japan (Gossman, 2000), India (Barua, 1996), Hong Kong (Fung and Ma, 2000), Israel (Lemish and Tidhar, 1999), Spain (Zabaleta, 1997), and so on.

In colonial and post-colonial societies, the contradiction between the old and the new is often conceived of as the contradiction between 'tradition' and 'modernity'. Studies of television in those societies thus tend to gravitate toward understanding the problem of stereotyping through the tradition/modernity frame. In a study of images of women on Nigerian television, for instance, Adeleye-Fayemi (1997) finds a notably schizophrenic treatment of women as either:

> . . . cast as powerful and dangerous priestesses, quarrelling
> co-wives, witches, and good time girls; or as long-suffer-
> ing women who shuffle in and out of scenes making a
> minimal contribution to the production, their roles
> having little significance to it except as supportive female
> presences as mothers, wives or other female relations.
> (pp. 127–8)

She attributes this situation to the prevalent claim made by the Nigerian middle class – who are the primary audience of television in the first place – that local cultural productions have been too tainted by foreign, colonial (or former colonial) world-views. This middle-class sector nominates itself as the cultural gatekeeper, supporting television only if it is made a tool for the maintenance and defence of (chauvinistic) cultural nationalism. This effectively controls gender representations on Nigerian television, and makes it difficult to develop a progressive feminist consciousness for the critique of the country's popular culture.

Adeleye-Fayemi's study elaborates on three main forms of this control on gender representations on TV. First, cultural nationalism appeals to what she calls 'primordial notions of masculinity versus femininity, with more value

placed on the former, and the restoration of values that had been eroded during years of colonialism and imperialism' (p. 126). Second, it bifurcates the TV roles of women into 'either/or' types to reflect the tradition/modernity split. On the one hand, women tend to be indigenised, even sometimes spiritualised as in the popular TV series *Arelu* shown in 1985–86, to embody mysterious powers of the 'African tradition'. On the other hand, their sexuality is feared as a result of their exposure to Western materialistic influences, as depicted on another programme called *Iyawo Alalubosa* (shown around 1980). In the programme, the young, beautiful, female protagonist is portrayed as restless, greedy and incapable of affection. She married a rich man, left him for another, out of greed for money and sexual adventure. In the end, her life was ruined and she was publicly humiliated. The third reason why the ideology of cultural nationalism in Nigeria has perpetuated negative stereotypes of women has to do with ideological vanguardism. Adeleye-Fayemi puts it this way:

> Cultural nationalism has made it extremely difficult to
> criticize systems or institutions that are prejudicial to
> African women, on the grounds that this will amount to
> 'thinking and behaving like western women,' thereby
> abandoning African cultural values. Cultural nationalism
> had its uses, being the basis, for example, of a concerted
> effort to develop locally produced and sustainable televi-
> sion production. But it also firmly set the tone for deter-
> mining how gender should be constructed. (pp. 126–7)

The three modes of control of representations on Third World TV discussed above – primordial conceptions of gender and race; subjugation of social identities to the tradition/modernity framework; and vanguardism – can in fact be generalised to examine the production of TV stereotypes in many other developing countries.

Examining the problem of TV stereotyping through the tradition/modernity framework has meant that many local researchers have learned to import and cultivate a broader theoretical canvas in Third World post-colonial criticism, more specifically Third World feminist criticism and critical race theory. This explains why the debates raised by TV researchers in non-Western countries often echo much of Third World post-colonial criticism utilised to examine various forms of cultural productions and related issues of oppression (e.g., international media's representations of HIV/AIDS, sex work, ethnic conflicts, human rights, etc.).

To conclude, I offer four general characteristics of TV research on stereotypes and representations, and on media research more generally, in the international arena:

- *Context-sensitivity.* Studies of TV images are rich in historical, political and cultural specificities, even when they are still invested in locating 'good/positive' and 'bad/negative' images.
- *Multiple fronts of engagement with the cultural elites.* Critical research uncovers stereotypical representations in order to mount multiple dissenting discourses against cultural chauvinism and conservatism espoused by the state and other political elites.
- *Refiguring the post-colonial cultural field.* Stereotypical representations in non-Western countries become part of what Appadurai (1996) has termed an 'ethnoscape' and a 'mediascape', signalling a broader global cultural field at play. Global and local *cultural hierarchies* are rendered visible; the layers of hierarchies constitute the post-colonial cultural field from within and from without. On the one hand, local TV images confront dominating stereotypes (about, say, 'the Oriental other') that flow from without; on the other hand, they confront local elite culture's stereotyping of ethnic or sexual minorities, whatever the case may be, from within.
- *Employment of self-reflexive critique.* Findings of stereotypes and representations are therefore used as a barometer to assess serious questions of national sovereignty, national unity versus diversity, progress of eco-nomic and social liberalisation, effects of globalisation, etc. Further, the same findings are also used to offer meta-critiques about the progress of social scientific and humanities research paradigms locally. As is typical and necessary in varied kinds of international media research today, the enmeshing of social scientific methods with humanities perspectives both enriches the research and creates more visible sites for political contestation and intervention.

John Nguyet Erni

RECOMMENDED READING

Barker, Chris (1999), *Television, Globalization and Cultural Identities*, Buckingham: Open University Press.

Curran, James and Park, Myung-Jin (eds) (2000), *De-westernizing Media Studies*, London and New York: Routledge.

Lester, Paul Martin (ed.) (1996), *Images That Injure: Pictorial Stereotypes in the Media*, Westport, Connecticut: Praeger.

Perkins, Tessa E. (1979), 'Rethinking Stereotypes' in M. Barrett, P. Corrigan, A. Kuhn and J. Wolff (eds), *Ideology and Cultural Production*, London: Croom Helm.

Shohat, Ella and Stam, Robert (1994), *Unthinking Eurocentrism: Multiculturalism and the Media*, London and New York: Routledge.

AUDIENCES

Introduction

Audiences are a huge problem for TV studies – physically outside the TV set, they are figuratively within it, in that the men and women behind, above and within TV production take securing and moulding audiences as their primary objective. What is the nature and experience of the human subjects that are imagined by these producers and regulators when they encounter TV? Since the advent of mass communications, social elites and professionals have been concerned to establish links between media effects and what they deem 'normal' behaviour (Blackman and Walkerdine, 2001). Here, we investigate the range of approaches to audiences, from effects studies to fan ethnography.

Toby Miller

The Constructed Viewer

Viewers of television certainly exist. However, they are also, all of them, a figment of various imaginings. There are viewers, and there are 'constructed viewers'. The latter are a figment of the sober, expensive and often influential imagination of impersonal institutions. Imagining them drives billion-dollar industries; it determines governments' relationship with their citizens; it goes to the heart of what we collectively think we know about ourselves, and how we know it.

So far from self-evident is 'the viewer' of TV that no single term is adequate: all are metaphors, and come with historical baggage.

- 'The viewer' neglects the importance of sound in TV, and individualises a social or family activity.
- 'Audience' comes from two pre-modern sources: an 'audience with' a prince or pope; and those assemblies in which everyone present could hear – audit – what was being said or sung. The size of such audiences was restricted to the physical extent of *audibility* of speech and music. The limits of a true 'audience' can be gauged by checking the biggest auditorium for un-amplified sound: the Hollywood Bowl. Impressive as it is, it can't

compete with the TV audience, which is sometimes counted in billions.
- 'The consumer' forgets that watching TV is a cultural, sense-making activity akin to talking. It 'consumes' nothing other than the couch potato's time, which some see as the real commodity in the TV industry, since it is this that is aggregated and sold to advertisers (who are therefore TV's real consumers).

Viewers may be actually existent, but can never be self-present, self-representing, 'knowing subjects'. Instead, watching in small, mutually isolated units, they belong primarily to the context and routines in which they watch. So there's a sense in which all viewers are 'constructed'. But not all constructions are equal. The ones that matter most are those imagined by three of the most important institutions of power in modernity: business, government and knowledge (or science). Each of these 'imagines' television viewers for its own purposes – and what they are imagined to be differs from one institution to the next (Hartley, 1992, Chapter 6).

BUSINESS

Television companies, advertisers and ratings agencies look for a *consuming* viewer. Typically they use direct contact with some hundreds of individuals from among the general population, using statisticians' protocols to assert that these otherwise randomly selected persons 'represent' that population as a whole by various demographic criteria, such as age, gender, ethnicity, class, family situation, education and location.

A very detailed picture of these people's consumer 'behaviour' is then built up, using some combination of focus groups, survey questionnaires, structured interviews, diary-keeping systems, People Meters and other data-gathering techniques, both active and passive, as well as large-scale statistical data-processing. In this context, 'behaviour' means what people do as private individuals in relation both to television viewing itself (how long, looking at what, in what context?), and to its hoped-for consequences (purchases directly related to advertised products and services).

Once a particular system is agreed, it becomes a very important 'currency' in negotiations between TV stations, their advertisers and regulatory agencies. If even its competitors concede that a given channel has won a ratings

The highest 'rates' in TV's currency – the Sydney Olympics opening ceremony

period, then that channel is able to set a premium on its advertising. Similarly, successful shows and formats attract higher advertising rates, up to the dizzy heights of advertising slots in the Superbowl final, or in the opening segment of the Olympics.

The constructed nature of the 'consuming viewer' is demonstrated on those relatively rare occasions when the construction itself changes. The People Meter caused some controversy when it was first introduced, because it seemed to show quite different viewing patterns, preferences and overall ratings from the diary system it supplanted (Ang, 1991). Stories abounded: for instance, one involving a single male householder and his child, randomly selected as hosts to the People Meter, who watched nothing but a non-commercial multicultural channel. Apparently the ratings company rapidly removed the meter on the grounds that it was 'faulty', to replant it in commercially more fertile soil, and to ensure the figures didn't 'over-estimate' the audience for 'minority' television.

More recently, the real value of the imagined viewer became all too clear in Australia. The three commercial free-to-air channels – 7, 9 and 10 – agreed to change from the ACNielsen ratings agency to a company called OzTAM (to which the two public TV channels, the ABC and SBS, also subscribed). However, the system used by OzTAM produced marked differences from Nielsen's ratings, both in the number of people watching and in programme rankings. The long-term front-running Channel 9, owned by Australia's richest man Kerry Packer, lost its overall lead. Although the move to change agencies had been led by Packer, and despite the fact that OzTAM was owned by the commercial TV channels themselves, the results saw Packer threatening legal action and Channel 9 unilaterally continuing to publish Neilsen's ratings (which kept it in the lead).

Why the panic? It was estimated at the time that

Channel 9 faced an annual loss of $100 million in advertising revenue, the end of the 20 per cent premium it had been charging for being number one, as well as a billion-dollar reduction in its share value. Nine's main rival Channel 7, and the smaller Channel 10, both saw increases in their share value worth hundreds of millions of dollars (*The Weekend Australian*, 17–18 February 2001; ABC News, 19 February 2001).

At such times, it becomes clear that the television viewer is very much a construction even within the belly of the beast itself; the industry relies on an *agreed* construction of the viewer, not a *true* one. But this figment of the imagination is worth billions, even in a small market like Australia. Its value in the giant US market is proportionately gigantic.

GOVERNMENT

Regulatory bodies, government departments, political parties and pollsters look for a '*public*' viewer. They are interested in individual 'voting behaviour', and in gauging public opinion across a range of issues. Television itself, as a medium of information, is an active participant in constructing the viewer-as-public, by such means as vox-pop interviews, news, current affairs and talk shows. As a medium, television is unsurpassed in the wonderfully excessive election-coverage shows that both fuel and assuage political anxiety in those moments when representative democracy returns sovereignty directly to the voters for a few hours (or weeks, in one recent presidential election).

The address to viewers as 'public' has always been apt to migrate from these obviously 'public affairs' genres into those traditionally understood as commercial. Advertisers appeal to 'the public' as well as to 'the consumer', invoking national, humanitarian or civic virtues as part of product branding. 'Aid' shows combine entertainment and philanthropy. There's nothing new here: in the 1960s the Wilson government in the UK put housing on the Cabinet agenda after the screening of *Cathy Come Home*. More recently *Murphy Brown* played a role in US public affairs when the lead character's appearance as a single mother was rebuked by then Vice-President Dan Quayle. The pleasure-seeking viewer of TV drama was understood by both politicians and the industry alike to be equally a member of the public, weighing issues of national moment in the act of having fun.

Government itself has a 'duty of care' to the citizens it represents, so the 'regulated viewer' is one with a range of beliefs, expectations and prejudices that need to be safeguarded (Hendershot, 1998). Television programming is policed in the name of the audience. Actual viewers are prevented from seeing material that regulators think

their imagined viewer would find offensive, distressing or inflammatory.

Government intervention into programme content is more vigorous and extensive in countries that don't enjoy the US Constitution's first amendment. Freedom of speech flowers exorbitantly on US cable shows. However, at the same time, commercial accommodations to lobby groups have made US network television among the world's least adventurous when it comes to expanding the seeable and sayable. The boundary between business and government is blurred by 'self-censorship' in the industry, which acts as 'nanny' on behalf of government, agreeing to self-regulation in order to avoid state intervention. Such arrangements are intrinsically conservative – the self-regulator is always more cautious than the official censor.

Historically, 'content' has been regulated as to its quotient of:

- *Sex* – usually meaning female nakedness falling short of genital display, though things are different on cable TV. Sex is not the same as 'romance' – kissing is OK (among heterosexual, same-race adults); it becomes 'sex' only when the female partner's top is removed. In countries

Cathy Come Home – entertainment and philanthropy

with 'public service' broadcasting, this does not take place before 9.00 p.m.
- *Violence* – usually meaning interpersonal violence between male strangers in fiction. The socially more common 'domestic' violence between intimates, whether factual or fictional, is very rare on television, as is adult–child or adult–elder violence. Violence in news, current affairs or documentaries is permissible under freedom of information codes, but rarely goes beyond scenes of collective political violence – riots, police crackdowns – or the outcomes of crimes in public places. It is rare to see dead bodies, at least in close-up, on television; rare to see individuals hurting each other in actuality footage (such stuff can't be rehearsed!). So the 'violence' from which 'the viewer' is protected is largely the symbolic conflict of storytelling – impersonal forces like 'good' and 'evil' biff it out, although frequently the only way to tell them apart is via efficiency: the goodies win more fights.
- *'Bad' language* – 'bad' language was once understood primarily as obscenity or blasphemy uttered as an oath or curse. More recently, sexist, racist and discriminatory language has become just as likely to attract complaints. Words that count as absolutely impermissible on television have changed too, both as a reaction to social movement activism, and because terms themselves get re-signified. The f-word was strongly prohibited during a period when racial epithets were permissible, but that situation has now been reversed. One word – the c-word – has remained universally taboo, although it is very common in some UK regional and class slangs. Language regulation is both partial and mutable: always more euphemistic than actual speakers, the 'constructed viewer' is currently browner, more female and more activist than was once imagined.

Television was the first and, apart from Nintendo/Sega computer games, so far the only major new mass medium whose expansion and social uptake was not driven by pornography. Printing/publishing in the early modern period, cinema in the early twentieth century, and the Internet more recently, all had to be 'cleared' of porn and fraud before they became 'mass' media. Television never went through that unregulated, proto-popular stage. It was governed from the start by the 'constructed viewer', whose childlike prissiness remains so forceful in the minds of regulators and network executives alike that even now, after more than half a century, female nudity is unknown on American prime-time television. Apparently it is less acceptable to 'community standards' than the mimesis of

violent death routinely inflicted on inadequate young men with poorly delineated characters by psychopaths dressed up as law-enforcement agents.

Government regulations control other aspects of the TV business than content – ownership and control of TV stations especially – but this is usually done in the name of 'the market' rather than 'the audience'. 'The market' is itself another example of powerful institutional imagining, but it is not the same as 'the audience'. 'The market' is a textualised and numerical model of large-scale economic activity. Television *audiences* are imagined as private citizens living at home (Spigel, 1992); television *companies* are imagined as public corporations living in 'the market'. Different rules apply.

Where market forces and state protection of audiences (for their own good) have coincided in a big way is in countries with 'public service broadcasting' – common in Europe and places like Canada and Australia, but unknown in this form in the USA (Tracey, 1997). Public service broadcasting retains public ownership of radio and television channels, and puts in place legislative arrangements that cast even commercial broadcasting as a national cultural resource rather than a commercial good. 'Consumer' and 'public' versions of the constructed viewer combine, keeping the television industry as a whole subject to the firm hand of the 'nanny state'.

KNOWLEDGE
Science, in the form of non-commercial audience research, looks for:

- The *'empirical'* or *'real'* viewer. There are two main kinds of this: the *quantitative* viewer and the *ethnographic* viewer. Quantitative viewers are statistically significant aggregations of frequencies ('how many' of something). Ethnographic viewers are constructed by researchers going round to people's homes and observing them 'being' viewers.
- The *'implied'* viewer is a rather different kind of constructed viewer, found in text-based disciplines (see Eco, 1981). This one is a figment of television itself. It's the 'you' to which TV's own communications are addressed, either directly ('Good evening and welcome to the show') or indirectly, by appealing to an intended demographic via various textual devices, some subtle ('audience positioning'), others as subtle as a flying mallet (e.g. 'yoof' TV).

In principle, the experience of watching television both exceeds and falls short of the profile of any institutionally imagined 'constructed viewer' (Hartley, 1999). Everyone is more than just a consumer, citizen or member of the public. Everyone is less – they might be outside a desired demographic, or not paying attention, or behaving perversely. Almost everyone exceeds what is desired of them by television: they 'have a life'. The exception proves the rule; 'life' was no substitute for the man recently reported to have married his TV set (with full ceremony, including a priest and a ring) after several romantic disappointments (source: ABC News, February 2001). And most people fall short: think what the world would be like if everyone actually did what advertisers and politicians exhorted them to do. 'We' are never quite what institutions 'construct' us to be but, meanwhile, audiencehood is diffused throughout everyday life (Abercrombie and Longhurst, 1998).

The 'constructed viewer' is well overdue for a revamp (Seiter, 1999). Old institutions are repurposing, perhaps evolving a more interactive model of the viewer as a service-demanding client for whom 'content' must be tailored. New institutions are imagining new viewers: interactive and narrowcast audiences are no longer 'objects' of mass marketing, manipulation and regulation, but 'subjects' of choice. Customisation means that viewers won't have to be aggregated, and texts don't have to be standardised. Seekers after information may subscribe to a 'Daily Me' news stream, providing personalised selections of story or topic. Viewers may become producers in a new video-literacy, already pioneered by the Jenni-cam and other web-cam sites. Knowledge seekers can access giant audiovisual archives – some may even be public – as television (pushed along by the Internet) finally sorts out how to develop a proper library system. Domestic TV sets will become platforms for multiple services, including broadcasting, cable/satellite, movie rental, phone, Internet, shopping, smart-house/lighting, and home-security services. In short, the 'constructed viewer' will be sitting up as well as sitting back. Some already are.

John Hartley

RECOMMENDED READING
Abercrombie, Nicholas and Longhurst, Brian (1998), *Audiences: A Sociological Theory of Performance and Imagination*, London: Sage Publications.

Ang, Ien (1991), *Desperately Seeking the Audience*, London: Routledge.

Eco, Umberto (1981), *The Role of the Reader: Explorations in the Semiotics of Texts*, London: Hutchinson.

Hartley, John (1999b), *Uses of Television*, London: Routledge.

Seiter, Ellen (1999), *Television and New Media Audiences*, Oxford: Oxford University Press.

TV Audiences and Everyday Life

A significant new focus for reception studies during the 1980s was the exploration of television audiences in their domestic environment. Everyday life, the day-to-day routines and social relations that characterise our experiences, commonly investigated using qualitative, ethnographic research methods, was a concept applied to television audiences. Previously, reception research in media audiences had been closely associated with communication studies, and the tradition of 'uses and gratifications', and cultural studies and the Birmingham Centre, in particular the work of Stuart Hall (1973). Research in media uses and gratifications identified the audience as having social and psychological needs, and mapping structures of demand for media products. Early reception studies rejected some of the more functionalist and behaviourist aspects of uses and gratifications research, but recognised that positioning the audience as a 'consumer' in the marketplace was more helpful to understanding the social uses of the media than the Marxist tradition which perceived the mass audience as manipulated by the media industry. More fruitful for new reception studies was Stuart Hall's encoding/decoding model which proposed a typology of viewers' interpretations of television texts and how these relate to programme-makers' media messages. At a time when ideas about reception were being debated, not only within communication studies but also in literary and film studies, Hall's working notes on a typology of production and reception 'meaning-systems' were influential.

Another influential development in television audiences and everyday life was the work of James Lull (1990). Lull was one of the first American sociologists to apply ethnography to family viewing practices, and he used anthropology and ethnomethodology (observation of routine behaviours) to consider the social uses of television in the home. In the 1970s, over a three-year period, Lull conducted a research project that focused on 200 families living in California and Wisconsin. From this research, he concluded that 'the social uses of television are of two primary types: structural and relational' (1990, p. 35). Television can act as an 'environmental source', or background noise; and it can act as a 'regulative source', a punctuation of time and activity: these are the *structural* uses of television. The *relational* uses are more complex: television can act to facilitate communication, or as a means to open up conversation; it can act as an 'affiliation or avoidance', a

means to bring the family together and also to create conflict; it can encourage 'social learning', such as providing information or problem-solving skills; and it can be a focus for 'competence/dominance', for example, as a means to exert authority, or facilitate an argument (1990, p. 36). Lull therefore established some important conceptual reference points for studies of television in the home.

David Morley (1986), Dorothy Hobson (1982) and other media researchers developed the work of Hall and Lull. These early studies represented a shift in reception research in the 1980s, and raised further questions about television audiences and everyday life, in particular gender relations and the 'politics of the living room'. Reception studies in the 1980s was influenced by feminist media research which identified consumption practices as significant to the social construction of gender. This type of research used qualitative, self-reflexive methods to study how TV viewing relates to gendered relations in the domestic environment. Morley used in-depth interviews to study eighteen households in South London. Morley argued that the subject of study should not be the individual viewer, but the family/household; his central findings were that gender was one factor that cut across all other differences in the households he studied: men would almost always dominate the TV. Hobson interviewed female fans of an early evening soap opera about life in a motel. She observed the domestic environment, often noting that women were engaged in a complex series of activities, such as cooking the evening meal, while at the same time attempting to watch their favourite soap on TV: thus the TV set being *on* was not synonymous with its output being *watched*. Morley and Hobson emphasised the importance of understanding individuals in the social context of their everyday domestic lives.

Significant contributions to thinking in the area of TV audiences and everyday life include both theoretical and empirical studies. Following the phenomenological tradition, which focuses on the spatio-temporal context of day-to-day relations and experiences, research by Roger Silverstone (1994), Paddy Scannell (1996) and others has focused on the concept of 'context', a somewhat vague term within early reception studies. Silverstone was influenced by the work of Anthony Giddens, a sociologist whose theory of modernity was based on 'ontological security' (a sense of security in oneself in relation to the patterns of everyday life) and 'time-space distanciation' (a process in which the separation of time and space leads to a disembedding and re-embedding of social relations). Silverstone applied these macro-sociological concepts to television and everyday life. He argued that we live in an ever-changing

domestic environment where time, space and subjectivities are disembedded and re-embedded within the framework of the mass media. Silverstone's theory of television, technology and everyday life thus draws on the concept of ontological security, questions of agency, and the relationship between domesticity and consumption. Paddy Scannell (1996), using historical and philosophical lines of enquiry, explored the relationship between natural time (day and night), abstract (clock) time and experiential (phenomenological) time. For Scannell, each of these events are part of the daily experience of broadcasting, which is tuned to experiential time but outlasts our own lifetime. Thus, Scannell's theory of television and everyday life draws on the concept of time and its relationship to media institutions.

Both Silverstone and Scannell made important contributions to understanding television and our day-to-day routines and social relations; however, their theoretical account could be regarded as premature. Before we can begin to understand the symbolic and material structures

in everyday life, it is important to consider what people have to say about their own experience, and the practicalities of television in the domestic space. An American study of television and everyday life by Kubey and Csikszentmihalyi (1990) used quantitative research methods to ascertain whether television viewing was an active or passive activity in the home. They considered when people watch television, who they watch television with, and what they choose to do while watching television. They found that '63.5 per cent of the time television was being viewed, people reported doing something else as well' (1990, p. 75), showing that television is part of the domestic space and is often incorporated into other household activities. However, despite this claim, the authors conclude that television viewing is a passive activity and that many people are affected by television in similar ways (1990, p. 174).

This claim is refuted by a UK study in television and everyday life. The British Film Institute (BFI) conducted a longitudinal, ethnographic study during the 1990s. This five-year study focused on diachronic rather than syn-

BRITISH FILM INSTITUTE AUDIENCE TRACKING STUDY

The 1988 One Day in the Life of Television project was a 'mass observation' study which involved 22,000 people from the United Kingdom who wrote a diary about their television viewing. The BFI Audience Tracking Study respondents were picked from this large, self-selected sample, and invited to participate. The BFI constructed a sample that was generally representative of the population as a whole. Variables such as sex, age, marital status, region, occupation, and household size and composition were taken into account. The longitudinal study was designed to run from 1991 to 1996 and consisted of fifteen questionnaire diaries completed by an initial 509 respondents, which had dropped to 427 respondents at the end of the project. Particular attention was given to different household compositions, such as single-parent families, student accommodation, and households with only one adult, as well as the more traditional composition of the nuclear family, reflecting the changing nature of household composition in the 1990s.

Key findings relate to television, life transitions and everyday life. Young people in this study were very aware of the transitional stages in their lives, and quite keenly anticipated their future adult status. Indeed, this had an influence on their television viewing patterns, so that young respondents would claim that 'children's programmes' had been eschewed in favour of more adult-oriented programmes. When anticipating a more adult status, young people emphasise work schedules and their

ability to maintain these schedules. This is particularly so in transitional periods from school to college, and school or college to work, and perhaps suggests that young adults perceive adult status as largely defined in relation to work.

In times of emotional stress, such as unemployment, or marital breakdown, television can be used as a distraction, and it can become a more central feature within the home. However, this seems to alter again when viewers actively change their personal circumstances, for example, by finding a new partner, or taking up a new leisure activity. This would suggest that watching television is a coping strategy that people use to help them through stressful situations. However, the fact that watching television can be a source of tension and a means to avoid contact with a partner or spouse is an indication that the role of television in everyday life is not free from conflict.

Some people adapted easily to retirement, but for others the transition was quite traumatic. In early retirement, people would often occupy themselves with a range of activities, stemming from a general work ethic and a need to feel active and useful. They would try to resist the 'seduction' of daytime TV, and were well aware of the changing patterns of their viewing between working and retired life. Physical and financial restrictions, and often diminishing numbers of social contacts, meant that as time went by they would generally spend more time at home and 'allow' themselves to watch more television.

Annette Hill

chronic cultural processes, considering life-cycle transitions such as leaving home and starting university, divorce and retirement in relation to patterns of television consumption (see box, p. 65). Gauntlett and Hill (1999) argued that 'the family' (and television) is not a fixed entity, but something that is in constant state of flux; they also argued that life biography ('experiential time') is more important than broadcasting ('institutional time'). The BFI also conducted an Industry Tracking Study during the same period, but an opportunity was missed to analyse both studies simultaneously and explore crossovers between production and consumption.

Another significant contribution to thinking in this area is the work of Shaun Moores. Moores (2000) combined an empirical and theoretical approach to 'mediated interaction'. Like Scannell, Moores used historical research to understand the relationship between broadcasting and viewers, and he also conducted qualitative, ethnographic research in early adopters of satellite TV. Moores was also influenced by Silverstone and Giddens and explored time-space distanciation in relation to interpersonal communication and geographical/domestic space. Moores argued that 'relations between performers and audiences in broadcasting, communication via telephone and computer networks, and routine negotiations involving the use of electronic media in everyday life' can be characterised as 'mediated interaction'. Television is not only a means of interacting with absent others, but also a 'fixed prop' for social relations and for practices of self-presentation. This current line of enquiry takes previous research on television and everyday life, such as Lull or Morley, and incorporates the 'politics of the living room' within the context of public workspaces and wider interactions.

Other principal lines of enquiry which currently characterise research in television and everyday life include an understanding that not only the viewer but also television is in a constant state of flux. In the past, research in reception studies tended to use in-depth interviews rather than longitudinal, ethnographic field work. If media researchers are to understand the role of television and everyday life in a changing society then it is important to chart these changes and map patterns of global production and consumption over time. Another new area of reception studies, which develops from the feminist research tradition, has been a self-reflexive approach to the place of media in everyday life and viewers' perceptions of themselves as an 'audience' (Alasuutari, 1999). This is particularly appropriate given rapid developments in information and communication technologies, and the changing nature of national, local, diasporic and exilic media communities who navigate

a converging media environment. Nicholas Abercrombie and Brian Longhurst's (1998) theory of the spectacle/performance audience paradigm belongs to this new area in reception studies. Abercrombie and Longhurst argue that the socially constructed and re-constructed audience is embedded in a 'mediascape' where identity formation and re-formation occur within everyday life. However, there is a danger that focus on everyday life, and the micro-level of human interaction, brackets out an understanding of the 'everyday' which is linked to power, political economics and globalised market forces. Previous research in reception studies has been criticised for being too apolitical. The future of research in television audiences and everyday life is one which continues to explore theoretical and empirical conceptualisation – conceptualisation which draws upon broad approaches to the study of reception in the domestic, work and leisure space.

Annette Hill

RECOMMENDED READING

Bennett, Tony and Watson, Diane (2002), *Understanding Everyday Life*, Oxford: Blackwell.

Gauntlett, David and Hill, Annette (1999), *TV Living: Television, Culture and Everyday Life*, London: Routledge.

Highmore, Ben (2002), *Everday Life and Cultural Theory*, London: Routledge.

Moores, Shaun (2000), *Media and Everyday Life in Modern Society*, Edinburgh: Edinburgh University Press.

Silverstone, Roger (1994), *Television and Everyday Life*, London: Routledge.

Fandom

The academic study of cultural consumption since the industrial revolution has been consistently bifurcated (see Rose, 2001, pp. 393–438). On the one hand, studies of how 'we' (intellectuals) consume culture – the disciplines of English literature and art history – have worked on the assumption that readers actively make interpretations, drawing on a detailed set of already held knowledges about similar texts, previous great works and other forms of cultural capital ('One is immediately reminded of Cicero's . . .'). On the other hand, studies of how 'they' (the working and lower middle classes – the 'masses') consume culture have, for much of the century, assumed that these readers do not do any work on interpreting the texts. Rather, in some way, they have ideas put straight into their brains (through processes such as ideology, hegemony, etc.). Even

when the same texts are being consumed, a tradition of thinking exists where the masses do not interpret in the same way because they lack 'discrimination' in their interpretation of these texts. Such a division has been employed by both right-wing conservative thinkers (such as F. R. and Q. D. Leavis) and by left-wing radical critics (such as Frankfurt School writer Theodor Adorno).

Work on fan audiences has finally made clear that such a distinction – between 'our' (academic) processes of interpretation and 'their' (non-academic) ways of making meaning – is unsustainable. While there are undoubtedly many different ways to make sense of a text, a simplistic binary that keeps us at arm's length from them does little to explain these; for fan studies show us that 'they' may indeed be 'us'.

The term 'fan' – an abbreviation of 'fanatic' – was developed in its current sense in the late 19th century to describe 'a keen and regular spectator of a (professional) sport, originally of baseball'. This description of the enthusiastic audience moved from its specifically baseball-oriented use first to other and then to less insistently masculinised parts of culture, so that by 1915 you could be a 'fan of films', and by the 1920s, social organisation around elements of commodified mass culture was commonplace: 'fan clubs' existed as a part of everyday vocabulary (OED, 1991, p. 567).

The research that pushed the study of television towards engagement with audiences and attempts to understand how they make sense of programmes – books like David Morley's *The Nationwide Audience* (1980), Dorothy Hobson's *Crossroads: the Drama of a Soap Opera* (1982) and Ien Ang's *Watching Dallas* (1985) – do not talk about television 'fans', but 'active audiences'. Many of the subjects who watch *Nationwide* for Morley's study would never normally watch it, and are only doing so for his research; while Hobson and Ang refer to 'viewers' rather than fans of the soap operas they discuss. The first 'fans' to be studied in detail were John Tulloch and Manuel Alvarado's *Doctor Who* fans: as part of their study of the production and reception of *Doctor Who*, these writers examined the ways in which fans made sense of the programme and related to its producers (Tulloch and Alvarado, 1983). However, the work most commonly cited as introducing fans to television studies is Henry Jenkins' *Textual Poachers* (1992). The 'viewers' of *Crossroads* and *Dallas* discussed by Hobson and Ang were, it is clear from their books, certainly 'enthusiastic'. But what caught the imagination of many television researchers (particularly in the cultural studies tradition) about the 'fans' described by Jenkins was the fact that they produced *material* culture of their own. They did not simply react to

an academic agenda, writing letters in response to academics' letters (as Ang's 'viewers' did) or answering questions when interviewed by an academic (Hobson). Rather they displayed agency in their everyday media consumption. Quite unprompted, they produced their own short stories, novels, audiotapes of related songs, scripts, magazines and even re-edited videotapes: almost every form of cultural production possible. There was no way that these viewers could be rendered passive by the application of the term 'consumers'. Nobody could deny that they were also producers, because the material evidence was there for everyone to see.

Jenkins showed not simply that fans are 'active' (producers), but also that they engaged with the television text in a number of ways. They didn't all interpret the programme in the same way, and they didn't all agree with what they saw as their programme's stance on various issues. From his analysis of the work that fans have done with their favourite television programmes, Jenkins shows that through a number of strategies – from the most respectful of the television programme, such as filling in the gaps in broadcast stories, to the most radical, such as taking characters out of the programmes completely, and giving them different names and situations – fans conducted their interpretation of the text in a variety of ways. For example, his study of a *Star Trek* fan novel, *The Weight* by Leslie Fish, shows that this fan interprets *Star Trek* as being a sexist and militaristic programme, but that she can also suggest ways in which those faults can be overcome within the programme's own universe and logic (Jenkins, 1992, pp. 177–84).

The evidence of material production was useful for allowing television studies to shake off the idea that television audiences are cultural dupes who simply believe what the producers want them to (although this tendency still survives – see Gripsrud, 1995; McKinley, 1997). Some writers have used this starting point to push this idea even further, and to insist that fan audiences make clear the fact that we cannot draw a simple line between production and consumption of texts (see McKee, 2002). That is to say that fan culture was useful for raising questions about how audiences are productive, but it may have been misleading in its focus only on material forms of production: for the act of making interpretations is also a productive one, even if those cannot so easily be seen and written about.

The fact that television fans form communities has also been important. For Marxist-inflected forms of television studies, the community is vitally important: one of the charges repeatedly laid against capitalist culture is that it encourages individualism, and the lack of communal solu-

Dr Who - the programme's fans were the first to be studied

tions to problems. Writers on television fans have therefore emphasised the importance of community formation: the fact that fans meet and discuss their ideas. And again, it is the fact that these television fan communities actually get together physically that makes them so visible for television researchers, but we must also bear in mind that such communities exist virtually as well. The Internet has allowed fan communities to form more quickly; it has allowed new communities to form around programmes where only a small number of fans might exist in any given geographical location, but a large enough number to sustain a community exist globally; and it has made it much easier to research fan communities: in a way making them more visible, once one has accepted that these communities might also enable fans to 'share and talk about . . . concerns within a broader social context'. Of course, fans existed in virtual communities before the Internet (see Cornell, 1997, which details the communities of *Doctor Who* fanzine producers and readers from the 1970s onwards); but this technology has certainly facilitated their emergence and management.

Of course, questions have been raised about the place of fan studies for television research. Many of these are the same charges laid against all studies of active audiences. Firstly, some writers critique the methodology of fan work, suggesting that it is not truly 'ethnographic' as researchers do not live with members of the cultures studied for extended periods of time (see, for example, Nightingale, 1993). In the strictest sense of the word 'ethnography', such charges are accurate: but they do tend to suggest that forms of evidence about fan activity gathered in other, non-ethnographic ways (for example, from letters or interviews) are somehow less real, a charge which is demonstrably untrue (see McKee, 1999). It should also be borne in mind that work on fan cultures has tended to be much more ethnographically precise than most work on

active audiences, simply because the fact that fan communities gather for conventions and other events makes them more easily accessible to researchers.

A second charge has been that fan audiences, like 'active' television viewers more widely, are active only in a very circumscribed way: their responses to television programmes tell us nothing about their wider engagement with politics, for example. Some critics charge that writing fan stories (for example) does not deal with real material issues of the state, capitalism and large-scale social organisation. Again, this is mostly true: but such charges tend to miss the point. The disciplines of television studies, media studies and cultural studies have developed precisely because of a sense that culture is important: that there is more to 'politics' than the traditional conception of the term would allow (masculine, public, state-based, large-scale concerns). The way in which people make sense of the world is centrally important for a post-structuralist politics, and the fact that this process of meaning-making is being undertaken actively by fan audiences is thus political in itself: for example, Janice Radway (1984) argues, in her study of fans of romance books, that the ways her readers use these books is political for them, even if it does not lead to the overthrow of patriarchy.

Third, some writers ask whether fans are 'representative' television viewers (see Hermes, 1995, p. 15), pointing out that not all consumers use all texts in this way. In one way, such questions are quite correct: for of course, in one sense, fans are not representative. The fact that many television viewers are creative and productive in their response to some television programmes does not mean that all viewers treat all programmes in this way. But, on the other hand, these viewers are not atypical. They should not be regarded as in some way abnormal. The very fact that the term 'fan' is first developed in relation to sports reminds us that there are many areas of culture – including television – where a strong engagement and involvement is a normal part of cultural participation. We should also note that although early fan work focused largely on the fans of cult programming (such as *Star Trek* and *Doctor Who*), fan responses to television are not confined to fantasy or science fiction genres. There are fan Internet pages for sitcoms (*The Brittas Empire*, http://www.valdefierro.com/brittas01.html); for soap operas like *EastEnders* (http://www.beadsland.com/ROM/eastenders/html/shome/); and for fan fiction based on cop shows like *The Bill* (http://www.tbfanfic.com), to name but a few examples of non 'cult' programming that has a visible fan presence. It is useful, though, to use Joke Hermes' work to suggest a *variety* of ways that viewers can engage with television texts. Her research suggests that

BUFFY THE VAMPIRE SLAYER

Buffy the Vampire Slayer is a post-network television production about a young woman who discovers that she has a birthright to protect the world from vampires. This self-reflexive series, aimed at an audience of intelligent young adults, exhibits a great knowingness about the conventions of television programming and of its own genre, and usurps these for comic and emotional effect: 'If the apocalypse comes, beep me.' Although it is not the highest rating show on American, British or Australian television, it is a very successful cult programme (see Reeves, Rodgers and Epstein, 1996). Although there are few academic studies of *Buffy* fans available, the programme's importance in terms of television research and fandom is a different one. Many of *Buffy*'s fans are intellectuals, and the amount of academic research that has been published on the programme by television researchers who are obviously fans is notable (for example, see the twenty articles on the programme that are collected in Lavery and Wilcox, 2002; or the twelve articles collected in Parks and Levine, 2002). Importantly, as well as websites, fanzines, e-mail lists and artwork, *Buffy*'s fan community produces *Slayage: the Online International Journal of Buffy Studies* (www.slayage.tv). Like *Whoosh! Online* (the journal of the International Association of Xena Studies – www.whoosh.org), *Slayage* is both fan work and academic work, simultaneously a fanpage (like www.gallifreyone.com); and an online academic journal (like *Intensities: Journal of Cult Media* – www.cult-media.com).

The journal has an editorial board of accredited academics, but also publishes fan art of variable quality. The editorial guidelines state that: 'Completed essays will be reviewed by members of the board and will be accepted for publication if three individuals approve'; but the range of contributors is much wider than one would normally expect in an academic journal, including high-school students, librarians, medical workers and a 'prominent vampirologist', as well as the usual cultural studies lecturers. The articles published in the journal – unlike much writing on television (see Hartley, 1999) – actually like their object of study.

Slayage shows us a new form of writing about television: the fan is the academic, in a site which is institutional (the editorial board of accredited academics) and yet outside of institutions (you do not have to enrol to study Buffy, there is no fee, nor any gatekeepers, guarding entry to the association; you do not have to attend a university library to find these articles).

This is not, of course, to say that everyone is equal. The class system is still in operation, although now the distinction might be between the 'knowledge class' and others (Frow, 1995). In particular, for television researchers interested in social equity, an interesting question might be: why do some fans get paid to employ their expertise and write articles about Buffy for *Slayage*, while other fans do not?

Alan McKee

some texts (in her case, women's magazines) are skimmed through rather than engaged with in detail (Hermes, 1995). Working with this insight, we can suggest a continuum of ways of engaging with texts: from a disengaged form of consumption where very little attention is paid to the text, or meaning made from it; to the detailed analysis, engagement, rewatching and commentary undertaken by committed fans of particular programmes. In this way, we can abandon the ideal of searching for the single truth about engagement with television, and rather accept a variety of forms of viewing.

Joke Hermes also wonders why television researchers have embraced fan studies so readily. This is a telling point. As Matthew Hills has noted, there is 'an ontological similarity between "fans" and "academics"' (Matthew Hills, quoted in Tulloch, 2001, p. 231). This returns back to the binary that opened this section. We can no longer insist that 'we' (the intellectuals) watch television one way, while 'they' (the masses) watch it another.

Some people engage with texts in great detail. They consume them again and again; they publish articles examining elements of these texts in great detail; they engage in arguments about meaning and about the worth of various texts (see McKee, 2001). They even meet up at conferences to discuss these matters communally. Some people are fans of Shakespeare, some of Derrida, some of Joss Whedon (see box above); they treat their texts in similar ways. Of course, some people are credentialled for this work, and paid to do it; we call them academics. And some do it on an unpaid basis: we call them fans. This is perhaps the most attractive element of fan studies: in setting up new distinctions – not between intellectual and mass, but between engaged or disengaged consumers (or positions in between) – a new relationship between categories emerges. Perhaps now we can see that the category of 'humanities intellectual' is, in fact, a subset of the category 'fan'. We are them; we are the fans who are lucky enough to get paid to be fans.

Alan McKee

RECOMMENDED READING

Bacon-Smith, Camille (2000), *Science Fiction Cultures*, Philadelphia: University of Pennsylvania Press.

Hills, Matt (2002), *Fan Cultures*, London and New York: Routledge.

Jenkins, Henry (1992), *Textual Poachers: Television Fans and Participatory Culture*, London and New York: Routledge.

Lewis, Lisa A. (ed.) (1992), *The Adoring Audience: Fan Culture and Popular Media*, London and New York: Routledge.

Tulloch, John and Jenkins, Henry (1995), *Science Fiction Audiences: Watching Doctor Who and Star Trek*, London and New York: Routledge.

Uses and Gratifications Research

In *The Uses of Mass Communications* (1974), Katz, Blumler and Gurevitch define uses and gratifications as a sequential investigation involving seven questions. What, they ask, are (1) the social and psychological origins of (2) needs which generate (3) expectations of (4) the mass media or other sources which lead to (5) differential patterns of media exposure ... resulting in (6) need gratifications and (7) other consequences, perhaps mostly unintended ones (p. 20)?

Almost a quarter of a century later, Philo and Miller chastised those who '. . . have examined the "social relations of media consumption", which could come down to asking if people listen to the radio whilst doing the ironing' (Philo and Miller, 1998, p. 14). This attack on vacuous studies of self-evident media pleasures was not directed at Blumler et al., but rather media ethnographers whose roots lay in cultural studies. This witnesses a common tendency to equate uses and gratifications with the notion of the active audience that emerged from the encoding/decoding and resistive reading models (Morley, 1992).

David Morley (1993) resists this conflation. Both uses and gratifications and studies of ideological resistance have been presented as utopian poles in the oscillation between pessimism and optimism in twentieth-century audience research. And both have provided antidotes to the 'hypodermic needle' model of influence inspiring the effects tradition. The difference is, uses and gratifications work evaded questions of media influence in a giddy celebration of rational audiences who knew what they wanted and how to get it. As such, this paradigm was conceptually and methodologically antithetical to a cultural studies that is grounded in a social theory of power.

Both of these views are unhelpful. It is more profitable to define uses and gratifications as being distinct from but also in some ways connected to what had gone before and was to follow in thinking on audiences. To this end, it is worth setting out the model's key concepts and methods so that we can appreciate points of departure and convergence with effects research and cultural studies.

The view that uses and gratifications performed an about-face from the idea of direct and immediate media influence is related to a foundational definition from Elihu Katz:

> Less attention should be paid to what media do to people and more to what people do to the media. Such an approach assumes that even the most potent of mass media content cannot ordinarily influence an individual who has no use for it in the social and psychological context in which he lives. The uses approach assumes that people's values, their interests, their associations, their social roles, are pre-potent, and that people selectively fashion what they see and hear to these interests. (Cited in McQuail, 1998, p. 152)

Katz's quote replaces the media dope with the rational consumer, but it does not announce a schism with what had gone before. Although effects research had tended to focus on short-term influences of specific programmes, in developing the idea of selective exposure and perception, key figures such as Lazarsfeld and Stanton had indicated audiences who sought media content to fulfil pre-existing social or psychological needs (Katz et al., 1974). Nor did the new approach dismiss the idea of effects out of hand; rather it was argued that the motivations behind media use were a vital intervening variable in any link between texts and cognitive, attitudinal or behavioural outcomes (McQuail, 1998).

Uses and gratifications departed from the effects tradition in two ways. First, the new model was centred on audience perception. Elite questions and concerns about media power had guided empirical work in the 1930s and 40s. Could what the public think and do be directly swayed by propaganda, popular culture or advertising? Yet no evidence of the magic media bullet had been found in the resultant data. Hence researchers had to come down from their dreaming spires to appreciate the media as everyday viewers, readers and listeners saw them (Katz et al., 1974).

At the same time, uses and gratifications was also built on a call for greater procedural rigour that drove its practitioners closer to positivist, quantitative methodologies (for an explanation of positivism, see Ruddock, 2001). Lazarsfeld et al. were criticised for failing to develop a gen-

eralisable picture of audience needs, preferences and behaviours by relying on qualitative and impressionistic methods. In contrast, Katz et al. advocated objective social science; a project that abandoned traditional academic prejudices in favour of an open-minded, systematic investigation of the audience via the identification, clarification and statistical correlation of key variables.

Freed from institutional imperatives, and assuming an active audience, scholars were able to observe different aspects of media culture. Much of the effects work had been commissioned by the US government or the corporate world (see Peters, 1996). As a result the question of media influence was limited to the issue of whether or not messages could 'sell' ideas, people or goods to audiences. Uses and gratifications argued that these ideas could only make sense if we understood the motivations drawing attention towards messages in the first place. McQuail, Blumler and Brown suggested that people turn to the media for one or more of four reasons, related to pleasure and the needs for personal security and information. Regarding the former, escapism or the desire for diversion could explain a huge part of media consumption; audiences do not seek persuasion, but a cognitive and emotional release from everyday tensions. They may also be looking for companionship, using media characters as social surrogates or as a means to establish contacts with other audience members. They may wish to receive social validation, seeing their own beliefs and values reflected in the media; or they may want to achieve a sense of mastery in the world, using the media as a means of surveillance keeping them 'in the know' (McQuail, Blumler and Brown, cited in Katz et al., 1974).

At this juncture intersections between uses and gratifications and the cultural studies notion of the active audience appear. Yet this appearance is most definitely deceptive: cosmetically similar conclusions are built upon very different conceptual bases, so that ultimately they mean quite different things. This can be seen in critiques of the paradigm written by Carey (Carey and Kreiling, 1974) and Elliot (1974), and acknowledged by McQuail (1998) and McQuail and Gurevitch (1974).

The key to understanding differences in what is meant by 'active' lies in defining what uses and gratifications means by antecedent psychological and sociological needs. As Elliot points out, the notion of a base psychological need existing before culture suggests a level of generality that is too banal to be of any real interest or analytical utility (Elliot, 1974). 'Discovering' that we all need a mental break is about as groundbreaking as finding that we all need food and water.

The sociological sounds closer to the mark, but is hampered by a functionalist orientation. Functionalism, in Carey's view (Carey and Kreiling, 1974), tended to see society as a harmonious organism made up of components that worked together to maintain equilibrium. We can see how this critique resonates with the McQuail et al. typology of gratifications. Life treating you badly? Laugh at the losers on Jerry Springer. Feeling lonely? Talk radio will keep you company. Doubting your beliefs? Buy a newspaper whose editorial line fits in with your own world-view. Feeling out of touch? The news headlines will fill you in. All in all you will be left with a sense of safety, of wellbeing: all seems right in the world.

In other words this newborn optimism had written 'dysfunctions' or conflict out of the media equation. This was the result of one conceptual and one methodological problem. Carey argued that in abandoning 'elitist' views of mass-media audiences, uses and gratifications had also deserted important questions of cultural power. As Ann Gray (1987) was later to argue, consumer sovereignty is an empty idea, as audiences hold no control over the production process. In this sense, audience activity is an exercise in making do. What we choose from the media isn't necessarily what we would want in an ideal world.

A cure for feeling down? The uses of *Jerry Springer*

STAR TREK: USES AND GRATIFICATIONS VERSUS FAN CULTURE

To highlight the differences between how uses and gratifications and cultural studies understand audience activity, it is worth contrasting gratifications with the pleasures outlined in ethnographic studies of fan cultures. This should be prefaced with an acknowledgment of the 'apples and oranges' nature of such comparisons. Research is inevitably coloured by theoretical and methodological choices; we should therefore not expect compatibility between paradigms bearing different intellectual luggage.

Having said this, uses and gratifications and media ethnographies do share common goals and problematics. The most obvious is a commitment to understand the categories that audiences use to explain and understand their media preferences. In the years since the publication of *The*

Uses of Communication, McQuail has also recognised the validity of Carey's comments, adding the notion of imaginative 'play' to the list of gratifications (McQuail, 1998). At the same time we should note that aspects of the original cultural critique have turned back upon themselves; in their study of the viewers of Sylvester Stallone's *Judge Dredd*, Barker and Brooks (1999) question the centrality of power and meaning in audience research. Such terms, in their view, mean little in studying Hollywood blockbusters which are, given new cinematic technologies such as widescreen vision and digital surround sound, primarily physical rather than cognitive experiences.

Yet quantitative methods are ill-suited to an explanation of *how* gratifications are gained (Elliot, 1974). This in turn is related to the problem of viewing media as a functional alternative in the fulfilment of needs that could be satisfied by

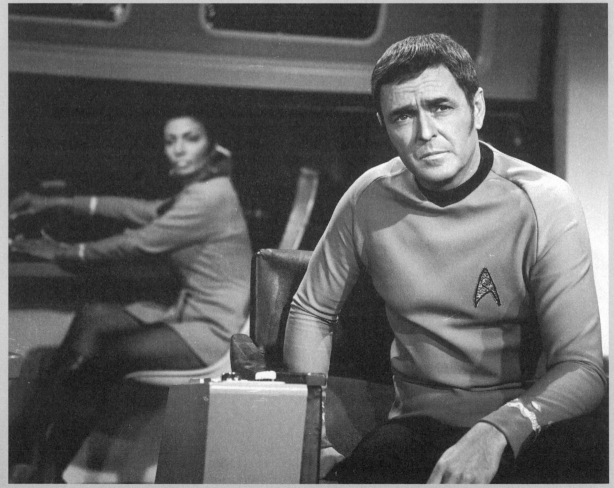

Star Trek – gratifying for audiences but how?

other forms of social intercourse. This becomes most apparent in work such as Henry Jenkins' *Textual Poachers* (1992) that points to the unique qualities of media consumption. Jenkins is concerned with overturning the image of science fiction fans in general, and *Star Trek* fans in particular, as anomic misanthropes who are incapable of sustaining 'authentic' human relationships; a view that is entirely consistent with the uses and gratifications conceptualisation of media use as a means of forming surrogate communities. Jenkins counters that *Star Trek*'s textuality allows audiences to read and imagine utopian spaces where everyday prejudices around class, race and sexuality disappear. Moreover the much-maligned fan conventions concretise these imagined communities. The important thing to note is that this can only happen within the receptive opportunities offered by the show. As Carey argued earlier, these pleasures can be found nowhere else since they are uniquely tied to symbolic expression. This illustrates the importance of viewing media as primary rather than secondary cultural institutions, as they become the basis for the organisation of material life. We might conclude that where uses and gratifications is useful as a means of describing broad typologies of media pleasures, it is not suited to an explanation of how these pleasures work.

Andy Ruddock

This led to the methodological assumption that since the audience were aware of the reasons why they turned to the media, they could be trusted to supply reliable accounts of their habits. Since numerous scholars have written of culture as a set of non-conscious rules, it is doubtful that such a level of self-awareness can be assumed in everyday life. Even if this were the case, can people be trusted to faithfully report on media behaviours? Would, for example, a married, middle-aged father of two be willing to confess a voracious appetite for porn to an unknown researcher?

James Carey contends that the problem lay in defining human beings as psychological and sociological rather than cultural beings (Carey and Kreiling, 1974). Inspired by anthropologist Clifford Geertz (1973), Carey argued that we understand ourselves and our surroundings through symbolic expression. As a consequence, uses and gratifications had erred in presenting the media as a secondary activity. The notion of 'pre-potence' suggests that we live in social and psychological worlds that exist *before* media representation. The texts we choose to expose ourselves to are thus reflections of a world that is already understood. The problem with this is that the media are a part of our material world; they are part of the milieu within which needs are formed. If human beings primarily form a sense of self and society via symbolic expression, then as the major means of that expression the media must be promoted to a primary position. The needs and gratifications outlined by Blumler et al. (1974) are therefore not formed through media; they are formed *in* media.

The consensus from a cultural studies point of view seems to be that while uses and gratification performed a vital role in placing the audience at the centre of media analysis, the rejection of theory and blind faith in statistical empirical methods provided a misleading view of audience activities as autonomous rather than structured. Additionally, an instrumental view of this activity, combined with a failure to appreciate or even consider how media texts worked, meant that the model was unable to explain the distinct pleasures offered by media as opposed to other sources of gratification.

Andy Ruddock

RECOMMENDED READING

Blumler, J. G. and Katz, E. (eds) (1974), *The Uses of Mass Communications: Current Perspectives on Gratifications Research*, London: Sage.

Carey, J. W. and Kreiling, A. L. (1974), 'Popular Culture and Uses and Gratifications: Notes Toward an Accommodation', in J. G. Blumler and E. Katz (eds), *The Uses of Mass Communications: Current Perspectives on Gratifications Research*, London: Sage.

Jenkins, H. (1992), *Textual Poachers: Television Fans and Participatory Culture*, New York and London: Routledge.

Katz, E., Blumler, J. G. and Gurevitch, M. (1974), 'Utilization of Mass Communication by the Individual', in J. G. Blumler and E. Katz (eds), *The Uses of Mass Communications: Current Perspectives on Gratifications Research*, London: Sage.

McQuail, D. (1998), 'With the Benefits of Hindsight: Reflections on the Uses and Gratification Paradigm', in R. Dickinson, R. Harindranath and O. Linne (eds), *Approaches to Audiences*, London: Arnold.

Morley, D. (1993), 'Pendulums and Pitfalls', *Journal of Communication*, vol. 14.

Ruddock, A. (2001), *Understanding Audiences*, London: Sage.

Media Effects

As a label, the term *media effects* commonly refers to a body of social scientific research on the influence of media images – particularly images of violence or of sexual activity – upon the attitudes, beliefs and behaviours of audiences, usually children. Effects research comprises a diverse set of methodologies and assumptions about audience activity and policy goals, but the field is most widely known for this concern with the psychological and social impact of explicit and/or controversial material. This perception is notable because it aligns media effects research with religiously defined codes of morality. Numerous researchers in the field focus on other socially damaging forms of media representation, such as racist or sexist characterisations, or narrative forms that promote the ideals of consumer culture, or for that matter the effects of media ownership concentration upon viewers' perceptions of news coverage. However, the fact that public debates over media effects, and the public policy they aim to shape, often focus on 'graphic' media images and not on these other issues tells us that media effects research can be used to support socio-political goals that go far beyond the wide-ranging collection of approaches and findings that define the field internally. As Nicholas Sammond notes in his study of Disney's construction of child audiences, it is important to remember that effects studies can have as great an impact on society as the media systems they investigate (Sammond, 1999). As we shall see, the networks of institutional support and sources of private and state funding that have historically shaped the development of effects research as a field do indeed reflect broader socio-political interests. But there are other possibilities for media effects research too, as some recent projects in cultural studies make clear.

The history of effects research is extensive. Indeed, it is fair to say that ideas about the impact of media images upon individuals and groups are as old as the mass market for moving images. However, it was only after the rise of statistical methods in the social sciences in the 1920s that media effects began to develop as an area of professional research. In the United States, the first major longitudunal, privately funded study of the effects of popular media on children took place in this period. Known as the Payne Fund studies, the project was carried out between 1929 and 1932. Its nineteen social scientific researchers conducted in-depth interviews with, and administered a series of psychological and physiological tests to, habitual child movie-goers – many of them inmates in reform schools and other

institutional settings. The study led to eleven publications, most of which, like Herbert Blumer and Philip Hauser's (1933) *Movies, Delinquency, and Crime*, sought to connect the changing indices of juvenile crime to images of criminality in popular films (de Cordova, 1990; Jowett et al., 1996). This era also saw the emergence of the effects of broadcast communication as an area of social scientific research. In 1937, the Rockefeller foundation funded the Office of Radio Research at Princeton University, and imported Austrian social scientist Paul Lazarsfeld as its director. The goal of the institute, both at Princeton and later at Columbia University, where it moved in 1940, was a broad one: 'to study what radio means in the lives of its listeners' (Katz, 1987, S25, n. 1). In his years as director of the institute, Lazarsfeld carried out this goal by commissioning and directing numerous studies of radio programmes and their listeners, wielding immense power over the burgeoning field of mass communications research.

Lazarsfeld shaped the field in two important ways. First, by emphasising the activities and life histories of audiences in the media process, Lazarsfeld contributed to the demise of simplistic 'magic bullet' or 'hypodermic needle' models of media effects. Such models, which gained currency with the Payne Fund studies, depict media messages as irresistible forces which invade the psyche of the audience member and directly influence behaviour. Lazarsfeld advocated a 'limited effects' model instead. Rather than proposing a directly causal relationship between media and behaviour, this model emphasised the ways in which responses to media are themselves mediated by the background and group affiliations of the individuals who make up the audience.

Second, Lazarsfeld oversaw the development of techniques for effects measurement that remain standard in social science and marketing research to this day. Among them was the focus group, in which a panel of consumers share responses and associations triggered by a broadcast, object or image with a trained facilitator, a technique now widely used in market research (Morrison, 1998). Other advances in measurement in this period were technological; together with Frank Stanton, a psychology PhD and director of research for the Columbia Broadcasting System (CBS), Lazersfeld developed the Stanton-Lazarsfeld Program Analyzer. Known as 'Little Annie', this technological apparatus tallied favourable and unfavourable audience responses to radio broadcasts during the act of listening, and was adopted by CBS as a tool for programme development.

Such market-oriented uses of social science research were not the only way in which media effects research

reflected broader social goals in the United States. As Christopher Simpson has shown, the work of Lazarsfeld and other mass communications scholars was deeply intertwined with the defence and foreign policy missions of the US government. During World War II, several communications scholars developed psychological warfare applications, while the propaganda-generating Office of War Information (OWI) employed a large number of prominent media effects researchers, including Lazarsfeld, as consultants and staff members (Simpson, 1994, p. 320). The close ties between defence and media effects research remained strong once the war ended. 'For years, government money ... made up more than 75 percent of the annual budgets of institutions such as Paul Lazarsfeld's Bureau of Applied Social Research at Columbia, Hadley Cantril's Institute for International Social Research at Princeton, Ithiel de Sola Pool's CENIS Program at MIT, and others' (Simpson, 1994, p. 316).

But these cold war era studies, oriented towards US media activities overseas, were only one aspect of the effects research agenda in the period. The postwar arrival of television, coinciding with the baby boom, gave rise to a 'domestic' interest in media studies: the effects of TV images on children. Objections to television were focused on highly popular Westerns and crime series, but they were fuelled by *Seduction of the Innocent*, a 1954 study of comic-book violence, sexual 'perversion' and other horrors by Frederic Wertham (Hendershot, 1998, p. 27). A key researcher in the early development of this field was Wilbur Schramm. A former English professor, Schramm served in the OWI during World War II. Upon return to civilian life he founded the Institute of Communications Research at the University of Illinois, where he conducted extensive military-funded research on persuasion through media. After moving to Stanford University in the mid-1950s, Schramm co-authored an influential study entitled *Television in the Lives of our Children* (Schramm et al., 1960). The study, based on large-scale empirical surveys, went some way towards mitigating the hysterical tone of Wertham's book. Conforming to the 'limited effects' model, it stressed the importance of family environment on children's responses to what the authors felt was an increasingly violent world of imagery on television. However, like Wertham, Schramm and his co-authors did not investigate the possible effects of commercial speech on children. Rather, as Spigel notes, *Television in the Lives of our Children* helped consolidate the popular postwar perception that television's effect on children was to make them 'grow up too fast' (Spigel, 1993, p. 282).

Schramm's qualified conclusions about the limited effects of media violence on children's behaviour should not be taken as a sign that effects research had left 'magic bullet' theories completely behind by the postwar period. In 1961, a highly publicised research project on children and violent behaviour proposed that children who witness violent acts tend to imitate these acts. The research, known as the 'Bobo doll' studies, was conducted by Schramm's colleague at Stanford, the behaviourist psychologist Albert Bandura. Bandura later based a model of media effects known as 'social learning theory' on this research. In the experiment, Bandura exposed a group of nursery school and kindergarten children to violent acts by an adult towards a 'Bobo doll' – a round, inflatable doll with a low centre of gravity, designed to spring upright when punched. The children were then allowed to play with some 'attractive' toys for a few minutes: 'a fire engine, a locomotive, a jet fighter plane, a cable car, a colorful spinning top, and a doll set complete with wardrobe, doll carriage, and baby crib' (Bandura et al., 1961, p. 576) before being given some 'less attractive' toys, including a Bobo doll. The children were observed to treat the doll in the manner they had previously witnessed, leading Bandura and his co-authors, Dorothea Ross and Sheila A. Ross, to conclude that 'mere observation of aggression, regardless of the quality of the model-subject relationship, is a sufficient condition for producing imitative aggression in children' (p. 582).

Although Bandura did not mention media in the first Bobo doll study, his findings were quickly linked to media effects. Following this initial publication, he expanded the basic experimental scenario to include films of violent acts rear-projected onto a television screen, and cartoons illustrating similar scenes (Bandura et al., 1963). Social learning theory became closely identified with media effects, and Bandura claimed that, for both children and adults, television and film served as key sources for the 'modeling' behaviours on which social learning is based (Bandura, 1977, p. 39). In its starkest form, social learning theory is open to numerous criticisms, from the inflexibility caused by the lack of any consideration of 'uses and gratifications' or any other mediating factor, to the clinical artifice of the 'Bobo doll' experiments, set in locations that bear little relationship to the actual conditions of television viewing. Nevertheless, perhaps *because* of this very simplicity, Bandura's theories of imitation and aggression have remained a strong model for both popular and academic understandings of media effects.

The persuasive simplicity of Bandura's cause and effect model made him a controversial figure for broadcasters when effects research came into the policy sphere in the

1960s. Although congressional hearings on television and violence had been taking place throughout the postwar decades, social unrest at the end of the decade prompted President Lyndon Johnson to form a National Commission on the Causes and Prevention of Violence. Its principal researchers were two social scientists, Sandra Ball of Washington State University (later Ball-Rokeach) and Robert K. Baker. The committee's findings were based on both audience studies and effects research. The overall data supported the idea that media violence, both in children's programming and in the news, had definite effects upon viewers; as a result, the researchers recommended that broadcasters be required to self-regulate violent content on television (Baker and Ball, 1969.) The investigators also recommended the establishment of a federally supported centre for media studies (Bogart, 1972).

However, to some policymakers these recommendations were neither strong nor specific enough. Senator John Pastore of Rhode Island responded to the commission by calling for further studies and, in a move that capitalised on the recent publication of a controversial government report on the health problems associated with smoking, requested that the office of the Surgeon General of the United States conduct another study specifically assessing the health risks that television viewing posed for children. The Surgeon General's report, published in 1972, was a six-volume assessment of these risks. Led by recent Stanford PhD George Comstock, the $1 million study involved a large number of effects researchers and employed a variety of methodologies to discern the impact of televised violence on child viewers. Although Comstock was a student of Bandura's, the latter was rejected as a research participant by the network officials serving on the commission's advisory board (*New York Times*, 26 May 1970, p. 26). Apparently, his insistence on a direct cause and effect model for thinking about media violence made his research unacceptable to policymakers working in collaboration with the television industry.

Despite this fact, Bandura's work has had an enduring impact on policy debates over the effects of non-broadcast media images, most notably pornography. In 1986, the final report of the Attorney General's Commission on Pornography, a commission composed of social scientists, religious and right-wing crusaders, and a CBS vice-president, relied extensively on social learning theory as the basis of its investigations (1986, pp. 1021–31). Guided by the assumed link between viewing/reading pornography and behaviour, the commission formulated a repressive set of final recommendations that included 'stepped-up enforcement of existing obscenity laws; increased cooper-

ation between local, state, and federal law enforcement personnel and the IRS … a computerized national database … forfeiture statutes, [and proscribed] transmission of obscene matter over cable TV and telephone lines' (Califia, 1994).

Although such repressive uses of media effects research have led many in progressive media studies to reject the basic premises of such research, this does not mean that the left should abandon the discourse of media effects altogether, especially given its widespread currency in public debates over media policy. Rather, as some scholars suggest, progressives might do better shifting the focus away from graphic imagery of sex and violence to other issues of social representation. As John Tulloch and Marian Tulloch note, violence research should also concern itself with 'institutional violence – the class violence of unemployment, the gender violence of bashings within the family, the prejudiced violence of racism' (Tulloch and Tulloch, 1993, p. 212). In their study, Tulloch and Tulloch also emphasised a model of audienceship based not on behaviours but on 'cognitive and attitudinal factors' (p. 212). As they noted, 'we do not accept that television violence "stimulates" or cues violent acts … Rather, violence in society is a matter of institutional values and structural control' (p. 225). Their study sought to understand how viewers might come to understand this fact through media, analysing a group of Australian schoolchildren's responses to a number of TV programmes which questioned institutional violence in addition to containing violent material, particularly the Vietnam-war-based series *Tour of Duty*. Combining both quantitative analysis and interviews, Tulloch and Tulloch concluded that social class, and the experience of everyday violence associated with working-class membership, played a crucial role in children's tolerance of violent material. And rather than seeing this response in pathological terms, Tulloch and Tulloch suggested that this was 'perhaps an appropriate response from a social group itself more subject to societal violence than others' (p. 243). This study and others like it suggest that progressive interventions in media policy need not abandon the effects model altogether; rather, they should offer alternatives to Pavlovian models of media consumption, ones that encourage 'the recognition that children, like television itself, are *agents* in the field of television violence, with complex class, gender, and age-influenced agendas of their own' (p. 244).

Anna McCarthy

CBS AND STANLEY MILGRAM

American television networks, and CBS in particular, have long taken an interest in the methods and directions of effects research. This investment in social scientific studies might seem counter to network interests at first. Why would media corporations want to support studies that might lead, potentially, to the restriction and regulation of programming? In fact, network-funded studies serve an important function for the television industry, as they help legitimise the participation of the industry in policymaking and give it a voice in policy debates. In the early 1970s, at the same time that the Surgeon General's commission was conducting its study, the CBS Office of Social Research commissioned Yale psychologist Stanley Milgram to conduct a study of television's ability to incite antisocial behaviour. Milgram was somewhat notorious in American social science research because of his 1968 'obedience studies'. These experiments assessed subjects' willingness to obey authority by deceiving them into believing they were administering electric shocks to other individuals when ordered to do so.

Milgram's television experiments for CBS, excerpted in the collection *The Individual in a Social World* (1992), involved establishing television's influence on 'antisocial behavior'. They are interesting because they involved an unprecedented degree of collaboration with the network's programming department. To allow Milgram to control variables precisely, the producers of the drama *Medical Center* rewrote scripts according to his directions. Milgram assessed viewer responses by establishing an elaborate set of laboratory-like conditions for screening and viewer monitoring. The experiment involved three variations on a specially written violent scene, inserted within an episode of the series. In this scene, a character, desperate for money, breaks into a medical charity box after seeing his former boss make an appeal for the charity on a bar-room TV screen. In one version of this scenario, the character is caught and punished at the end. In another, he gets away with it. In a third version, he considers breaking into the box but decides against it. Milgram also used a fourth 'control' screening in his experiment; this episode, according to Milgram, was 'romantic, sentimental, and entirely devoid of any violence or antisocial behavior' (Milgram, 1992, p. 290).

The different versions were shown to audiences in a variety of settings, from preview theatres to broadcast television. The screenings in the former sites, mounted under the pretext of market research, were the most extensive, and involved the most direct application of a cause-effect hypothesis to the question of TV's influence on behaviour. After the screening, the subjects, expressly chosen from minority groups (Milgram, 1992, p. 288), were asked to show up individually at another address at a particular date and time to receive a free radio. On arrival, however, they discovered that the gift distribution centre was closed. A charity collection box similar to the ones featured in the programme sat in the corner of the empty waiting room, monitored by concealed closed-circuit video cameras. Upon exiting, the subject entered a small room in which a seated clerk explained that the radios could actually be picked up from him.

Milgram's goal was to find out whether exposure to the scene showing theft from a charity would lead people to imitate the behaviour they saw on the screen – to this end, he even left a dollar dangling from the charity box in the waiting room in some renditions of the experiment. However, he failed to demonstrate that those who had viewed the antisocial behaviour were any more likely to break into the box than those who had not. His study, published a year after the Surgeon General's report, must surely have pleased the CBS executives who commissioned it. 'It is possible,' he concluded, 'that people have been entirely too glib in discussing the negative social consequences of the depiction of television violence . . . if television is on trial, the judgment of this investigation must be the Scottish verdict: not proven' (Milgram, 1992, p. 306).

Anna McCarthy

Medical Center – TV on trial

RECOMMENDED READING

Simpson, Christopher (1994), *Science of Coercion: Communication Research and Psychological Warfare, 1945–1960*, New York: Oxford University Press.

Spigel, Lynn (1993), 'Seducing the Innocent', in William Solomon and Robert W. McChesney (eds), *Ruthless Criticism: New Perspectives in US Communications History*, Minneapolis: University of Minnesota Press.

Tulloch, J. C. and Tulloch, M. I. (1993), 'Understanding TV Violence: A Multifaceted Cultural Analysis', in Graeme Turner (ed.), *Nation, Culture and Text: Australian Cultural and Media Studies*, London: Routledge.

Public Opinion[*]

The notion of public opinion is generally associated with democratic forms of politics, with systems of representation in which what people think has a bearing on how they are governed. In recent times, the role of television – as the public's dominant source of information about politics – has become pivotal to the way public opinion is represented and to the form, shape and content of people's attitudes.

The history of public opinion is bound up with the history of democratic forms of government. In ancient Greece, political power was not contingent upon public opinion in the way we now understand it, but both 'publics' and the idea of 'opinion' were relevant conceptual categories. Groups of citizens would assemble, debate issues and be addressed by performers and politicians. The arts of rhetoric and oration – skills with little relevance in many of the feudal societies that followed – developed in this context. This classical tradition might be said to inform contemporary notions of citizen participation, in which people come together to debate and discuss issues of the day – an ideal of rational citizenship that stems partly from Aristotle, who regarded the 'joint pronouncement' of the public as a greater source of wisdom than the views of discrete individuals (Aristotle, 1962). While Aristotle's view was not uncontested (not least by Plato), his writing suggests that emergence of an idea of citizenship articulated through public opinion.

With the rise of feudalism in Europe, the category of 'citizen' was replaced by the more subservient category of 'subject' (subjected to feudal law and to religious discipline)

[*] This section includes extracts from *Constructing Public Opinion* (Lewis, 2001), edited and revised by the author for this book.

whose identity was defined by their position in feudal hierarchies. Public approbation – except, perhaps, as witness to forms of discipline and punishment – became irrelevant. During the Renaissance, the rigidity of these political and economic structures became more fragile. The emerging class of merchants and traders could not be easily subsumed within the old order, while the invention of the printing press in the 16th century created new possibilities for the construction of publics and the dissemination of opinion (Habermas, 1989). During the 17th century collective forms of expression evolved from riots and parades in the first half of the century into more overtly political forms – notably the petition – in the second (Herbst, 1993).

By the 18th century, the public – defined by an electoral franchise that limited participation to men of property – was partly constructed as a platform for the rising middle classes to challenge the legitimacy of a crumbling feudal order. The emerging bourgeoisie sought a more rational form of politics, one that might replace the more arbitrary edicts of monarchs (Peters, 1995). Discussions of public affairs in the genteel salons and in the less exclusive coffee houses and colonial taverns, and the increasing availability of information and ideas in published forms, facilitated the creation of what Jürgen Habermas (1989) has called the 'public sphere', an arena in which rising middle-class prosperity could challenge governmental authority. The rise of artisan and working-class movements in the 18th and 19th centuries – along with the dramatic spectacle of the French Revolution – forced a broadening of the term, one solidified by the development of public spaces (such as parks and museums) in the more urban landscape of the 19th century.

By the twentieth century, the extension of voting rights created a more inclusive, universal public, whose opinions were part of the political process. The move from a rarefied, opinion-holding class to a mass public meant that, conceptually, public opinion could no longer be contained within discrete places – like the salons or the coffee houses. Nonetheless, mass publics were contained in a different sense, by the technologies of sampling and survey methodology in the form of the public opinion poll. From the 1920s, Gallup became an advocate of polling as a more scientific and democratic expression of public will than pressure groups and other vocal minorities (Gallup, 1966). Although this argument is not without its flaws (not least because of the cost of conducting an opinion poll), it is, as Sidney Verba argues, an important one – particularly in a system in which the economic power of big business is linked with the cultural power of public relations (Verba, 1996). If the pioneers of modern polling were technocratic,

'Horse race' polls are prominent in TV coverage of public opinion – Peter Snow's swingometer, General Election night on UK TV.

in the sense that they reduced public opinion to a set of columns and percentages in response to survey questionnaires, they were also partly motivated by an egalitarian spirit (Salmon and Glasser, 1995).

And yet the growth of public opinion polling during the twentieth century has been such that *public opinion* has become almost synonymous with the results of public opinion *polls*. The instrument of measurement was thus being mistaken for the thing itself (Blumer, 1948). This conflation of public opinion with poll responses has been subject to considerable critical scrutiny, not least because it is the pollster rather than the public who will define the terms of the rather stilted, one-sided conversations that constitute polling interviews. Indeed, it could be argued that the dominant voice behind polls is not the public but the pollster, while the public's role in the enterprise is limited to acquiescence, evasion or refusal, with no control over the interpretation of those responses (see, for example, Bourdieu, 1979; Herbst, 1993; Lewis, 2001; Salmon and Glasser, 1995).

Despite this critical scrutiny, in the television era, just as television uses surveys to find out about its own audience, the poll has become the dominant form of representing the public. The media's use of polls as a way to express public opinion has grown rapidly in recent decades (Asher, 1998), and television networks now regularly conduct or commission their own polls. The opinion poll has become a convenient mechanism for television news to signify that it is in touch with its audience, with the happy benefit of delivering public opinion in a form that can be packaged and sold as 'news'. Polling results also frame the discourse of the politicians and political commentators who appear on news programmes: so, for example, a political leader who is 'riding high in the polls' will often be framed in that context, with an accompanying lexicon of positive terms (such as 'confident', 'in control' or 'popular'). And yet the amount

of polling data available far exceeds television's capacity to report it. If public opinion polls are best understood as a *representation* of public opinion (rather than a transparent reflection of it), the coverage of public opinion polls on television involves the representation of a representation.

Reporting public opinion on television is mediated by a series of journalistic assumptions and routines of news gathering. The most notable of these is the primary role of elites in setting the agenda for news and current affairs coverage. As a consequence, public opinion is much more likely to be discussed when it relates to elite agendas. Research by Behr and Iyengar (1985) found that while the media coverage of issues often influenced public concern about those issues (generally referred to as 'agenda-setting'), levels of public concern did not appear to influence TV news coverage. Instead, television news takes its lead from debates among political leaders rather than poll responses nominating issues of concern. Unless it is directly linked to a news event, if polls suggest strong support for a policy, the presence of those polls (or the opinion they propose) in media debates often depends upon the willingness of political leaders to promote them. Similarly, issues that are germane to policies pursued by political elites are not only more likely to generate poll questions, but the responses to those questions are more likely to be reported.

The centrality of elite agendas is represented symbolically by television's focus on 'horse-race' polling – those polls that measure the popularity of political leaders or political parties. In terms of specific policy or ideological preferences horse-race polls are extremely ambiguous: they may be a guide to electoral outcomes, but they tell us very little about the programmes or even the philosophies people like or dislike. So, for example, polls successfully predicted the conservative Ronald Reagan winning a second term in the US in 1984 at a time when opinion polls in general suggested a majority were shifting to the left (Ferguson and Rogers, 1986), and research in general suggests that the relationship between candidate preferences and more policy-related preferences is often extremely vague (Lewis, 2001; Mayer, 1992).

Murray Edelman argues that the power of party machinery and the ability of powerful interests to influence political leaders mean that elections are rituals that work to symbolise rather than enact a democratic will (Edelman, 1988). It could be argued that the prominence of horse-race polls in television's coverage of public opinion serves the same function. Polls that focus on public support for one political party or candidate or another symbolically define public opinion as being in synchronicity with one or other of the options available. This sets in place a hierarchy

of polling responses in which the choice of party or candidate becomes the ruling grammar of the discourse of public opinion. If the dominant television news narrative is based upon the shifting support for political parties or candidates signified by one set of polls, this obliges journalists and commentators to use *other* polling responses to explain those shifts.

While there has been comparatively little attention paid to the way television represents public opinion, a number of researchers have explored the way in which television – and the media in general – influences public opinion. Television's influence on public opinion is partly contingent upon the way public opinion is defined. If public opinion is defined by the technology of polling, we are looking for a very specific form of influence – namely the ways in which television might shape the way people respond to survey questionnaires. Even if we are critical of the authenticity of polls as the voice of the people, the importance of polls as a form of representation means that this form of influence can be politically significant. While early research in this area was somewhat inconclusive (see 'Mass Communication Studies', p. 4) there is now a body of evidence indicating a number of ways in which television frameworks can influence poll responses. A number of studies (e.g. Funkhouser, 1973; Iyengar and Kinder, 1987; Iyengar, Peters and Kinder, 1982) have indicated that responses to public opinion surveys *follow* rather than precede media agendas, and often have very little to do with any evaluative analysis of the significance of an issue *outside* the arena of news reporting.

Television would also appear to play a role, albeit a more complex one, if we define public opinion more in terms of people's day-to-day conversations. William Gamson's work with a series of discussion groups attempted to more closely replicate everyday political conversations among peers. His analysis of these conversations indicates the complexity of the relationship between media frames and public discourse. On the one hand, the use of such frames among his discussion group respondents can be related to their prominence in media discourse, and yet there are moments when public discussions, drawing from a range of experiential and other sources, can either elide or resist dominant media frames (Gamson, 1992). Philo's work in Britain reaches similar conclusions, arguing that television supplies much of the symbolic or conceptual raw material for understanding the world, 'limiting what audiences can see and in providing key elements of political consciousness and belief' (Philo, 1990, p. 205).

In a similar vein, Shanto Iyengar has explored how television's focus on events rather than thematic, historical or explanatory contexts – what he refers to as episodic rather than thematic coverage (Iyengar, 1991) – frames people's understanding of the world. In the episodic framework, things – whether crimes or terrorist acts – just happen. Iyengar's research suggests that viewers supplied with thematic, contextual information are more able to turn their attention to social causes and possible forms of government intervention that might address those causes, while the episodic structure focuses viewers' attention on coping only with the manifestations of social problems.

Iyengar, like Gamson and Philo, suggests that episodic framing serves the interests of political elites who are reluctant for government to address social problems, in the sense that a neo-liberal philosophy benefits from a discourse in which poverty, crime or environmental degradation have no clear causes or solutions. There is, as a consequence, little responsibility placed on political figures for addressing the structural causes of social problems. As this suggests, the relationship between television and public opinion is critical in establishing democratic credentials for forms of political power. Whether as a form of representation or as a source of information, television is necessarily involved in the *construction* of public opinion.

Justin Lewis

RECOMMENDED READING

Lewis, J. (2001), *Constructing Public Opinion: How Elites Do What They Like and Why We Seem To Go Along With It*, New York: Columbia University Press.
Salmon, C. and Glasser, T. (eds) (1995), *Public Opinion and the Communication of Consent*, New York: Guilford Press.

Children and Education

No aspect of television has been more hotly debated than its potential to help or harm children. Does television make children violent? Stupid? Complacent? Is television hopelessly tainted by commercialism, or does it have potential to aspire to loftier goals than profit? Finally, does it have any value as a tool for education, and, if so, what exactly should television teach children?

One school of thought, exemplified by Marie Winn, is that TV is inherently mind-numbing, regardless of content. From this perspective, TV is a waste of time for all ages, but it may be particularly harmful for children who are, supposedly, inherently more vulnerable to the siren call of the 'plug-in drug' (Winn, 1977). At the opposite end of the

spectrum, some advocates argue that TV not only has educational potential but is actually particularly well suited to teaching. Edward L. Palmer, one of the founders of the Children's Television Workshop (*Sesame Street*'s creator), argues that school and family should be the most important institutions for teaching children but that television has enormous potential as a third educational institution. Palmer reasons that television is non-threatening and non-punitive, it is accessible to children who cannot yet read, and it uses creative audiovisual techniques that cannot be duplicated in a classroom. Furthermore, unlike computers, television is ubiquitous; virtually every child has access (Palmer, 1988, p. 10). Even in poorer countries, where not every home has a television, educational programming can potentially be used in classrooms.

Producers, activists and educators have largely taken it for granted that children's television can be broken down into two categories: entertainment and education. While on the surface this sounds reasonable, it also makes sense to take a step back and ask what exactly we mean by 'education' in the first place. One could argue, for example, that all television is educational. Even if no 'curriculum' is intended, television speaks to viewers as sharing certain beliefs and as fitting into pre-existing ideological systems. Consumers are made, not born, and television is an early agent for teaching children about brand loyalty, licensed products, cross-merchandising and, of course, managed obsolescence. No one knows better than middle-class kids that a toy or video game that is cool one minute will be old-hat the next. Ads and toy-promoting shows help drive home this lesson. Television also educates children in dominant ideas about gender, race and class, thereby normalising power hierarchies (Seiter, 1993). And it introduces kids to audiovisual narratives that they must use cognitive skills to decipher. Even a programme for infants, the British *Teletubbies*, uses direct address to introduce viewers to the rudiments of storytelling (Hendershot, 2000).

Good educational shows are expensive to make and, left to their own devices, commercial television producers will gravitate to more profitable fare that sells toys and candy ads. In response, American activist groups like Action for Children's Television (Hendershot, 1998; Seiter, 1993) and the Center for Media Education have fought long and hard to increase the quality of children's television, in large part through government regulation. Action for Children's Television (1968–92) made a number of regulatory gains in the 1970s, most of which were undone by the Reagan and Bush administrations. Perhaps their greatest victory was the passing of the Children's Television Act of 1990, which states that each broadcaster must show the Federal

Communications Commission (FCC) that it has provided three hours of weekly programming serving children's 'educational and informational needs'. Forced to make educational programmes, American producers have focused on shows teaching either 'social' or 'informational' lessons.

Social programmes centre on interpersonal issues, while informational programmes teach traditional school topics like maths or history. In 2001, the networks' 'educational' shows included *Disney's Recess* (ABC), *NBA: Inside Stuff* (NBC) and *NFL Under the Helmet* (Fox). These series may have included educational elements but, as their titles indicate, they also clearly promoted their corporate sponsors. More sincere efforts to produce entertaining shows teaching classroom-type lessons included Fox's *The Magic Schoolbus* (about science, originally produced for the Public Broadcasting Service [PBS]) and ABC's *Squigglevision* (about science and maths). The networks are increasingly acquiring educational programmes that have already proven their mettle on PBS or cable; CBS's ratings for two- to five-year-olds shot up 550 per cent after they acquired educational shows from the children's cable channel Nickelodeon (*Broadcasting & Cable*, 2001). Even as programming has changed in response to the 1990 Act, the networks' bread-and-butter remains series like *Mighty Morphin Power Rangers* and *Pokémon*, both Japanese imports.

Educational television has traditionally been the domain of public television, which, in recent years, has become increasingly privatised around the world. Countries with a strong public service tradition, however, have tried to maintain support for children's shows. In Britain and Japan, public funding for broadcasting was set up as an early precedent, and it was simply a given that programming for children would be adequately funded (Palmer, 1988, pp. 26–31). In the United States, conversely, educational programming has been a relentless uphill battle. One of the earliest education advocates was FCC Commissioner Frieda Hennock, who proposed setting aside a group of TV channels for educational, non-profit use in the early 1950s. The FCC agreed to reserve over 200 stations, but two-thirds of these stations were in the UHF band (channels fourteen and higher) which, unlike the VHF band (channels two to thirteen), could not easily be received by most televisions.

While the technical difficulties of UHF were ongoing, the more pressing problem for early educational television was that the FCC had set aside channels without providing funding. In spite of this obvious deterrent, educational television, called 'ETV', gradually grew, and by 1963, approximately one in ten stations in the US was ETV. The

SESAME STREET

Sesame Street was created by the Children's Television Workshop in 1969. The show used animation and short vignettes and was modelled after commercial television, a decision which provoked controversy among adults who objected to the programme's fast pace and flashy look. Some developmental psychologists worried it would make children hyperactive, while conservatives worried that its psychedelic style would turn kids on to LSD, and right-wingers questioned its picture of racial integration and its inclusion of blacklisted 'Communist' guests. Currently, however, *Sesame Street* is widely respected and regarded as the most successful educational programme ever created.

Each new season of *Sesame Street* advances a carefully conceived curriculum and is the result of extensive research and testing. The Workshop engages in two kinds of research: formative and summative. Formative research

involves testing segments before they are aired and reformulating them in response to the results. Summative research involves post-broadcast testing of effectivity. Most *Sesame Street* research is formative. The Workshop's testing-production circuit, which has been coined the 'CTW model', is basically a feedback loop. First, a new curriculum objective is formulated on a topic appropriate for the three- to five-year-old target audience. Next, an experimental segment is produced and tested for appeal and educational effectiveness. The segment is revised in response to the formative data, and only then is it broadcast. Reactions to the new segment are typically brought back to curriculum developers for the next season.

The Workshop has undertaken co-productions of *Sesame Street* in over fifteen countries, including Mexico, Spain, France, Portugal, Canada, Israel, Germany and the Netherlands. In each country, local educators devise their own curriculum and set up the same testing-production circuit that the CTW uses in the US. This is costly, which means that some co-productions only run for one season. Germany and the Netherlands are able to produce new episodes every year, while new seasons of the Latin American *Plaza Sésamo* are sporadic. Although the CTW model is widely accepted by many researchers and educational programme producers around the world as the most effective means of producing quality children's programmes, the model can only fully function in the countries that can afford it. In fact, the CTW has developed a second approach to foreign versions of *Sesame Street* whereby the foreign country produces only the opening titles and composes the rest of the programme by drawing on the Workshop's archive of vignettes, dubbing the segments into the local language.

The evolution of *Sesame Street* is symptomatic of the increasing commercialisation of educational television programming. Initially funded by the Ford Foundation, the Carnegie Corporation and the US government's Department of Health, Education and Welfare, *Sesame Street* now sustains itself via its endowment, corporate underwriting and profits from licensed merchandise. In the early days, when a voice-over at the end of the show told viewers that '*Sesame Street* was brought to you by the letter A', it was a joke, the point being that the show was sponsored not by a toy company but by the alphabet. Now that *Sesame Street* advertises and has expanded its licensing, and PBS is so heavily sponsored by corporations, the joke has taken on a new irony.

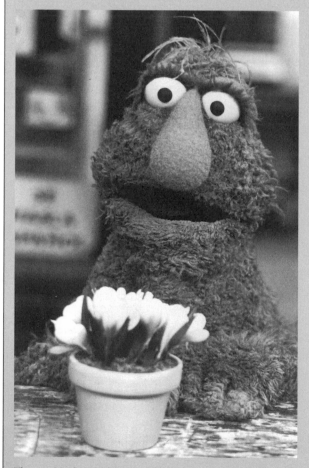

The cognitive boost of *Sesame Street*

Heather Hendershot

stations were funded by universities, schools, community groups and even public libraries. Operating on shoestring budgets, ETV stations typically ran a wide variety of programmes: lecture classes at all levels; local public affairs programming; documentary programmes; cultural programming such as opera or ballet; and news analysis (Schramm, Lyle and De Sola Pool, 1963, pp. 13–15). The Internet is often spoken of as offering 'revolutionary' potential for distance learning, as if no other technological means for home schooling pre-existed it. Yet ETV – and educational radio before it – was way ahead of the Internet. And unlike distance learning as it is presently conceived, as a for-profit venture, or as an extension of a college campus, ETV did not involve payment, registration or grading. Anyone could turn on the television in the afternoon, after work or school, for a quick Spanish lesson before dinner. Whereas today's educational television is widely seen as something for children only, ETV targeted all age groups.

Eventually, the ETV stations provided the skeleton for the Public Broadcasting Service (PBS). At the urging of a 1967 Carnegie Commission Report, PBS and the Corporation for Public Broadcasting (which would fund PBS) passed through Congress with little opposition. The explicit goal of PBS was education for all ages. The head of one former ETV station, for example, pledged to use federal funding 'to expand such televised services as nurses' training, driver training, adult literacy, family hygiene, farming programs, and forestry' (Ledbetter, 1997, p. 23). This kind of curriculum is surprising from our contemporary standpoint, since PBS's educational mission today is largely infantilised. In fact, as PBS was progressively defunded in the 1990s (Ledbetter, 1997; McChesney, 1999), educational children's shows became the rallying cry for PBS supporters.

Aside from ETV, what we would now consider educational programming did not really exist in the 1950s and 60s. *Ding Dong School*, *Romper Room*, *Captain Kangaroo* and *Mister Rogers' Neighborhood* all defined 'education' in social rather than cognitive terms. While *Mister Rogers* dealt with serious emotional issues, other shows taught lessons like: obey your parents, wash your hands before you eat, tie your shoes properly, and go to church. Most of these early shows talked down to kids and gave them little of substance to chew on. The change in attitude that came in the late 1960s, with the advent of *Sesame Street*, owes much to shifting scientific conceptions of the inherent intelligence of children. Preschool was reconceptualised as an opportunity to teach children cognitive skills and to give them, like the eponymous government-funded program, a 'head start'. Theoretically, educational pre-

school television could also give kids a cognitive boost and make them better prepared for school.

The adult stars of educational television have changed dramatically since the 1950s, and this change points to the growing assumption of the inherent intelligence of children. In the 1950s, *Ding Dong School*'s Miss Frances was a grandmotherly figure who gently instructed children and was clearly an authority figure. Steve Burns of Nickelodeon's *Blue's Clues*, a contemporary preschool educational programme, doesn't *tell* kids anything. Rather, he *asks* them questions, feigning ignorance of virtually everything, as children shout out answers (which are always correct) on the show's audio track. Steve is a not an adult but rather an overgrown child who actually needs guidance from mentally superior children. David Buckingham has noticed a similar shift in British programmes such as *Blue Peter* and *Newsround*, in which the adult presenters have, over the years, become younger and more childlike. Buckingham attributes this shift to a growing 'embarrassment about the fact of adult power' as Britain reconceptualises its paternalistic public service tradition (Buckingham, 1995, p. 52).

Given the conceptual gulf between the cultural and intellectual worlds of adults and children, the great mystery of children's television is how adults ever succeed in creating shows that appeal to kids at all. While tests indicate that children do actually learn something from educational shows, these programmes also serve patently adult needs. It is, after all, adults who engage in the funding and policy debates circulating around educational television. These grown-ups are trying to help young TV viewers who seem barely aware of – much less grateful for – the battles being waged on their behalf.

Heather Hendershot

RECOMMENDED READING

Buckingham, David (1993), *Children Talking Television: The Making of Television Literacy*, London: Falmer.

Buckingham, David (2000), *The Making of Citizens: Young People, News, and Politics*, London and New York: Routledge.

Palmer, Edward L. (1993), *Toward a Literate World: Television in Literacy Education – Lessons from the Arab Region*, Boulder: Westview Press.

Seiter, Ellen (1999), *Television and New Media Audiences*, Oxford and New York: Oxford University Press.

Singer, Dorothy G. and Singer, Jerome L. (eds) (2001), *Handbook of Children and the Media*, Thousand Oaks: Sage.

Online Resources

Center for Media Education website: www.cme.org.

Public Health Message Audiences

In our media-saturated culture, it has become increasingly difficult to determine exactly what constitutes a public service announcement (PSA). Health messages appear in a variety of forms, in both news and entertainment programming, and the distinction between publicly and privately funded messages has blurred. For instance, US television networks incorporate anti-drug themes into shows such as *ER* to fill federally mandated PSA time. Networks, along with private, non-profit organisations like the Ad Council, custom-tailor PSAs to feature their own television actors so that they can simultaneously promote their shows. Given the complicated communicative context in which PSAs operate, it is necessary to consider a variety of approaches to their study.

MEDIA EFFECTS RESEARCH AND PSAs

The most common method of studying PSAs falls under the umbrella of *media effects* research. Much of this research draws on the *transmission model* of communication, where the key elements of the communicative process are understood to be the source of a message, the message itself, and the receivers or audience. The question this research seeks to address, in Harold Laswell's terms, is *who says what to whom and with what effect*? Such studies are designed to measure the efficacy of PSA messages, with the primary aim of determining their degree of success in increasing awareness about a particular health issue, changing attitudes, or influencing the behaviour of their target audiences.

PSAs have played a key role in drug abuse prevention campaigns. In a typical media effects study, Newcomb, Mercurio and Wollard (2000) examine the effectiveness of rock stars as sources of anti-drug messages in PSAs targeting adolescents. Previous effects research has shown that not only are teens often unresponsive to the scare tactics employed in many anti-drug PSAs, but their attitudes towards drug use may even grow more favourable after exposure to such ads, a phenomenon known as the 'boomerang effect'. Since popular music plays a significant role in youth culture *and* rock stars tend to be associated with drug use, Newcomb et al. postulated that teens would see rockers as credible anti-drug abuse spokespersons. They tested their hypotheses using four PSAs from the Rock Against Drugs (RAD) campaign. Their findings suggest that neither rock musicians nor adolescents are homo-

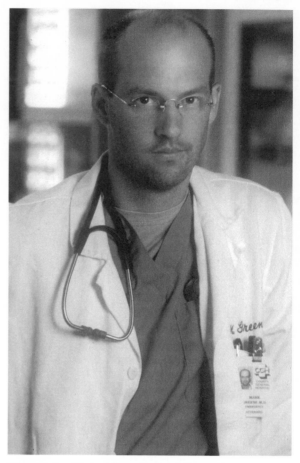

ER – covert public service announcement?

geneous groups – for example, high-risk teens listen to different music than do low-risk teens – and thus, predictably, they deemed further refinement of the RAD approach is necessary.

The media effects approach to studying PSAs does not consider the larger social and cultural aspects of public health messages. Other paradigms of communications research are better suited to this task.

POLITICAL ECONOMY AND THE ANTI-DRUG CAMPAIGN

While the US Federal Communications Commission has never officially mandated the amount of free time that networks must donate to PSAs, such donation of time has traditionally been considered part of the networks' obligation to the public in return for free use of the publicly owned airwaves. Since the ongoing deregulation of US television advertising across the 1990s, the amount of clutter on television has been increasing, but the amount of time that the networks donate to PSAs has decreased. Now, when adver-

tising slots are not filled, the networks increasingly use that time to promote their own shows rather than providing free-time public service campaigns. In addition, as public service campaigns move toward paid-media strategies, the networks, advertising agencies and other interests benefit financially from what was once a public service. For example, the White House Office of National Drug Control Policy has awarded multi-million dollar ad campaigns to various advertising agencies, including Ogilvy and Mather.

These are some of the issues addressed through a political economic approach to studying public service announcements. The strength of the materialist, political-economic approach lies in its ability to provide compelling accounts of economic structures and their effects on politics and ideology; it is increasingly important with the rise of *neo-liberalism*, or policies that maximise the role of markets and profit-making and minimise the role of non-market institutions.

A political economic analysis would be concerned primarily with identifying the interests that anti-drug public service campaigns serve. For example, Buchanan and Wallack (1998) have examined the work of the Partnership for a Drug Free America (PDFA), a privately funded mass-media campaign created by professional marketing personnel during the Reagan era. These authors criticise the PDFA's relationship to alcohol, tobacco and pharmaceutical companies, which are among their major contributors. The PDFA does not condemn drinking, smoking or the overuse of prescription drugs in their PSAs, even though these forms of drug abuse pose greater threats to public health than illegal drugs like marijuana and cocaine. Buchanan and Wallack also chastise the PDFA's PSA messages, which attribute drug problems strictly to individual drug users, oversimplifying a very complex social problem.

CULTURAL STUDIES AND PSAs

A cultural studies approach to PSAs rejects the narrow focus of cause-and-effects research and instead focuses on broader social and economic systems underlying human social behaviours and individual choices. Drawing on historical and sociological models, it considers the power relations underlying the production of PSAs and the underpinnings of the social problems that they are intended to change. A cultural studies approach might question the taken-for-granted assumption that PSAs are 'good', call into question the social and political implications of PSA messages by interrogating how meanings are produced through signifying practices, or examine the mechanisms by which PSAs are used as social control.

Because a cultural studies approach questions what things *mean*, it might ask, what *is* a PSA, and why are some ads considered to be PSAs and others not? An obvious answer might be that PSAs are 'public', messages not meant for profit but for the public good. Immediately, problems arise in this definition. For a message to be considered in the public's general interest, a fairly broad consensus in the population is assumed. Clearly, an announcement by the Ku Klux Klan or the American Communist Party would not be considered a 'public service announcement', even though it fits the above criteria in the eyes of members of these organisations. These are extremes, but the problem inherent in this limitation of the domain of 'public' becomes clearer when we note that PSAs rarely promote inflammatory issues that many citizens approve of, such as a woman's right to choose abortion or an unemployed or under-employed person's right to have adequate health care. An advertisement forwarding such positions would be considered a 'political advertisement' instead of a PSA, as though PSAs are somehow politically 'neutral'. This conservatism of PSAs not only demarcates their semantic domain, it functions in practice to define the 'public' as apolitical.

Another approach to defining PSAs is to distinguish them from other advertisements, which generally are connected to a *commodity*. Traditional critiques of conventional advertising tend to focus on the ideological linkage or identification, called *fetishism*, that ads create between a consumer (and ad target) and a thing being sold (Montes-Armenteros, 1997). With no product to promote, PSAs are typically assumed to be non-ideological. However, advertisements are not only ideological in that they promote capitalism through commodity worship, but also in that their messages are created using *representations* of people that carry along with them an array of sexist and racist implications. Cultural studies analyses of PSA content reveal that these ads are similarly biased, in that many (e.g. anti-drug PSAs) disproportionately target, and subtly demonise, youth and minorities.

A critical approach combining political economic and cultural studies methods can illuminate the cultural meanings and political underpinnings of PSAs. It also can provide future PSA creators with the means to craft more self-critical and socially conscious messages; for example, ACT UP has used 'activist advertising' to challenge problematic mainstream models for researching and treating HIV/AIDS. More recently, 'insurgent' advertising approaches, such as that developed by Adbusters, have arisen as a new medium for spreading public awareness. Insurgent advertising, like PSAs, is publicly oriented and

PHARMACEUTICAL ADVERTISING: DRUG-DEALING DIRECT TO CONSUMER

Scantily clad women snowboard across fields of grain without sneezing. Socially anxious socialites, their purses stuffed with pills, smile graciously at dinner parties. Elderly people zip about on trendy scooters thanks to new-found arthritis relief. These stories are just a few of those told in pharmaceutical advertisements on US television in the year 2000. Unlike the lower budget over-the-counter ads in which construction workers battled headaches, or white-coated lab techs lectured over schematic diagrams of dissolving pills, production values in these new prescription drug ads are very high, and familiar faces – such as former US Senator Bob Dole peddling Viagra – are frequent.

While spending on not-for-profit public health messages is down, spending on pharmaceutical advertising has reached an all-time high. The advocates of these private sector 'PSAs' claim that advertisements serve to 'empower' patients (borrowing language from the consumer movement) by increasing disease awareness.

Critics suggest that when drugs are marketed like make-up and refrigerators, there are deleterious consequences; the ads de-emphasise risk, promote treatment that may not be the safest or most effective, increase health costs and manipulate vulnerable target populations – such as the elderly and the mentally ill.

Due to these concerns, direct-to-consumer (DTC) advertising is not legal in many parts of the world, such as Canada, in member nations of the European Union, and Australia, where pharmaceutical marketing is only directed at physicians (although there is currently talk in Canada and the EU of revamping restrictions). Advertising was also restricted in the US in the two decades after the passage of the Kefauver-Harris amendments in 1962, which transferred the responsibility for the regulation of prescription-drug promotional material from the Federal Trade Commission (FTC) to the Food and Drug Administration (FDA). However, in response to pressure from the pharmaceutical industry and a brief moratorium on DTC ads in order to study their effects, in 1985 the FDA decided to permit these ads. Although marketing is still primarily aimed at physicians, DTC advertising comprises the fastest growing segment of sales expenditures. In 1995, US$345 million was spent on DTC ads, but this figure reached US$2.1 billion in 2000. The highest proportion of this spending goes to television ads. While these ads were non-existent just a decade ago, a relaxation of drug marketing regulations by the FDA in 1997 has spawned a frenzy of televised drug promotions. This increase in drug advertising has been controversial. In April 2001, after a survey conducted by the San Francisco Department of Public Health suggested that advertising of AIDS drugs could lead to unprotected sex, the FDA warned many manufacturers that their anti-AIDS drug advertising was misleading – frequently featuring robust AIDS patients in exceptional health – and ordered changes to these ads. The agency is currently reviewing its 1997 draft guidance on drug ads. The American Medical Association has considered resolutions that suggest restricting – and even banning – drug advertising. And concerns have been raised in the US by the media and by legislators about the potential links between DTC spending and rising drug costs; proposals to introduce a bill restricting DTC advertising were still under discussion in late 2002.

What effects do these ads have? Do they help or harm public health efforts? Do they create new illnesses and new ways of viewing disease and health? Whose interests do they serve, and how do they affect the cost of health care? Some of these questions have been addressed through marketing research, which produces massive quantities of data that assess the relationship between ads and drug sales. More critical studies have focused on the impact that DTC ads have on the physician–patient relationship. However, many crucial questions remain unaddressed, and there is a desperate need for more attention – including audience research, political economic analysis and cultural-historical studies – to be given to pharmaceutical marketing.

Kelly Gates, Marie Leger and Dan McGee

non-profit but, unlike the latter, it does not pretend to be apolitical, and takes an uncompromising position against transnational corporations and in favour of consumers. Insurgent advertising uses parody, humour, reflexivity and intertextuality to entertain and inform the public about clearly and honestly demarcated political issues. Although relatively new, such approaches offer an important alternative to PSAs.

Kelly Gates, Marie Leger and Dan McGee

RECOMMENDED READING

Ludwig, Michael J. (1997), 'The Cultural Politics of Prevention: Reading Anti-Drug PSAs', in Katherine Toland Frith (ed.), *Undressing the Ad: Reading Culture in Advertising*, New York: Peter Lang, pp. 131–150.

Tulloch, John and Lupton, Deborah (1997), *Television, AIDS, and Risk: A Cultural Studies Approach to Health Communication*, Concord, MA: Paul and Co, Publishing Consortium.

Wallack, Lawrence, Dorfman, Lori, Jernigan, David and Tehmba, Makani (1993), *Media Advocacy and Public Health: Power for Prevention*, Newbury Park, CA: Sage.

Online Resources

The Ad Council: www.adcouncil.org
Adbusters: www.adbusters.org
The Kaiser Network: www.kaisernetwork.org

Class

In a living room in the home of a discount chain-store employee in South East Michigan, United States, the hostess and a small group of female friends are speaking disapprovingly, sometimes heatedly, about the portrayal of abortion as a 'poor woman's problem' in the made-for-television movie, *Roe vs Wade*.

> Doctors' wives can have one. Attorneys' wives, you know. You can be a well-to-do woman and still want an abortion. You don't have to be a street person, and they made it look like only bad people, you know [choose abortion] . . . That's not reality. In reality any woman could need an abortion whether she's on the streets, in a $50,000 or $400,000 home. (Press and Cole, 1999, p. 75)

Sitting on a couch among these women are two audience researchers, Press and Cole, who spent time in the homes of women from different social class backgrounds, 'trying to mine these conversations' to understand how women connect their personal experiences to abortion as it is depicted on prime-time television (Press and Cole, 1999, p. 1).

Scenes like this are increasingly common in television audience research and Press and Cole's research illustrates the growing use of ethnographic methods in the analysis of television viewing in everyday contexts. Research approaches, methods and designs, as well as television genres and their viewers, vary tremendously; however, it is fair to speak of a general 'ethnographic turn' in audience studies. One of the most important outcomes of this shift is a renewed interest in 'social class as a determinant of TV viewing and feelings about TV viewing' (Seiter, 1999, p. 6).

The theoretical reformulations and epistemological debates in communications and cultural studies which prompted audience research to integrate ethnographic methods have been carefully delineated elsewhere and cannot be adequately delineated within the space of a short chapter (Moores, 1993; Morley, 1992; Nightingale, 1996;

Seiter, 1999; Silverstone, 1994; Tulloch, 2001). It must suffice to say that the opening of audience studies to different forms of investigation and interpretation was catalysed in part by growing objection to the behaviourism underpinning dominant research approaches in United-States-based mass communications research, framed within a 'stimulus-response' model devoid of any concept of social power. And while British cultural studies, growing out of the University of Birmingham, explicitly brought to audience research the very ideology critique conspicuously absent in US mass communications research, investigation within this approach itself was coming under scrutiny. In an influential article published in *Screen*, Rosalind Coward (1977) helped instigate a post-structuralist critique of what has come to be called the 'Birmingham model'. Coward and others interrogated the determinism implicit in the view that social class position produces in television viewers particular kinds of readings. Researchers working within and around the Centre for Contemporary Cultural Studies at Birmingham were criticised for accepting categories of class as given – obscuring the contradictions and conflicts of class as lived experience – and for erasing the operations of race, ethnicity and gender in audience interpretations and interactions with television.

While class analysis dropped off the radar screen for many scholars of communication and culture in the wake of such critique, some audience researchers opened up class for closer reflection and did so largely through the incorporation of ethnographic methods from anthropology. Press and Cole's research exemplifies the use of ethnographic methods 'to deconstruct the meaning of class', bringing into view differentiated positions within class, unexpected commonalities across classes, and the complex ways in which race, gender and ethnicity interact with class in the production of meaning.

Ethnography is particularly well suited for investigating the class-inflected interpretative practices and identity positions of television viewers. As Ellen Seiter emphasises in her research on television and computers, 'media consumption is embedded in the routines, rituals, and institutions – both public and domestic – of everyday life' (Seiter, 1999, p. 2). Ethnography attends to the everyday contexts, practices and relationships within which television consumption is situated. With its focus on specific practices within local contexts, ethnography calls attention to the material conditions which construct specific kinds of viewing and in which audiences construct specific meanings from their engagement with television. It is the 'scene' of viewing that Seiter observes, the classed (as well as gendered and raced) contexts in which television is viewed and

discussed, and which in turn gives rise to classed under-
standings of media representations.

By concentrating on the social settings within which tel-
evision viewing is situated, ethnographic methods have
helped produce more nuanced notions of class and inter-
pretations of how class location may structure the practices
of television viewing and the meanings drawn from view-
ing. For example, the ethnographic data produced in the
research by Press and Cole clearly refutes the notion of
a unified working class. To more accurately map the
differentiated positions taken up by their pro-choice work-
ing-class participants, the researchers found it necessary to
distinguish between 'working-class identified' and 'middle-
class identified' women. Because of its focus on the specific
and historically situated, the new ethnography of television
audiences, particularly within a feminist framework, has
'generally led away from' the essentialism that marked
much earlier television research on class (Press and Cole,
1999, p. 144).

The greater emphasis on social class position that
ethnography has helped stimulate within television stud-
ies is not directed at audience members alone. The theo-
retical and methodological demands of ethnography are
also generating a new self-reflexivity among audience
researchers about the influence of their own social class
position. Researchers engaged in ethnographic audience
research have begun to rigorously question how their own
class position and socially constructed interpretations
influence the research process. Class, the new audience
ethnography insists, not only structures the contexts and
conditions of viewing television; class also structures the
contexts and conditions of research on television audi-
ences. In her work on video, Ann Gray demonstrates this
self-reflexivity in her confidence that the shared class posi-
tion between herself and the women she studied 'was cru-
cial to the quality' of their conversations and 'the talk that
ensued was, in most instances, enriched by that shared
knowledge' (Gray, 1992, p. 34).

The self-reflexivity which is increasingly being put into
practice within audience studies was largely absent from
earlier work on audiences (reflective, no doubt, of the
widespread absence throughout qualitative social scien-
tific research). The pitfalls of David Morley's 'academic
posture' in The 'Nationwide' Audience have been a frequent
source of critique of his influential study. Although the
research reflects systematically on class as a determining
variable in viewers' readings of the news magazine pro-
gramme, Ang keenly observes that 'Morley has not
deemed it necessary to reflect upon his own position as a
researcher' (Ang, 1989, p. 110).

The necessity of self-reflexivity is a defining strength of
Seiter's ethnographic work on attitudes towards and talk
about television viewing. Turning visible her own interests
and positions, Seiter represents her study as 'clearly
bounded by concerns that preoccupied me as a white
middle-class academic: careers and work, sharing of child
care and housework, gender stereotyping' (Seiter, 1999,
p. 55). Seiter's work is informed by a careful awareness of
her 'own role in moulding what is said and how it gets said',
as well as what goes unsaid (p. 30). Seiter's ethnographic
methods grow out of this mindfulness, evident in her
emphasis on repeated and lengthy contact periods with
participants in her study which make possible a deeper
familiarity with their everyday lives. This has allowed her to
'comment self-reflexively' on her 'commonalities with the
other women in the group as a mother, as well as the dif-
ferences that derived from my status as an intellectual with
a relatively well-paid, comfortable job' (p. 35). The class
differences between Seiter and the women she studied were
to a certain extent 'levelled' by her personal 'involvement in
the everyday labours of caring for small children' (p. 53).
While Seiter's self-reflexivity contributed to a certain
diminishing of distance between researcher and
researched, the workings of class were not erased: 'the
group was not a forum for free speech: differences in social
power outside of the group determine who can speak and
what can be said' (p. 51).

The distance between Press and Cole and the women
they studied – the effect of class locations as well as race
and ethnicity – was something the researchers deter-
minedly 'struggled to assess' (Press and Cole, 1999, p. xi).
Coming from the middle-class environment of the univer-
sity, and from the class privileges (and cultural capital) that
education confers, both researchers struggled with differ-
ent aspects of their encounter with women in many cases
very different from themselves. Class differences made
themselves felt during discussions with working-class
women in their homes, 'sometimes in minor reminders of
our difference from our informants, sometimes precipitat-
ing major epiphanies concerning what separated us'
(p. xiv). The experiences of class difference brought into
focus not just the subjectivities of the women studied, but
those of the researchers as well. These experiences 'raised
our consciousness about how our own class backgrounds
helped establish particular identities for us in the world
and in relation to others' (p. xvi). In the case of Press and
Cole's research, the practice of 'listening to difference' clar-
ified their understanding of the significance of class in their
respondents' lives, and in their own. 'Our subjects had in
effect restored our subjectivity' (p. ix). Strikingly, it was the

collapse of class distance that formed the greatest barrier to the researchers' analytic work. Most difficult was the analysis of conversations with women most similar to themselves. 'The middle-class pro-choice chapter held up completion of the book for a year' while the researchers struggled to 'put enough distance between us and these women to reach any sort of theoretical conclusions about their words' (p. xvi).

The practice of self-reflexivity around issues of subjectivity and class is not always easy or comfortable. It can also be painful, as shown by Valerie Walkerdine's experiences conducting ethnographic research on television practices among young working-class girls in England. Walkerdine has scrutinised the invasiveness embedded in the 'gaze' that middle-class academics cast upon the cultural tastes and practices of working-class subjects. Social class, in Walkerdine's analysis, is one of the most powerful structuring differences between the observer and the observed. Watching from an armchair 'in the living room of a council house in the centre of a large English city' while a family watches a video, Walkerdine confronts her own complicated relation to social class. As the father replays again and again a graphic boxing round in *Rocky II*, Walkerdine becomes 'paralysed' and repulsed by the father's own performance of 'macho sexism'. Later, in the familiar middle-class environs of her university office, she watches the film again and her response shifts from disgust to engagement as her own conflicted class background comes into view. 'The film brought me up against such memories of pain and struggle and class that it made me cry' (Walkerdine, 1986, p. 169). She recalls the working-class conditions of her childhood, and the middle-class comforts and privileges conferred upon her by a university education. Like the father she observed, she too 'wanted Rocky to win', because his 'struggle to become bourgeois' was a visceral reminder of her own painful struggle. Her research activity thus became an opportunity to examine her 'multiple positioning as both middle-class academic and working-class child' and how these varied positionings come to bear on the setting and practice of research (Walkerdine, 1986, p. 169).

The new audience ethnography, with its characteristic concentration on local specificity of the interplay of class and media, is not without limitations. By emphasising the local, ethnography may potentially buffer audience research against the risk of essentialism and reification common to treatments of class in earlier audience studies. However, as Corner has cautioned, this same emphasis runs the risk of displacing 'an engagement with the macro-structures of media and society' (Corner, 1991, p. 269).

Viewing *Rocky II* – the complications of social class

One of the key challenges for audience researchers is to connect insights on class as it is daily reproduced in varied and complex ways in the lives of television viewers to the wider historical and political economic contexts of media production and distribution. Some scholars have already called attention to the multiple ways that 'local settings are themselves embedded within and intersected by the wider structural formations of a society' (Moores, 1993, p. 32).

Television audience researchers need to foreground the fact that 'in this very living out of their everyday lives . . . people are inscribed into large-scale and historical relations of force which are not of their own making' (Ang, 1996, p. 137). Working-class women may assume identities which resonate with middle-class norms and attitudes in some situations; however, the real possibilities for organising the resources required to assume the material conditions of daily middle-class life are increasingly out of reach. Seiter has shared her uneasiness that 'during the years when audience researchers were focusing on close readings of the text, the structure of media corporations underwent massive deregulation, conglomeration, and shifts of power' (Seiter, 1999, p. 137). Indeed, at a moment when many scholars abandoned their attention to entrenched divisions of social class, the television industry itself stepped up its efforts to analyse audiences along class lines. As critics such as Ien Ang have demonstrated, we must critically examine the definitions and representations of audiences produced by the ratings industry, as well as the assumptions and implications of their audience measurement techniques. It is true, as many scholars have noted, that ratings industry research tells us very little if anything about actual audiences' behaviours and beliefs. But such efforts – and the enormous outlays of capital supporting them – tell us everything about the unrelenting salience of class to the

capitalist institutions of media and advertising which pro-
duce television. Turning increasing attention towards the
local contexts of class negotiation around television, audi-
ence researchers would do well to adopt Seiter's concern to
not lose sight of the political economic structures underly-
ing these specific scenes. Indeed, ethnography can help
audience researchers question how actual media technolo-
gies are implicated in the daily reproduction – indeed, the
deepening – of class divides.

Lora Taub

RECOMMENDED READING

Moores, Shaun (1993), *Interpreting Audiences: The
Ethnography of Media Consumption*, London, Thousand
Oaks: Sage Publications.

Press, Andrea L. and Cole, Elizabeth (1999), *Speaking of
Abortion: Television and Authority in the Lives of Women*,
Chicago: University of Chicago Press.

Seiter, Ellen (1999), *Television and New Media Audiences*,
Oxford, New York: Oxford University Press.

Tulloch, John (2001), *Watching Television Audiences: Cultural
Theories and Methods*, London: Arnold.

Walkerdine, Valerie (1986), 'Video Replay: Families, Films and
Fantasy', in Victor Burgin, James Donald and Cora Kaplan
(eds), *Formations of Fantasy*, London: Methuen, pp.
167–199.

GENDER

Introduction

Joanne Woodward once remarked of her different experiences as an actor on film and TV that: 'When I was in the movies I heard people say, "There goes Joanne Woodward." Now they say, "There goes somebody I think I know"' (quoted in McLuhan, 1974, p. 339). She had become what ethnomethodologists refer to as a 'personalised stranger', a figure the public assumes to know at a quite intimate level – not in terms of real-life secrets, but as someone with whom diurnal interaction is taken for granted (Watson, 1973, pp. 16, 19 n. and 19). This familiarity and normalcy has driven gender studies on a restless and productive search to understand the pleasures and limitations of television as both a representational apparatus and a workplace. As well as the images and myths presented to us, issues of power and gender determine both the control of family television sets and the nature of prime-time programming. As feminist critiques have emerged, so TV itself has represented feminism and changed in response to it (see Brunsdon et al., 1997, p. 1).

Toby Miller

Gender, Representation and Television

For the past thirty years, the terms 'gender', 'representation' and 'television' have been linked together in much scholarly and popular writing, and it appears they will continue to be linked for many years to come. A closer look at the three terms should shed light on the reasons for this linkage but, as we might expect, none of the terms is simple or static. 'Television' is not only a technology but a social institution with varied relationships to the countries in which it is produced and/or consumed, and to the economic, religious and ideological frameworks of those countries. Its programming, for example, may be controlled and shaped by national governments, commercial interests, religious entities or local communities (to name some arrangements), and the various beliefs and interests – including those relating to gender – that motivate them. Television is also a cul-

tural forum, often watched by viewers around the world for many hours every week. Its schedule, information and stories are part of shaping how its viewers organise their days, and think and feel about themselves and their worlds, including how they conceive of themselves as gendered beings. Television is also in the throes of tremendous change, transmogrifying into digital signals, and cable and Internet delivery; becoming more interactive and more oriented to niche programming; and holding out, in these changes, the promise (however slim) of more viewer negotiation over representations of gender, as well as more alternatives to conventional gender depictions.

'Representation' is what television is all about, denoting, as the term does, signs, symbols, images, portrayals, depictions, likenesses and substitutions. And 'gender', perhaps the trickiest of the three terms, is often defined as the *cultural* meanings or representations assigned to *biologically* sexed bodies, with the terms 'masculine' and 'feminine' usually referring to culturally produced gender, and 'male and 'female' to biologically produced sex.

Recently, however, a number of scholarly books and articles, including Judith Butler's books *Gender Trouble* (1990) and *Bodies That Matter* (1993), have shaken this definition of gender, and argued, in Butler's words, that 'the sexes' are not 'unproblematically binary in their morphology and constitution'; and, further, that if 'the immutable character of sex is contested, perhaps this construct called "sex" is as culturally constructed as gender; indeed, perhaps it was always already gender . . . '. Butler and others can point to enormous ranges of hormone distributions in individuals we typically call male and female; ranges of secondary sex characteristics such as facial and body hair and muscle mass; more instances of sexual dimorphism (babies born with both penises and vaginas) than we realise; more instances of transgenderism – individuals with one sex organ who feel like members of the other gender – and so forth. There are enough actual instances, in other words, to call into question the binary division of two sexes and, given what seems to be incontrovertible evidence of a wide range and breadth of gender manifestations, surely enough evidence to call the division of *two* genders into question. So in this respect, Butler here advocates a radical reconception of *both* gender and sex as cultural constructions, as performances, enactments, itera-

tions of regulatory norms that make bodies *matter* according to laws of human history rather than those of nature. Without going into the details of the argument here, and without saying much more about culture and biology, nurture and nature, or some combinations thereof, it is important to recognise that Butler's work has made the investigations of gender and its television-based representations an ever more pressing pursuit, and has expanded the boundaries of gender's definition and potential power. It is in cultural fora like television that specific representations or significations of gender get generated day in and day out and circulated as tacit and not so tacit norms to millions of viewers the world over (based, of course, on the different beliefs and interests that undergird both the norms and the shaping of the television programmes). And it is for this reason that gender, representation and television need to be thought of together and examined ever more fully for their specific interrelations in all television systems throughout the world.

RESEARCH ON GENDER AND TELEVISION

Over the past thirty-five years, work on semiotics, structuralism, discourse, post-structuralism and media has made the case that it is through *representational* or signifying systems such as language, photography, film and television that the categories that seem so natural to us and the differences that organise our thinking and our lives (like masculinity and femininity, male and female) actually get determined. Inquiries into the representational system of television and the cultural constructions of gender have thus been conducted by scholars in many different countries, and include studies of Taiwanese prime-time melodramas and their depictions of femininity and masculinity by Szu-ping Lin (2000); of a televised version of a Hindu 'sacred serial' and the construction of ideas about 'Indian Womanhood' by Purnima Mankekar (1997); of the construction of Asian femininity in Australian television programming by Suvendrini Perera (1997); of Chilean telenovelas by Michèle Mattelart (1986); of prime-time soap operas in Israel by Tamar Liebes and Elihu Katz (1990); of Dutch viewers of *Dallas* by Ien Ang (1985); of women and soap opera in the UK by Christine Geraghty (1991); of representations of African-American femininity and US television by Jacqueline Bobo and Ellen Seiter (1997); and representations of non-normative femininity on US TV by Julie D'Acci (1994), to mention only a few. Similar studies need to be generated and expanded so that the relationships between gender and television in all their global dimensions have thorough and systematic examination in the coming years.

Dallas – the focus of Ang's (1985) study of Dutch viewers, gender and TV

Much of the research on gender and television had its beginnings in the worldwide second-wave feminist movements of the past thirty-five years, and initially focused on representations of femininity. This was soon followed by work on representations of masculinity, and on representations of non-normative sexualities such as gayness and lesbianism. In the course of this trajectory, it soon became apparent that to study gender in isolation was to replicate what the category itself excludes or represses – the myriad other social identities upon which and against which notions of masculinity and femininity are produced: identities involving race, ethnicity, class, age and sexuality. It became apparent that future work on the representations of gender would have to take into account the ways the categories masculinity and femininity depend on such exclusions and repressions – the ways, for example, that normative femininity on early US television was represented as middle class, white, young, maternal and heterosexual, and was utterly dependent on the excluded categories of working class, black, ethnic, old, non-maternal and lesbian as its repressed others. It became clear, in other words, that scholars could not continue to speak of the category gender without recognising its dependence on its formative exclusions.

During these years of research, many different methodologies have been employed to study the relationships among television, representations and gender – methodologies that range from content analysis to narrative and textual analysis to industry analysis to ethnographic audience studies to analyses based in psychoanalysis, among others. A particular approach based in cultural studies incorporates several of these methods and has proven to be extremely productive and flexible in this type of study. For example, there is D'Acci's (1994) analysis of the police series *Cagney and Lacey* and also her later account of *Honey*

West (D'Acci, 1997). See above (Lin, 2000, and onwards) for other examples of this 'integrated approach', which is further described in D'Acci (2001).

AN APPROACH TO THE STUDY OF GENDER

This 'integrated approach' to gender and television analysis conceives of its field of study as involving four interrelated sites or spheres: television production, reception, programming and the social/historical context. Each of these sites (not simply programming) is involved in producing representations of gender, and each needs to be examined for the ways in which it does so. This is not to say that every individual study of gender and television needs to include an investigation of each site – it would be virtually impossible to do this. It is simply to say that the specific activities of each site and the potential interactions among them should be considered when conceiving the particular research project, when posing the questions that impel the research, and when drawing conclusions. Using examples from television in the US and UK, it is possible to suggest some of the ways this approach functions and some of the conclusions it has yielded.

When we think of the study of gender and television, we tend to think of the ways gender is represented in programmes (news, commercials, fictional forms, and so forth) and how those representations constitute the norms up against which actual people enact, or do not enact, *culturally legitimated* femininity and masculinity. We will return to a discussion of programming shortly, but representations of gender are continually constructed and very much operative in the other spheres as well. If we take *production* and US television, for example, we find that there are two basic levels on which gender is constructed and which need much more investigation. First, at the general structural level of the corporate capitalist enterprise, the way gender is imagined, thought, represented in the mind's eye of the television industry, has everything to do with the historical distribution of jobs, money and power – with the functioning of the industry as an economic and social sector. This, of course, has countless repercussions for not only the division of labour and wages but for what actually ends up on the home screen as well. As Crystal Zook's (1999) study (which chronicles the appearance of black writers at Fox entertainment television in the late 1980s and 1990s) makes only too plain, black women writers have been an extraordinarily scarce presence in the history of US television production.

Second, gender is produced at the level of the overall production process – in the myriad imperatives that directly govern the construction of audiences and programmes. A majority of these imperatives are tightly tied up with gender, such as the ways the industry has consistently fashioned its market and programmes according to gender, historically targeting middle-class, white, heterosexual women/mothers as its primary overall audience (because they have been thought to be the primary consumers of the products advertised on TV); the ways it has developed formulaic programmes that it thinks and hopes will appeal to conventionally produced and identified males and females; and the ways it has divided its programming and scheduling according to the formulaic genres and times of day that it thinks will draw large numbers of respective male and female viewers (for example, sports on weekends to attract men, soaps during weekdays to attract women, and so forth). Only these few specific imperatives can be suggested here, but the main point to be made is that the sphere of production (whether it is commercial, public, community, cable access or state-controlled) needs to be rigorously examined for all the ways it depends upon conventional gender demarcations for its functioning and its production of audiences and programmes; and consequently for how it contributes to, draws on and circulates particular representations and conceptions of gender as opposed to others.

The sphere of *reception* is replete with its own gender dimensions that need intensive examination. They involve, first, the overall institution of viewing – the social and environmental factors that comprise viewing situations and revolve around gender, such as traditional family hierarchies and the venue of home viewing documented in the work of David Morley (1986), Ann Gray (1992) and others. Likewise, conventional gender roles and their enactments in out-of-home public venues such as bars, community centres and so forth also call for further investigation. Anna McCarthy's (2001) work on television in public places is particularly instructive in relation to these.

Second, it involves the gender dimensions of the actual viewer/programme interactions, including how meaning, pleasure and other forms of affect may actually get produced; how audience members may absorb, reject or negotiate the norms of gender offered up by programmes; how particular groups (teenagers, for example) may choose programmes based on conventional gender designations; how audiences may use representations to rally for changes in conventional assumptions about gender; how fans may become avidly identified with programming in gender-based ways, and so forth.

If we turn to the sphere of *programming* itself, we recognise the complexity of gender representations in

actual television shows. We see, as the feminist critics in the late 1970s and 1980s came to see, that gender cannot be analysed in isolated 'images' alone, but must be seen as it is produced in all of its specificity, in and through all the formal dimensions of television. We see that gender is represented in the unfolding of the narrative, in the genre and in each of the techniques such as camera work (close-ups and soft focus, for example); editing (romantic dissolves, for example); sound (authoritative speech or voice-overs, for example); and *mise en scène* (which includes lighting, make-up, costumes, sets, props and the way the characters move, and might, for example, generate a figure of typical 'macho' dimensions – a large white body, toting a gun, and jumping over rooftops).

Finally, the *social and historical context* is the major sphere that demarcates the ways general social events, movements, beliefs and changes produce or represent particular notions about gender in and for the society at large. Here, for example, we see how, among many other things, social movements such as the women's movements, the gay and civil rights movements and the fundamentalist religious movements introduced different and conflicting representations of gender into US society during the last half of the twentieth century, representations that influenced the television industry, its programming and reception, and in turn further influenced the social/historical context.

It is unequivocally clear that gender, representation and television are thoroughly imbricated with one another. Further understanding and analysis of how and why they work together is nothing short of imperative.

Julie D'Acci

RECOMMENDED READING

Brunsdon, Charlotte, D'Acci, Julie and Spigel, Lynn (eds) (1997), *Feminist Television Criticism: A Reader*, Oxford: OUP.

D'Acci, Julie (1994), *Defining Women: Television and the Case of Cagney and Lacey*, Chapel Hill: University of North Carolina Press.

Morley, David (1986), *Family Television: Cultural Power and Domestic Leisure*, London: Comedia.

Zook, Crystal (1999), *The FOX Network and the Revolution in Black Television*, New York: OUP.

Gender and Stereotyping

While the concept of stereotyping has been a major preoccupation within media studies since the 1970s, there is no consensus on how stereotypes perform their ideological

work. This lack of consensus is ironic, considering that part of the effectiveness of stereotypes is believed to derive from their appeal to consensus as an organisational principle. Since the mid-1980s, the efficacy of 'stereotype theory' has been called into question by a number of researchers, including Tessa Perkins (1979), Richard Dyer (1993), Martin Barker (1989) and Ellen Seiter (1986), who in different ways seek to lay bare some of the contradictions at the heart of the term 'stereotype'. Defined by Perkins in her influential essay on gender and stereotyping as 'evaluative concepts' about status and role, and as 'prototypes of shared cultural meaning', the term stereotype was coined by the American social scientist Walter Lippmann in 1922 (Perkins, 1979, p. 156). According to Lippmann, stereotypes had four major characteristics: they were an ordering process; a short cut; referred to the real 'world'; and expressed our 'values' and 'beliefs' (Dyer, 1993, p. 11). However, Lippmann's non-pejorative conceptualisation of stereotyping had shifted within media studies by the 1970s to the idea of stereotypes as rigid, simplistic, overdetermined and inherently false; the problem with stereotypes, the argument went, was that they misrepresented people's 'lived identities' by falling back upon narrowly conceived preconceptions of racial, cultural and gendered difference, thus perpetuating pernicious myths about social, cultural and racial groups.

In response to the taken-for-granted status of stereotype theory in 1970s' studies of the media, Perkins questioned some of the underlying assumptions of the term, including the imputed rigidity of stereotypes. Instead, she argued that we should pay close attention to 'the social relationship to which [stereotypes] refer, . . . their conceptual status, and ask under what conditions are stereotypes more or less resistant to modification' (Perkins, 1979, p. 141). As Barker has noted, borrowing from Steve Neale, one of the contradictions within the received model of stereotyping is the ambivalent status of the stereotype's perceived accuracy; while some representations are considered stereotypes because they deviate from the 'real' world, in other cases no such claims of inaccuracy are seen as necessary or relevant (Neale, 1980, in Barker, 1989). Recognising categorisation as a basic cognitive process that people employ to make sense of their lives and their group affiliations, Barker questions the utility of the concept of stereotyping, arguing that aside from generating endless studies, stereotype theory has little to offer media studies. Barker's critique points to the limited heuristic uses of the term stereotype, and one might ask, in light of Barker's scepticism, can 'positive stereotypes' exist and ought they be cultivated and supported by media producers and critics?

Despite the lack of a consensus on whether anything positive can be derived from stereotyping, critics have agreed that the ideological work of stereotyping involves closing down the range of possible meanings, making 'fast, firm, and separate what is in reality fluid and much closer to the norm than the dominant value system cares to admit' (Dyer, 1993, p. 16).

The discursive centre of work on stereotypes has shifted since the 1970s, with many contemporary critics employing the concept as less a self-evident normative category and more a site exploring the complex social and institutional processes to which they refer. Rather than perceive stereotypes as *de facto* 'bad', a more protean, open approach has emerged, allowing a nuanced understanding of the various forms and functions stereotypes can take. Not surprisingly, work on gender and stereotyping has generated a huge amount of research since the 1970s. Referred to as the 'images of' or 'representation of' paradigm, this work grew out of American behaviourist-influenced social science research in which short-term effects of the media were measured through surveys, experiments and content analysis. Content analysis, the empirical logging of pre-determined categories, such as the numbers and demographic characteristics of male and female characters in a television series, was extremely popular in the US in the 1970s, and countless quantitative studies were offered as empirical proof of commercial television's sexism. Researchers argued that since the launch of television, women had been outnumbered by men on television by two to one, and that within a few years of television's launch, 68 per cent of characters on prime-time television were men; when women were represented, they were shown as 'less intelligent than men, less capable, and less career-oriented' (Davis, 1990, p. 326). The research argued that the paucity of women on television, coupled with the limited roles they played, contributed to a misleading impression of women's real accomplishments in society.

While helpful in providing a snapshot of gender representation on television, content analysis has been criticised for privileging description over analysis (and content over form), and for remaining sensitive to the researcher's biases in identifying and labelling analytical categories. In addition, the modelling behaviour theory underpinning most content analysis – the idea that viewing negative role models of people like yourself will inexorably undermine your self-worth – has been questioned by Ien Ang and others (Ang, 1997, p. 161), who is sceptical of this implied relationship between viewer and media text. Taking issue with modelling theories of the media, which in Ang's view imply 'a rationalistic view of the relationship between image

and viewer', Ang calls for an appreciation of the larger 'emotional involvement' audiences invest in characters, one that acknowledges the 'fictional status of characters that are not meant to be read referentially but as an ensemble of textual devices for engaging the viewer' (Ang, 1997, p. 162).

Since the 1970s, feminist television criticism has gradually moved away from the 'representations of' model and from associated reflection theories that impute a fit between women's representation in the media and 'real women' in favour of a 'critique of TV's constructions of all social categories, including gender, sexual identity, race, nation, and everyday life itself' (Brunsdon et al., 1997, p. 8). This shift from quantifiable codings of the manifest content of television texts towards a consideration of issues of intertextuality, production conditions and the social contexts of television programming accompanied the rise of cultural studies' approaches to how meaning is negotiated by television audiences (Brunsdon et al., 1997, p. 10). As Perkins points out, one of the weaknesses of the narrow definition of stereotypes in content analysis is the difficulty in accounting for the way in which the content of stereotypes is not arbitrarily chosen, but is selected from those features that have the greatest ideological staying power (Perkins, 1979, p. 156). It also fails to contextualise stereotypes within the larger interplay of signification in a particular programme or series; in other words, a character might begin a television series as a clichéd representation but may evolve as the programme or series continues into a more contradictory and semiotically elusive character.

Much of the writing in the 1970s on media stereotyping imposed an implicit teleology of progress in media portrayals of women, often accompanied by the hope that as women rose to positions of power in the media industries, gender representations on television would continue to improve. These studies often concluded with the same clarion call: a redress in the balance of gender representations on television so that women could have access to roles currently played by men (Davis, 1990, p. 329). To a large degree, subsequent critics have rejected the teleological suppositions of the 'progress' model; however, if many traditional content analyses offered a rather naive account of textuality and social determination, they were nevertheless useful in placing the issue of gender representation and television in play within academic and policy circles.

In addition to tracking how representations of women fared in comparison to those of men on television, research on gender and stereotyping has sought to demonstrate how representations of women have shifted over the years, shaped by the social, cultural and political contexts of their creation. Survey accounts of women's changing roles since

the 1950s are often framed by a narrative of 'limited progress' in which, the story goes, *some* progress is inevitably deemed to have been made in terms of gender stereotypes. One exception to progressive teleology is Patricia Mellencamp's (1997) argument that strong female characters in *I Love Lucy* (1951–58) and *The George Burns and Gracie Allen Show* (1950–58), women whose characterisation provided an ongoing meta-commentary on the frustrations of domestic life, were replaced in the late 1950s by a new breed of contented homemakers. The female-comedian-as-sitcom-star has shown considerable staying power in the history of the American sitcom, from Roseanne Barr (*Roseanne*, 1988–97) to Ellen DeGeneres (*Ellen*, 1994–98) and Brett Butler (*Grace Under Fire*, 1993–98). Fracturing the seeming domestic bliss of 1960s' sitcoms was a more diverse range of female representations on prime-time television, suggesting the inadequacies of reflectionist and teleological accounts of gender stereotypes on television.

The 1970s provide an interesting case study for gender stereotyping; because a number of these shows did challenge some of the prevailing assumptions of gendered identity, provoking lively debates about the nature of stereotyping, the decade is viewed as something of a turning point in television's representation of women. Seen as a foundational moment in terms of 'progressive' representations of women, *The Mary Tyler Moore Show* was one of the first long-running television series to draw upon feminist concerns and to flag a feminist subjectivity through the trope of the single working woman (Rabinovitz, 1989, p. 3). Mary Richards' characterisation was viewed by many viewers and feminist critics as a breath of fresh air although, as Bonnie Dow has argued, its feminist message was qualified inasmuch as it 'blended discourses of the "new woman" with traditional messages about the need for women to continue fulfilling traditional female roles as caretakers and nurturers in the . . . "family" of the workplace' (Dow, 1996. p. 25). But at the same time as *The Mary Tyler Moore Show* seemed to espouse a feminist agenda, other shows with female protagonists at the time were stark reminders of persistent sexist representations, even when a character's occupation might have militated against such a narrowly defined role. *Police Woman* (1974–78) and *Charlie's Angels* (1976–81) revealed some of the deep-seated ambivalences within American feminism; seen as an example of 'jiggle TV', *Charlie's Angels*' sexualised protagonists were contradictory signifiers for female audiences, suggesting the ideals of agency and self-determination through the narrative framework of the detective genre on the one hand, and passive objectification synonymous with the eroticised pin-up girl on the other.

Feminist subjectivity – *The Mary Tyler Moore Show*

Working within the parameters of female-centred crime fiction, *Cagney and Lacey* (1982–88) was a more radical departure from its 1970s' predecessors although, as Danae Clark has argued (1990), the importance of *Cagney and Lacey* to feminism lies 'beyond its presentation of a new or "better" image of women'. As a popular television text aimed at women and dealing head-on with women's issues, *Cagney and Lacey* potentially 'challenge[d] the boundaries of patriarchal discourse at the same time as it allow[ed] viewers to actively enter into the process of its meaning construction' (Brown, 1990, p. 118). A similar argument has been made in defence of soap operas, which, in addition to dealing with women's issues through 'reaction and interaction rather than action' (Modleski, 1983, p. 68), in the British context have included strong female characters and women from diverse racial and class backgrounds (see, for example, *Coronation Street* [1960–], *Brookside* [1980–] and *EastEnders* [1984–]).

Commercial television has responded to the women's movement in many ways, refracting changing attitudes towards political and psycho-social issues but never straying far from established programming formulae and cultural norms. Widely discussed possible exceptions include *The Avengers* (1966–69), *Roseanne*, *Murphy Brown* (1988–97), *Prime Suspect* (1990–96), *Absolutely Fabulous* (1992–95) and *Designing Women* (1986–93): dramas and sitcoms with strong female leads that pushed the limits of feminist discourse on popular television. Feminist television critics have paid close attention to the ways in which feminist agendas have played out narratively and thematically (including Judith Mayne's '*LA Law* and Prime-Time Feminism', 1997), with special consideration given to what's called the 'post-feminist' turn in television: what some have viewed as television's way of addressing women's current ambivalences regarding feminism. Calling *thirtysomething* (1987–91) a '"postfeminist" vision of the

D'Acci's (1994) study of *Cagney and Lacey* broke new ground

home to which women have "freely" chosen to return', Elspeth Probyn argues that the meanings of women's roles in prime-time television are now more indeterminate than ever, with discourses of new traditionalism, motherhood, and balancing work and career problematising constructions of gendered identity (Probyn, 1997, pp. 128–9). And yet if television women are now capable of articulating their identities in complex and contradictory ways, they remain constructed in line with a conservative ideology which deems that, however assertive they may be, they can never deviate too much from the 'feel good' ideology of the show's commercial sponsors and must almost always conform to accepted norms of beauty and behaviour. If sexist imagery is still alive and kicking on television, it is now often embedded within discursive systems that are far from straightforward in their evocation of cultural meanings, all of which makes coming up with hard and fast rules about how gender stereotyping works on television a continuing challenge. Despite the difficulty among contemporary scholars in agreeing upon a full theoretical account of the operation of gender stereotyping on television, the notion of the progressive stereotype remains powerful in the discourse of media reformers and popular commentators, suggesting that the issue will continue to frame our understanding of the medium.

Alison Griffiths

RECOMMENDED READING

Brunsdon, Charlotte, D'Acci, Julie and Spigel, Lynn (1997) (eds), *Feminist Television Criticism: A Reader*, Oxford: Oxford University Press.

Davis, Donald M. (1990), 'Portrayals of Women in Prime-Time Network Television: Some Demographic Characteristics', *Sex Roles*, vol. 23, nos. 5/6, pp. 325–332.

Dow, Bonnie J. (1996), *Prime-Time Feminism: Television, Media Culture, and the Women's Movement Since 1970*, Philadelphia: University of Pennsylvania Press.

Perkins, Tessa E. (1979), 'Rethinking Stereotypes', in, M. Barrett, P. Corrigan, A. Kuhn and J. Wolff (eds), *Ideology and Cultural Production*, London: Croom Helm.

Gender and British Television

British television studies has its disciplinary roots in British cultural studies, an approach which, John Fiske writes, is founded upon 'the belief that meanings and the making of them (which together constitute culture) are indivisibly linked to social structure and can only be explained in terms of that structure and its history' (1992, p. 285). Generally, studies of gender and British television have shared the concerns of this wider critical project. Analyses of programme content and reception usually pay close attention as well to the wider social contexts in which television programmes are produced, transmitted and viewed. Television is understood as social practice and gender issues are examined in relation to power structures, to the politics of social class and ethnicity, and to prevailing industry conditions. A positive effect of this approach is that the emphasis upon context has made British feminist and gender scholars less eager to pronounce gender representations as 'good' or 'bad', 'progressive' or 'regressive' and, in accordance with Stuart Hall's encoding/decoding model (1980), more inclined to emphasise a variety of interpretations and uses. Through its emphasis upon social context, the cultural studies approach accommodates and addresses a range of operations that complicate absolute value judgments about the 'meanings' of television programmes.

A major area of interest for scholars of British television and gender has been audience studies, which combines elements of sociological study with audience-oriented textual analysis. In *Family Television* (1986), David Morley (a key figure in British cultural studies) surveyed domestic view-

ing practices in Britain and found a number of marked differences in the viewing behaviours of men and women. Men, he found, tended to carefully plan their viewing and to fully concentrate on programmes. Women, on the other hand, tended to regard watching television as a social activity and did not give it their full attention. Men were likely to commandeer the remote control and use it to control the family's viewing, flipping channels regardless of what other family members might be watching at the time. They demonstrated a marked preference for factual programmes (documentaries, news and current affairs) and for realistic action-oriented genres such as crime drama. John Fiske (1992) similarly suggests that male viewers prefer action to dialogue and favour fiction genres that centre upon one or two male protagonists and which provide unambiguous points of identification and moral perspective. Fiske suggests that while women prefer 'open' texts, which invite interpretation, men prefer goal-centred linear narrative trajectories and 'closed', authoritative texts. Fiske allies these male preferences to a culturally constructed masculinity where 'masculinity, individualism, competition, all merge "naturally" into the general (that is, the dominant) ideology of patriarchal capitalism' (1992, p. 293).

The television genre that has been subjected to the most analysis in relation to gender is British soap opera. Because it makes such a deliberated address to a female audience, analysis of soap opera's textual strategies offers valuable insights into questions of gendered representations, interpellation and reception. In the US, British soap opera is known as 'British social realist drama' to distinguish it from its more glamorous and fantastical American equivalents. Like the 'kitchen sink' dramas of the 1960s, British soaps focus on the gritty 'realities' of working-class life. Storylines hinge around family and community relationships and social issues such as crime, AIDS, teenage pregnancy, drug addiction, homelessness, marriage breakdowns and so on. The majority of British soaps are named after their fictional settings (*EastEnders*, *Coronation Street*, *Brookside*, *Emmerdale*), and the centrality of a single localised space provides these exceptionally long-running series (*Coronation Street*, for example, was first broadcast in 1960 and is still in production) with a continuity and consistency that transcends the inevitable changes of characters and cast members. Most of the action takes place in domestic or community spaces (the local pub, corner shop, café, launderette etc.). The soap's self-contained fictional setting is closed off from the rest of the world; characters live, work and socialise in the same constricted locality, forming an intense, introspective community of shifting personal relationships, allegiances and conflicts that pro-

vides the raw material for the soap's drama. Its realist aesthetic, characterised by naturalistic lighting and static camerawork, maintains a constructed 'ordinariness' that, together with the *faux* real-time effect achieved by the broadcast of several episodes a week, encourages familiarity and involvement with characters' daily lives.

Strong female characters predominate in British soaps, occupying central and active roles in both family and community. As Christine Geraghty points out, 'more frequently than other genres, soaps feature women characters normally excluded by age, appearance or status' (1991, p. 17). All age groups are represented, and familiar character 'types' (such as the grandmother figure, the spinster, the attractive mature woman, the flighty young woman) are common to all British soaps (see Dyer, 1981). Tania Modleski (1982 and 1983) analyses a variety of strategies that soaps use to address a specifically female audience. She notes how storylines, which usually centre upon relationships and characters' emotional states, make a deliberated appeal to women's traditional competences of understanding and caring for the emotional needs of others, positioning the female viewer as an omniscient 'ideal mother'. Soaps' segmented narrative structure, multiple synchronous storylines, dialogue-driven plots and reiteration of key events from different perspectives address the female viewer as a housewife who, busy during the day with domestic chores, needs to be able to drop in and out of viewing without missing vital information or losing the narrative thread. Soaps offer no single hero or overarching moral perspective; instead, they present and represent story events from the viewpoints of a variety of characters. As a result, soaps are characterised by moral ambiguities and contradictions that make them unusually open to interpretation; no one viewpoint prevails. The genre's refusal of absolutes and endless deferral of any 'final' resolution, Modleski argues, constitute its narrative form as distinctively feminine. The pleasures of viewing reside in processes of interpretation and a continuously rekindled anticipation, rather than in expectation of the sort of climactic denouements that characterise traditional linear narratives and which constitute, many scholars have suggested, a 'masculine' narrative form dedicated to closure.

Because the generic distinctiveness of British soap opera (like American soap) has its origins in a traditional notion of women as housewives and mothers, its evolution through the decades usefully traces changes in the status and lifestyles of women. Since the early 1980s, the most popular British soaps have been broadcast not in the daytime, to a presumed audience of housewives, but during

The male as vulnerable chauvinist – John Thaw as *Inspector Morse*

the prime-time 7.00–8.30 p.m. slot. The scheduling shift reflects the fact that women today are likely to be out at work during the day, rather than at home doing the house-work. At the same time, the later timeslot has meant that male viewers now constitute a far larger proportion of the audience. As a result, contemporary British soaps feature many more major male characters and action-oriented sto-rylines, reflecting not just the interests of male viewers but also the changing interests and experiences of women. While the emphasis upon relationships remains, explosive action (usually in the form of crime) is a regular feature of contemporary British soap opera. Increasingly, it is narra-tive structure rather than content that distinguishes British soap from other television genres.

Outside soap, gender constructions in British televi-sion are too varied to generalise about. Although broadly 'conventional' gender representations are still to be found in most genres, it is equally evident that, since the early 1980s at least, considerable efforts have been made by pro-ducers to present more complex and varied characters of both sexes. 'Hard man' action series of the 1970s such as The Sweeney (1974–78) and The Professionals (1977–81), which featured tough, no-frills male partnerships, have given way in the 1990s to the unreconstructed chauvinism and vulnerability of the curmudgeonly male protagonists of crime series such as Inspector Morse (1987–2000) and Dalziel and Pascoe (1997–). Such characters are essentially traditional patriarchal figures, but they rely on intelligence rather than brawn and their conservatism is presented as out of sync with contemporary society – a dislocation that is generally constituted as a weakness, symptomatic of a certain rigidity of values and thinking that is constructed as problematic in these series. In both series, older chau-vinistic male characters are paired with younger, more enlightened male colleagues who function as foils and bridges between the assumptions of the past and those of the present.

Women crime fighters surfaced on British television in the early 1980s, with leading female roles in series such as The Gentle Touch (1980–84) and Juliet Bravo (1980–85). These early portrayals of high-ranking women police offi-cers tended to emphasise a supposedly 'feminine' compas-sionate policing style that often seemed to have more to do with social work than with catching evil villains. But they broke new ground, putting women in charge of male teams in traditionally all-male working environments. Later series showed an increased willingness to diversify and complicate female characters, throwing off the burdens of 'feminine sensitivity' and 'superwoman' perfection. In the Emmy-award-winning Prime Suspect (1990–96), chain-smoking police inspector Jane Tennison (Helen Mirren) is high-powered and intelligent, but also edgy, obstinate, ruthlessly ambitious, self-centred and incapable of main-taining relationships outside her job. Coroner Sam Ryan (Amanda Burton) in the drama series Silent Witness (1996–) is an equally complex – though rather more sym-pathetic – figure, her professional success shadowed by fail-ures in her personal life. While this trend can be interpreted as simply reinforcing the notion that women must sacrifice their personal lives to achieve career success, it is worth noting that comparable male characters (Inspector Morse, Dalziel) share this inability to maintain personal relation-ships and family life.

Female action heroes have been few and far between – surprisingly so, given that British television produced the ur-heroine of the fantasy action genre in the form of The Avengers' Emma Peel (Diana Rigg). Emma Peel featured in The Avengers from 1965 to 1967 and brought a radical and powerful combination of female sexuality, intelligence and lethal combat skills to the small screen for the first time (see Miller, 1997). Despite the enormous popularity and iconic status of Mrs Peel, British television has subse-quently produced few female action heroes of any conse-quence, instead importing American series such as Xena: Warrior Princess (1995–2001), Nikita (1996–) and Buffy the Vampire Slayer (1997–). This lack reflects not cultural taste but rather the fact that the high production value end of the British television industry has tended to spe-cialise in period dramas which bring in significant rev-enue from the global television market. Series such as Pride and Prejudice (1995) and Wives and Daughters (1999), by their nature, broadly reassert gender stereo-types. They tend to feature brooding male heroes and strong-willed young women whose main preoccupation and ambition is marriage.

Perhaps the most unusual, and culturally specific, engagement with gender lies in British television's love affair with men in drag, a tradition that has its origins in nineteenth-century music hall. Entertainers such as Danny La Rue, comedian Les Dawson, Australian import Dame Edna Everage and the brassy blonde Lily Savage all enact an exaggerated 'pantomime dame' version of female-ness that slides headlong into the grotesque but also directs its pointed humour at masculinity and its inade-quacies. Such figures deliver, as this suggests, ambiguous and paradoxical messages; they may be interpreted equally as thoroughly misogynistic or as parodic enactments of femininity as performance. To this tradition, too, belongs the hugely successful comedy series Absolutely Fabulous (1992–95, 2001) – a show written, produced and acted by

Women (at last) behaving badly – *Absolutely Fabulous*

women. Patsy (Joanna Lumley) and Edina (Jennifer Saunders) do not only perform femininity but also, in their relentless alcohol-fuelled, sex-obsessed pleasure seeking, hold up a mirror to a certain brand of masculine irresponsibility and 'laddism'. In the 1990s, women on British television, it seems, have at last earned the right to behave badly.

Sara Gwenllian Jones

RECOMMENDED READING

Brunsdon, Charlotte, D'Acci, Julie and Spigel, Lynn (eds) (1997), *Feminist Television Criticism: A Reader*, Oxford: Oxford University Press.

Dyer, Richard (ed.) (1981), *Coronation Street*, London: BFI Publishing.

Fiske, John (1992), 'British Cultural Studies and Television', in Robert C. Allen (ed.), *Channels of Discourse, Reassembled*, London and New York: Routledge, pp. 284–326.

Geraghty, Christine (1991), *Women and Soap Opera: A Study of Prime-time Soaps*, Cambridge: Polity Press.

Morley, David (1986), *Family Television: Cultural Power and Domestic Leisure*, London: Routledge.

Gender and US Television

The study of gender and US television has emerged from two primary perspectives. In the 1970s, feminist social scientists in the field of communication began using quantitative and qualitative methods such as content analysis to examine the formation of gender roles and stereotypes in the media. One of the limitations of this research was that it identified 'positive' and 'negative' gender portrayals, but did not address the historical, institutional or structural conditions that generated such portrayals in the first place. Another perspective came from feminist film theorists in the humanities who were drawing upon literary theory, psychoanalysis and cultural Marxism to analyse how genders are constructed and reproduced within systems of mass culture. This work treated gender images as products of capitalist and patriarchal systems and ideologies, and tried to analyse them in relation to shifting socio-historical conditions. This essay focuses on the latter perspective, which has become the established paradigm for research on gender and US television in the humanities, and has since influenced social scientific perspectives.

Most early humanities research on gender and US television focused on the soap opera genre. In the late 1970s and 1980s, feminist film critics who had been using psychoanalytic theories to study classical Hollywood cinema, particularly melodrama, began adapting some of these ideas to study TV soap opera. This scholarship suggested the need for a reworking of feminist film theories concerning the gaze, the apparatus, spectatorship and identification in order to account for the specificities of television content and form. Both Tania Modleski (1979; 1983) and Sandy Flitterman-Lewis (1992) wrote seminal essays that explained how television narrative, editing, *mise en scène* and viewing practices differed from those of film. Modleski's work focused on the rhythms of television and domestic labour, suggesting both were structured around patterns of distraction and interruption. Since the episodic, multi-linear narrative structure of the soap opera is tailored to women's work in the home, women's entertainment and pleasure, she argued, ultimately occurs in the service of patriarchy. Modleski also revealed how the narrative structure of soap operas interpellates the female viewer as an 'ideal mother' or a 'moral and spiritual guide', providing her with omniscient access to characters' motives and desires, while at the same time encouraging her to repress and sublimate her own. Sandy Flitterman-Lewis (1992) considered whether film theory could be adapted to describe television viewing at all, given its different aes-

thetic and narrative properties. Her careful examination of soap opera segments and television commercials suggested that commercials continued the impulse for narrative rather than interrupting it. These and other studies by Robert Allen (1985) and Laura Stemple Mumford (1995) helped to establish a body of critical literature on soap opera.

While some scholars focused on soap opera, others began to explore different aspects of gender and television. One of the early outlets for humanities-based feminist television scholarship was the feminist film theory journal *camera obscura*, which began publishing work on television in the 1980s. Pathbreaking essays by Lynn Spigel on 1950s television sitcoms and domestic space, Sasha Torres on the hit 1980s drama *thirtysomething*, Constance Penley on *PeeWee's Playhouse* and Lynn Joyrich on 1950s television melodrama spurred further interest in gender and US television. Other journals such as *Critical Studies in Mass Communication*, *Journal of Communication Inquiry*, *Film Quarterly*, *Cinema Journal*, *Screen* and *Wide Angle* also published work on gender and television during this period. Scholars began examining sitcoms such as *I Love Lucy*, dramas such as *Magnum PI* and *Miami Vice*, the music videos of Pat Benetar and Madonna, and sports programming as well. By the early 1990s a group of feminist television scholars organised 'Console-ing Passions: The International Conference of Feminism, Television and Video', which was first held at the University of Iowa in 1992 and has since become one of the main venues for research on gender and television.

Some of the most influential work on gender and US television has come from feminist scholars working from a historical perspective. Lynn Spigel and Mary Beth Haralovich, for example, insisted that 'gender' and 'television' could only be understood by examining a complex set of socio-economic, industrial and textual relations. In her book *Make Room for TV* (1992), Lynn Spigel analysed social and cultural discourses on television technology and the family in the 1950s and developed a framework for exploring how television's installation altered gender relations in white middle-class suburbs during this period. Spigel's book provided an important model for understanding the social construction of television technology while simultaneously initiating a feminist historiography of the medium. Mary Beth Haralovich (1989) explored how social and industrial discourses addressed homemakers as the 'ideal consumers' of 1950s television as well as the host of new commodities that appeared within it. Their work generated a wave of historical feminist television scholarship. Collections such as Lynn Spigel and Denise

Mann's *Private Screenings: Television and the Female Consumer* (1992), Mary Beth Haralovich and Lauren Rabinovitz's *Television, History, and American Culture: Feminist Critical Essays* (1999) and Janet Thumim's *Small Screens, Big Ideas: Television in the 1950s* (2002), as well as Anna McCarthy's *Ambient Television* (2001), extended Spigel's and Haralovich's early work in different directions. In addition, research by scholars Moya Luckett (1999), Ella Taylor (1989), Elana Levine (2002), Jane Feuer (1995) and Kathleen Rowe (1995) explored how changes in television programming coincided with changes in gender discourses during the 1960s, 70s and 80s. Their research examined series such as *Peyton Place*, *Mary Tyler Moore*, *Charlie's Angels*, *Moonlighting* and *Roseanne* respectively. Michele Hilmes (1997) even pushed this historiography back before the age of television, examining how the practices of early radio networks (like the designation of daytime as women's programming) initiated the gendering of broadcasting long before television made its way into the living room.

As feminist dialogues about US television continued, scholars began to recognise conspicuous absences in some of this early research, particularly around issues of racial/ethnic and sexual difference. Jacqueline Bobo and Ellen Seiter made a crucial intervention in 1991 with their essay 'Black Feminism and Media Criticism', which analysed the made-for-television movie series *The Women of Brewster Place*. In the essay, they also critiqued the ethnocentricity of feminist cultural criticism, arguing that 'black women and other women of colour have been either neglected or only selectively included in the writings of feminist cultural analysts' (Bobo and Seiter, 1991, p. 168). Herman Gray's (1995) research on black sitcoms such as *The Cosby Show* and *Frank's Place* also demonstrated the complexity of racial representation on US television, reminding us that racial politics are inextricably tied to television's construction of family life and civil rights in the US. And Sasha Torres' anthology *In Living Color* (1998) brought together research about television and the history of racism in the US, pushing the analysis to include Native, Latino and Arab Americans as well.

In an effort to integrate sexual difference into critiques of television, queer studies scholars began to analyse images of gays, lesbians and bisexuals, especially as 'out' characters made their way on the airwaves in shows like *LA Law*, *Roseanne*, *Ellen*, *Spin City* and *Will and Grace*. Larry Gross provided one of the first comprehensive analyses of gay and lesbian representation in US media with his book *Up from Invisibility* (2001). Other queer critiques of US television, many inspired by Alexander Doty's book *Making Things Perfectly Queer*

(1993), considered commercial programmes featuring 'straight' characters as a way of demonstrating how queer reading strategies became a matter of necessity (and sexual survival) in a hetero-normative society.

In the mid-1990s the study of gender and US television shifted to other genres such as prime-time dramas, talk shows and science fiction series. One of the most important studies to emerge was Julie D'Acci's book *Defining Women: Television and the Case of Cagney and Lacey* (1994), which painstakingly detailed the industrial, social and textual negotiations required to place two female cops in CBS's prime-time detective series. Not only did D'Acci's study posit 'gender' as a process of ongoing sexual, class and racial/ethnic differentiation, it also set a new standard in TV studies by formulating a comprehensive method for studying television, meaning-making processes and historical change, which D'Acci named the 'integrated model'. Other scholars such as Mimi White and Jane Shattuc recognised the surging popularity of the talk show. White's *Tele-Advising* (1992) exposed the confessional and therapeutic discourses operationalised in the talk show format, linking them to structures of family and consumer life in the US. Shattuc's *The Talking Cure* (1996) evaluates whether the talk show can offer anything like a public sphere, and explains how transgressive gender, race and class representations are sometimes recuperated to affirm social norms and sometimes used to challenge them. Moving the study of gender and US television 'out there', Constance Penley (1989) and Henry Jenkins (1992) both published widely cited studies of *Star Trek* fan communities. Their research interwove feminist, queer and TV studies to explore the parallel worlds imagined by science-fiction slash fans, who rewrite episodes according to their own utopian desires. This research on science fiction spurred further work on fandom and cult TV, particularly on series such as *The X-Files*, *Xena: Warrior Princess* and *Buffy the Vampire Slayer*, which featured powerful female characters that often challenged gender norms.

As critical discourses of multiculturalism and globalisation gained influence in the 1990s, feminist television scholars began to develop more complex definitions of gender that took into account racial/ethnic, sexual and national differences. The book *Feminist Television Criticism* (Brunsdon et al., 1997) represented an attempt to internationalise the study of gender and television in the US by assembling classic essays by scholars from the US, UK, India, Canada and Australia. The editors of the anthology were careful to include essays on gender and television across different genres, sexual, racial/ethnic and class backgrounds, and national contexts. The project also demonstrated the inter-

disciplinarity of the field, bringing together scholars in television and film studies, communication, anthropology, history, sociology and women's studies. New research on gender and television outside the US has begun to shape and extend critical dialogues in important new directions. Purnima Mankekar's fascinating book *Screening Culture, Viewing Politics: An Ethnography of Television, Womanhood and Postcolonial India* (1999) is suggestive of the fruitful research generated through interdisciplinary thinking. Combining approaches from anthropology, cultural studies and television studies, Mankekar explores how upwardly mobile urban women engage with state-sponsored television serials in India, and maps a framework for future analyses of gender and television in other national contexts.

Another trend in the study of gender and US television is underpinned by television's convergence with new technologies. As the medium takes on new configurations, scholars have considered how television's content and form has changed with cable, satellite and computer technologies. In 1994 a special issue of *camera obscura* explored the formation of the first cable television channel for women, Lifetime. Recently, scholars have begun to analyse the new women's network Oxygen Media, which promises to 'superserve women's interests' by offering content via cable, satellite and the Internet (Everett et al., 2003). As television converges with digital technologies in the 1990s and 2000s, feminist scholars remind us of the need to analyse sites of technological convergence as sites of gendered discourse and power struggles (Seiter, 2000; Parks, 2003). During such moments there is a potential for new content and forms of television to emerge and for further democratisation of media access, but gendered assumptions still surround television and computer technologies and often circumscribe their use as a result. Still, one of the promising aspects of technological convergence is the possibility that new televisual forms might emerge. This has been a persistent concern of Margaret Morse, whose work has ranged from a provocative study of television's structural similarities to freeways and shopping malls (1990) to her more recent book *Virtualities* (1998), which examines television, video and digital art. Morse's research is especially significant because it imagines the possibility of a feminist re-tooling of television and computer technologies and moves the critical discourse on gender and US television beyond the study of commercial entertainment alone. Such work encourages scholars and media-makers alike to pursue new constellations of television and computer technologies, and challenges us to keep our thinking about the forms and meanings of 'television' dynamic.

Lisa Parks

RECOMMENDED READING

Brunsdon, Charlotte, D'Acci, Julie and Spigel, Lynn (eds) (1997), *Feminist Television Criticism: A Reader*, Oxford: Oxford University Press.

Haralovich, Mary Beth and Rabinovitz, Lauren (eds) (1999), *Television, History, and American Culture: Feminist Critical Essays*, Durham: Duke University Press.

Kaplan, E. Anne (1992), 'Feminist Criticism and Television', in Robert Allen (ed.), *Channels of Discourse, Reassmbled*, Chapel Hill: University of North Carolina Press, pp. 247–283.

Spigel, Lynn and Mann, Denise (eds) (1992), *Private Screenings: Television and the Female Consumer*, Minneapolis: University of Minnesota Press.

Television in the Home

Television is a domestic medium: it remains *the* dominant medium of national domestic cultures and occupies a great proportion of household leisure time. All of this is fairly self-evident and indeed television's very 'everydayness' presents particular problems and challenges to researchers who have approached this most important characteristic of television in different ways. Television is placed, watched and used within different kinds of domestic settings across the globe, and as such presents itself as an important and constitutive part of national domestic life. Television is also important in that it brings the public into the private domain. It is then, at its core, a contradictory medium. It offers a 'window on the world' for those in the sitting room while bringing that world into the familiar, the domestic, the everyday. But, arguably, it is a domestic medium in another sense. It is aware of itself as a domestic form. In other words, its output and mode(s) of address assume a domestic audience. This is evidenced in the scheduling of programmes which are shaped on assumptions as to who is available to watch at specific times of day (Paterson, 1980). Television also has a distinctive visual and aural form which Raymond Williams conceptualised as 'flow', a seamless transmission of programming (Williams, 1974), while John Ellis, contrasting broadcasting with cinematic address, drew attention to the rapid segmentation of scenes which assume a distracted (domestic) audience (Ellis, 1982). Although Williams and Ellis had little to say about audience, their observations evoke ideas of the viewers at home. The study of television in the home can be categorised as follows: historical developments, 'family television', and media and everyday life. The key themes which have informed these studies are: place, space and boundaries; public and private; power relations, especially of gender and class; taste preferences and access; technology and globalisation.

Historical studies have explored how and in what ways television arrived in homes especially in the US and Britain. Lynn Spigel analysed the complex public discourses of television, home and family in the US in the 1950s (Spigel, 1992) and Tim O'Sullivan gathered personal memories of the arrival of television in the home (O'Sullivan, 1991). Both studies discuss how television changed the shape and physical dimensions of domestic settings and other scholars have demonstrated how television has shaped our ideas of the domestic, of time and space and articulated the so-called private world of domestic with the wider life of the nation.

It is true to say, however, that the majority of studies of television in the home have focused on the contemporary activities of the domestic viewer. Early research into television had tended to focus on analysis of text and especially institution. The former took its frameworks from literary studies and semiotics while the latter adopted a political economy and sociological approach. The audience was traditionally taken to be a mass of pretty easily influenced individuals, and studies tended to reinforce this conception. Ideology was a key concept in understanding the relationship between media message and audience 'effect'. The actual, domestic context of viewing was certainly neglected until the 1970s and was increasingly informed by a reconceptualisation of the audience as diverse and active in character and viewing practice. As scholars began to research the significance of the domestic with regard to reception, feminist scholars argued that the domestic is a far from neutral space, but is made up of a dynamic network of relationships, often organised around power and inequality. The domestic, they said, is inhabited differently by men and women. Actually getting to watch television was often fraught and had to be struggled over within the chaos of daily life. Dorothy Hobson, in her pioneering study of housewives at home watching soap opera (Hobson, 1982), soon found that demands and obligations of domestic and childcare duties threatened and disrupted the concentrated pleasure of viewing a favourite soap opera. David Morley and Ann Gray found that viewing patterns and habits varied according to gender and, significantly, that power relations were brought to bear on things as mundane as who controls the remote control and who decides what should be watched on the communal screen (Gray, 1987, 1992; Morley, 1986).

The domestic, then, is a dynamic and often contradictory site that must be attended to if we are to understand

THE 'CULTURAL POLITICS' OF TELEVISION IN THE HOME

The following are examples of the cultural political frameworks which researchers have used in their approaches to specific – usually small-scale qualitative – studies of household uses of television and other related communications and entertainment technology:

- preference and availability;
- social shaping of technology;
- gender dynamics and viewing choice;
- politics of the domestic in relation to media use;
- public discourses articulated within the private;
- diasporic identities;
- crossing boundaries and shifts in time and space;
- taste, class and gender;
- television (and other new media) as technology;
- formations of national identity;
- changing discourses of nationalism and national identity.

Ann Gray

what happens when people watch television. The viewing context is not singular but plural and can vary depending upon those who are watching and what is being watched. Attention to the phenomenology of television viewing suggests that, while the relationship of viewer to text is significant, what goes on socially during and after television viewing is as much a part of what we understand as 'watching television' as is the interpretation of texts. Studies of television and the family have revealed that television viewing, within complex family life, functions in many different ways. Scholars turned their attention to the *how* of television watching within the domestic setting, observing how different family members related to each other and the television at different times of the day and week. This is to give television an unprivileged but active part in family and household dynamics – very much in contrast, for example, to those who see television as dominating family life or 'replacing' more traditional social activities within the household (Bryce, 1987). Of course, 'family' households and, indeed, notions of 'the family' vary a great deal according to social, cultural and national setting. James Lull's work has revealed the comparative differences with examples from China and the US (Lull, 1988, 1991).

The 'family television' studies in the main treat 'television' as a stable, knowable phenomenon which can be used by households in a number of ways. More recent studies

suggested that the meanings of television and other communications technologies cannot be decided outside of the context of their use. This is to acknowledge the 'profound embeddedness of television consumption in everyday life', requiring a research perspective which Ien Ang calls 'radical contextualisation' (Ang, 1996, p. 69). Ang is aware of the infinite expandability of the notion of context, but suggests that if researchers approach their study within a framework of a *cultural politics*, then these specific concerns, e.g. gender and identity, national identity, race and ethnicity (see below), can be foregrounded in the research design. By attending to the quotidian of television watching and media use more generally, scholars have placed new items on the research agenda. Theories of subjectivity, identity and community provided important frameworks for more radical ways of thinking about media use and subjectivity. This is to say that television can be used in shaping a sense of self and of others.

New questions are now being brought to bear on television in the home. These are related to the changing landscape of television and media more generally, especially the impact of globalisation on the availability and nature of programming, which threatens to confound the sense of a national cultural sphere inhabited by broadcasters and viewer/citizens alike. Television itself is diversifying and fragmenting in both form and content. Different patterns of institutional ownership, satellite, cable and potentially interactive forms of television are changing not only the 'look' of television, but also how it is watched. Households in the West are now likely to have more than one television set, with the kitchen and the bedroom as designated places for viewing, displacing the previously sacrosanct 'sitting room'. New questions are required and have already been explored through more recent studies, which have incorporated newer media forms as technology and where television becomes *one* possible communications medium available for use (Moores, 1996, 2000; Morley and Silverstone, 1990).

The cultural study of television in the home has always insisted on relating the micro-processes of television use to their broader social and cultural contexts. Two examples of more recent studies grounded in household television viewing have put substance into often empty categories of identity, modernity, tradition and post-colonialism. Marie Gillespie examines the use of television and video by young Punjabi people in South London. Issues her study raises centre around questions of identity and tradition and the extent to which television and film are articulated within the contradictions of tradition and modernity (Gillespie, 1995). Purnima Mankekar, in her study of television view-

ing by families in New Delhi, India, explores the attempt by the national broadcasting network to construct a consumer culture, and especially the role of the post-colonial Indian woman as symbolic of new kinds of national identity (Mankekar, 1999).

Close attention to the seemingly banal events around television sets in the home provides rich data which, when analysed, can make a considerable contribution to our understanding of the articulation of global and national media in the cultures of everyday life.

Ann Gray

RECOMMENDED READING

Bryce, J. (1987), 'Family Time and Television Use', in T. Lindlof (ed.), *Natural Audiences*, Norwood, New Jersey: Ablex.

Gray, A. (1992), *Video Playtime: The Gendering of a Leisure Technology*, London: Routledge.

Lull, J. (ed.) (1988), *World Families Watch Television*, Newbury Park and London: Sage.

Morley, D. (1986), *Family Television: Cultural Power and Domestic Leisure*, London: Comedia.

O'Sullivan, T. (1991), 'Television Memories and Cultures of Viewing, 1950–65', in J. Corner (ed.), *Popular Television in Britain: Studies in Cultural History*, London: BFI Publishing.

Out-of-home TV networks

Although we don't always notice them, television and video technologies are commonplace elements of social space outside the home. Their uses in non-domestic venues vary widely. Television viewing in public places can be an opportunity for collective interaction with strangers and friends, and certain type of programmes in particular – soap operas, live sporting events – bring large groups of people together in communal social activities (Lemish, 1982; McCarthy, 1999; Wenner, 1998). In other cases, the presence of TV sets (e.g. small coin-operated receivers in transit areas) allows individuals to separate themselves from others, using spectatorship as a way of creating a zone of privacy. And in other sites still – for example, the music and video retailers' large videowalls displaying rapidly changing and mixing images – the image serves as an ambient, architectural element rather than a focus of a viewing gaze (Simpson, 1997).

These very divergent possible uses of TV screens outside the home, ranging from commerce, to community, to entertainment, convey the video medium's ability to inte-

grate closely with the social structures that characterise its location. The interactions around, and placement of, TV sets in everyday locations reflect the rhythms of social life within such sites. This is true not only for out-of-home TV but also for television in domestic space; as has often been noted, home viewing is an activity in which broader familial power struggles are played out (Lull, 1990; Morley, 1990; Spigel, 1992). Indeed, localised struggles over the uses and parameters of TV viewing can always teach us something about the broader forms of power and contest that organise a particular social environment. In the United States, for example, dry-cleaners, laundromats, gas stations and other small work spaces often feature television sets. In such spaces, TV helps employees pass the time and ameliorate the routines of the workspace. Its presence helps collapse distinctions between work and leisure on the job and, in service locations especially, the physical placement of the screen can serve to demarcate public and private areas of a space (McCarthy, 2001, pp. 132–5).

However, although such small-scale and individualised placements of the TV screen are probably the most commonplace uses of the technology, a more economically significant use is its deployment on a larger scale, in the form of in-house, satellite-delivered networks designed for sites of work, transit and leisure like the airport or the shopping mall. Such spaces are increasingly becoming hosts for commercial television programming. Distributed by corporations such as CNN Private Networks, these programmes are usually commercially sponsored, beamed by satellite to a number of sites simultaneously. They can be amazingly specific in the audiences they target: one rather extreme example is the Newborn Channel, placed in post-partum delivery rooms to provide new mothers with instruction on matters such as breastfeeding and infant health, and featuring advertisements for newborn-related products. Out-of-home TV networks tailored for particular sites and their users started to appear in Europe at the end of the 1990s, but they arose a decade earlier in the United States. The first one to attract success in the form of major sponsors was the Cable News Network's 'Airport Channel', later known as CNN Airport Network. The company's version of its own history is intertwined with the oft-told story of CNN's rise to prominence in the same period. Deborah Cooper, a vice president of the Airport Network, told a *New York Times* reporter in 2000 that the network was born out of viewer demand, getting its start from the high demand for CNN news during the Gulf War in 1991, 'when passengers were stuck in airport terminals during

TV AND BRAND EQUITY IN THEME RETAILING

Increasingly, media companies have their own stores, and in-house television systems feature prominently within them. In addition to motion picture companies like Warner Bros. and Disney, cable television companies have started to establish stores in shopping malls and urban entertainment destinations like New York's Times Square. Viacom, the parent company of a number of cable channels in the United States, has its own retail outlet, as does its subsidiary, the child-oriented TV network Nickelodeon. The goal of the latter stores, a goal supported by their in-house media, is less the sale of goods than it is the reinforcement of the corporate brand. As an article in *Advertising Age* noted, the goal of the Nickelodeon stores was to 'bring [the] brand to life . . . Stores are painted green, orange and purple. Costumed characters roam the aisles, and employees cater first to kids. Interactive elements allow customers to make stickers, while a kid-only "Hideout Hut" houses a large screen TV that can entertain children while parents shop' (Jensen, 1997, p. 45).

This kind of environmental immersion is designed to strengthen 'brand equity'. The term refers to the value assigned to a brand; as a form of corporate asset, brand equity is closely monitored in investment circles and can be a central factor in mergers and acquisitions. In establishments where the commodity for purchase is quite literally a media image, like the Viacom store or Discovery Communications stores, brand equity involves giving the characters on screen a life off screen, in the world of the consumer. In-house media are often enlisted for this purpose; for example, both the Disney store

and the Warner Bros. store, both selling products based on *animated* characters, render the sales floor an ersatz Hollywood soundstage with movie lights and other scenographic elements associated with the film studio. In the Disney store, human-size models of Disney characters point boom microphones at the overhead screens on which Disney movies play, involving the TV set in a fantasy scenario that collapses Disney production and reception and brings animated characters to life.

In making the store seem like a place where media images are not only sold but *made*, video screens help promote the idea of on-screen images as discrete commodities. The large screen in the Warner Bros. store, continually playing classic Warner Bros. movies and cartoons, can be specially programmed to frame and isolate different aspects of the image. In one industry magazine illustration, the computer control carves one narrative moment into multiple views (Bugs Bunny emerges from his star dressing room to encounter a janitorial Daffy Duck). The image of Bugs Bunny is enlarged on one segment of the videowall; other areas show a portrait of Bugs, a medium shot of Daffy Duck, and a long shot of the scene. Installed in a prominent place in the store, this screen parses the image into its characterological elements – which are also, of course, its most commercial components.

Point-of-purchase video is a commonplace element of the retail landscape. But what is striking about such single-brand retail uses of video is the way they help extract several image commodities from one source, promoting the brand's presence in everyday life in the process.

Anna McCarthy

an international crisis and began clamoring for access to CNN's live coverage of a war that had everyone glued to television' (Sharkey, 2000, section C9).

There are reasons to question such accounts of the rise of the out-of-home network. Industry coverage of the Airport Network and others suggests that their success derived from a quite different set of circumstances. One crucial factor was the 1980s' crisis in ratings and audience measurement, a crisis precipitated by the growth of cable television and the introduction of new audience measurement techniques like the 'People Meter'. Both of these developments showed that audiences for the 'big three' networks (NBC, CBS, ABC) were smaller than previously believed and, additionally, that home viewers were not always paying much attention to the TV set when it was on (Ang, 1991, pp. 68–97). The networks joined together in

response to this state of affairs, and – via the National Television Association (NTA) – jointly commissioned a Nielsen study of the out-of-home audience. In searching out non-domestic viewers, their goal was twofold: to demonstrate that most TV sets outside the home are tuned to network programming and, additionally, to give the out-of-home audience a *value*, as a commodity exchanged for sponsorship, in the ratings-based economy of commercial broadcasting (McCarthy, 2001, p. 97). The study did find a large number of out-of-home viewers, the majority of whom were watching network television. According to the director of research for the NTA, this audience was significant because its very existence reflected broader lifestyle changes among consumers in this period: 'a rise in the number of working women, college students, and business travellers . . . indicates it is increasingly important for the

industry to quantify all television viewing, regardless of viewing location, and to track the viewing behavior of these important demographic groups' (quoted in Layne, 1993).

A second institutional factor contributing to the development of out-of-home TV networks was the growing concern among advertising professionals with the phenomenon known as 'clutter'. A popular agency 'buzzword' in the 1980s, *clutter* refers to the idea of media saturation. Industry professionals postulate that the more advertising a viewer is exposed to, the less effective any individual ad's sales pitch will be. According to out-of-home TV industry professionals, home-viewed advertisements were prone to the clutter effect because of the increasing number of ads appearing on TV; on top of this, viewer behaviours like 'zapping' (avoiding commercials with the remote control) made the home suddenly a site of profound uncertainty when it came to *knowing* advertising audiences. Clutter, zapping and, especially, the ratings slippage of the 'big three' networks led advertisers to diversify their media buys at the end of the 1980s (Rothenberg, 1989). In these years preceding the Internet, out-of-home television was the cutting edge of new and alternative media, part of the expanding advertising category of 'place-based media', and it found a small place on many national advertisers' promotional budgets.

As a category, place-based media marks the ascendancy of niche marketing models in advertising. As the president of the Resort Sports Network of Maine noted, 'Place-based media really is about reaching niche-based audiences' (Rory Strunk, quoted in Mandese, 1995). Place-based media allowed marketers to equate demographics with location in ways more precise than traditional spatially modelled consumer classification instruments, which generally targeted consumers based on postal code information. Specifically, they allowed networks to offer advertisers an 'audience commodity' that was defined in very precise terms by virtue of its location in public space. For example, because people in medical waiting rooms can be assumed to be in ill-health, advertising for over-the-counter medications would, by this logic, find an audience more attentive and receptive than in other places (Jackson, 1997). Advertisers found this logic attractive because it allowed them to intervene in the consumer decision-making process close to the point of sale: the place where – according to market research – most decisions about brand purchases are made (Berstell, 1992). Researchers for Lifetime Medical Television, a network designed to target women consumers in waiting areas, discovered, after following women after they left the waiting room, that many women visited pharmacies directly after their doctors' visits (Moore, 1990). Although such research does not prove that these women bought the products advertised in their waiting rooms, it produced the kind of highly specific, contextual knowledge about consumer itineraries and movements that has a high value in the economy of the advertising business. It is because they allow for this kind of targeted advertising that out-of-home TV networks – whether we watch them or not, and regardless of how much they annoy us – are here to stay.

Anna McCarthy

RECOMMENDED READING

Lemish, Dafna (1982), 'The Rules of Viewing Television in Public Places', *Journal of Broadcasting*, vol. 26, no. 4, pp. 758–81.

McCarthy, Anna (2001), *Ambient Television: Visual Culture and Public Space*, Durham, NC: Duke University Press.

Wenner, Lawrence A. (1998), 'In Search of the Sports Bar: Masculinity, Alcohol, Sports, and the Mediation of Public Space', in Genevieve Rail (ed.), *Sport and Postmodern Times*, Albany: State University of New York.

Gender and Queerness

In television and cultural studies, the term 'queer' has described two overlapping concepts. It can refer to (but is by no means limited to) representations of self-identified 'queer' characters (lesbian, gay, bisexual or transgendered). More precisely, however, 'queer' describes characters, relationships, sensibilities and cultural vocabularies that may be understood as 'queer' whether or not they are explicitly identified as such in the text itself; homosexuality, homosociality, camp, hypermasculinity, and gender and/or sexual ambiguities are all aspects of queerness. In its latter use, queerness is commonly constituted, and celebrated, as an effect of active interpretation by 'queer readers' who respond to suggestive or ambiguous meanings in the text. This connotative, allusional or 'subtextual' notion of queerness, in which queerness is considered to be a product of reading practices rather than a set of textually present meanings, has been strongly criticised by theorist Alexander Doty. Queerness, Doty argues, 'is only "connotative", and therefore deniable or "insubstantial", as long as we keep thinking within conventional heterocentrist paradigms, which always have already decided that expressions of queerness are *sub*-textual, *sub*-cultural, *alternative* readings, or pathetic and delusional attempts to see something that isn't there . . .' (Doty, 1993, p. xii).

Doty points out that the heterosexuality of film and television characters is usually assumed, even where the text furnishes no explicit information about characters' sexual orientations, while queerness is always called upon to prove itself. Rejecting a subordinate status for queerness, Doty argues that straight readings of texts are also a matter of interpretation:

> I've got news for straight culture: your readings of texts are usually 'alternative' ones for me, and they often seem like desperate attempts to deny the queerness that is so clearly a part of mass culture. (1993, p. xii)

Same-sex relationships in television series are often sites of queer meaning, play or potential. Discussing American situation comedies such as *Laverne and Shirley*, *Kate and Allie* and *The Golden Girls*, Doty notes 'the lesbian tenor or temper' (1993, p. 42) that accompanies their emphasis upon emotional bonds between women. Similarly, series such as *Batman* (1966–68) and *Cagney and Lacey* (1982–88), which prioritise a homosocial primary relationship between their protagonists, have attracted substantial gay and lesbian followings (see Brooker, 2000, and D'Acci,

1994). But it is not only 'queer' viewers who may understand homosocial relationships between television characters as having an inherently queer aspect. In his 1992 study of television fan cultures, Henry Jenkins discusses 'slash' fiction – fan writing that describes erotic encounters between television or film characters of the same sex (Jenkins, 1992, pp. 185–222). Slash authors, Jenkins observes, are usually heterosexual women writing about romantic sexual relations between male characters. Series such as *Star Trek*, *The Professionals*, *Starsky and Hutch* and *The X-Files* have each inspired thousands of such stories. Through slash, Jenkins argues, heterosexual women authors articulate 'a refusal of fixed-object choices in favor of a fluidity of erotic identification, a refusal of pre-determined gender characteristics in favor of a play with possibility' (Jenkins, 1992, p. 189). Jenkins' formulation of slash could serve equally well as a definition of queerness itself.

Queerness is not confined to representations of the homosocial or the homoerotic. It also may be identified in texts which undermine or problematise the naturalised performance of heterosexuality. For example, in the *Star Trek: Voyager* episode 'Someone To Watch Over Me', the female cyborg Seven of Nine (Jeri Ryan) decides to find out more about human (heterosexual) romance. To this end, she goes on a date with a crewman. Her bewildered inability to perform conventional femininity or romantic interest manifests in a series of inappropriate responses and comic mishaps. After accidentally dislocating her date's shoulder as they dance, Seven eventually concludes that 'dating is a poor means of interaction'. Here, queerness resides not in any expression of homoerotic attraction but rather in Seven's insurmountable disinterest in and incomprehension of the rituals of conventional heterosexual romance. Queerness occurs 'within the space of the contraheterosexual and the contra-straight' (Doty, 1993, p. 15).

Until the late 1980s, explicit representations of lesbians and gay men were rare in television programmes. Where they did occur, they usually repeated the same old stereotypes: limp-wristed sissies like Mr Humphries in the British situation comedy *Are You Being Served?* (1972–84); confused and unhappy young men like Steven Carrington in the American soap opera *Dynasty* (1981–89); or aggressive butch lesbians like Frankie in the Australian prison drama *Prisoner Cell Block H* (1979–86). Lesbians and gay men were represented as deviant, tragic, predatory and/or comic figures. Their presence on the small screen was intended to elicit horror, laughter, pity or disgust from a mainstream heterosexual audience.

In the late 1980s, British television began to enthusiastically include a variety of lesbian and gay characters in

Uninhibited and unapologetic – *Queer As Folk* (UK)

XENA: WARRIOR PRINCESS (RENAISSANCE PICTURES/STUDIOS USA, 1995–2001)

Cult television series *Xena: Warrior Princess* (*XWP*) relates the adventures of leather-clad Amazonian warrior Xena (Lucy Lawless) and her companion/lover Gabrielle (Rénee O'Connor). Filmed in New Zealand, the series is set in a fantastical pre-Christian world that is, in Kathleen E. Bennett's words, 'a place free of today's obsessions with sexual identity politics and not obliged to provide any historical verisimilitude' and is therefore 'a realm open to the imagination, culturally and erotically' (Bennett, 1997, website).

Explicitly queer – *Xena Warrior Princess*

XWP is an explicitly 'queer' text rather than an explicitly 'lesbian' one. The exact nature of the relationship between Xena and Gabrielle is never finally stated; in some episodes, one or other is involved in a heterosexual romance, in others lesbianism is subtly alluded to, while in many other episodes the lesbian relationship is so strongly implied as to render heterosexuality, rather than lesbianism, 'subtextual'. Come what may, the primary relationship between Xena and Gabrielle is always upheld. The fluidity, ambiguities and pervasiveness of the series' play with gender and sexuality make it an excellent subject for analysis of the many ways in which queerness can be textually constructed and situated. Xena and Gabrielle conform, in some respects, to a stereotypical 'butch and femme' model of lesbian. Xena is tall, athletic, taciturn and aggressive; Gabrielle is smaller, feminine, talkative and a pacificist. Xena wears dark leather armour and fights with a sword and chakram (a circular bladed disc), while Gabrielle wears soft earth colours and fights with a staff. Comedy episodes such as 'Warrior . . . Princess' and 'Here She Comes, Miss Amphipolis' emphasise Xena's inability to successfully perform femininity – failures that campily foreground a notion of gender itself as cultural performance.

Often, the storyline itself entails that the characters be read as queer. Many episodes involve the 'loss' of either Xena or Gabrielle and relate their desperate, sometimes death-defying, attempts to reunite. Seemingly innocuous dialogue and actions are rendered 'queer' by the performances of the actors, who add emotional intensity to simple lines and play with *double entendres*. In addition to Xena and Gabrielle's frequent declarations of love for and commitment to each other, the series' dialogue includes many in-jokes and asides that rely upon an understanding of Xena and Gabrielle as a couple for their meaning and/or humour. For example, in the episode 'For Whom the Bell Tolls', Joxer asks Xena if a mark on her neck is a 'hickey' (love bite) and Gabrielle responds with an exaggerated embarrassment that suggests she and Xena are lovers. Queer meanings are also added in the editing process by juxtaposi-

tions that subtly invite queer interpretations of plot events. For example, in the episode 'Crusader', Xena finds herself competing with Najara, another female warrior, for Gabrielle's affections. After losing to Najara in a bar-fight, Xena tells the barmaid that Najara has a weakness and 'it's the same one I've got': the scene immediately cuts to a medium shot of Gabrielle.

Lesbian and bisexual fans of *XWP* frequently express both frustration and fascination with the series' refusal to make explicit a lesbian relationship between Xena and Gabrielle. The teasing, ambiguous, connotative construction of the characters' relationship is undoubtedly a source of pleasure for a great many fans, engaging their imaginations and inviting speculation in the discussions, critical essays and fan fiction stories that are the central arena of active fandom. In an essay titled 'Why Subtext Should Never Become Maintext in *Xena: Warrior Princess*', fan Fiona Hough points to series such as *Moonlighting* and *Lois and Clark* that constructed 'subtextual' heterosexual relationships between their main characters. These series, Hough points out, immediately lost their tension and appeal when their producers allowed these relationships to start 'down the slippery path of giving in to temptation' (Hough, 1998, website). Despite this, queer fans looked forward to the final episode of the series in the hope that it would finally confirm their readings of the central Xena/Gabrielle relationship. The final episode – titled 'Friends In Need II' – was broadcast in June 2001. Its broadcast met with a storm of controversy; Xena was killed and decapitated, leaving Gabrielle to go on alone – not the ending that most fans had looked forward to. Nevertheless, the episode did offer fairly explicit final confirmation of a romantic, sexual relationship between its two protagonists, featuring a ten-second kiss between them. Near the end of the episode, Xena appears to Gabrielle as a ghost. After expressing their love for each other, Xena speaks her last words to Gabrielle: 'Wherever you go, I'm always at your side.'

Sara Gwenllian Jones

mainstream programmes. This development seems to have arisen from a combination of factors, including a heightened awareness of homosexuality following the 1980s' AIDS epidemic; recognition of the 'controversy appeal' of lesbian and gay characters; and British terrestrial television's legal obligation to produce programmes that educate and inform its audiences, and that adequately and responsibly represent minorities (including lesbians and gay men). Channel 4's weekly gay magazine show *Out on Tuesday* went on air in 1989. The following year, BBC2 broadcast two landmark miniseries. *Oranges Are Not The Only Fruit*, adapted from Jeanette Winterson's best-selling autobiographical novel of the same title, tells the story of Jess, a teenage girl whose emerging sexuality is savagely repressed by her fundamentalist Christian mother and members of the evangelical church (see Hinds, 1997; Marshment and Hallam, 1994). *Portrait of a Marriage* focuses on the famous love affair between novelists Vita Sackville-West and Violet Trefusis. In the series, the central lesbian relationship is presented as passionate and romantic, in contrast to the dull but worthy obligations of heterosexual family life. Both series were produced and promoted as 'quality drama' or 'art television' – a classification that has, Hilary Hinds notes, 'a strong association with and expectation of "adult" and "realistic" representations of sex' (Hinds, 1997, p. 207).

Lesbian and gay representations on British television have not been confined to the quality drama slot. Primetime drama series such as *Bad Girls* (1999–) and *This Life* (1995–96) have featured lesbian, gay and/or bisexual major characters, as have most British soap operas, including *Emmerdale* (1972–), *EastEnders* (1985–), *Brookside* (1982–) and *Hollyoaks* (1995–). Britain's longest running and most conservative soap opera, *Coronation Street* (1960–), features a male-to-female transsexual character, Hayley Cropper, who married her male partner in Amsterdam. In a move roundly condemned at the time by the British tabloid press, *EastEnders* screened 'soap's first gay kiss' in 1989. Five years later, *Brookside*'s teenage lesbian Beth Jordache (played by Anna Friel) kissed her girlfriend. This time, the British press responded with enthusiasm and sensitivity – a difference that perhaps testifies to greater tolerance of sexual intimacy between women, but which may also reflect the popularity of the carefully wrought Beth Jordache character. The episode increased *Brookside*'s audience ratings by 20 per cent and in May 2001, six years after she was written out of the series, Beth Jordache was voted one of 'the 100 greatest television characters of all time' in a nationwide poll for Channel 4. More recently, Channel 4's *Queer As Folk*

(2000), a miniseries about the lives of a group of young gay men in and around Manchester's gay Canal Street area, won critical acclaim for its uninhibited and unapologetic portrayal of life on the gay scene. Unlike other series, which usually feature only one or two token lesbian or gay characters in an otherwise heterosexual line-up, almost every character in *Queer As Folk* is queer.

In the 1990s, American mainstream television also became more willing to include gay or lesbian major characters. *LA Law* (1986–94) introduced the bisexual CJ Stone in 1990. Played by English actress Amanda Donohoe – a casting choice that echoes Hollywood cinema's tradition of associating 'deviant' sexualities with Europeanness – CJ's lesbian affairs never progressed far beyond romance and the occasional dispassionate kiss. In 1997, in a much anticipated move, comedy actress Ellen DeGeneres outed both herself and her character Ellen Morgan in the ABC situation comedy *Ellen*. The so-called 'Puppy Episode', in which Ellen announced her sexuality, featured cameo performances from a range of stars including kd lang, Oprah Winfrey, Demi Moore and Laura Dern. The episode's broadcast was celebrated at '*Ellen* parties' across America. However, the event was marred by death threats against Ellen DeGeneres and widespread anti-gay protests by the religious right, which advocated a boycott of ABC. The following year, citing falling ratings, ABC cancelled the series. But, although *Ellen* ultimately did not survive coming out, it has paved the way for other mainstream series such as the sitcom *Will and Grace* (1998–), which centres around a gay man and a straight woman who share an apartment, and a US version of *Queer As Folk*.

Sara Gwenllian Jones

RECOMMENDED READING

Doty, Alexander (1993), *Making Things Perfectly Queer: Interpreting Mass Culture*, Minneapolis and London: University of Minnesota Press.

Hinds, Hilary (1997), 'Fruitful Investigations: The Case of the Successful Lesbian Text', in Charlotte Brunsdon, Julie d'Acci and Lynn Spigel (eds), *Feminist Television Criticism: A Reader*, Oxford: Clarendon Press.

Jones, Sara Gwenllian (2000a), 'Histories, Fictions and *Xena: Warrior Princess*', *Television and New Media*, vol. 1, no. 4.

Marshment, Margaret and Hallam, Julia (1994), 'From String of Knots to Orange Box: Lesbianism on Prime Time', in Diane Hamer and Belinda Budge (eds), *The Good, the Bad and the Gorgeous: Popular Culture's Romance With Lesbianism*, London and San Francisco: Pandora.

Targeting Women

From the beginning of commercial broadcasting in the United States, national advertisers and national networks divided the audience by gender. In the businesses of broadcasting (radio or television) and subscription television (cable and satellite), advertisers pay higher prices for male audiences than female audiences. At best, women were a secondary audience targeted either when men were presumed unavailable (e.g., 11 a.m. on Wednesday) or when a rival network monopolised the male audience (e.g., Superbowl Sunday). Advertisers' greater demand for men than for women had an impact on the programming and scheduling strategies adopted by broadcast networks and cable channels. This entry examines that impact in terms of programming and schedules for network television and then for cable channels.

The basic schedule for national broadcasting dates back to the radio networks created by RCA and CBS. That schedule divided the day into segments: 6–10 a.m. early morning; 11 a.m.–2 p.m. morning; 3–6 p.m. afternoon; 7–10 p.m. prime time; 11–12 p.m. late night. Schedulers assumed that each segment corresponded to an audience, based on beliefs about employment, domestic chores and household composition. The assumptions were institutionalised by national networks and advertisers in 1929, by their acceptance of the first organisation to measure audiences and generate ratings, the Cooperative Analysis of Broadcasting. The assumptions have persisted, with some modifications, to the present. Their impact can be seen in the structure of the networks' programming day.

In stereotypical terms, from 6 to 10 a.m., families arose; father wanted some news as he ate breakfast and then drove to work; children ate, were disinterested in hard news, and were driven or went to school; mother oversaw these daily events. For programmers, early morning meant different types of audiences with different goals. As the decision maker, father sought hard news; the children were more amenable to human interest and entertainment features. These also appealed to mother, who 'naturally' had an interest in fashion, cooking and similar domestic matters. In early television, RCA's NBC pioneered this mixture with *Today* which used low-key newsreaders, state-of-the-art technology and a chimpanzee to deliver a blend of news, features, promotions for RCA equipment, plugs for NBC shows, and ads disguised as news or chat. This formula underwent numerous twists since the 1950s, but remains the basic model for the current versions of *Today, Good Morning America, Live! with Regis* and *The Early Show.*

Formula 'family' viewing – *Good Morning America*

While the family dashes past the television set, pleasant personalities offer snippets of 'advertainment' in a comforting manner.

With everyone gone, the idealised mother began her housework. As she did her daily chores, she could attend only to snatches of broadcast materials. Networks claimed that the rhythms of housework and the interests of housewives led to their adoption of the melodramatic serial or soap opera as the cornerstone of the morning schedule. Each episode repeated key points so that mother could dip into the story whenever she had a break. Missing a day was no problem: the main points were frequently recapitulated, especially on Friday and Monday. The soap operas' focus on human relationships, families and melodrama matched feminine interests. These themes were generally enunciated by pairs of actors posed in front of inexpensive sets, on soundstages. Such low production values reflected low budgets, which in turn reflected the low commercial value attached by advertisers to the soaps' main viewers – women, particularly traditional housewives. The irony of this can not be overstated.

After the network soaps, the schedule was filled with syndicated programming such as talk shows, game shows, local news, cooking shows, etc. This array of genres expanded in the afternoon as the idealised family reassembled with local stations running cartoons, teen-oriented music shows and syndicated reruns of old series. Local and national news provided the transition into prime time.

Traditionally, networks selected programmes for the early part of prime time that targeted the whole family without alienating male viewers: situation comedies, family comedies, simple melodramas, variety shows, etc. As the night progressed, networks scheduled shows from male-oriented genres; male protagonists included police officers,

private detectives, military officers, spies, lawyers, physicians, etc., whose lives were replete with danger, adventure and intrigue. Female characters typically displayed more beauty than brains and were often victimised. Networks assumed that men preferred such programming and that men controlled the television set. This, plus advertisers' willingness to pay more for men, shaped how networks built prime-time schedules, commissioned shows and selected casts. Prime time was the network's main chance to deliver that male audience. Networks spent significant funds on programmes believed capable of attracting men and even more money on series whose ratings demonstrated success. As advertisers focused on younger male audiences in the mid-1960s, networks narrowed their focus on men to emphasise 18–34-year-olds.

Perhaps the most remarkable success in prime time was ABC's *Monday Night Football*, which monopolised male audiences and was less expensive to produce than regular programming. *Monday Night Football* proved that men would watch sports on weeknights. The show was so successful that CBS and NBC were forced to run programmes targeting women and children in households with two television sets. *Monday Night Football* confirmed that male audiences were *the* audience, that everybody else was an unattractive alternative.

The networks' segmentation of the day into parts and audiences was as stereotyped in 1929 as it is today. This segmentation tells us little about most people's lives during socio-economic upheavals like the Great Depression, World War II, the civil rights movements, the recessionary cycle from 1975 to 1989 or the dot.com boom and bust of the 1990s. But the segmentation reveals much about advertisers' biases and hence about that part of the population for whom network programmes were intended. Prime time, which earned the greatest advertising revenues, was intended primarily for male heads of middle-class households; when such men were not available, programming targeted their wives and their children. The networks' broadcast programming was the most widely circulated and easily accessible cultural material in the United States, making broadcasting the massest of mass media. But that programming was not intended to speak to, or for, the great mass of the American population.

In the mid-1970s, socio-economic shifts pressured advertisers and networks to further narrow their notion of the audience and to modify programming practices during prime time. The 1975–1989 recessionary cycle forced more women to seek employment outside the home. While the feminist movement provided ideological support for that, the movement agitated for women's access to professional

education and professional careers, arguing that women should control their own income, credit and property. Economic necessity and feminism combined for many women, as working women exerted more control over their earnings, more college-educated women entered the workforce at higher wage levels and middle-class women pursued professional training outside the pink-collar ghetto of social work, teaching, etc. For advertisers, these trends were captured by new demographic categories.

Women were divided into women and working women, then subdivided by economic status into upscale or downscale. Men also underwent subdivision by economic status, but all men were assumed to be wage-earners despite corporate downsizing of blue-collar and white-collar workers throughout the 1980s. Advertisers still targeted men, but upscale men aged 18–34 became their most prized trophy; yet, upscale women and their disposable income piqued advertisers' interest. With the almost universal presence of videocassette recorders and multiple television sets in upscale households, men might wield the remote control, but women could tape and view whatever they wished.

This was of particular interest to ABC, CBS and NBC, which persuaded the ACNielsen Company to assume that any programme taped would be viewed. For the ratings, taping became viewing if the VCR was connected to the household's main television set to which Neilsen's People Meter was linked. In the 1980s, the 'big three' networks faced new rivals in the form of mini-networks like Fox and cable channels, which also proliferated as cable subscriptions reached the magic 70 per cent penetration rate. Thus, most upscale homes had access to all of the local television stations and to the mix of channels selected by the cable operator. Under these conditions, some programme producers tried designing programmes to appeal to upscale men and upscale women.

These designs variously blended genres, injected serial elements into episodic programmes, added a female protagonist to an ensemble cast, built shows around a couple or ensemble of couples, etc. These strategies were not always successful as Fox's *Alien Nation* demonstrated. Based on a moderately profitable film, the series' premise was that a spaceship transporting thousands of enslaved aliens crashed outside Los Angeles and the survivors were integrating into human society. *Alien Nation* combined domestic melodrama, police house drama, science fiction, fish-out-of-water comedy and social commentary in its brief run on Fox. All network programming has become increasingly sexualised in content, and gender-integrated in casting, as ABC, CBS, NBC, Fox, Warner Bros. and UPN emulate the more risqué programming on cable channels,

WHO IS TELEVISION'S AUDIENCE?

Who is television's audience – the people watching the shows or the people pushing their identification buttons on the ACNielsen People Meters every fifteen minutes when the light flashes? Common sense tells us that everybody who watches television is in the audience. Industry practices suggest that whoever is measured by the Nielsen Company is the audience. Current relations of demand and supply between advertisers, networks, cable channels and the ratings monopolist suggest that the audience is upscale men aged 18–34 who subscribe to cable. Television, then, is far from being a reflection of society.

Eileen R. Meehan

especially on subscription channels like HBO. Currently, the six networks are owned, respectively, by Disney, Westinghouse, General Electric, News Corporation, AOL Time Warner and National Amusement's Viacom, which is trying to buy CBS. The owning companies all have operations in programme production and in cable channels.

In the 1960s, visionaries argued that cable television would revolutionise television because cable had the technological capability to be interactive and to expand the number of channels to the point where every possible taste would be served. This focus on technology could not foresee the recessionary cycle, Reaganist deregulation and media corporations transforming themselves into transindustrial conglomerates. However, if the visionaries observed how cable operators were actually programming in the 1960s and 1970s, they would have realised that cable operators relied on broadcast television for their models. Some channels turned a single programming category into an entire schedule. For example, ESPN programmed all sports, all the time, for all the guys. Other channels mimicked the standard network segmentation. For example, despite declaring itself 'television for women', Lifetime built its schedule to attract housewives from morning to early afternoon, to attract the household as it reassembled, and finally to target heterosexual couples during prime time via programming that was both 'male and female friendly'. Interestingly, the trade press has consistently questioned Lifetime's economic viability, claiming that the female audience is a very narrow, highly specialised niche. ESPN has not been so questioned. This contrast again suggests that 'the audience' means men.

This was further underlined by the differential treatment accorded ESPN and Lifetime when Disney joined the Hearst Company as co-owner of the two channels. With Disney, ESPN got a major infusion of cash, leading to the proliferation of ESPN channels and a chain of restaurant/bars called ESPNzones. Lifetime had a modest but similar aspiration – launching a channel oriented towards women in their teens and twenties – but Disney and Hearst preferred not to expand operations targeting women. Lifetime's version of television for women remained locked onto the networks' segmentation, which targets women only when men are absent.

Eileen R. Meehan

RECOMMENDED READING

Meehan, Eileen R. (2001), 'Gendering the Commodity Audience', in Eileen R. Meehan and Ellen Riordan (eds), *Sex and Money: Feminism, Political Economy, and Media Studies*, Minneapolis: University of Minnesota Press.

RACE

Introduction

Whiteness has dominated television. TV emerged from white-dominated countries, and those nations continue to export most television. Internally, they demonstrate how processes of racialisation happen – the means of associating certain qualities with a group on racial lines, or of utilising existing stereotypes to characterise images within programmes. As television spread through the Third World, former colonial powers and the US dominated, so at the level of cultural imperialism, it is possible to look on TV as Eurocentric, despite the importance of Japanese, Chinese, Indian and Latin production. But just as feminism has affected how TV goes about its work, so struggles against colonialism and racism have seen television respond. Concerns about opportunities for both adequate representation and access to production have led to work on the experience of indigenous peoples in white-invader nations, and diasporic populations as well.

Toby Miller

Television and Race in Britain: Comedy

The history of television and migration are deeply connected in Britain. The advent of television in the 1950s coincided with the large-scale migration of people from former British colonies to the industrial heartlands of the UK. Since then television has represented and refracted, in myriad ways, the changing face of British 'race' relations. The development of TV comedy provides us with a particularly sensitive barometer of shifting sentiments and ideologies governing policies and public attitudes to 'race' relations. TV comedy bears deep political resonances. Comedy is often regarded as outside the realm of politics, and any attempt at analysis is regarded as a futile and fruitless task, especially given the subjective and idiosyncratic nature of humour. Yet in the interplay between the teller, the receiver and the butt of the joke, comedy articulates and expresses power relations and prejudices. TV comedy serves the interests of social control. One of its key func-

tions is 'to police the ideological boundaries of a culture, to act as a border guard on the frontiers between the dominant and the subordinate, to keep laughter in the hands of the powerful' (Medhurst, 1989, p. 16). It can also challenge and ridicule power by satirising the powerful, and promoting social and attitudinal change. Comedy is inherently contradictory.

Some analysts doubt the positive social functions of comedy. For example, attempts at using TV comedy to foster harmonious 'race' relations are seen as misguided. It is argued that the emergence of British 'racial' comedy series, signalled by the advent of *Till Death Us Do Part* (BBC, 1966–74), has been used to legitimate an ideology of British 'tolerance', while propagating racism. The TV sitcom is a racist form as such (Husband, 1988). But is it possible or productive to generalise in this way? To accuse a TV programme or genre of being racist is not to open it up to analysis but to render it analytically obsolete. The accusatory tones of political correctness tend to censor racist discourse and such repression may exacerbate rather than combat racism. Comedy by its very nature transgresses social taboos, speaks the unspeakable, degrades people and groups, creates a sense of intimacy and community and defuses social tensions. But what happens when racialised discourse becomes institutionalised in TV comedy?

After more than forty years, *Till Death Us Do Part* and its American counterpart *All in the Family* are still key points of reference in discussions about racism and the politics of TV comedy. Alf Garnett, the key character of the sitcom, has acquired legendary status as a foul-mouthed (yet, for some, loveable) bigot, giving a powerful voice to a stream of racist thoughts and language unprecedented in public broadcasting. But are we being invited to laugh at or with the bigot? Is he the teller or the butt of the humour? The writer of the series, Johnny Speight, came from a Jewish family in the East End of London and grew up acutely sensitised to racism. He has always insisted that his intention was to expose bigotry and ridicule it. Whether he succeeded remains contentious.

Till Death Us Do Part was the most popular TV show of the mid-1960s. At its height it was regularly viewed by 18 million viewers. It seems likely that many of them did not see Garnett as a butt of humour despite his stupidities,

such as the idea that if white people were given transfusions of 'black blood' they might transform into 'coons'. But by explicitly voicing the prejudices of white British audiences, the show helped ignite public debate about immigration and racism. At the time integration, or the attempt to create a national unity and deny diversity, was the dominant discourse shaping policy. Like Garnett, the Conservative MP Enoch Powell strongly opposed this policy. In his now infamous 'Rivers of Blood' speech, he warned that blood would flow in Britain as a result of its overly relaxed immigration laws. Like Alf Garnett, he mobilised racist rhetoric and advocated repatriation, playing on fears of job loss, 'invasion' and 'swamping', exaggerating the numbers of immigrants coming to Britain (a theme which was later picked up on by Margaret Thatcher).

Sitcoms of the 1960s and 70s depicted British black and Asian people as a problem and a threat. *Love Thy Neighbour* (ITV, 1972–75) played on the idea of warring neighbours after the arrival of a black family into a white suburban area. It reflected anxieties about assimilation, the key term in 1970s' 'race' relations policy. Assimilation policy still demanded a loss of cultural identity on the part of immigrants, and conformity to essentialist constructions of predominantly white, English Britishness. In *Love Thy Neighbour* racial conflict was passed off as no more than petty squabbles over the garden fence: the social realities of racism did not get exposed (Medhurst, 1989, p. 18). *Mixed Blessings* (ITV, 1978) used racial jokes and played on fears of 'miscegenation' and 'mixing blood': the 'threat' of the 'other' had crossed the garden fence and come right into the heart of the home.

The absolute foreignness and otherness of 'immigrants' was stressed and ridiculed. *Mind Your Language* (BBC, 1975–77) is considered by many commentators the most ignorant and blatantly offensive sitcom of the 1970s. It was set in an English Language Teaching Centre and used 'foreign' English learners with 'funny accents' as the butt of derisive humour. But not only is it among the most widely exported of all British sitcoms, some British Asian families with whom I have worked enjoyed it immensely, along with other sitcoms charged with racism. Their enjoyment cannot be reduced to assertions about their victim status or their collusion and internalisation of racism. Rather, humour works in unpredictable ways. The aesthetics of the jokes and the social and power contexts in which they are received play an important role in how they are interpreted.

During the 1980s there was a shift in anti-racist discourse from the rather narrow preoccupation with stereotypical imagery, and replacing negative with positive images, to tackling institutional racism via equal opportunities policies aimed at raising the employment profile of minority ethnic groups at all levels. A number of all-black sitcoms emerged focusing on family life, such as *No Problem* (ITV, 1983–85). All-black sitcoms were seen by some as no more than 'white comedies with a racial content' (Husband, 1988). *No Problem,* for example, was based on the lives of five black teenagers left to fend for themselves in suburbia after their parents' return to Jamaica, thus 'structuring voluntary repatriation at the heart of the situation, and rendering the black family a priori deficient and incomplete' (Gilroy, 1983, p. 25). According to Gilroy, the show perpetuated the idea that blacks themselves, not racism, must be the butt and target of ethnic humour. In his view, the absence of any overt politics simply encouraged white viewers to laugh at black families from a common-sense racist perspective.

Frontline (BBC, 1984–85), set in Bristol and Cardiff, echoed dominant images of black communities following the 1981 'race riots' in several cities as a result of the heavy-handed policing and harassment of black and Asian people. For some critics it meant progress as Rastas had until then been invisible on TV screens, but for others it cemented stereotypes of black comical figures, with their weird hand-shaking rituals and an incomprehensible Jamaican patois. Once more, the butt of the joke seemed to be black characters. However, in a seeming paradox, the show pleased many black British people who found in it an otherwise very rare affirmation of their language and culture in broadcasting.

There were all-Asian comedy shows too. *Tandoori Nights* (Channel 4, 1985–87) played on the rivalry between two restaurants: 'The Jewel in the Crown' and 'The Far Pavilions'. It used techniques of 'reverse racism' (Asian anti-whites), and new kinds of representations of Asian women as sexy and left-wing, alongside the theme of inter-racial romance. But, as one critic pointed out, it managed to get away with poking fun at, for example, allegedly unhygienic Bangladeshis, in the apparent interests of realistic dialogue between one rival restaurant owner and another (Naughton, 1985).

Disappointment at the sitcoms of the 1980s was all the greater given the advent of Channel 4, a new channel committed to serving minority interests of all kinds under a policy of positive discrimination. Black and Asian writers and producers complained that they were under pressure to speak to, from or on behalf of their putative communities. Institutional expectations placed a heavy 'burden of representation' on minority ethnic cultural producers. Many were part of a vibrant avant-garde, experimental

Turning racism on its head – *Goodness Gracious Me*

black film movement that explictly set out to challenge the images and narratives of popular TV and film genres.

The late 1980s saw the arrival of *The Lenny Henry Show*. He was one of the popular 'new wave' or 'alternative' comedians, now established entertainers (such as Ben Elton, Victoria Wood, Rik Mayall, French and Saunders). This generation refused racist and sexist jokes and created a new repertoire of butts – the Conservative Party, Margaret Thatcher, the political and business elites. In fact Lenny Henry had started out telling racist jokes on the Northern comedy circuits, and had accepted highly stereotypical roles which he later regretted. The development of his career shows the emergence of an acute political consciousness, in parallel with his fans.

One of the most popular recent comedy shows is *Goodness Gracious Me* (BBC, 1996–2001), a sketch show which has broken boundaries in British humour. Written and performed by a group of talented British Asians, confident and at ease with their hyphenated identities, it subverts stereotypes and turns racism on its head in highly irreverent, humorous and, for most, inoffensive ways. The show leapt out of the ghetto of 'ethnic humour' to send up both white racism and the idiosyncracies of British Asian families. The success of *Goodness Gracious Me* on mainstream TV signals that mainstream now no longer means white. Its second and third series were scheduled at peak viewing times. At the height of its success, some of its comic routines and catch-phrases were ubiquitous in British school playgrounds. Punjabi phrases entered everyday British vocabulary, much as earlier Jewish stand-up comedians introduced Yiddish expressions into the language. 'Asian coconuts' (like the Kapoors who demanded that their name be pronounced in an anglicised manner Cooper) were mocked for being black on the outside and white middle-class aspirants inside. 'English teabags' were ridiculed for being white on the outside and brown inside, for their appropriation of the trappings of Indian exoticism and spiritualism. The humour confounds expectations and uses the comic techniques of reverse racism, parody and pastiche to turn stereotypes around.

Marie Gillespie

FROM COMIC ASIANS TO ASIAN COMICS

Reversal is a central comic technique. The title *Goodness Gracious Me* is an oblique reference to a 1960s' film *The Millionairess*, in which Peter Sellers plays a 'blacked up' Asian and is the butt of humour. Now the butt is reversed. In one *Goodness Gracious Me* sketch, a group of Indian students come to England for a holiday in search of authentic English villages and complain bitterly about the homeless beggars on the streets and the awful food. Another shows a white English employee in an Indian firm plagued by his colleagues' failure to pronounce his name ('Jonathan') correctly.

The sketch 'Going For An English' has acquired classic status. Indian restaurants are essential to modern British culture, and 'going for an Indian', often after the pub, is popular everywhere (though probably most customers do not realise that 95 per cent of 'Indian' restaurants belong to Bengalis, and that popular styles such as Balti were invented in the UK). Here the setting is late on a Friday night at an English restaurant in downtown Bombay. Several drunken Indians stagger in. A white waiter helps them slump into their seats.

> 'I'm totally off my face. How come every Friday night we end up in a Bernie Inn?'
> 'Cos that's what you do, innit? You go out, you get tanked up and you go for an English.' [They peer bleary-eyed at the menu. . . .]
> 'Could I just have a chicken curry?'
> 'Oh no, Nina, it's an English restaurant, you've got to have something English, no Spices Shisis.'
> 'But I don't like it, it's too bland.'
> 'Jam-mess! [Mispronouncing 'James'.] What've you got that's not totally tasteless?'
> 'Steak and kidney pie, sir?'
> 'There you are, steak and kidney pee!'
> 'No, no, it blocks me up – I won't go to the toilet for a week!'
> 'That's the whole point of having an English.' [. . .]

(Incidentally the Bernie Inn restaurant chain, famed for serving 'traditional' English roast-meat-and-veg, was founded by an Italian immigrant.)

Without stereotypes there would be no comedy. It is not enough to replace negative with positive images. In any case, given the often huge variability in audience evaluations of programmes, negative or positive for whom? Where? When? This is an overly simplisitic approach to solving the kind of problems sitcoms present. The same image can evoke contradictory responses in audiences. Equal opportunities policies are a necessary but not a sufficient strategy. It cannot be assumed that the quality of representations of 'race' will improve due to an increase in the quantity of black or Asian media professionals. Nor can it be assumed that every black or Asian person has an interest in pursuing a 'race'-related agenda. If the points of access to broadcasting institutions are multiplied at all levels, enabling creative development and the space to experiment with new kinds of identities and syntheses, then this must surely be a step in the right direction. But one of the problems with equal opportunities programmes is poor monitoring. It is usually impossible to know whether they have been successful, and if not, why not.

Those who share a joke share a certain intimacy: jokes confirm closeness. Those who share a joke belong to a community, however temporary, of people alike enough in outlook and feeling to be joined in sharing a joke (Cohen, 2000). This is certainly the case with young British Asians and *Goodness Gracious Me*. The social intimacy and pleasure of laughter explains why we tell jokes and what they are for. But jokes are also exclusionary. Jokes define social categories and group boundaries incorporating some as insiders and others as outsiders, delighting some and offending others. Jokes that trade on stereotypes of national, racial and ethnic categories give pleasure and offence simultaneously. But the key question remains always: who is making who else laugh at whom, and why?

Marie Gillespie

Recommended Reading

Cohen, T. (2000), *Jokes: Philosophical Thoughts on Joking Matters*, Chicago: University of Chicago Press.

Gilroy, P. (1983), 'C4 Bridgehead or Bantustan?', *Screen*, vol. 24, no. 3.

Husband, C. (1988), 'Racist Humour and Racist Ideology in British Television or I Laughed Till You Cried', in C. Powell and G. Paton (eds), *Humour in Society: Resistance and Control*, London: Macmillan.

Medhurst, A. (1989), 'Laughing Matters', in *The Colour Black: Black Images on British Television*, London: BFI Publishing.

Naughton, J. (1985), 'Tandoori Nights', *The Listener*, 11 July.

Race and US Television

Color television wholly eliminates the interval in which
your mind must take a black and white image into the
dark room of your brain and print it, on the intellect, as
the true colored picture which the eye actually sees in
nature. (Frank Stanton, former CBS President, 1951,
quoted in Boddy, 1998, p. 29)

Throughout its history, US television has mobilised the
markers of racial and ethnic difference: in terms of its
elaborate deferral in the service of a protracted white nor-
mativity in the 1950s; as a symptom of social conflict in
the 60s and early 70s; as an index of integration in the late
70s and 80s; and as a lucrative part of audience segmenta-
tion and niche marketing from the mid-80s through the
present. The textual features of racial representation on
the small screen – the cultural politics of the stereotype
and the catalogues of racial symbol – are so familiar that
they are an everyday part of the specular life of television.
Indeed, these racial tropes have become a naturalised part
of the industrial and technological development of televi-
sion itself: characteristic of the 'progressive' discourse of
1950s' racial synchrony, Frank Stanton's words above are a
homage to television's thoroughly racialised imaginary,
the reflexive immediacy of a utopian social interconnect-
edness. Uttered at the dawn of the television age, amid
rising community mobilisation against social and racial
injustice, Stanton's colour-blindness illustrates the dangers
of separating out the televisual experience from its indus-
trial and institutional production. Similarly, scholarly
studies of television must be wary of the seductive
metaphors made possible by engaging the small screen as
a racial projection. As intricate forms of social identifica-
tion, affiliation and performativity, racial and ethnic rep-
resentations have complex histories of deployment and
protest that cannot be separated from institutions of
media ownership and employment, public and cultural
policy, and social movement activism. Broad engagement
with racial issues in commercial media culture through an
analysis of the cultural politics of representation and the
institutional logics of industrial practice can help dislodge
the conception that consumer choice and free and open
markets alone dictate the success or failure of television
programming. This is, after all, the ideological bedrock
underlying the contemporary US TV landscape.

US television came of age in the 1950s with white sub-
urbia both its representational horizon and its hallowed

Amos 'n' Andy, the first US serial with an all-black cast

demographic. However, television's fictional representa-
tions of American everyday life were a far cry from the
massive social turmoil in the country as racial minorities
clashed with the institutions of state and local power in the
streets. While the networks dealt with civil rights issues in
their nightly news reports (Southern US reporter assign-
ments in the 1950s were quickly coined 'the race beat'), net-
work comedy and variety programmes tended to rely on
tropes of black domesticity, although there was plenty of
room to read against the grain and find affirmative specta-
torial pleasures. There were a few programmes that fea-
tured African-American actors in lead roles. For example,
Ethel Waters took part in NBC's first experimental broad-
cast in 1939 and went on to star in ABC's *Beulah* in the
early 1950s. While the programme was the first nationally
broadcast US weekly serial to feature a black actor in a
leading role, Waters was restricted to working within the
relatively safe representational confines of black maternal
domesticity. Social-movement-led media reform began
almost immediately with the National Association for the
Advancement of Colored People (NAACP) deciding at its
annual convention in 1951 to censure *Beulah* for its stereo-
typing. The organisation also appeared in US Federal
Court seeking an injunction against the premiere of *Amos
'n' Andy*, the first US serial with an all-black cast, first
broadcast on CBS in 1951 (although the programme had
its origins in a late 1920s' Chicago radio programme). As
television viewership skyrocketed in the 1950s and network
television became the 'electronic hearth' around which the
collective American audience gathered in supposed con-
sensus, the coverage of the civil rights movement brought
the issues fully into the American suburban living room,
even though black voices in the struggle were rarely
granted the opportunity to speak for themselves.

The 60s-era civil unrest and social justice movements for racial equality would play a huge role in shifting racial representation on network television, but not necessarily in a fully progressive direction. For example, the networks were ordered by President Lyndon Johnson to kill the live feed of Fannie Lou Hamer's fiery 'Is this America' speech, which the networks later were to air in its entirety. In addition, Earl K. Moore's 1964 landmark lawsuit on behalf of the United Church of Christ forced a pro-segregation Georgia TV station to forfeit its licence for failing to address the needs of its audience, specifically African-Americans and civil rights proponents. As civil rights became part of the lexicon of everyday life in the mid- and late 1960s, motivating the legislative agenda of the 'Great Society', there were a proliferation of reports which served to regularise and contain media reform protest such as the 1968 Kerner Commission (which identified the media as contributors to racial unrest) and the 1969 report of the Equal Employment Opportunity Commission (which held hearings into the LA industry's hiring practices). Late 1960s' programmes like *I Spy* (1965–68) and *Julia* (1968–71) moved beyond the good-natured buttressing of whiteness in the 1950s to a more complex form of minority-citizenship rhetoric organised around racial containment, where racial minorities were shown to be part of the class aspirations of the American success story rather than simply serving it. The trajectory of much future programming was facilitated by the comfortable conservatism of success and the mythic 'levelling-hand' of the US dollar: it is more than historical coincidence that the stars of *Julia* and *I Spy* – Diahann Carroll and Bill Cosby – would become part of a 1980s wave of upwardly mobile black affluence on television in *Dynasty* (1981–89) and *The Cosby Show* (1984–92).

Perhaps unwilling to forgive the networks for his disastrous showing in the televised 1960 presidential debate, Nixon supported a number of regulatory initiatives through the mid-1970s such as tax certificates for minority station ownership. However, public policy moved towards deregulation as the country slipped into a long-term recession. Facing strong calls for more 'relevant' representation, and in response to over a decade of civil rights and media reform pressure, the networks began to air programming that they felt more realistically depicted minority life in poor and urban America. Programmes such as *Good Times* (1974–79) were often keen in their interrogation of class prejudice, but they reaffirmed the mythic promise that individual effort and enterprise (rather than structural and radical social reform) could transform the conditions of racial injustice. Most network attempts at diversity contained black representation within the logic of integration and periodically sprinkled the occasional Asian and Latino/a to flesh out and add dynamism to the psychology of white characters. There were exceptions, of course, like *Roots* (1977), based on Alex Haley's 'factional' ancestral search, which was tremendously successful with some 80–100 million viewers per episode and helped to popularise the consecutive night miniseries. The programme marked a generational shift in televised black representation, acknowledging the tremendous crossover audiences mobilised by an assessment, however incomplete, of a thoroughly racialised American history.

The fragmentation of the three-network system in the 1980s was precipitated by competition from both videocassette technology and cable programming. Hoping to manage the crisis, the networks focused on demographic criteria such as race and ethnicity and developed 'narrowcasting' strategies aided by the development of new ratings technologies. Premiering in September 1984, *The Cosby Show* saved the situation comedy as a genre and pushed NBC to the top spot in the network wars. Hoping that the show would tap into a positive African-American consciousness (if not a deeply embedded US racial unconscious), Bill Cosby hired a prominent black psychiatrist to read every script and help 'recode' the historical image of blackness on network television. *Cosby*'s racial problematics, as Herman Gray notes, were part of a 1980s' realignment of black middle-class subjectivity within the logic of network television's institutional practices of assimilation, pluralism and multiculturalism (Gray, 1995).

Launched in 1986, the Fox network drew on NBC's success with crossover programming. Its initial expansion strategy involved the purchase of lower-priced urban carrier stations, and the network seized on the opportunity to exploit these stations' existing viewership. Fox's early target audience of primarily younger minority viewers who were fond of variety and situation comedy programmes was seen as a fortuitous alignment between station acquisition, racial representation and urban demography. This representational trend, however, fell out of favour in the network's 1990s expansion which culminated in Fox's claiming of the televised rights to the National Football League's Sunday games and their more traditional – and predictable – white male audiences (Zook, 1999). While Warner Bros. and Paramount have followed Fox's foray into network television, backed by the deep pockets of their corporate parents, their promises of representational diversity will most likely replicate the industrial parabola of Fox: building market share on the viewership of minority audiences, then 'expanding' to the hallowed white middle-class

demographic. Attempting to block Fox's proposed purchase of a Philadelphia TV station, the NAACP joined NBC in lobbying the Federal Communications Commission (FCC) to look into issues of foreign ownership in Rupert Murdoch's TV network, although NBC retracted its threat of investigation in exchange for Murdoch's decision to allow NBC programming on his Asian STAR-TV network. Such international exchanges indicate the domestic leveraging power of a US network supported by a global media conglomerate.

A steady stream of deregulatory public policy leading up to the Telecommunications Act of 1996 has been instrumental in shaping US television since the 1980s. The story of one media institution in particular is illustrative of the complex relationship between the political economy of ownership and the representation of race. One of the earliest basic-cable channels, Black Entertainment Television (BET) launched in 1980 with a music video line-up that predated Music Television (MTV) by a year. After engineering early corporate partnerships with Time Warner and TCI, BET was recently sold to Viacom for $3 billion and its former president turned to such issues as the privatisation of social security and death-estate tax breaks for wealthy African-Americans. The Viacom/BET merger was supported by the Rainbow/PUSH Coalition – the international organisation for racial and social justice headed by Jesse L. Jackson – but generated protests by smaller minority groups such as the Black Entertainment and Telecommunications Association. As a result of the FCC's relaxation of dual-network ownership rules, Viacom also acquired CBS and United Paramount Network (UPN), both of which screen a number of comedies targeted at African-American communities. The FCC maintains that Viacom's purchase of UPN is 'essential to the continued viability of UPN' and that UPN's purchase guarantees against 'a loss of diversity' at the national and local affiliate level ('FCC Relaxes', 2001). In order to keep creative programming and management talent safe from complete assimilation under the umbrella of corporate synergy, Viacom decided to keep BET a separate operating unit and its existing management remained largely intact. Viacom also owned the international distribution rights for *The Cosby Show* for almost ten years – using the show's success to leverage its corporate lobbying for international deregulation – and the programme was successful in a number of countries around the world, including among both black and white South African audiences (Havens, 2000). In addition, Home Box Office (HBO) – which began to reach out to black and Hispanic constituencies when it formed HBO Productions to produce television programmes like

Roc – also owns 16 per cent of BET. As US television goes global, the alignment between targeted programming and a deregulatory policy environment, in this case between a number of networks clustered around an avowed demographic mandate, has effects that reach far beyond the US marketplace.

The institutional production of audience is part of the discursive taxonomy that allows television institutions to engage with the private consumer of media. While television has always been an enumerative technology (ratings systems have existed since the 1930s at least) most demographic tools have been put into place only relatively recently. As industrial fragmentation has led to an increased focus on targeted programming, these demographic techniques have also diversified. In 1992, the Screen Actors Guild began issuing an annual report that tracked casting opportunities for African-Americans, Latino Hispanics, Asians-Pacific Islanders, and Native Americans. The difficulty with accounting-style analysis of racial representation is that it has led to a network television version of 'stacking', where minority characters play on the dramatic team only to be relegated to supporting roles. According to network common sense, the cosmetic diversification of ensemble casts, rather than hiring an all-minority group, helps to avoid sacrificing one demographic over another. Sometimes, however, greater

The importance of diversity (statistics) – *Martial Law*

diversity in representation via corporate multiculturalism simply leads to an affirmation of racial and ethnic stereotypes rather than their confrontation.

Facing pressure from the NAACP and other advocacy groups, the networks signed diversity initiatives in 1999 designed to facilitate the 'full inclusion of minorities in employment, casting, image portrayal, content creation, and program development, distribution, promotion and financing' ('NBC, ABC, NAACP in Accords', 2000). Reports found that the proposed network diversity initiatives only resulted in a slight gain from 12 per cent of all characters in 1999 to 14 per cent in 2001, although NBC had almost doubled the number of minority characters. In May 2001, the Multiethnic Coalition handed ABC a D– grade based on its fall schedule. The actual diversity numbers are so low that the cancellation of a *single* show, like CBS's *Martial Law*, can completely negate a single network's representation of Asian-Pacific Americans.

The 2000 US Census identified Hispanics as the fastest-growing ethnic minority in the country. With cable penetration in Hispanic communities lower than the national average, the television industry has set its eyes on long-term growth. Both DirecTV and EchoStar launched Spanish-language services in October 1999 and plans are being drawn up for the launch of the third Hispanic TV network (Azteca America) to compete with Spanish-language powerhouses Telemundo and Univision. As the President of Telemundo, Joaquin Blaya, a long-time player in the Spanish-language media business, spurred a joint venture between Telemundo, Univision and Nielsen Media Research to create a nationwide ratings system that could focus on the viewing habits of the Hispanic community in the early 1990s. As of late 2001, NBC was planning to acquire Telemundo, a move opposed by Hispanic groups such as National Council of La Raza and National Hispanic Media Publications on the grounds that it would restrict minority ownership and programme content and quality. Meanwhile, as part of its counterbalancing forays into corporate citizenship, NBC took part in a recent initiative called the 'Four Directions Talent Search', designed to bring unsigned, tribally affiliated Native-American talent to network programming.

Recent Federal Court decisions struck down initiatives for low-power radio stations and defeated a number of long-standing minority recruiting rules for radio and TV operators, under the guise that race-based hiring is unconstitutional (a common argument for anti-affirmative action advocates). US media policy's embrace of consolidation and convergence – like the BET story recounted above – has been largely counterproductive from the standpoint of diversity in both the textual and political economy of television. Although there is talk of incentives like the reintroduction of tax certificates to spur minority station purchase – rolled back in a 1995 Congressional decision that helped Fox to derail its competitor's ability to garner minority investors – stronger measures like quotas do not look likely. With 'minority discount' a common lingo in the media advertising trade for the lower rates paid to stations that target minority viewers, and federal subsidisation for racial diversity a distant reality in these federalist, deregulatory times, US viewers may have to be satisfied with a mere gloss of colour on their television screens.

Nitin Govil

RECOMMENDED READING

Gray, Herman (1995), *Watching Race: Television and the Struggle for 'Blackness'*, Minneapolis: University of Minnesota.

Hamamoto, Darrell Y. (1994), *Monitored Peril: Asian Americans and the Politics of TV Representation*, Minneapolis: University of Minnesota Press.

Noriega, Chon A. (2000), *Shot in America: Television, the State, and the Rise of Chicano Cinema*, Minneapolis: University of Minnesota Press.

Steenland, Sally (1989), *Unequal Picture: Black, Hispanic, Asian and Native American Characters on Television*, Washington, DC: National Commission on Working Women.

Torres, Sasha (ed.) (1998), *Living Color: Race and Television in the United States*, Durham: Duke University Press.

Zook, Kristal Brent (1999), *Color By Fox: The Fox Network and the Revolution in Black Television*, New York: Oxford University Press.

Television and Orientalism

Orientalism, proposed by Edward Said (1995), refers to the network of interlocking discourses about the 'orient' constructed in Western civilisation. The orient, in Western conceptions, consists of stereotypically inflated *others* drastically different from the collective imagination of the civilised West. Said's argument was initially focused more on Europe and Islamic culture, but has been applied to the general cultural dynamics between developed countries and the rest of the world (Hall, 1992). For Said, the sites of discursive production of Orientalism include academic and creative institutions that generate a historical and intertextual web of academic knowledge, popular culture and common sense.

The thesis of Orientalism assumes that the orient is not an inert fact of nature. It is not merely there for the West to examine. The orient, within the discursive system of the West, is an imagined construction. However, this anti-essentialist claim has a material base. 'The orient is an integral part of European material civilization and culture. Orientalism expresses and represents that part culturally and even ideologically as a mode of discourse with supporting institutions, vocabulary, scholarship, imagery, doctrines . . .' (Said, 1995, p. 2). It is supported by the political economy of modern institutions and the power differential between the West and the rest. Said's thesis has been appropriated by nationalists as ammunition for essentialising and demonising the West. It has also been criticised for being too totalistic, as if any rupture within Orientalism is impossible (Sardar, 1999). However, his thesis provides us with a sharp theoretical perspective to examine the discursive divide in the representation of otherness in global cultural oppositions.

In this section, in order to understand better contemporary versions of Orientalism, I will analyse a few selected American popular TV dramas featuring Chinese characters. For many years, the flow of cultural products has been mostly from the Americas to the East, but there are signs of some 'reverse flow' in recent years (Barker, 1999). There have been more exchanges between Chinese and American movie directors and actors. Blockbuster films, when compared to television, tend to travel across cultural boundaries more easily, while television, because of its domesticity, tends to be more contextualised and closer to the discursive perspective of the local. Can the thesis of Orientalism be applied to television? Is the domestic medium of television a discursive site of Orientalist discourse? Can the stereotypes of the orient be rehabilitated in this age of intensive global exchange? These questions touch on the theoretical perspectives of media imperialism, globalisation, post-modern hybridisation and the role of television in these processes.

The X-Files started off more or less as cult television in 1993, but has entered the mainstream as a complex, trend-setting and stylistically hybridised television drama. It has also attracted followers among the Chinese communities in Hong Kong and other Asian countries (*The X-Files* has not been released in mainland China). Imploding the relatively stable us/them boundary of the cold war binary, *The X-Files* has reworked the discourse of otherness as the enemies from within the United States and from the world of aliens in outer space and in the rest of the world. Drawing on abduction narratives and earlier conspiracy genres (Graham, 1996), *The X-Files* suggests the incredible

The X-Files – reworking the discourse of 'otherness'

charge that the US government is involved in a vast conspiracy with former Nazi and Japanese scientists to assist alien beings in performing experiments and genetic hybridisation on American citizens. It has mobilised the public sentiments of mistrust of authority and what Morley and Robins (1995) call 'Japan panic'. Japan is geographically located in the East – but its high-speed modernisation has destabilised its discursive position as a society of the inferior orient. In term of technological advances, it seems to be catching up or even competing with the West. Recently, Japan has been seen as a declining nation; nevertheless, the cultural instability and anxiety may be one of the undercurrents that fuel the depiction of lethal Japanese technocrats in Western popular culture.

In the post-cold-war period, the us/them binary is more fluid, multiple and unstable. In *The X-Files*, the American West, embodied in the characters of FBI agents Mulder and Scully, to some extent incorporates alternative paradigms such as the paranormal and the meta-scientific. But in this body of hybridised and ambiguous televisual text, the discursive space available for Chinese characters, as opposed to others, is still very limited. In the episode 'Hell Money' (third series, 3X19), the narrative hinges on the underground connection between Hong Kong, China and the Chinese immigrant society in the United States. The episode struck Hong Kong audiences with its depiction of the Chinese as traditional, superstitious, malicious and bloodthirsty. In the story, a Chinese immigrant family in the United States has fallen into the trap of a Chinese secret society which organises underground gambling and trades fresh human organs. The Chinese are living in a world of murder, torture and exploitation. Built around this textual Chinese underworld are incomprehensible Chinese characters, repulsive Chinese medicine, secret rituals and mysterious philosophies of filial piety, death and afterlife. These signs and icons serve good narrative functions for *The X-*

Files as a horror/action/police/science fiction narrative. This hybridised SF genre predisposes the representations of most *X-Files* characters, other than the hero and the heroine, to the mysterious world of the unknown and of horror. *The X-Files* is not a straightforward demonisation of the 'non-West'. In fact, bits and pieces of floating signs in this textual world are intertextually connected to other fictional and non-fictional media representations. Far from being merely fabrications, these representations have strong links with previous creative depictions of Chinatowns and with news stories about Chinese illegal immigrants and the trading of human organs. However, taking all these generic and intertextual pre-depositions into account, the thesis of Orientalism still provides an insightful perspective for seeing through the binary of the West and the oriental. Chinese culture is projected as traditional, with a timeless history, yet uncivilised, barbaric and mysterious.

The X-Files producer Chris Carter has also produced another SF/police drama series called *Millennium*. In this series, the FBI veteran has the specialty of apprehending homicidal psychopaths. This can be considered as the loosening up of the rational/scientific ideal of modernity. One interesting episode entitled 'Bardo Thodol' (third season, MLM-317) features a Japanese scientist experimenting with genetic engineering but contracting a fatal infection himself: his hand and face deformed and swollen gradually under the close and prolonged examination of the television camera. Three points can be said about the configuration of Orientalism in this small piece of text. First, as discussed above, the textual world of the orient in this episode is saturated with traditional, religious and cultic motifs. Second, within this mysterious pre-modern world there is a modern oriental scientist with a PhD. This echoes with the techno advances in Asia and the migration of intellectuals from the East to the West. But this smart oriental invents a fatal bio-product and he dies a horrible death at the end. The story is another textual expression of Japan panic and technophobia on the part of the Orientalists. Third, the differences between the West and the East are marked and inflated, while the differences within the East are collapsed and obscured. In this episode, Japanese, Chinese and even Tibetan icons and characters are hybridised to such an extent that the Japanese are replaceable by the Chinese. Through Western eyes, different orients are often hybridised, decontextualised and over-generalised.

The above two cases seem to fit nicely into the discourse of Orientalism. However, the representations of the orient have recently been complicated by diverse and reverse cultural flows between the East and the West. Another recent American TV action drama series *Martial Law* features Hong Kong Chinese actor Sammo Hung as a kung fu master and veteran policeman who is sent to America in an exchange from the Shanghai police force. Sammo is a positive character who can hardly be seen as a derogatory stigmatisation of the orient. He outsmarts bad guys and some of his American partners by his charming and surprisingly athletic martial arts despite his obesity. The underlying joke of the show is the five-foot-seven, 230-pound, 44-year-old Sammo kicking and flipping like Jackie Chan. The story moves along the politically correct line of Sino-American co-operation, while the Chinese characters are built on the long tradition of Western imagination of Chinese kung fu and philosophies. Bruce Lee on the big screen has been a key model of this. On the TV screen there was David Carradine, who played the lead role in the long-running series *Kung Fu* in the early 1970s. Carradine, as a Caucasian, recycled Orientalist imagery in the positive mode, highlighting the wisdom and physical strength of Shaolin philosophy and martial arts. Now Sammo, a Hong Kong stuntman rather than a Caucasian, plays the lead role in domestic American television. However, there are still traces of Orientalist discourse. Sammo burns incense, performs impossible kung fu kicks and teaches his partners Chinese wisdom and Tai Chi philosophy. These are marked differences that distinguish the pre-modern from the modern, the intuitive from the rational, and the power of the fist from the power of the mechanics. Sammo drinks Diet Coke, speaks English and tells his partner that he learns from the Discovery Channel. These treatments complicate and make fun of the Orientalist stereotype. Of course, there are occasions for mutual learning: the Americans learn from the legendary oriental and the Chinese learn from the scientific West. The orientals in *The X-Files* appear in the esoteric/negative mode, while in *Martial Law*, they are depicted in the exotic/positive mode. But both are discursive forms of stereotypical dualism of the modern West and the traditional rest.

There are reasons for this mixing of the esoteric/negative and the exotic/positive. First, the world is now having shifting ethnoscapes where diverse cultural narratives have been absorbed into the dynamic of global/local hybridisation. Intensive global migrations and tourism characterise these shifting ethnoscapes. Because of the implosion of boundaries between the Eastern and Western ethnoscapes, it is more easy for previous inflated international stereotyping to be rehabilitated. In the case of *Martial Law*, the influx of Hong Kong and Chinese artists into the United States brings about some changes. John Woo, Sammo Hung, Jackie Chan and Yuen Wo-ping (the martial

KUNG FU (1972–75)

Kung Fu, a TV series produced by Ed Spielman in the 1970s, is a sort of an Eastern Western in which a Shaolin priest, played by David Carradine, is wandering in the middle of the decidedly unenlightened Old West. Martial arts star Bruce Lee was, for a time, considered to play the lead role grasshopper Kwai Chang Caine. The show was never a tremendous ratings success in the United States, but it attracted a loyal legion of fans who were interested in Eastern culture.

In the show, Chinese culture is represented in a restricted range of kung fu tricks and quasi-Chinese philosophy. Caucasian actor David Carradine playing the role of a Chinese can be appropriately seen as a representation of a representation. *Kung Fu* was enthusiastically received in Hong Kong in the 1970s. Arguably, it can be said that this American TV show was having some Orientalistic effects by telling highly urbanised Hong Kong Chinese what Chinese culture was through Orientalist eyes. However, imported American TV programmes were quickly removed from the prime-time hours. Hong Kong prime-time television has been filled up with local programming since the mid-1970s. The argument of media imperialism and Orientalisation seems problematic in the case of Hong Kong (Ma, 1999).

Eric K. W. Ma

Kung Fu – representation of a representation?

arts director of the movie *The Matrix*) were all closely connected peers in Hong Kong. Together they have brought the practices of Hong Kong action movies and TV dramas into the United States. Second, the market logic of mass production leads to standardisation and disenchantment. In order to 're-enchant' cultural products and stimulate consumption, there is a strong tendency for American popular culture to absorb exotic cultures from all over the world to re-energise itself. Third, the increasing number of Chinese immigrants and the strengthening of their political power within America may add pressure for politically correct media representation.

The most problematic part of the Orientalism thesis is about its ability to reproduce subjectivity. Orientalism can

be exported to and reproduce itself in the rest of the world. It is argued that Orientalism is so powerful and encompassing that some people from the East may see themselves through the discursive web of Orientalism. In other words, the orientals can be orientalised by Orientalism. This leads to the question of transnational discursive effects which are often assumed in various theoretical forms of media imperialism. However, the assumption of powerful imperialism has been problematised in recent globalisation theories (Baker, 1999). On the textual level, as indicated above, Orientalism may oscillate between the esoteric/negative and the exotic/positive modes. On the reception level, it is relatively easier for transnational viewers to discern the discrepancies between Orientalist discourse and everyday practices. Contextual interpretations can also be injected when television programmes travel across nations (Liebes and Katz, 1992). I tend to agree with Lodziak (1986) who argues that the ideological effect of television works better for the dominant groups rather than the subordinate. Extending this argument to the transnational context, Orientalism works better in reinforcing Chinese stereotypes among a domestic American audience, but is less powerful in 'orientalising' Chinese audiences in their own contexts. However, one obvious transnational effect of Orientalism may be the construction of an essentialised West in the reverse, or what is called 'Occidentalism'. Through subtle stereotypical dualism, Orientalism triggers the imagination of the West as a unified and modernised whole, no matter whether the orient is depicted in the esoteric/negative mode as in *The X-Files* or the exotic/positive mode as in *Martial Law*. It is found that the discourse of Occidentalism (Carrier, 1995) can be and has been mobilised to intervene in local and global cultural politics in the East; but this is a complicated subject far beyond the scope of the present discussion.

Eric K. W. Ma

RECOMMENDED READING

Barker, Chris (1999), *Television, Globalization and Cultural Identities*, Buckingham: Open University Press.

Hall, Stuart (1992), 'The West and the Rest: Discourse and Power', in Stuart Hall and Bram Gieben (eds), *Formation of Modernity*, Cambridge: Polity Press.

Sardar, Ziauddin (1999), *Orientalism*, Buckingham: Open University Press.

Targeting Minorities

Targeting minorities is a relatively recent phenomenon in television circles in large part due to the fact that the discourse of minorities as an amalgamation of individuals and groups that deserve to be taken seriously and can simultaneously yield a profit can be traced back no earlier than the 1960s. In the context of contemporary broadcasting, this meant that in terms both of public service, such as the British Broadcasting Corporation (BBC) or Public Broadcasting System (PBS) models in England and the United States respectively, and commercial broadcasting, geared to maximising profits not audiences, there existed little imperative to reach minorities from the mainstream before these were identified, let alone studied. 'To serve the public interest', the philosophical cornerstone of the US broadcasting licence process, was not interpreted in terms other than technical efficiency and profitability until influences of the civil rights and women's movement seeped into the Federal Communications Commission (FCC) commissioner's rhetoric (Barnouw, 1975). In other words, an audience, minority or not, is a historically specific social construct and, though people may predate the existence of the construct, there will not be an impetus to reach them before they are envisioned as an audience (Ang, 1991). Most of the material in this entry will focus on United States experience, whether through discussions of its increasingly corporate supported PBS or through discussions of the commercial networks. Historically, however, PBS has not differed much from and, in fact, has at times dragged behind in relation with commercial broadcasters on the issue of targeting minorities.

The construction of minority audiences shapes their ethnicity as it targets and attempts to tap into their disposable income. When early radio companies in the US tried to unload non-commercially-viable hours to others, for example, Mexican American interests seized the opportunity to reach their community (Rodriguez, 1999). However, this situation differed from contemporary targeting of minorities as 'wasted' airtime was utilised by marginal populations to communicate among themselves. In fact broadcasting institutions did not want to alienate the majority mainstream audience – that is, the mythical white middle class – with any threatening minority representations so the thought of targeting minority audiences, as an additional step, did not even exist until quite recently.

Whereas traditionally minorities include racial and ethnic groups, such as African-Americans, Latina/os, Asian Americans and Native Americans in the US, this is

ROSIE PEREZ

The career of Rosie Perez demonstrates some of the potentials and pitfalls of contemporary approaches to target minorities in US television and film. To begin with there are few roles for Latinas in television or film and many times these are played by non-Latina actresses. Against this backdrop, Latinas walk a fine line between occasional roles and unemployment so that their own creative input is largely circumscribed once in a television show or film. Rosie Perez enjoyed a brief moment in the Hollywood limelight in the late 1980s and early 90s. She began her career, as did Jennifer Lopez, another major Latina star, as a dancer in the Fox television show *In Living Color*. Dancing is something closely associated with African-Americans and Latina/os in the US cultural imaginary. Rosie's jump to the silver screen came in Spike Lee's *Do the Right Thing* (1989) in which Rosie opened the film with a very strong pelvic dance scene and also played the role of the lead character's girlfriend. Rosie's inescapably strong and high-pitched Nuyorrican accent defined as well as limited her roles (Nuyorrican is the term used to refer to populations of Puerto Rican descent living in New York). Among other movies she appeared in were *White Men Can't Jump* (1992), *Untamed Heart* (1993), *Fearless* (1993) and *It Could Happen to You* (1994). She played supporting roles in other films as well as appearing in several talk and infotainment shows on television before nearly disappearing from the limelight.

Rosie Perez did not go unnoticed. She appealed to different types of audiences for different reasons. As such she was a component of a multi-level approach of targeting minorities – one that aims to appeal to minority audiences without offending majority audiences. As such, Rosie's many roles were both com-

Rosie Perez in *Do the Right Thing* (1989)

forting and familiar, in terms of historical representations of Latinas in film and television, as well as unusual in that she was cast in a melodrama (as opposed to the more usual comedies and dance films) and nominated for an Oscar for that performance in *Fearless*. While Rosie appealed to mainstream audiences because of her sensual street savvy, accompanied by her ethnic looks and dancing abilities, as many of the mainstream interviews and reviews of her films suggested, her reception among minority audiences was far more complex. Whereas many, primarily but not exclusively, Latinos found her sexy and loved having a Latina on the screen, many Latinas found her characters stereotypical and largely demeaning. This gendered and ethnically inflected reading of Rosie demonstrates that targeting minorities is a complicated process if we look at interpretive possibilities. If we look just at the bottom line of profit, for the film and television industry Rosie was a useful Latina actress: for a brief period, she helped both to attract ethnic audiences and not to alienate the minority audience.

Angharad Valdivia

not the only deployment of the concept. Other minorities include sexual minorities, with a need to differentiate between gays and lesbians because of the differential purchasing power and life histories that gender is likely to effect (Clark, 2001), the elderly and the disabled. Recent demographic trends in most industrialised countries promise to make the elderly an increasingly powerful minority. Most of the literature on minorities concurs that the term is not necessarily a numerical indicator but rather a measure of relative power. Thus minorities themselves are another social construct. For example, at the outset of the second wave of the women's movement, women were considered a minority though they generally make up 52 per cent of the population. Programming targeted at women had existed since nearly the beginning of television history. Soap operas, in fact, were an effort to target

women so as to increase the sales of soap while simultaneously disposing of the unprofitable daytime broadcasting hours – demonstrating the inextricable relationship between audience construction, programming and marketing. However, following the political activism of the 1960s, we began to see television shows aimed at women, representing more women and produced by women on prime time.

Research suggests that broadcasting industry 'common sense' on minorities, in terms of what they watch, what they prefer, with what they identify, was and remains largely based on prejudice rather than on 'objective' research (Gandy, 1998; Gray, 1995). Theories of consumerism fall prey to normalising tendencies of culture at large. As well, given that most broadcasting programming and film development was and continues to be done by

majority culture individuals, the small creative input of minorities is likely to have an additional effect.

The relative effort expended in attempting to reach minority audiences depends on four marketing criteria (Astroff, 1988), all of which build on each other. Thus a group must be identifiable, then accessible, then measurable and finally profitable in order to be considered a worthwhile minority. Identifiability works in favour of African-Americans but not lesbians – the latter can be any race, age or class and might need to remain unidentified in order to keep their jobs, housing, etc. Prejudicial 'common sense' which sees all African-Americans and Latina/os as poor survived in a climate in which there was no attempt to measure the potential profitability of these audiences. As the purchasing power of African-Americans began to be acknowledged, broadcasting responded with more programming in clearly marked times. Popular 70s shows such as *The Jeffersons* and *Good Times*, what MacDonald (1983) termed 'the new minstrelsy', rehashed old stereotypes to great success among white and black audiences (see *Ethnic Notions*, Riggs, 1986). As with the previous black comedy hit *Amos 'n' Andy*, however, the lines of interpretation differed widely as research suggests that whereas these shows were funny and comfortable for US whites precisely because they did not deviate from racist representations, among the black audience there was a thirst for any type of black representation in what had otherwise been a primarily lily-white landscape. However, even the actors in these sitcoms argued against the stereotypes they were forced to perform week after week (see *Color Adjustment*, Riggs, 1991). Much later, the *Cosby Show* was also popular in apartheid South Africa, suggesting once more wildly different motives for the show's popularity (Jhally and Lewis, 1992). More complex shows such as *Frank's Place*, which were apparently well received within African-American communities (Gray, 1995), were eventually cancelled despite high critical acclaim. This latter instance suggests that targeting of minorities through mainstream television continues to be measured against the number of majority audiences the show will alienate.

The hugely successful *Cosby Show* was one of the first minority shows to portray a wealthy, nuclear, African-American family. As such it was touted as the epitome of the potential of television in racial matters and was rewarded with the National Association for the Advancement of Colored People (NAACP) Positive Image Award many times. As part of NBC's targeting approach, the show was slotted on black Thursday, followed by *A Different World* and/or other black-oriented shows. This type of scheduling represented a further refinement in targeting minorities, clustering all shows on one night so both minority and majority audiences would not accidentally turn on at the wrong time. Majority audiences could be assured that the bulk of prime-time nights remained white and minority audiences knew to watch on Thursdays. Furthermore, majority audiences would not be threatened by the carefully scripted *Cosby Show*, designed to appeal to all audiences.

Another major breakthrough in terms of targeting minorities came in the 1990s with the Fox Broadcasting network's efforts to establish itself as a viable competitor to the big three, NBC, ABC and CBS. In airing such 'irreverent' shows as *In Living Color* and *Martin*, Fox broke with the established broadcast wisdom of following a 'safe' path so as not to alienate the white audience. As a result, there was much controversy, but also Fox undeniably gained a stronghold as a network able to get large audiences and therefore secure its share of advertising revenue. Moreover, Fox demonstrated that minority audiences were able to pay for themselves, as it were, delivering enough numbers to make it profitable to make shows targeted primarily at them without overdue concern of alienating majority audiences. This content finding would not have been possible without the increased availability of channels which enabled the breaking down of large audiences into niche markets, some of which could be minority oriented. This finding has been applied to the proliferation of music television channels, which spans racial and ethnic as well as music genre possibilities. The global expansion of MTV and several countries' counter-programming with 'native' music channels suggests that this is a widely influential trend that could not have happened before the advent of cable television.

Contemporary US approaches to targeting minorities remain in a state of evolution and deserve ongoing scrutiny. New demographic and programming developments continue to challenge a broadcasting industry with strong tendencies towards stasis and the status quo. For example, the predominant discussion of minorities in terms of 'black and white' formulations will have to change as the Latina/o population is quickly becoming the most numerous minority. Latina/os are less easily identifiable than African-Americans as they span the entire racial spectrum and therefore will present increased challenges to marketing-driven broadcasters for whom identifiability is the first step to targeting. Attempts to homogenise the Latina/o audience have already resulted in stereotyping the Latina/o population as Spanish speakers (Dávila, 2000; Rodriguez, 1999) despite the fact that not all Latina/os speak or prefer programming in Spanish. Latina/o profes-

sionals in the industry actively promote this strategy (Rodriguez, 1999; Sinclair, 1999). Other than the short-lived *All American Girl* and *Northern Exposure*, Asian Americans and Native Americans are nearly absent and certainly have yet to be found worthy of targeting. Still, as recently as the year 2000, the over-the-air television industry was severely criticised for its lack of any minority characters in its new show line-up so that the further complexities of targeting Latina/os, whether Spanish speaking or not, have not apparently appeared in the industry radar screen as it is still quite ambivalent about whether to target minorities or not.

Angharad Valdivia

RECOMMENDED READING

Astroff, Roberta J. (1988), 'Spanish Gold: Stereotypes, Ideology, and the Construction of a US Latino Market', *Howard Journal of Communication*, vol. 1, no. 4, pp. 155–173.

Jhally, Sut and Lewis, Justin (1992), *'Enlightened' Racism: The Cosby Show, Audiences, and the Myth of the American Dream*, Boulder: Westview Press.

MacDonald, J. Fred (1983), *Blacks on White TV: Afro-Americans in Television since 1948*, Chicago: Nelson-Hall Publishers.

Rodriguez, América (1999), *Making Latino News: Race, Language, Class*, Thousand Oaks, California: Sage.

First Peoples' Television

The development of television in First Peoples' communities began in the 1970s, triggered by the convergence of new mass-media technologies – in particular satellites and small-scale inexpensive video – and burgeoning movements for cultural rights and democratisation of media on the part of indigenous and media activists who shared skills, strategies and ideologies of progressive social change. Indigenous television, which includes participation in everything from national and regional broadcasting and cable, to very local low-power hook-ups, has emerged along with radio and film-making in many locations – New Zealand/Aotearoa, the US, Mexico, Brazil, Bolivia, to name a few prominent examples, as well as emerging work from indigeneous minorities in Taiwan and Japan's Ainu. However, it is most widely developed in Canada and Australia – our focus here – because of the prominence of these cases and the exemplary role they have played for efforts elsewhere. In both cases, indigenous activists lobbied forcefully to have control over media production, representations and circulation, a concern that was supported by the interest of media activists and some government officials in trying out new communication technologies that initially were regarded as experimental, but increasingly were recognised as basic to socio-cultural development of indigenous citizens living in both remote and urban areas.

First Peoples everywhere have struggled to find ways to turn the imposition of new communications technologies – in particular the arrival of satellite television in remote areas – to their advantage. Indeed, media projects have often become a site for cultural activism by those who see the political promise and cultural possibilities of indigenously controlled media-making as a way of strengthening local knowledge, as well as inserting an indigenous presence into the mediascapes of the nations that encompass them. In Canada, for example, the development of indigenous television in the early 1970s, as an experimental negotiation with the government, culminated thirty years later in the showcase national service, the Aboriginal Peoples Television Network (APTN) which began broadcasting on 1 September 1999, the sole nationally sponsored First Peoples' television service in the world to carry exclusively indigenous programming (see box, opposite). Indigenous media is produced and consumed not only by people living in remote areas; the work also circulates to other native communities as well as to non-aboriginal audiences via regional, national and even international television, as the case of APTN demonstrates. Such circulation, some argue, is an important dimension of building a framework for tolerance in multicultural societies. By contrast, others have argued that isolating indigenous work to a particular channel or programming slot can possibly create 'media reservations' (Roth, 2000), constructing a televisual space parallel to the kind of segregation that characterises First Peoples' socio-political experience. At the same time, a number of researchers regard the capacity of indigenous television to link formerly isolated communities as essential to building a strong national indigenous constituency based on programming reflecting cultural persistence (Roth, 1994) – as in the case of Television Northern Canada, the Pan-Northern distribution service which historically preceded APTN, and which many regard as a crucial step in the 1999 creation of Nunavut, Canada's first Inuit-governed territory.

Indigenous television is particularly well suited for inquiry into alternatives to the mass-media industries that dominate late capitalist societies, as they occupy a clear position of cultural and socio-political difference from dominant assumptions about media aesthetics and practices. These concerns motivated the activist researcher Eric

ABORIGINAL PEOPLES TELEVISION NETWORK (CANADA)

The Aboriginal Peoples Television Network (APTN) was licensed by the Canadian Radio-television Tele-communications Commission (CRTC) in February 1999 as a national service targeted to native/non-native audiences in Canada and available in the US by satellite. As the sole (inter)national broadcasting service in the world which carries exclusively indigenous-perspective programming (news, current affairs, comedy, variety, drama, children's programmes, cookery shows, documentary films, international programmes), APTN represents a new hybrid model of public/private broadcasting. Multicultural, multilinguistic and multiracial in content, production staff and management, it is both local and global in scope.

Faye Ginsburg and Lorna Roth

Michaels' work with the Warlpiri people at Yuendumu in Australia's central desert, where he helped to develop low-power television, as an alternative to the onslaught of commercial television introduced by the newly launched communications satellite, a development whose alterity and possibility he invoked in the title, *The Aboriginal Invention of Television in Central Australia* (1986).

In the mid-1980s, that experiment became a model for a government-sponsored effort to develop culturally appropriate low-power television in remote communities (Molnar, 1990); a regional Aboriginal media association, CAAMA, won the licence for the commercial satellite downlink to Central Australia. That station, Imparja, provides a modest amount of programming in four local Aboriginal languages as well as mainstream television. Australia's national public service television, the ABC, and its multicultural counterpart, the SBS, each established indigenous units in 1988; these sponsor a range of work from documentary to talk shows, to news and entertainment, to music videos.

These units, along with CAAMA, have played a significant role as training grounds for emerging media talent from the indigenous community. Yet, some producers feel their claim to an indigenous identity within a more cosmopolitan framework is sometimes regarded as inauthentic, as if their comfort with these aspects of modernity erased their legitimacy as 'natives'.

The question as to whether minority or dominated peoples can assimilate media to their own cultural and political concerns or are inevitably compromised by its presence haunts much of the research and debate on the topic of the cross-cultural spread of media. Some have expressed alarm that these new technologies are inevitably destructive of indigenous cultural values, echoing the concerns over the deleterious effects of mass culture first articulated by the Frankfurt School. Rather than casting judgment on these efforts to use media as forms of expressive culture and political engagement, many see in the growing use of video and other mass media an increasing awareness and strategic objectification of culture, as enabling some degree of agency to 'talk back' to hegemonic forms of representation, even if under less than ideal conditions (Ginsburg, 1991).

Indigenous television producers are actively using new technologies for their own purposes. They are documenting traditional activities with elders; creating works to teach young people literacy in their own languages; engaging with dominant circuits of mass media through mainstream as well as alternative arenas; communicating among dispersed kin and communities on a range of issues; using video as legal documents in negotiations with states; presenting videos on state television to assert their presence televisually within national imaginaries; producing public service programming; or creating award-winning shorts and feature films. While activism and policy concerns initially shaped much of indigenous media, it is important to acknowledge the current range of genres they produce that are more commonly associated with entertainment and information programming. These include drama, current affairs, political analysis, humour, cooking shows, variety shows, music videos and sports.

More generally, the capacity to narrate stories and retell histories from an indigenous point of view – what Ginsburg calls 'screen memories' (Ginsburg, Lughod and Larkin, 2002) and what Shinar calls 're-membering' (Shinar, 1996), through media forms that can circulate beyond the local, has been an important force for constituting claims for land and cultural rights, and for developing alliances with other communities. Whatever the contradictions, as new technologies have been embraced as powerful forms of collective self-production, they have enabled cultural activists to assert their presence in the polities that encompass them, and to more easily engage with larger movements for social transformation aimed at the recognition and redress of human and cultural rights, processes in which media play an increasingly important role.

Faye Ginsburg and Lorna Roth

BIBLIOGRAPHY

GENERAL INTRODUCTION

Allen, Robert C. (1985), *Speaking of Soap Operas*, Chapel Hill: University of North Carolina Press.

Alvarado, Manuel and Buscombe, Edward (1978), *Hazell – The Making of a TV Series*, London: British Film Institute/Latimer.

Beltran, L. R. and Fox, E. (1980), *Communicacíon dominada. Estados Unidos en los medios de América Latina*, Mexico City: Nueva Imagen/ILET.

Bennett, Tony, Boyd-Bowman, Susan, Mercer, Colin and Woollacott, Janet (eds) (1981), *Popular Television and Film*, London: British Film Institute.

Brunsdon, Charlotte, D'Acci, Julie and Spigel, Lynn (eds) (1997), *Feminist Television Criticism: A Reader*, New York: Oxford University Press.

Buckingham, David, Davies, Hannah, Jones, Ken and Kelley, Peter (1999), *Children's Television in Britain: History, Discourse and Policy*, London: British Film Institute.

Buscombe, Edward (ed.) (1975), *Football on Television*, London: British Film Institute.

Cesareo, G. (1974), *La Televisione sprecata*, Milan: Feltrinelli.

Comstock, George and Scharrer, Erica (1999), *Television: What's On, Who's Watching, and What it Means*, San Diego: Academic Press.

Cunningham, Stuart and Jacka, Elizabeth (1996), *Australian Television and International Mediascapes*, Melbourne: Cambridge University Press.

Curran, James, Gurevitch, Michael and Woollacott, Janet (eds) (1977), *Mass Communication and Society*, London: Edward Arnold.

Curran, James and Park, Myung-Jin (2000), 'Beyond Globalization Theory', in James Curran and Myung-Jin Park (eds), *De-Westernizing Media Studies*, London: Routledge, pp. 3–18.

Dines, Gail and Humez, Jean M. (eds) (1995), *Gender, Race and Class in Media: A Text-Reader*, Thousand Oaks: Sage.

Downing, John D. H. (1996), *Internationalizing Media Theory: Transition, Power, Culture: Reflections on Media in Russia, Poland and Hungary 1980–95*, London: Sage.

Dyer, Richard, Geraghty, Christine, Jordan, Marion, Lovell, Terry, Paterson, Richard and Stewart, John (1980), *Coronation Street*, London: British Film Institute.

Eco, Umberto (1972), 'Towards a Semiotic Inquiry into the Television Message', trans. Paola Splendore, *Working Papers in Cultural Studies,* vol. 3, pp. 103–121.

Fiske, John and Hartley, John (1978), *Reading Television*, London: Methuen.

Garfinkel, Harold (1992), *Studies in Ethnomethodology*, Cambridge: Polity Press.

Goonasekera, Anura and Lee, Paul S. N. (eds) (1998), *TV Without Borders: Asia Speaks Out*, Singapore: Asian Media Information and Communication Centre.

Haralovich, Mary Beth and Rabinovitz, Lauren (eds) (1999), *Television, History, and American Culture: Feminist Critical Essays*, Durham: Duke University Press.

Harcourt, Wendy (ed.) (1999), *Women@Internet: Creating New Cultures in Cyberspace,* London: Zed Books.

Hodge, Bob and Tripp, David (1986), *Children and Television,* London: Polity Press.

Jhally, Sut and Lewis, Justin (1992), *Enlightened Racism: The Cosby Show, Audiences, and the Myth of the American Dream*, Boulder: Westview Press.

Jones, Stephen G. (ed.) (1998), *Cybersociety 2.0: Revisiting Computer-Mediated Communication and Community*, Thousand Oaks: Sage Publications.

Kaplan, E. Ann (ed.) (1983), *Regarding Television: Critical Approaches – An Anthology*, Frederick: University Publications of America.

McLuhan, Marshall (1974), *Understanding Media: The Extensions of Man*, Aylesbury: Abacus.

Mattelart, Armand (1976), *Multinationales et systèmes de communication*, Paris: Anthropos.

Maxwell, Richard (1995), *The Spectacle of Democracy: Spanish Television, Nationalism, and Political Transition*, Minneapolis: University of Minnesota Press.

Moran, Albert (1998), *Copycat TV: Globalisation, Program Formats and Cultural Identity*, Luton: University of Luton Press.

Morley, David (1980), *The Nationwide Audience*, London: British Film Institute.

Newcomb, Horace (1974), *TV: The Most Popular Art*, Garden City: Anchor Press/Doubleday.

Newcomb, Horace (ed.) (1976), *Television: The Critical View*, New York: Oxford University Press.

Newcomb, Horace (1994), 'Television and the Present Climate of Criticism', in Horace Newcomb (ed.), *Television: The Critical View*, 5th edition, New York: Oxford University Press, pp. 3–13.

Newcomb, Horace (ed.) (1997), *Encyclopedia of Television*, Chicago: Fitzroy-Dearborn.

Noam, Eli and Millonzi, Joel C. (eds) (1993), *The International Market in Film and Television Programs,* Norwood: Ablex.

O'Donnell, Hugh (1999), *Good Times, Bad Times: Soap Operas and Society in Western Europe*, London: Leicester University Press.

Robins, Kevin and Webster, Frank (1999), *Times of the Technoculture: From the Information Society to the Virtual Life,* London: Routledge.

Schiller, Herbert I. (1969), *Mass Communication and American Empire*, Boston: Beacon Press.

Schramm, Wilbur (1973), 'Communication Research in the United States', in *The Voice of America Forum Lectures 1962: Mass Communication*, pp. 1–9.

Smith, Anthony (ed.) (1998), *Television: An International History*, 2nd edition, Oxford: Oxford University Press.

Streeter, Thomas (1996), *Selling the Air: A Critique of the Policy of Commercial Broadcasting in the United States*, Chicago: University of Chicago Press.

Turner, Graeme (2000), 'Studying Television', in Graeme Turner and Stuart Cunningham (eds), *The Australian TV Book*, Sydney: Allen & Unwin, pp. 3–12.

Williams, Raymond (1962), *Communications,* Harmondsworth: Penguin.

Williams, Raymond (1974), *Television: Technology and Cultural Form*, London: Fontana.

Forms of Knowledge

INTRODUCTION

Newcomb, Horace (1974), *TV: The Most Popular Art*, Garden City: Anchor Press/Doubleday.

MASS COMMUNICATION STUDIES

Beniger, J. (1987), 'Towards an Old New Paradigm: The Half-Century Flirtation With Mass Society', *Public Opinion Quarterly*, vol. 51.

Benjamin, W. (1970), 'The Work of Art in the Age of Mechanical Reproduction', in *Illuminations,* London: Jonathan Cape.

Hovland, C. (1959), 'Reconciling Conflicting Results Derived From Experimental and Survey Studies of Attitude Change', *The American Psychologist*, vol. 14.

McQuail, D. (1988), *Mass Communication Theory*, London: Sage.

Ouellette, L. (1999), 'Television Viewing as Good Citizenship?: Political Rationality, Enlightened Democracy and PBS', *Cultural Studies*, vol. 13, no. 1.

Thompson, John B. (1997), 'Mass Communication and Modern Culture', in T. O'Sullivan and Y. Jewkes (eds), *The Media Studies Reader*, London: Arnold.

Wilensky, H. (1995), 'Mass Media and Mass Culture: Interdependence or Independence?', in O. Boyd-Barrett and C. Newbold (eds), *Approaches to Media: A Reader*, London: Arnold.

Williams, R. (1963), *Culture and Society*, London: Penguin.

THE POLITICAL ECONOMY OF TELEVISION

Abramson, J. (1997), '96 Campaign Costs Set Record at $2.2 Billion', *New York Times*, 24 November.

Bagdikian, B. H. (1997), *The Media Monopoly*, 5th edition, Boston: Beacon.

Bourdieu, P. (1998), *On Television*, trans. Priscilla Parkhurst Ferguson. New York: New Press.

Cohen, J. and Solomon, N. (1992), 'Media Beat', *The Guardian* (New York), 15 April.

Cornford, J. and Robins, K. (1998), 'Beyond the Last Bastion: Industrial Restructuring and the Labour Force in the British Television Industry', in G. Sussman and J. A. Lent (eds), *Global Productions: Labor in the Making of the 'Information Society'*, Cresskill, NJ: Hampton.

Downing, J. (1990), 'The Political Economy of US Television', *Monthly Review*, May.

Gandy, O. H. Jr (1992), 'The Political Economy Approach: A Critical Challenge', in *Journal of Media Economics*, Summer.

Garnham, N. (1990), *Capitalism and Communication: Global Culture and the Economics of Information*, London: Sage.

Giddens, A. (2000), *Runaway World: How Globalization is Shaping Our Lives*, New York: Routledge.

Golding, P. and Murdock, G. (1991), 'Culture, Communication, and Political Economy', in J. Curran and M. Gurevitch (eds), *Mass Media and Society*, London: Edward Arnold.

Hamelink, C. (1983), *Finance and Information: A Study of Converging Interests*, Norwood, NJ: Ablex.

Hamelink, C. (1994), *The Politics of World Communication*, Thousand Oaks, CA: Sage.

McChesney, R. W. (1993), *Telecommunications, Mass Media and Democracy: The Battle for the Control of US Broadcasting, 1928–1935*, New York: Oxford University Press.

McPhail, T. (1993), 'Television as an Extension of the Nation State: CNNI and the Americanization of Broadcasting', unpublished manuscript.

Mattelart, A. (1991), *Advertising International: The Privatisation of Public Space*, trans. M. Chanan, London: Comedia and Routledge.

Mosco, V. (1996), *The Political Economy of Communication*, Thousand Oaks, CA: Sage.

Murdock, G. (1978), 'Blindspots about Western Marxism: A Reply to Dallas Smythe', *Canadian Journal of Political and Social Theory*, vol. 2, no. 2.

Perelman, M. (1998), *Class Warfare in the Information Age*, New York: St Martins.

Postman, N. and Powers, S. (1992), *How to Watch TV News*, New York: Penguin.

Robins, K. (1991), 'Prisoners of the City: Whatever Could a Postmodern City Be?', *New Formations*, December.

Schiller, D. (1988), 'How to Think About Information', in V. Mosco and J. Wasko (eds), *The Political Economy of Information*, Madison, WI: University of Wisconsin Press.

Schiller, H. I. (1981), *Who Knows: Information in the Age of the Fortune 500*, Norwood, NJ: Ablex.

Smythe, D. (1977), 'Communications: Blindspot of Western Marxism', in *Canadian Journal of Political and Social Theory*, vol. 1, no. 3.

Strother, D. (1999), 'Television Ads', in D. A. Perlmutter (ed.), *The Manship School Guide to Political Communication*, Baton Rouge: Louisiana State University Press.

Sussman, G. (1997), *Communication, Technology, and Politics in the Information Age*, Thousand Oaks, CA: Sage.

Tunstall, J. (1977), *The Media are American*, New York: Columbia University Press.

Webster, F. (1995), *Theories of the Information Society*, London: Routledge.

Williams, R. (1975), *Television: Technology and Cultural Form*, London: Fontana.

VIOLENCE AND EFFECTS RESEARCH

Comstock, George and Scharrer, Erica (1999), *Television: What's On, Who's Watching and What It Means*, San Diego: Academic Press.

Cook, Donald (2000), 'Testimony of the American Academy of Paediatrics on Media Violence Before the US Senate Commerce Committee', 13 September.

Fowles, Jib (1999), *The Case for Television Violence*, Thousand Oaks, CA: Sage Publications.

Gauntlett, David (1998), 'Ten Things Wrong with the "Effects Model"', in Roger Dickinson, Ramaswani Harindranath and Olga Linné (eds), *Approaches to Audiences: A Reader*, London: Arnold.

Hogben, Matthew (1998), 'Factors Moderating the Effect of Televised Aggression on Viewer Behaviour', *Communication Research*, vol. 25, no. 2.

Huesmann, L. R. and Miller, L. S. (1994), 'Long-term Effects of Repeated Exposure to Media Violence in Childhood', in L. R. Huesmann (ed.), *Aggressive Behavior: Current Perspectives*, New York: Plenum.

Huston, Aletha C., Donnerstein, Edward, Fairchild, Halford, Feshback, Norman D., Katz, Phyllis A., Murray, John P., Rubenstein, Eli A., Wilcox, Brian L. and Zuckerman, Diana (1992), *Big World, Small Screen: The Role of Television in American Society*, Lincoln, NE: University of Nebraska.

Josephson, Wendy L. (1995), *Television Violence: A Review of the Effects on Children of Different Ages*, Ottawa: Department of Canadian Heritage.

Morgan, Michael (ed.) (2002), *Against the Mainstream: Selected Writings of George Gerbner*, New York: Peter Lang Publishers.

Murray, John P. (1980), *Television and Youth: 25 Years of Research and Controversy*, Boys Town, NE: The Boys Town Center for the Study of Youth Development.

Paik, Haejung and Comstock, George (1994), 'The Effects of Television Violence on Antisocial Behavior: A Meta-Analysis', *Communication Research*, vol. 21, no. 4.

Shanahan, James and Morgan, Michael (1999), *Television and its Viewers: Cultivation Theory and Research*, Cambridge: Cambridge University Press.

United States Senate Committee on Commerce, Science, and Transportation (2000), *Children's Protection from Violent Programming Act: Report of the Committee on Commerce, Science, and Transportation on S. 876*, Washington: US GPO.

Williams, Tannis MacBeth (ed.) (1986), *The Impact of Television: A Natural Experiment in Three Communities*, Orlando: Academic Press.

Online Resources

www.aap.org/advocacy/releases/mediaviolencetestimony.pdf
www.theory.org.uk/effects.htm
www.hc-sc.gc.ca/hppb/familyviolence/html/tvviolence.htm
www.purl.access.gpo.gov/GPO/LPS7638

ETHNOGRAPHY

Abu-Lughod, Lila (1999), 'The Interpretation of Culture(s) After Television', in S. Ortner (ed.), *The Fate of 'Culture' and Beyond*, Berkeley: University of California Press.

Ang, Ien (1996), *Living Room Wars*, London: Routledge.

Barrio, Leoncio (1988), 'Television, Telenovelas, and Family Life in Venezuela', in J. Lull (ed.), *World Families Watch Television*, Thousand Oaks: Sage.

Bryce, Jennifer (1987), 'Family Time and Television Use', in T. Lindlof (ed.), *Natural Audiences*, Norton, NJ: Ablex.

Clifford, James (1988), 'On Ethnographic Authority', in *The Predicament of Culture*, Harvard, MA: Harvard University Press.

Clifford, James and Marcus, George (eds) (1986), *Writing Culture*, Berkeley: University of California Press.

Couldry, Nick (2000), *The Place of Media Power: Pilgrims and Witnesses of the Media Age*, London: Routledge.

Couldry, Nick (2003), 'Passing Ethnographies: Rethinking the Sites of Agency and Reflexivity', in P. Murphy and M. Kraidy (eds), *Transnational Culture and Media Ethnography*, Luton: University of Luton Press

Dornfeld, Barry (1998), *Producing Public Television, Producing Public Culture*, Princeton, NJ: Princeton University Press.

Gamson, Joshua (1994), *Claims to Fame: Celebrity in Contemporary America*, Berkeley: University of California Press.

Gans, Herbert (1980), *Deciding What's News* (2nd edition), New York: Vintage.

Geertz, Clifford (1988), *Works and Lives*, Stanford: Stanford University Press.

Gillespie, Marie (1995), *Television, Ethnicity and Cultural Change*, London: Routledge.

Ginsburg, Faye (1999), 'Shooting Back: From Ethnographic Film to Indigenous Production/Ethnography of Media', in T. Miller and R. Stam (eds), *Companion to Film Theory*, Oxford: Blackwell.

Gitlin, Todd (ed.) (1987), *Watching Television*, New York: Pantheon.

Gray, Ann (1992), *Video Playtime*, London: Routledge.

Hobson, Dorothy (1980), 'Housewives and the Mass Media', in S. Hall et al. (eds), *Culture, Media, Language*, London: Unwin Hyman.

Livingstone, Sonia and Bovill, Moira (1999), *Young People, New Media*, London: LSE Publications.

Lull, James (ed.) (1988), World FamiliesWatch Television. Beverley Hills: Sage.

Lull, James (1991), *Inside Family Viewing*, London: Routledge.

Marcus, George (1998), 'Ethnography In/Of the World System', in *Ethnography Through Thick and Thin*, Berkeley: University of California Press.

Martín-Barbero, Jesús (1993), *Communication, Culture and Hegemony*, London: Sage.

Moores, Shaun (1996), *Satellite Television and Everyday Life*, Luton: University of Luton Press.

Morley, David (1986), *Family Television: Cultural Power and Domestic Leisure*, London: Comedia.

Nightingale, Virginia (1996), *Studying Audiences: The Shock of the Real*, London: Routledge.

Radway, Janice (1988), 'Reception Study: Ethnography and the Problems of Dispersed Audiences and Nomadic Subjects', *Cultural Studies*, vol. 2, no. 3.

Rogge, Jan-Uwe and Jensen, Klaus (1988), 'Everyday Life and Television in West Germany', in J. Lull (ed.), *World Families Watch Television*, Thousand Oaks: Sage.

Seiter, Ellen (1999), *New Media Audiences*, Oxford: Oxford University Press.

Silverstone, Roger (1985), *Framing Science: The Making of a BBC Documentary*, London: BFI Publishing.

Silverstone, Roger (1994), *Television and Everyday Life*, London: Routledge.

Silverstone, Roger, Hirsch, Eric and Morley, David (1992), 'Information and Communication Technologies and the Moral Economy of the Household', in R. Silverstone and E. Hirsch (eds), *Consuming Technologies*, London: Routledge.

Traudt, Paul and Lont, Cynthia (1987), 'Media-Logic-In-Use: The Family as Locus of Study', in T. Lindlof (ed.), *Natural Audiences*, Norwood, NJ: Ablex.

Tufte, Thomas (2000), *Living with the Rubbish Queen: Telenovelas, Culture and Modernity in Brazil*, Luton: University of Luton Press.

Tulloch, John and Alvarado, Manuel (1983), *Doctor Who: The Unfolding Text*, Basingstoke: Macmillan.

Tulloch, John and Moran, Albert (1986), *A Country Practice: 'Quality' Soap*, Sydney: Allen & Unwin.

TELEVISION AND THE FRANKFURT SCHOOL

Adorno, T. W. (1978 [1932]), 'On the Social Situation of Music', *Telos*, vol. 35, Spring.

Adorno, T. W. (1982), 'On the Fetish Character of Music and the Regression of Hearing', in Andrew Arato and Eike Gebhardt (eds), *The Essential Frankfurt School Reader*, New York: Continuum.

Adorno, T. W. (1989), 'On Jazz', in Stephen Bronner and Douglas Kellner (eds), *Critical Theory and Society. A Reader*, New York: Routledge.

Adorno, T. W. (1991), *The Culture Industry*, London: Routledge.

Adorno, T. W. (1994), *The Stars Down to Earth and Other Essays on the Irrational in Culture*, London: Routledge.

Adorno, T. W. et al (1969 [1950]), *The Authoritarian Personality*, New York: Norton.

Adorno, T. W. with Simpson, G. (1941), 'On Popular Music', *Studies in Philosophy and Social Science*, vol. 9, no. 1.

Arato, Andrew and Gebhardt, Eike (eds) (1982), *The Essential Frankfurt School Reader,* New York: Continuum.

Benjamin, Walter (1969), *Illuminations*, New York: Shocken.

Bloch, Ernst (1986), *The Principle of Hope*, Cambridge: MIT Press.

Bronner, Stephen and Kellner, Douglas (eds) (1989), *Critical Theory and Society. A Reader*, New York: Routledge.

Gitlin, Todd (1972), 'Sixteen Notes on Television and the Movement', in George White and Charles Newman (eds), *Literature and Revolution*, New York: Holt, Rinehart and Winston.

Herzog, Herta (1941), 'On Borrowed Experience. An Analysis of Listening to Daytime Sketches', *Studies in Philosophy and Social Science*, vol. IX, no. 1.

Horkheimer, Max and Adorno, T. W. (1972), *Dialectic of Enlightenment*, New York: Herder and Herder.

Jay, Martin (1993), *The Dialectical Imagination*, Boston: Little, Brown and Company.

Kellner, Douglas (1989), *Critical Theory, Marxism, and Modernity*, Cambridge and Baltimore: Polity and John Hopkins University Press.

Kellner, Douglas (1995), *Media Culture. Cultural Studies, Identity, and Politics Between the Modern and the Postmodern*, London and New York: Routledge.

Kellner, Douglas (1997), 'Critical Theory and British Cultural Studies: The Missed Articulation', in Jim McGuigan (ed.), *Cultural Methodologies*, London: Sage, pp. 12–41.

Kracauer, Siegfried (1995), *The Mass Ornament*, Cambridge, MA: Harvard University Press.

Lazarsfeld, Paul (1941), 'Administrative and Critical Communications Research', *Studies in Philosophy and Social Science*, vol. IX, no. 1.

Lowenthal, Leo (1957), *Literature and the Image of Man*, Boston: Beacon Press.

Lowenthal, Leo (1961), *Literature, Popular Culture and Society*, Englewood Cliffs, NJ: Prentice-Hall.

Lowenthal, Leo with Guttermann, Norbert (1949), *Prophets of Deceit*, New York: Harper.

Marcuse, Herbert (1955), *Eros and Civilization*, Boston: Beacon Press.

Marcuse, Herbert (1964), *One-Dimensional Man*, Boston: Beacon Press.

Rosenberg, Bernard and White, David Manning (eds) (1957), *Mass Culture*, Glencoe, Ill.: The Free Press.

Wiggershaus, Rolf (1994), *The Frankfurt School*, Cambridge: Polity Press.

MEDIA IMPERIALISM

Abu-Lughod L. (1993), 'Finding a Place for Islam: Egyptian Television Serials and the National Interest', *Public Culture*, vol. 5 no. 3, pp. 494–512.

Bagdikian, B. (2000), *The Media Monopoly*, Boston: Beacon Press.

Bitterlli, U. (1989), *Cultures in Conflict: Encounters Between European and Non-European Cultures 1492–1800*, Cambridge: Polity Press.

Boyd-Barrett, O. (1977), 'Media Imperialism: Towards an International Framework for the Analysis of Media Systems', in J. Curran, M. Gurevitch and J. Woolacott (eds), *Mass Communication and Society*, London: Edward Arnold.

Boyd-Barrett, O. (1980), *The International News Agencies*, London: Constable.

Galtung, J. and Vincent, R. (1992), *Global Glasnost: Toward a New World Information and Communication Order?*, Cresskill, NJ: Hampton Press.

Guback T. and Varis, T. (1982), 'Transnational Communication and Cultural Industries', *Reports and Papers on Mass Communication*, no. 92, Paris: UNESCO.

Hamelink, C. (1983), *Cultural Autonomy in Global Communications*. New York: Longman.

Herman, E. and McChesney, R. (1997), *The Global Media*, London: Cassell.

Hoskins, C. and McFadyen, S. (1991), 'The US Competitive Advantage in the Global Television Market: Is it Sustainable in the New Broadcasting Environment?', *Canadian Journal of Communication*, vol. 16, no. 2, pp. 207–24.

Katz, E. and Wedell, G. (1977), *Broadcasting in the Third World*, Cambridge, MA: Harvard University Press.

Lasch, S. and Urry, J. (1994), *Economies of Signs and Space*, London: Sage.

Lerner, D. (1958), *The Passing of Traditional Society*, New York: Free Press.

Liebes, T. and Katz, E. (1990), *The Export of Meaning*, Oxford: Oxford University Press.

Nordenstreng, K. and Varis, T. (1974), 'Television Traffic – A One-way Street?', *Reports and Papers on Mass Communication*, no. 70, Paris: UNESCO.

Schiller, Herbert (1969), *Mass Communications and American Empire*, New York: A. M. Kelley.

Schiller, Herbert (1976), *Communication and Cultural Domination*, White Plains: International Arts and Sciences Press.

Sepstrup, P. and Goonasekura, A. (1994), 'TV Transnationalization: Europe and Asia', *Reports and Papers on Mass Communication*, Paris: UNESCO.

Sinclair J., Jacka, E. and Cunningham, S. (1996), *New Patterns in Global Television: Peripheral Vision*, Oxford: Oxford University Press.

Sreberny-Mohammadi, A. (1997), 'The Many Cultural Faces of Imperialism', in P. Golding and P. Harris (eds), *Beyond Cultural Imperialism*, London: Sage.

Sreberny-Mohammadi, A. (2000 [1991]), "The Global and Local in International Communication" (third revision) in J. Curran and M. Gurevitch, eds, *Mass Media and Society*, Third Edition, London: Arnold, pp. 93–120.

Sreberny-Mohammadi, A. Nordenstreng, K. Stevenson, R. and Ugboajah, F. (1985), 'Foreign News in the Media: International Reporting in 29 Countries', *Reports and Papers in Mass Communication*, no. 90, Paris: UNESCO.

Tomlinson, J. (1991), *Cultural Imperialism*, Baltimore, MD: John Hopkins Press.

Tracey, M. (1988), 'Popular Culture and the Economics of Global Television', *Intermedia*, vol. 16 no. 2.

Tunstall, Jeremy (1977), *The Media are American*, New York: Columbia University Press.

UNESCO (1980), *Many Voices, One World: International Commission for the Study of Communication Problems*, Paris: UNESCO.

Waisbord, S. (2000), 'Media in South America: Between the Rock of the State and the Hard Place of the Market', in J. Curran, and M. Park (eds), *De-Westernizing Media Studies*, London: Routledge.

CULTURAL STUDIES AND TELEVISION

Altman, Rick (1999), *Film/Genre*, London: BFI Publishing.

Bobo, Jacqueline and Seiter, Ellen (1997), 'Black Feminism and Media Criticism: The Women of Brewster Place' in Brunsdon, Charlotte, D'Acci, Julie and Spigel, Lynn (eds), *Feminist Television Criticism: A Reader*, Oxford: Oxford University Press.

Brunsdon, Charlotte (1998), 'What's the Television of Television Studies?' in Geraghty, Christine and Lusted, David (eds), *The Television Studies Book*, London: Edward Arnold.

Brunsdon, Charlotte and Morley, David (1978), *Everyday Television: 'Nationwide'*, London: BFI Publishing.

Caughie, John (2000), *Television Drama: Realism, Modernism and British Culture*, Oxford: Oxford University Press.

Collins, Richard (1993), 'Public Service versus the Market Ten Years On: Reflections on Critical Theory and the Debate on Broadcasting Policy in the UK', *Screen*, vol. 34 no. 3.

Collins, Richard (1999), *From Satellite to Single Market: New Communication Technology and European Public Service Television*, London: Routledge.

Corner, John (2001), 'Television and Culture: Duties and Pleasures' in Morley, David and Robbins, Kevin (eds), *British Cultural Studies: Geography, Nationality and Identity*, Oxford: Oxford University Press.

D'Acci, Julie (1994), *Defining Women: Television and the Case of Cagney and Lacey*, Chapel Hill: University of North Carolina Press.

Fiske, John (1987a), 'British Cultural Studies and Television' in Robert C. Allen (ed.), *Channels of Discourse: Television and Contemporary Criticism*, Chapel Hill: University of North Carolina Press.

Fiske, John (1987b), *Television Culture*, London: Methuen.

Garnham, Nicholas (1998), 'Political Economy and Cultural Studies: Reconciliation or Divorce?' in Storey, John (ed.), *Cultural Theory and Popular Culture: A Reader* (2nd edn), Harlow: Longman.

Grossberg, Lawerence (1998), 'Cultural Studies vs Political Economy: Is Anybody Else Bored with this Debate?' in Storey (ed.), *Cultural Theory and Popular Culture*.

Hall, Stuart (1980), 'Encoding and Decoding' in Hall, Stuart, Hobson, D., Lowe, A. and Willis, P. (eds), *Culture, Media, Language*, London: Hutchinson.

Hartley, John and Pearson, Roberta (eds) (2000), *American Cultural Studies: A Reader*, Oxford: Oxford University Press.

Hoggart, Richard (1958), *The Uses of Literacy*, London: Penguin Press.

Kellner, Douglas (1995), *Media Culture. Cultural Studies, Identity, and Politics Between the Modern and the Postmodern*, London and New York: Routledge.

Lusted, David (1998), 'The Popular Culture Debate and Light Entertainment in Television' in Geraghty, Christine and Lusted, David (eds), *The Television Studies Book*, London: Edward Arnold, pp. 175–90.

McGuigan, Jim (1992), *Cultural Populis*, London: Routledge.

Miller, Toby (1997), *The Avengers*, London: BFI Publishing.

Morley, David (1980), *The Nationwide Audience: Structure and Decoding*, London: BFI Publishing.

Morley, David (1992), *Television, Audiences and Cultural Studies*, London: Routledge.

Morley, David and Brunsdon, Charlotte (1999), *The Nationwide Television Studies*, London: Routledge.

Morris, Meaghan (1990), 'Banality in Cultural Studies' in Patricia Mellencamp (ed.), *The Logics of Television: Essays in Cultural Criticism*, Bloomington: Indiana University Press/London: BFI Publishing).

Spigel, Lynn (1992), *Make Room for TV: Television and the Family Ideal in Postwar Amercia*, Chicago: University of Chicago Press.

Streeter, Thomas (1996), *Selling the Air: A Critique of the Policy of Commercial Broadcasting in the United States*, Chicago: University of Chicago Press.

Turner, Graeme (1996), *British Cultural Studies: An Introduction*, London: Routledge.

Williams, Raymond (1975), *Television: Technology and Cultural Form*, New York: Schocken Books.

POPULAR TELEVISION CRITICISM

Arlen, Michael J. (1969), *The Living Room War*, New York: Viking.

Arlen, Michael J. (1981), *Camera Age: Essays on Television*, New York: Farrar, Straus, Giroux.

Laurent, Lawrence (1962), 'Wanted: The Complete Television Critic', in Robert Lewis Shayon (ed.), *The Eighth Art*, New York: Holt, Rinehart and Winston.

Seldes, Gilbert (1956), *The Public Arts*, New York: Simon and Schuster.

Shayon, Robert Lewis (1971), *Open to Criticism*, Boston: Beacon.

Watson, Mary Ann (1985), 'Television Criticism in the Popular Press', *Critical Studies in Mass Communication*.

TEXTUAL ANALYSIS

Allen, Robert C. (1999), 'Home Alone Together: Hollywood and the "Family Film"', in M. Stokes and R. Maltby, *Identifying Hollywood Audiences: Cultural Identity and the Movies*, London: BFI Publishing.

Bennett, Tony (1998), *Culture: A Reformer's Science*, London: Sage Publications.

Brunsdon, Charlotte, D'Acci, Julie and Spigel, Lynn (eds) (1997), *Feminist Television Criticism*, Oxford: Oxford University Press.

Brunsdon, Charlotte and Morley, David (1978), *Everyday Television: Nationwide*, London: BFI Publishing.

Eco, Umberto (1972), 'Towards a Semiotic Enquiry into the Television Message', *Working Papers in Cultural Studies*, vol. 3.

Eco, Umberto (1987), *Travels in Hyperreality*, London: Picador.

Fiske, John and Hartley, John (1978), *Reading Television*, London: Methuen.

Gitlin, Todd (1987; rev. edn 1993), *The Sixties: Years of Hope, Days of Rage*, New York: Bantam.

Gray, Herman (1995), *Watching Race: Television and the Struggle for 'Blackness'*, Minneapolis: Minnesota University Press.

Hall, Stuart and Whannel, Paddy (1964), *The Popular Arts*, London: Hutchinson Educational.

Hartley, John (1999a), *Uses of Television*, London and New York: Routledge.

Hartley, John (1999b), '"Text" and "Audience": One and the Same? Methodological Tensions in Media Research', *Textual Practice*, vol. 13, no. 3.

Hoggart, Richard (1960), 'The Uses of Television', *Encounter*, vol. 76.

Katz, Elihu (2000 [1983]), 'The Return of the Humanities and Sociology', in John Hartley and Roberta E. Pearson (eds), *American Cultural Studies: A Reader*, Oxford: Oxford University Press.

Kress, Gunther and van Leeuwen, Theo (1996), *Reading Images: The Grammar of Visual Design*, London: Routledge.

Lotman, Yuri (1990), *The Universe of the Mind: A Semiotic Theory of Culture*, Bloomington: Indiana University Press.

McGuigan, Jim (1992), *Cultural Populism*, London: Routledge.

Miller, Toby (1997), *The Avengers*, London: BFI Publishing.

Morris, Meaghan (1988), *The Pirate's Fiancée: Feminism, Reading, Postmodernism*, London: Verso.

Morrison, David E. (1998), *The Search for a Method: Focus Groups and the Development of Mass Communication Research*, Luton: University of Luton Press.

Newcomb, Horace (1974), *Television: The Most Popular Art*, New York: Doubleday Anchor Books.

Philo, Greg and Miller, David (1998), *Cultural Compliance: Dead Ends of Media/Cultural Studies and Social Science*, Glasgow: Glasgow University Media Group.

Schiller, Herbert (1996), *Information Inequality*, London: Routledge.

Sconce, Jeffrey (2000), *Haunted Media: Electronic Presence from Telegraphy to Television*, Durham, NC: Duke University Press.

Sinfield, Alan (1994), *Cultural Politics – Queer Reading*, London: Routledge.

Spigel, Lynn (1997), 'The Making of a TV Literate Elite', in Christine Geraghty and David Lusted (eds), *The Television Studies Book*, London: Arnold.

Spigel, Lynn (2000), 'Television Studies for "Mature" Audiences', *International Journal of Cultural Studies*, vol. 3, no. 3.

Spigel, Lynn (2001), *Welcome to the Dreamhouse: Popular Media and Postwar Suburbs*, Durham, NC: Duke University Press.

Volosinov, Valentin (1973), *Marxism and the Philosophy of Language*, New York: Seminar Press.

Williams, Raymond (1974), *Television: Technology and Cultural Form*, London: Fontana.

Windschuttle, Keith (1998), 'Cultural Studies vs Journalism', in M. Breen (ed.), *Journalism: Theory and Practice*, Sydney: Macleay Press.

Wolfe, Tom (1969), 'What If He is Right?', in *The Pump House Gang*, New York: Bantam Books.

NEW TECHNOLOGIES

Caldwell, John Thornton (ed.) (2000), *Electronic Media and Technoculture*, New Brunswick: Rutgers University Press.

Harries, Dan (ed.) (2002), *The New Media Book*, London: BFI Publishing.

Kling, Rob (ed.) (1996), *Computerization and Controversy: Value Conflicts and Social Choices*, 2nd edition, San Diego: Academic Press.

McChesney, Robert W. (1997), *Corporate Media and the Threat to Democracy*, New York: Seven Stories Press.

Marvin, Carolyn (1988), *When Old Technologies Were New*, New York: Oxford University Press.

Noble, David (1984), *Forces of Production: A Social History of Industrial Automation*, New York: Knopf.

Paredes, Maribel (2000), 'The Development of the US Advanced Television System 1987–1997: The Property Creation of New Media', PhD dissertation, University of California, San Diego.

Schiller, Daniel (1999), *Digital Capitalism*, Cambridge, MA: MIT Press.

Seiter, Ellen (1999), *Television and New Media Audiences*, Oxford and New York: Oxford University Press.

Silverstone, R. and Hirsch, E. (eds) (1992), *Consuming Technologies: Media and Information in Domestic Spaces*, London: Routledge.

Williams, Raymond (1975), *Television: Technology and Cultural Form*, New York: Schocken Books.

Zettl, Herb (2000), *Video Basics 3*, Belmont, CA: Wadsworth/Thomson Learning.

TELEVISION MARKETING

Berger, Arthur A. (2000), *Ads, Fads, and Consumer Culture: Advertising's Impact on American Character and Society*, Lanham, MD: Rowan & Littlefield.

Eastman, Susan T. and Klein, Robert A. (1991), *Promotion and Marketing for Broadcasting and Cable*, Prospect Heights, IL: Waveland Press.

Ewen, Stuart (1988), *All Consuming Images: The Politics of Style in Contemporary Culture*, New York: Basic Books.

Poltrack, David (1983), *Television Marketing: Network, Local, and Cable*, New York: McGraw-Hill.

Rothenberg, Randall (1994), *Where the Suckers Moon: An Advertising Story*, New York: Knopf.

Twitchell, James B. (1996), *Adcult USA: The Triumph of Advertising in American Culture*, New York: Columbia University Press.

Online Resources

www.adage.com (Leading trade publication for the advertising industry)

www.adbusters.org (An anti-advertising publication)

www.adcritic.com (Site where you can find most current advertising and provide your own criticism)

www.broadcastingcable.com (The weekly trade publication for the television industry)

kafka.uvic.ca/~rzarchik/sexobject.html (Authority and TV ads)

www.liketelevision.com (Access classic television commercials)

www.spotsndots.com (Daily news of TV sales)

www.tvads.cjb.net (TV ads from around the world)

www.tv-turnoff.org (Organisation that promotes turning off your television set)

www.televisioncommercials.com (View new and classic TV commercials)

TELEVISION AND THE LAW

Aufderheide, Patricia (1999), *Communications Policy and the Public Interest: The Telecommunications Act of 1996*, New York: Guilford.

Boyle, James (1996), *Shamans, Software and Spleens: Law and the Construction of the Information Society*, Cambridge, MA: Harvard University Press.

Classen, Steven Douglas (forthcoming), *Watching Jim Crow: The Struggles Over Mississippi Television, 1955–1969*, Durham, NC: Duke University Press.

Coase, Ronald H. (1959), 'The Federal Communications Commission', *Journal of Law and Economics*, vol. 11, p. 1.

Collins, Richard (1990), *Television: Policy and Culture*, Boston: Unwin Hyman.

Collins, Ronald K. L. and Skover, David M. (1990), 'The First Amendment in an Age of Paratroopers', *Texas Law Review*, vol. 68, no. 6.

Friendly, Fred W. (1977), *The Good Guys, the Bad Guys, and the First Amendment: Free Speech vs Fairness in Broadcasting*, New York: Vintage.

Kline, David (1995), 'Savvy Sassa', *Wired* 3.03, March, p. 112.

Ó Siochrú, Seán and Girard, Bruce, with Mahan, Amy (2002), *Global Media Governance: A Beginner's Guide*, Boston: Rowan and Littlefield.

Paley, William S., (1971 [1938]) FCC *Informal Engineering Conference*, vol. II, pp. 252–3, 16 June 1936, quoted in Frank C. Waldrop and Joseph Borkin, *Television: A Struggle for Power*, New York: Arno Press and the New York Times.

Price, Monroe E. (1995), *Television, the Public Sphere, and National Identity*, New York: Oxford University Press.

Rand, Ayn (1967), 'The Property Status of the Airwaves', in *Capitalism: The Unknown Ideal*, New York: American Library, p. 122.

Smythe, Dallas W. (1952), 'Facing the Facts about the Broadcast Business', *University of Chicago Law Review*, vol. 20, pp. 96–107.

GLOBALISATION

Ang, Ien (1996), *Living Room Wars: Rethinking Media Audiences for a Postmodern World*, London: Routledge.

Curtin, Michael (forthcoming), *Playing to the World's Biggest Audience: The Globalization of Chinese Film and TV*.

Gillespie, Marie (1995), *Television, Ethnicity and Cultural Change*, London: Routledge.

Gripsrud, Jostein (1995), *The Dynasty Years: Hollywood Television and Critical Media Studies*, London: Routledge.

Lull, James (1991), *China Turned On: Television, Reform, and Resistance*, London: Routledge.

Mankekar, Purnima (1999), *Screening Culture, Viewing Politics*, Durham: Duke University Press.

Mattelart, Armand, Delcourt, Xavier and Mattelart, Michelle (1984), *International Image Markets*, London: Comedia.

Miller, Toby, Maxwell, Richard, Govil, Nitin and McMurria, John (2001), *Global Hollywood*, London: BFI Publishing.

Morley, David and Robins, Kevin (1995), *Spaces of Identity: Global Media, Electronic Landscapes and Cultural Boundaries*, London: Routledge.

Schiller, Herbert I. (1971), *Mass Communications and American Empire*, New York: Beacon Press.

Smythe, Dallas W. (1981), *Dependency Road: Communications, Capitalism, Consciousness, and Canada*, Norwood, NJ: Ablex.

Straubhaar, Joseph (1991), 'Beyond Media Imperialism: Asymmetrical Interdependence and Cultural Proximity', *Critical Studies in Mass Communication*, vol. 8.

Tomlinson, John (1999), *Globalization and Culture*, Chicago: University of Chicago Press.

TELEVISION PRODUCTION AND DISTRIBUTION

Alvarado, M. and Buscombe, E. (1978), *Hazell: The Making of a TV Series*, London: BFI Publishing.

Crofts, S. (1995), 'Global *Neighbours*?', in R. Allen (ed.), *To Be Continued . . . :Soap Operas Around the World*, London and New York: Routledge.

Cunningham, S. and Jacka, E. (1996), *Australian Television and International Mediascapes*, Oakleigh: Cambridge University Press.

Dornfeld, B. (1998), *Producing Public Television, Producing Public Culture*, Princeton, NJ: Princeton University Press.

Feuer, J., Kerr, P. and Vahimagi, T. (1984), *MTM: 'Quality Television'*, London: BFI Publishing.

Gitlin, T. (1994), *Inside Prime Time* (rev. edn), London: Routledge.

Herman, E. S. and McChesney, R. W. (1997), *The Global Media: The New Missionaries of Global Capitalism*, London: Cassell.

Mattelart, A. (1979), *Multinational Corporations and the Control of Culture: The Ideological Apparatuses of Imperialism*, Sussex: Harvester.

Mattelart, A., Delcourt X. and Mattelart, M. (1984), *International Image Markets: In Search of an Alternative Perspective*, London: Comedia.

Schlesinger, Philip (1987), *Putting 'Reality' Together: BBC News*, (rev. edn), London: Methuen.

Sinclair, J. (1999), *Latin American Television: A Global View*, Oxford: Oxford University Press.

Sinclair, J., Jacka, E. and Cunningham, S. (1996), *New Patterns in Global Television: Peripheral Vision*, Oxford: Oxford University Press.

Tulloch, J. and Moran, A. (1986), *A Country Practice: Quality Soap*, Sydney: Currency Press.

POLICY

Aufderheide, Patricia (1991), 'Public Television and the Public Sphere', *Critical Studies in Mass Communication*, no. 8, pp. 168–83.

Bennett, T. (1992), 'Useful Culture', *Cultural Studies*, vol. 6, no. 3.

Collins, R. and Murroni, C. (1996), *New Media, New Policies: Media and Communication Strategies for the Future*, Cambridge: Polity Press.

Cunningham, S. (1992), *Framing Culture: Criticism and Policy in Australia*, Sydney: Allen & Unwin.

Dunleavy, P. and O'Leary, B. (1987), *Theories of the State: The Politics of Liberal Democracy*, London: Macmillan.

Giddens, A. (1998), *The Third Way: The Renewal of Social Democracy*, Cambridge: Polity Press.

Goldsmith, B., Thomas, J., O'Regan, T. and Cunningham, S. (2001), 'Asserting Cultural and Social Regulatory Principles in Converging Media Systems', in Marc Raboy (ed.), *Global Media Policy in the New Millennium*, Luton: University of Luton Press.

Hartley, J. (1999), *Uses of Television*, London: Routledge.

Herman, Edward S. and McChesney, Robert W. (1997), *The Global Media: The New Missionaries of Corporate Capitalism*, London and Washington: Cassell.

McChesney, Robert W. and Herman, Edward S. (1999), *The Global Media: The New Missionaries of Global Capitalism*, London: Cassell.

McQuail, D. (1998), *Media Performance: Mass Communications and the Public Interest*, London: Sage.

Mosco, V. (1995), *The Political Economy of Communication*, Thousand Oaks: Sage.

Raboy, M. (2001), 'Introduction: Media Policy in the New Communication Environment', in Marc Raboy (ed.), *Global Media Policy in the New Millennium*, Luton: University of Luton Press.

Tunstall, J. and Palmer, M. (1991), *Media Moguls*, London and New York: Routledge.

PUBLIC VERSUS PRIVATE

Ang, Ien (1991), *Desperately Seeking the Audience*, New York: Routledge.

Aufderheide, Patricia (1991), 'Public Television and the Public Sphere', *Critical Studies in Mass Communication*, no. 8.

Aufderheide, Patricia (2000), *The Daily Planet,* Minneapolis: University of Minnesota Press.

Baughman, James (1985), *Television's Guardians: The FCC and the Politics of Programming, 1958–1967*, Knoxville: University of Tennessee Press.

Brants, Kees, Hermes, Joke and van Zoonen, Liesbet (eds) (1998), *The Media in Question: Popular Cultures and Public Interests*, London: Sage.

Collins, Richard (1993), 'Public Service versus the Market Ten Years On: Reflections on Critical Theory and the Debate on Broadcasting Policy in the UK', *Screen*, vol. 34, no. 3, pp. 243–257.

Garnham, Nicholas (1983), 'Public Service versus the Market', *Screen*, vol. 24, no. 1, pp. 6–27.

Hartley, John (1992), *Tele-ology*, London: Routledge.

Hoynes, William (1994), *Public Television for Sale: Media, the Market, and the Public Sphere,* Boulder: Westview Press.

McGuigan, Jim (1992), *Cultural Populism*, London: Routledge.

Minow, Newton ([1961] 1984), 'Address to the National Association of Broadcasters, Washington DC, 9 May 1961' in Frank J. Kahn, *Documents of American Broadcasting*, Englewood Cliffs, NJ: Prentice-Hall, pp. 207–17.

Murdock, Graham (1992), 'Citizens, Consumers and Public Culture', in Michael Skovmand and Kim Christian Schroder (eds), *Media Cultures: Reappraising Transnational Media*, London: Routledge.

Ouellette, Laurie and Lewis, Justin (2000), 'Moving Beyond the Vast Wasteland: Cultural Policy and Television in the US', *Television and New Media*, vol. 1, no. 1.

Ouellette, Laurie (2002), *Viewers Like You? How Public Television Failed the People*, New York: Columbia University Press.

Rowland, Willard D. and Tracey, Michael (1990), 'Worldwide Challenges to Public Service Broadcasting', *Journal of Communication*, vol. 40, no. 2.

Steiner, Gary (1963), *The People Look at Television*, New York: Knopf.

Tracey, Michael (1998), *The Decline and Fall of Public Service Broadcasting*, Oxford: Oxford University Press.

STEREOTYPES AND REPRESENTATIONS: INTERNATIONAL

Adeleye-Fayemi, Bisi (1997), 'Either One or the Other: Images of Women in Nigerian Television', in Karin Barber (ed.), *Readings in African Popular Culture*, Bloomington, Indiana: International African Institute in association with Indiana University Press.

Anuar, Mustafa K. and Wang, Lay Kim (1996), 'Aspects of Ethnicity and Gender in Malaysian Television', in David French and Michael Richards (eds), *Contemporary Television: Eastern Perspectives*, New Delhi and Thousand Oaks, CA: Sage.

Appadurai, Arjun (1996), 'Disjuncture and Difference in the Global Cultural Economy', in *Modernity at Large: Cultural Dimensions of Globalization*, Minneapolis, MN: University of Minnesota Press.

Barker, Chris (1999), *Television, Globalization and Cultural Identities*, Buckingham: Open University Press.

Barua, Mahasveta (1996), 'Television, Politics, and the Epic Heroine: Case Study, Sita', in Deepika Bahri and Mary Vasudeva (eds), *Between the Lines: South Asians and Postcoloniality*, Philadelphia, PA: Temple University Press.

Browne, Beverly (1998), 'Gender Stereotypes in Advertising on Children's Television in the 1990s: A Cross-National Analysis', *Journal of Advertising*, vol. 27, no. 1.

Cheng, Hong (1997), '"Holding Up Half of the Sky?" A Sociocultural Comparison of Gender-role Portrayals in Chinese and US Advertising', *International Journal of Advertising*, vol. 16, no. 4.

Curran, James and Park, Myung-Jin (eds) (2000), *De-westernizing Media Studies*, London and New York: Routledge.

Enteman, Willard F. (1996), 'Stereotyping, Prejudice, and Discrimination', in Paul Martin Lester (ed.), *Images That Injure: Pictorial Stereotypes in the Media*, Westport, Connecticut: Praeger.

French, David and Richards, Michael (eds) (1996), *Contemporary Television: Eastern Perspectives*, New Delhi and Thousand Oaks, CA: Sage.

French, David and Richards, Michael (eds) (2000), *Television in Contemporary Asia*, New Delhi and Thousand Oaks, CA: Sage.

Fung, Anthony and Ma, Eric (2000), 'Formal vs Informal Use of Television and Sex-role Stereotyping in Hong Kong', *Sex Roles*, vol. 42, nos. 1/2.

Furnham, Adrian, Abrmasky, Staci and Gunter, Barrie (1997), 'A Cross-cultural Content Analysis of Children's Television Advertisements', *Sex Roles*, vol. 37, nos. 1/2.

Furnham, Adrian and Farragher, Elena (2000), 'A Cross-cultural Content Analysis of Sex-Role Stereotyping in Television Advertisements: A Comparison Between Great Britain and New Zealand', *Journal of Broadcasting and Electronic Media*, vol. 44, no. 3.

Gilly, Mary C. (1990), 'Sex Roles in Advertising: A Comparison of Television Advertisements in Australia, Mexico, and the United States', in *Southwest Journal of Business and Economics*, vol. 7, no. 1.

Gossman, Hilaria (2000), 'New Role Models for Men and Women? Gender in Japanese TV Dramas', in Timothy J. Craig (ed.), *Japan Pop!: Inside the World of Japanese Popular Culture*, Armonk, New York: M. E. Sharpe.

Hargreaves, A. (1997), 'Gatekeepers and Gateways: Post-colonial Minorities and French Television', in A. Hargreaves and M. McKinney (eds), *Post-colonial Cultures in France*, London: Routledge.

Krishnan, Prabha and Dighe, Anita (1990), *Affirmation and Denial: Construction of Femininity on Indian Television*, New Delhi: Sage.

Kuhn, Raymond (2000), 'Squaring the Circle?: The Reconciliation of Economic Liberalization and Cultural Values in French Television', in James Curran and Myung-Jin Park (eds), *De-westernizing Media Studies*, London and New York: Routledge.

Lemish, Dafna and Tidhar, Chava (1999), 'Still Marginal: Women in Israel's 1996 Television Election Campaign', *Sex Roles*, vol. 41, nos. 5/6.

Lester, Paul Martin (ed.) (1996), *Images That Injure: Pictorial Stereotypes in the Media*, Westport, Connecticut: Praeger.

McArthur, L. Z. and Resko, B. G. (1975), 'The Portrayal of Men and Women in American Television Commercials', *Journal of Social Psychology*, vol. 97 no. 2, pp. 209–20.

Milner, Laura and Collins, James (2000), 'Sex-role Portrayals and the Gender of Nations', *Journal of Advertising*, vol. 29, no. 1, pp. 67–79.

Perkins, Tessa E. (1979), 'Rethinking Stereotypes', in M. Barrett, P. Corrigan, A. Kuhn and J. Wolff (eds), *Ideology and Cultural Production*, London: Croom Helm.

Reading, Anna (1995), 'The President's Men: Television, Gender and the Public Sphere in Central and Eastern Europe', in Farrel Corcoran and Paschal Preston (eds), *Democracy and Communication in the New Europe: Change and Continuity in East and West*, Cresskill, NJ: Hampton Press.

Shohat, Ella and Stam, Robert (1994), *Unthinking Eurocentrism: Multiculturalism and the Media*, London and New York: Routledge.

Sunindyo, Saraswati (1993), 'Gender Discourse on Television', in Virginia Matheson Hooker (ed.), *Culture and Society in New Order Indonesia*, Kuala Lumpur, Malaysia: Oxford University Press.

Zabaleta, Inaka (1997), 'Private Commercial Television versus Political Diversity: The Case of Spain's 1993 General Elections', in Marsha Kinder (ed.), *Refiguring Spain: Cinema, Media, Representation*, Durham, NC: Duke University Press.

Audiences

INTRODUCTION

Blackman, Lisa and Walkerdine, Valerie (2001), *Mass Hysteria: Critical Psychology and Media Studies*, Houndmills: Palgrave.

THE CONSTRUCTED VIEWER

Abercrombie, Nicholas and Longhurst, Brian (1998), *Audiences: A Sociological Theory of Performance and Imagination*, London: Sage Publications.

Ang, Ien (1991), *Desperately Seeking the Audience*, London: Routledge.

Eco, Umberto (1981), *The Role of the Reader: Explorations in the Semiotics of Texts*, London: Hutchinson.

Hartley, John (1992), 'Invisible Fictions', in *Tele-ology: Studies in Television*, London and New York: Routledge.

Hartley, John (1999a), '"Text" and "Audience": One and the Same? Methodological Tensions in Media Research', *Textual Practice*, vol. 13, no. 3.

Hartley, John (1999b), *Uses of Television*, London: Routledge.

Hendershot, Heather (1998), *Saturday Morning Censors: Television Regulation Before the V-Chip*, Durham, NC: Duke University Press.

Seiter, Ellen (1999), *Television and New Media Audiences*, Oxford: Oxford University Press.

Spigel, Lynn (1992), *Make Room for TV: Television and the Family Ideal in Post-war America*, Chicago: Chicago University Press.

Tracey, Michael (1997), *The Decline and Fall of Public Service Broadcasting*, Oxford: Oxford University Press.

TV AUDIENCES AND EVERYDAY LIFE

Abercrombie, Nicholas and Longhurst, Brian (1998), *Audiences*, London: Sage.

Alasuutari, Pertti (ed.) (1999), *Rethinking the Media Audience*, London: Sage.

Bennett, Tony and Watson, Diane (2002), *Understanding Everyday Life*, Oxford: Blackwell.

Gauntlett, David and Hill, Annette (1999), *TV Living: Television, Culture and Everyday Life*, London: Routledge.

Hall, Stuart (1973), 'Encoding and Decoding in the Television Discourse', *Stencilled Paper*, Birmingham, UK: Centre for Contemporary Cultural Studies, University of Birmingham.

Highmore, Ben (2002), *Everday Life and Cultural Theory*, London: Routledge.

Hobson, Dorothy (1982), *Crossroads: The Drama of a Soap Opera*, London: Methuen.

Kubey, Robert and Csikszentmihalyi, Mihaly (1990), *Television and the Quality of Life: How Viewing Shapes Everyday Experience*, Hillsdale, New Jersey: Lawrence Erlbaum.

Lull, James (1990), *Inside Family Viewing: Ethnographic Research on Television Audiences*, London: Routledge.

Moores, Shaun (2000), *Media and Everyday Life in Modern Society*, Edinburgh: Edinburgh University Press.

Morley, David (1986), *Family Television: Cultural Power and Domestic Television*, London: Comedia.

Scannell, Paddy (1996), *Radio, Television, and Modern Life: a Phenomenological Approach*, Oxford: Blackwell.

Silverstone, Roger (1994), *Television and Everyday Life*, London: Routledge.

FANDOM

Ang, Ien (1985), *Watching Dallas: Soap Opera and the Melodramatic Imagination*, London: Methuen.

Bacon-Smith, Camille (2000), *Science Fiction Cultures*, Philadelphia: University of Pennsylvania Press.

Cornell, Paul (ed.) (1997), *License Denied: Rumblings From the Doctor Who Underground*, London: Virgin Publishing.

Frow, John (1995), *Cultural Studies and Cultural Value*, Oxford: Clarendon Press.

Gripsrud, Jostein (1995), *The Dynasty Years: Hollywood Television and Critical Media Studies*, London: Routledge.

Hartley, John (1999), *Uses of Television*, London and New York: Routledge.

Hermes, Joke (1995), *Reading Women's Magazines: An Analysis of Everyday Media Use*, Cambridge: Polity Press.

Hills, Matt (2002), *Fan Cultures*, London and New York: Routledge.

Hobson, Dorothy (1982), *Crossroads: The Drama of a Soap Opera*, London: Methuen.

Jenkins, Henry (1992), *Textual Poachers: Television Fans and Participatory Culture*, London and New York: Routledge.

Jenkins, Henry (1995), '"At Other Times, Like Females." Gender and *Star Trek* Fan Fiction', in Henry Jenkins and John Tulloch, *Science Fiction Audiences: Watching Doctor Who and Star Trek*, London and New York: Routledge, pp. 196–212.

Lavery, David and Wilcox, Rhonda (eds) (2002), *Fighting the Forces: What's at Stake in Buffy the Vampire Slayer*, Lanham, MD: Rowan and Littlefield Publishing Group.

Lewis, Lisa A. (ed.) (1992), *The Adoring Audience: Fan Culture and Popular Media*, London and New York: Routledge.

McKee, Alan (1999), 'Researching the "Reception" of Indigenous Affairs in Australia', *Screen*, vol. 40, no. 4 (Winter 1999), pp. 451–454.

McKee, Alan (2001), 'Which is the Best *Doctor Who* Story? A Case Study in Value Judgements Outside the Academy', *Intensities: The Journal of Cult Media*, issue 1, http://www.cult-media.com/issue1/Amckee.htm.

McKee, Alan (2002), 'How to Tell the Difference Between Production and Consumption: A Case Study in *Doctor Who* Fandom', in Sara Gwenllian Jones and Roberta E. Pearson (eds), *Worlds Apart: Essays on Cult Television*, Minneapolis: University of Minnesota Press.

McKinley, E. Graham (1997), *Beverly Hills 90210: Television, Gender and Identity*, Philadelphia: University of Pennsylvania Press.

Morley, David (1980), *The Nationwide Audience: Structure and Decoding*, London: British Film Institute.

Nightingale, Virginia (1993), 'What's "Ethnographic" About Ethnographic Audience Studies?', in Graeme Turner (ed.), *Nation, Culture, Text: Australian Cultural and Media Studies*, London and New York: Routledge, pp. 164–178.

OED (1991), *Compact Oxford English Dictionary*, Oxford: Oxford University Press.

Parks, Lisa and Levine, Elana (eds) (2002), *Red Noise: Buffy the Vampire Slayer and Critical Media Studies*, Durham and London: Duke University Press.

Radway, Janice A. (1984), *Reading the Romance: Women, Patriarchy, and Popular Literature*, Chapel Hill, NC: University of North Carolina Press.

Reeves, Jimmie L., Rodgers, Mark C. and Epstein, Michael (1996), 'Rewriting Popularity: The Cult Files', in David Lavery, Angela Hague and Marla Cartwright (eds), *Deny All Knowledge: Reading The X-Files*, Syracuse, NY: Syracuse University Press.

Rose, Jonathon (2001), *The Intellectual Life of the British Working Classes*, New Haven and London: Yale University Press.

Tulloch, John (2001), *Watching Television Audiences: Cultural Theories and Methods*, London: Arnold.

Tulloch, John and Alvarado, Manuel (1983), *Doctor Who: The Unfolding Text*, London: Macmillan.

Tulloch, John and Jenkins, Henry (1995), *Science Fiction Audiences: Watching Doctor Who and Star Trek*, London and New York: Routledge.

USES AND GRATIFICATIONS RESEARCH

Barker, M. and Brooks, K. (1999), *Knowing Audiences: Judge Dredd, His Fans, Friends and Foes*, Luton: University of Luton Press.

Blumler, J. G. and Katz, E. (eds) (1974), *The Uses of Mass Communications: Current Perspectives on Gratifications Research*, London: Sage.

Carey, J. W. and Kreiling, A. L. (1974), 'Popular Culture and Uses and Gratifications: Notes Toward an Accommodation', in J. G. Blumler and E. Katz (eds), *The Uses of Mass Communications: Current Perspectives on Gratifications Research*, London: Sage.

Elliot, P. (1974), 'Uses and Gratifications Research: A Critique and Sociological Alternative', in J. G. Blumler and E. Katz (eds), *The Uses of Mass Communications: Current Perspectives on Gratifications Research*, London: Sage.

Geertz, C. (1973), *The Interpretation of Culture*, New York: Basic Books.

Gray, A. (1987), 'Reading the Audience', *Screen*, vol. 28.

Jenkins, H. (1992), *Textual Poachers: Television Fans and Participatory Culture*, New York and London: Routledge.

Katz, E., Blumler, J. G. and Gurevitch, M. (1974), 'Utilization of Mass Communication by the Individual', in J. G. Blumler and E. Katz (eds), *The Uses of Mass Communications: Current Perspectives on Gratifications Research*, London: Sage.

McQuail, D. (1998), 'With the Benefits of Hindsight: Reflections on the Uses and Gratification Paradigm', in R. Dickinson, R. Harindranath and O. Linne (eds), *Approaches to Audiences*, London: Arnold.

McQuail, D. and Gurevitch, M. (1974), 'Explaining Audience Behavior: Three Approaches Considered', in J. G. Blumler and E. Katz (eds), *The Uses of Mass Communications: Current Perspectives on Gratifications Research*, London: Sage.

Morley, D. (1992), *Television, Audiences and Cultural Studies*, London: Routledge.

Morley, D. (1993), 'Pendulums and Pitfalls', *Journal of Communication*, vol. 14.

Peters, J. D. (1996), 'The Uncanniness of Mass Communication in Interwar Social Thought', *Journal of Communication*, vol. 46, no. 3.

Philo, G. and Miller, D. (1998), *Cultural Compliance: Dead Ends in Cultural/Media Studies and Social Science*, Glasgow: Glasgow UniversityMedia Group.

Ruddock, A. (2001), *Understanding Audiences*, London: Sage.

MEDIA EFFECTS

Attorney General's Commission on Pornography (1986), *Final Report*, Washington, DC, Department of Justice, July, vol. I.

Baker, R. K. and Ball, S. J. (eds) (1969), *Violence and the Media*, National Commission on the Causes and Prevention of Violence, Washington, Government Printing Office.

Bandura, Albert (1977), *Social Learning Theory*, Englewood Cliffs, NJ: Prentice-Hall.

Bandura, Albert, Ross, Dorothea and Ross, Sheila A. (1961), 'Transmission of Aggression Through Imitation of Aggressive Models', *Journal of Abnormal and Social Psychology*, vol. 63.

Bandura, A., Ross, D. and Ross, S. H. (1963), 'Imitation of Film-mediated Aggressive Models', *Journal of Abnormal and Social Psychology*, vol. 66, no. 1.

Blumer, Herbert and Hauser, Philip Morris (1933), *Movies, Delinquency, and Crime*, New York: The Macmillan Company.

Bogart, Leo (1972), 'Warning: The Surgeon General has Determined That TV Violence is Moderately Dangerous to Your Child's Mental Health', *Public Opinion Quarterly*, vol. 36, no. 4.

Buxton, William J. (1994), 'From Radio Research to Communications Intelligence: Rockefeller Philanthropy, Communications Specialists, and the American Intelligence Community', in A. G. Gagnon and Stephen Brooks (eds), *The Political Influence of Ideas: Policy Communities and the Social Sciences*, Westport, CN: Praeger.

Califia, Pat (1994), *Public Sex: The Culture of Radical Sex*, Pittsburgh, PA: Cleis Press.

de Cordova, Richard (1990), 'Ethnography and Exhibition: The Child Audience, the Hays Office, and Saturday Matinees', *camera obscura*, no. 23.

Hendershot, Heather (1998), *Saturday Morning Censors: Television Regulation Before the V-Chip*, Durham, NC: Duke University Press.

Jowett, Garth, Jarvie, Ian C. and Fuller, Kathryn H. (1996), *Children and the Movies: Media Influence and the Payne Fund Controversy*, New York: Cambridge University Press.

Katz, Elihu (1987), 'Communications Research Since Lazarsfeld', *Public Opinion Quarterly*, vol. 51, no. 2.

Milgram, Stanley (1992), *The Individual in a Social World*, New York: McGraw Hill.

Morrison, David (1998), *The Search for a Method: Focus Groups and the Development of Mass Communication Research*, Luton: University of Luton Press.

Sammond, Nicholas (1999), 'The Uses of Childhood: The Making of Walt Disney and the Generic American Child, 1930–1960', PhD Dissertation, University of California, San Diego.

Schramm, Wilbur, Lyle, Jack and Parker, Edwin (1960), *Television in the Lives of our Children*, Palo Alto, Ca.: Stanford University Press.

Simpson, Christopher (1994), *Science of Coercion: Communication Research and Psychological Warfare, 1945–1960*, New York: Oxford University Press.

Spigel, Lynn (1993), 'Seducing the Innocent', in William Solomon and Robert W. McChesney (eds), *Ruthless Criticism: New Perspectives in US Communications History*, Minneapolis: University of Minnesota Press.

Surgeon General's Scientific Advisory Committee on Television and Social Behavior (1972), *Television and Growing Up: The Impact of Televised Violence*. Report to the Surgeon-General, US Public Health Service, Washington, DC: Government Printing Office.

Tulloch, J. C. and Tulloch, M. I. (1993), 'Understanding TV Violence: A Multifaceted Cultural Analysis', in Graeme Turner (ed.), *Nation, Culture and Text: Australian Cultural and Media Studies*, London, Routledge.

Wertham, Frederic (1954), *Seduction of the Innocent*, New York: Rinehart & Co.

PUBLIC OPINION

Aristotle (1962), *The Politics*, Baltimore: Penguin Books.

Asher, H. (1998), *Polling and the Public*, Washington: Congressional Quarterly Press.

Behr, R. and Iyengar, S. (1985), 'Television News, Real World Cues, and Changes in the Public Agenda', *Public Opinion Quarterly*, vol. 46.

Blumer, H. (1948), 'Public Opinion and Public Opinion Polling', *American Sociological Review*, vol. 13.

Bourdieu, P. (1979), 'Public Opinion Does Not Exist', in A. Mattelart and S. Siegelaub (eds), *Communication and Class Struggle*, New York: International General.

Edelman, M. (1988), *Constructing the Political Spectacle*, Chicago: University of Chicago Press.

Ferguson, T. and Rogers, J. (1986), *Right Turn: The Decline of the Democrats and the Future of American Politics*, New York: Farrar, Strauss and Giroux.

Funkhouser, G. R. (1973), 'The Issues of the Sixties: An Exploratory Study in the Dynamics of Public Opinion', *Public Opinion Quarterly*, vol. 37.

Gallup, G. (1966), 'Polls and the Political Process – Past, Present and Future', *Public Opinion Quarterly*, vol. 29.

Gamson, W. (1992), *Talking Politics*, Cambridge: Cambridge University Press.

Glynn, C., Herbst, S., O'Keefe, G. and Shapiro, R. (1999), *Public Opinion*, Boulder: Westview Press.

Habermas, J. (1989), *The Structural Transformation of the Public Sphere: An Inquiry Into a Category of Bourgeois Society*, Cambridge: MIT Press.

Herbst, S. (1993), *Numbered Voices*, Chicago: University of Chicago Press.

Iyengar, S. (1991), *Is Anyone Responsible?*, Chicago: University of Chicago Press.

Iyengar, S. and Kinder, D. (1987), *News That Matters*, Chicago: University of Chicago Press.

Iyengar, S., Peters, M. and Kinder, D. (1982), 'Demonstrations of the "Not-So-Minimal" Consequences of Television News Programs', *American Political Science Review*, vol. 81.

Lewis, J. (2001), *Constructing Public Opinion: How Elites Do What They Like and Why We Seem to Go Along With It*, New York: Columbia University Press.

Mayer, W. G. (1992), *The Changing American Mind*, Ann Arbor: University of Michigan Press.

Peters, J. D. (1995), 'Historical Tensions in the Concept of Public Opinion', in C. Salmon and T. Glasser (eds), *Public Opinion and the Communication of Consent*, New York: Guilford Press.

Philo, G. (1990), *Seeing and Believing: The Influence of Television*, London: Routledge.

Salmon, C. and Glasser, T. (eds) (1995), *Public Opinion and the Communication of Consent*, New York: Guilford Press.

Verba, S. (1996), 'The Citizen as Respondent: Sample Surveys and American Democracy', *American Political Science Review*, vol. 90, no. 1.

CHILDREN AND EDUCATION

Buckingham, David (1993), *Children Talking Television: The Making of Television Literacy*, London: Falmer.

Buckingham, David (1995), 'On the Impossibility of Children's Television: The Case of Timmy Mallett', in Cary Bazalgette and David Buckingham (eds), *In Front of the Children: Screen Entertainment and Young Audiences*, London: British Film Institute.

Buckingham, David (2000), *The Making of Citizens: Young People, News, and Politics*, London and New York: Routledge.

Center for Media Education website: www.cme.org

Hendershot, Heather (1998), *Saturday Morning Censors: Television Regulation Before the V-Chip*, Durham: Duke University Press.

Hendershot, Heather (2000), 'Teletubby Trouble: How Justified Were Rev. Falwell's Attacks?', *Television Quarterly*, vol. 31, no. 1, Spring.

'Kids WB! Rules Saturday', (15 January 2001), *Broadcasting & Cable*, vol. 131, no. 3, p. 18.

Ledbetter, James (1997), *Made Possible By . . . The Death of Public Broadcasting in the United States*, New York: Verso.

McChesney, Robert W. (1999), *Rich Media Poor Democracy: Communication Politics in Dubious Times*, Urbana and Chicago: University of Illinois Press.

Palmer, Edward L. (1988), *Television and America's Children: A Crisis of Neglect*, New York: Oxford University Press.

Palmer, Edward L. (1993), *Toward a Literate World: Television in Literacy Education – Lessons from the Arab Region*, Boulder: Westview Press.

Schramm, Wilbur, Lyle, Jack, De Sola Pool, Ithiel (1963), *The People Look at Educational Television*, Stanford: Stanford University Press.

Seiter, Ellen (1993), *Sold Separately: Children and Parents in Consumer Culture*, New Brunswick: Rutgers University Press.

Seiter, Ellen (1999), *Television and New Media Audiences*, Oxford and New York: Oxford University Press.

Singer, Dorothy G. and Singer, Jerome L. (eds) (2001), *Handbook of Children and the Media*, Thousand Oaks: Sage.

Winn, Marie (1977), *The Plug-In Drug: Television, Children, and the Family*, New York: Viking Press.

PUBLIC HEALTH MESSAGE AUDIENCES

Buchanan, David R. and Wallack, Lawrence (1998), 'This is the Partnership for a Drug-Free America: Any Questions?', *Journal of Drug Issues*, vol. 28, no. 2.

Ludwig, Michael J. (1997), 'The Cultural Politics of Prevention: Reading Anti-Drug PSAs', in Katherine Toland Frith (ed.), *Undressing the Ad: Reading Culture in Advertising*, New York: Peter Lang, pp. 131–150.

Montes-Armenteros, Chemi (1997), 'Ideology in Public Service Advertisements', in Katherine Toland Frith (ed.), *Undressing the Ad: Reading Culture in Advertising*, New York: Peter Lang.

Newcomb, Michael D., Mercurio, Claire St Antoine and Wollard, Candace A. (2000), 'Rock Stars in Anti-Drug Abuse Commercials: An Experimental Study of Adolescents' Reactions', *Journal of Applied Social Psychology*, vol. 30, no. 6.

Tulloch, John and Lupton, Deborah (1997), *Television, AIDS, and Risk: A Cultural Studies Approach to Health Communication*, Concord, MA: Paul and Co, Publishing Consortium.

Wallack, Lawrence, Dorfman, Lori, Jernigan, David and Tehmba, Makani (1993), *Media Advocacy and Public Health: Power for Prevention*, Newbury Park, CA: Sage.

Online Resources

The Ad Council: www.adcouncil.org
Adbusters: www.adbusters.org
The Kaiser Network: www.kaisernetwork.org

CLASS

Ang, Ien (1989), 'Wanted: Audiences. On the Politics of Empirical Audience Studies', in Ellen Seiter, Hans Borchers, Gabriele Kreutzner and Eva-Maria Warth (eds), *Remote Control: Television, Audiences and Cultural Power*, London: Routledge.

Ang, Ien (1996), *Living Room Wars: Rethinking Media Audiences for a Postmodern World*, New York: Routledge.

Corner, John (1991), 'Meaning, Genre and Context: The Problematics of "Public Knowledge" in the New Audience Studies', in James Curran and Michael Gurevitch (eds), *Mass Media and Society*, London: Arnold.

Coward, Rosalind (1977), 'Class, "Culture" and the Social Formation', *Screen*, vol. 18, Spring.

Gray, Ann (1992), *Video Playtime: The Gendering of a Leisure Technology*, London: Routledge.

Moores, Shaun (1993), *Interpreting Audiences: The Ethnography of Media Consumption*, London, Thousand Oaks: Sage Publications.

Morley, David (1992), *Television, Audiences and Cultural Studies*, London: Routledge.

Nightingale, Valerie (1996), *Studying Audiences: The Shock of the Real*, London: Routledge.

Press, Andrea L. and Elizabeth Cole (1999), *Speaking of Abortion: Television and Authority in the Lives of Women*, Chicago: University of Chicago Press.

Seiter, Ellen (1999), *Television and New Media Audiences*, Oxford, New York: Oxford University Press.

Silverstone, Roger (1994), *Television and Everyday Life*, London: Routledge.

Tulloch, John (2001), *Watching Television Audiences: Cultural Theories and Methods*, London: Arnold.

Walkerdine, Valerie (1986), 'Video Replay: Families, Films and Fantasy', in Victor Burgin, James Donald and Cora Kaplan (eds), *Formations of Fantasy*, London: Methuen.

Gender

INTRODUCTION

Brunsdon, Charlotte, D'Acci, Julie and Spigel, Lynn (1997), 'Introduction', in Charlotte Brunsdon, Julie D'Acci and Lynn Spigel (eds), *Feminist Television Criticism: A Reader*, New York: Oxford University Press, pp. 1–16.

McLuhan, Marshall (1974), *Understanding Media: The Extensions of Man*, Aylesbury: Abacus.

Watson, Rod (1973), 'The Public Announcement of Fatality', *Working Papers in Cultural Studies*, vol. 4, pp. 5–20.

GENDER, REPRESENTATION AND TELEVISION

Ang, Ien (1985), *Watching Dallas: Soap Opera and the Melodramatic Imagination*, London and New York: Methuen.

Bobo, Jacqueline and Seiter, Ellen (1997), 'Black Feminism and Media Criticism: *The Women of Brewster Place*', in Charlotte Brunsdon, Julie D'Acci and Lynn Spigel (eds), *Feminist Television Criticism: A Reader*, Oxford: Oxford University Press, pp. 167–183.

Brunsdon, Charlotte, D'Acci, Julie and Spigel, Lynn (1997), *Feminist Television Criticism: A Reader,* Oxford: Oxford University Press.

Butler, Judith (1990), *Gender Trouble*, New York: Routledge.

Butler, Judith (1993), *Bodies That Matter*, New York: Routledge.

D'Acci, Julie (1994), *Defining Women: Television and the Case of Cagney and Lacey*, Chapel Hill: University of North Carolina Press.

D'Acci, Julie (1997), 'Nobody's Woman? *Honey West* and the New Sexuality', in Lynn Spigel and Michael Curtin (eds), *The Revolution Wasn't Televised*, New York: Routledge.

D'Acci, Julie (2001), 'Television Genres', in N. J. Smelser and P. B. Bates, *International Encyclopedia of Social and Behavioral Sciences,* Oxford: Pergamon Press.

Geraghty, Christine (1991), *Women and Soap Opera*, London: Polity.

Gray, Ann (1992), *Video Playtime: The Gendering of a Leisure Technology,* London: Routledge.

Liebes, Tamar and Katz, Elihu (1990), *The Export of Meaning: Cross-Cultural Readings of Dallas*, Oxford: Oxford University Press.

Lin, Szu-ping (2000), *On Prime Time Television Drama and Taiwanese Women*, PhD Dissertation, University of Wisconsin-Madison.

McCarthy, Anna (2001), *Ambient Television: Visual Culture and Public Space,* Durham, NC: Duke University Press.

Mankekar, Purnima (1997), 'Television Tales and a Woman's Rage: A Nationalist Recasting of Draupadi's Disrobing', in Charlotte Brunsdon, Julie D'Acci and Lynn Spigel (eds), *Feminist Television Criticism: A Reader*, Oxford: Oxford University Press, pp. 253–272.

Mattelart, Michèle (1986), *Women, Media and Crisis: Femininity and Disorder*, London: Comedia.

Morley, David (1986), *Family Television: Cultural Power and Domestic Leisure*, London: Comedia.

Perera, Suvendrini (1997), 'Representation Wars: Malaysia, *Embassy* and Australia's *Corps Diplomatique*', in Charlotte Brunsdon, Julie D'Acci and Lynn Spigel (eds), *Feminist Television Criticism: A Reader*, Oxford: Oxford University Press, pp. 337–350.

Zook, Crystal (1999), *The FOX Network and the Revolution in Black Television,* New York: Oxford University Press.

GENDER AND STEREOTYPING

Ang, Ien (1997), 'Melodramatic Identifications: Television Fiction and Women's Fantasy', in Charlotte Brunsdon, Julie D'Acci and Lynn Spigel (eds), *Feminist Television Criticism: A Reader*, Oxford: Oxford University Press.

Baehr, H. and Dyer, G. (eds) (1987), *Boxed In: Women and Television*, New York: Pandora.

Barker, Martin (1989), *Comics: Ideology, Power and the Critics*, Manchester: Manchester University Press.

Brown, M. E. (ed.) (1990), *Television and Women's Culture*, London: Sage.

Brunsdon, Charlotte, D'Acci, Julie and Spigel, Lynn (1997) (eds), *Feminist Television Criticism: A Reader*, Oxford: Oxford University Press.

Clark, Danae (1990), '*Cagney and Lacey*: Feminist Strategies of Detection', in M. E. Brown (ed.), *Television and Women's Culture*, London: Sage.

Davis, Donald M. (1990), 'Portrayals of Women in Prime-Time Network Television: Some Demographic Characteristics', *Sex Roles*, vol. 23, nos. 5/6.

Dow, Bonnie J. (1996), *Prime-Time Feminism: Television, Media Culture, and the Women's Movement Since 1970,* Philadelphia: University of Pennsylvania Press.

Dyer, Richard (1993), *The Matter of Images: Essays on Representations*, London: Routledge.

Mayne, Judith (1997), '*LA Law* and Prime-Time Feminism', in Charlotte Brunsdon, Julie D'Acci and Lynn Spigel (eds), *Feminist Television Criticism: A Reader*, Oxford: Oxford University Press.

Mellencamp, Patricia (1997), 'Situation Comedy, Feminist, and Freud: Discourses of Gracie and Lucy' in Charlotte Brundston, Julie D'Acci and Lynn Spigel, *Feminist Television Criticism: A Reader*, New York: Oxford University Press, pp. 60–73.

Modleski, Tanya (1983), 'The Rhythms of Reception: Daytime Television and Women's Work', in E. A. Kaplan (ed.), *Regarding Television*, Los Angeles: American Film Institute.

Neale, Steve (1980), 'The Same Old Story – Stereotypes and Difference', *Screen Education*, vol. 32, no. 3.

Perkins, Tessa E. (1979), 'Rethinking Stereotypes', in M. Barrett, P. Corrigan, A. Kuhn and J. Wolff (eds), *Ideology and Cultural Production*, London: Croom Helm.

Pribram, Deidre (ed.) (1988), *Female Spectators: Looking at Film and Television*, London: Verso.

Probyn, Elspeth (1997), 'New Traditionalism and Post-Feminism: TV Does the Home', in Charlotte Brunsdon, Julie D'Acci and Lynn Spigel (eds), *Feminist Television Criticism: A Reader*, Oxford: Oxford University Press.

Rabinovitz, Lauren (1989), 'Sitcoms and Single Moms: Representations of Feminism on American TV', *Cinema Journal*, vol. 29, no. 1.

Seiter, Ellen (1986), 'Stereotypes and the Media: A Re-evaluation', *Journal of Communication*, vol. 36, no. 2.

GENDER AND BRITISH TELEVISION

Allen, Robert C. (1985), *Speaking of Soap Operas*, Chapel Hill: University of North Carolina Press.

Allen, Robert C. (ed.) (1992), *Channels of Discourse, Reassembled*, London and New York: Routledge.

Ang, Ien (1991), *Desperately Seeking the Audience*, New York: Routledge.

Ang, Ien (1985), *Watching Dallas: Soap Opera and the Melodramatic Imagination*, London and New York: Methuen.

Brunsdon, Charlotte, D'Acci, Julie and Spigel, Lynn (eds) (1997), *Feminist Television Criticism: A Reader*, Oxford: Oxford University Press.

Butler, Judith (1990), *Gender Trouble: Feminism and the Subversion of Female Identity*, London: Routledge.

Craig, Steve (ed.) (1992), *Men, Masculinity and the Media*, Newbury Park: Sage.

Dyer, Richard (ed.) (1981), *Coronation Street*, London: BFI Publishing.

Easthope, Anthony (1990), *What a Man's Gotta Do: the Masculine Myth in Popular Culture*, Winchester: Unwin Hyman.

Fiske, John (1992), 'British Cultural Studies and Television', in Robert C. Allen (ed.), *Channels of Discourse, Reassembled*, London and New York: Routledge, pp. 284–326.

Geraghty, Christine (1991), *Women and Soap Opera: A Study of Prime-time Soaps*, Cambridge: Polity Press.

Hall, Stuart (1980), '"Encoding/Decoding" in Centre for Contemporary Cultural Studies', in (ed.) *Culture, Media, Language*, London: Hutchinson.

Meehan, Diane M. (1983), *Ladies of the Evening: Women Characters of Prime-Time Television*, Metuchen: Scarecrow.

Miller, Toby (1997), *The Avengers*, London: BFI Publishing.

Modleski, Tania (1982), *Loving with a Vengeance: Mass-Produced Fantasies for Women*, Hamden: Anchor.

Modleski, Tania (1983), 'The Rhythms of Reception: Daytime Television and Women's Work', in E. Ann Kaplan (ed.), *Regarding Television – Critical Approaches: An Anthology*, American Film Institute Monograph Series, vol. 2, Frederick, MD: University Publications of America.

Modleski, Tania (ed.) (1986), *Studies in Entertainment: Critical Approaches to Mass Media*, Bloomington: Indiana University Press.

Morley, David (1986), *Family Television: Cultural Power and Domestic Leisure*, London: Routledge.

GENDER AND US TELEVISION

Allen, Robert (1985), *Speaking of Soap Operas*, Chapel Hill: North Carolina University Press.

Bobo, Jacqueline and Seiter, Ellen (1991), 'Black Feminism and Media Criticism: *The Women of Brewster Place*', *Screen*, vol. 32, no. 3, pp. 286–302.

Brunsdon, Charlotte, D'Acci, Julie and Spigel, Lynn (eds) (1997), *Feminist Television Criticism: A Reader*, Oxford: Oxford University Press.

D'Acci, Julie (1994), *Defining Women: Television and the Case of Cagney and Lacey*, Chapel Hill: University of North Carolina Press.

D'Acci, Julie (ed.) (1994–95), 'Lifetime: A Cable Network "For Women"', *camera obscura*, vols 33–34 (special issue).

Doty, Alexander (1993), *Making Things Perfectly Queer: Interpreting Mass Culture*, Minneapolis: University of Minnesota Press.

Everett, Anna, Parks, Lisa and Penley, Constance (2003), 'Log On: Corporate Feminism and the Oxygen Media Research Project', in John Caldwell and Anna Everett (eds), *Digitextualities*, London: Routledge.

Feuer, Jane (1995), *Seeing Through the Eighties: Television and Reaganism*, Durham: Duke University Press.

Flitterman-Lewis, Sandy (1983), 'The Real Soap Operas: TV Commercials', in E. Ann Kaplan (ed.), *Regarding Television: Critical Approaches – An Anthology*, Frederick, MD: University Publications of America, pp. 84–96.

Flitterman-Lewis, Sandy (1992), 'Psychoanalysis, Film, and Television', in Robert C. Allen (ed.), *Channels of Discourse, Reassembled*, Chapel Hill: University of North Carolina Press, pp. 203–246.

Gray, Herman (1995), *Watching Race: Television and the Struggle for 'Blackness'*, Minneapolis: University of Minnesota Press.

Gross, Larry (2001), *Up from Invisibility: Lesbians, Gay Men, and the Media in America*, Columbia: Columbia University Press.

Haralovich, Mary Beth (1989), 'From Sitcoms to Suburbs: Positioning the 1950s Homemaker', *Quarterly Review of Film and Video*, vol. 11, no. 1, pp. 61–83.

Haralovich, Mary Beth and Rabinovitz, Lauren (eds) (1999), *Television, History, and American Culture: Feminist Critical Essays*, Durham: Duke University Press.

Hilmes, Michele (1997), *Radio Voices: American Broadcasting, 1922–1952*, Minneapolis: University of Minnesota Press.

Jenkins, Henry (1992), *Textual Poachers: Television Fans and Participatory Culture*, New York: Routledge.

Kaplan, E. Ann (1992), 'Feminist Criticism and Television', in Robert C. Allen (ed.), *Channels of Discourse, Reassembled*, London and New York: Routledge, pp. 247–283.

Levine, Elana (2002), 'Wallowing in Sex: US Television and Everyday Life in the 1970s', Doctoral Dissertation in Department of Communication Arts, University of Wisconsin-Madison.

Luckett, Moya (1999), 'A Moral Crisis in Prime Time: *Peyton Place* and the Rise of the Single Girl', in Mary Beth Haralovich and Lauren Rabinovitz (eds), *Television, History, and American Culture: Feminist Critical Essays*, Durham: Duke University Press, pp. 75–97.

McCarthy, Anna (2001), *Ambient Television*, Durham, NC: Duke University Press.

Mankekar, Purnima (1999), *Screening Culture, Viewing Politics: An Ethnography of Television, Womanhood and Postcolonial India*, Durham, NC: Duke University Press.

Modleski, Tania (1979), 'The Search for Tomorrow in Today's Soap Operas: Notes on a Feminine Narrative Form', *Film Quarterly*, vol. 33, no. 1.

Modleski, Tania (1983), 'The Rhythms of Reception: Daytime Television and Women's Work', in E. Ann Kaplan (ed.), *Regarding Television: Critical Approaches – An Anthology*, Frederick, MD: University Publications of America, pp. 67–75.

Morse, Margaret (1990), 'An Ontology of Everyday Distraction: the Freeway, the Mall and Television', in Patricia Mellencamp (ed.), *Logics of Television: Essays in Cultural Criticism*, Bloomington: Indiana University Press, pp. 193–221.

Morse, Margaret (1998), *Virtualities: Television, Media Art and Cyberculture*, Bloomington: Indiana University Press.

Parks, Lisa (2002), 'Flexible Microcasting: Gender, Generation and Television and Internet Convergence', in Lynn Spigel (ed.), *The Persistence of Television: From Console to Computer*, Durham: Duke University Press.

Penley, Constance (1989), 'Brownian Motion: Women, Tactics and Technology', in Constance Penley and Andrew Ross (eds), *Technoculture*, Minneapolis: University of Minnesota Press, pp. 135–161.

Rowe, Kathleen (1995), *The Unruly Woman: Gender and the Genres of Laughter*, Austin: University of Texas Press.

Seiter, Ellen (2000), 'Television and the Internet', in John Caldwell (ed.), *Electronic Media and Technoculture*, New Brunswick: Rutgers University Press.

Shattuc, Jane (1996), *The Talking Cure: TV Talk Shows and Women*, New York: Routledge.

Spigel, Lynn and Mann, Denise (eds) (1992), *Private Screenings: Television and the Female Consumer*, Minneapolis: University of Minnesota Press.

Stemple Mumford, Laura (1995), *Love and Ideology in the Afternoon: Soap Opera, Women and Television Genre*, Bloomington: Indiana University Press.

Taylor, Ella (1989), *Prime-Time Families: Television Culture in Postwar America*, Berkeley: University of California Press.

Thumim, Janet (ed.) (2002), *Small Screens, Big Ideas: Television in the 1950s*, London: IB Tauris.

Torres, Sasha (ed.) (1998), *In Living Color: Race and Television in the US*, Durham, NC: Duke University Press.

White, Mimi (1992), *Tele-Advising: Therapeutic Discourse in American Television*, Chapel Hill: University of North Carolina Press.

TELEVISION IN THE HOME

Ang, I. (1996), *Living Room Wars: Rethinking Media Audiences for a Postmodern World*, London: Routledge.

Bryce, J. (1987), 'Family Time and Television Use', in T. Lindlof (ed.), *Natural Audiences*, Norwood, New Jersey: Ablex.

Ellis, J. (1982), *Visible Fictions: Cinema, Television, Video*, London: Routledge and Kegan Paul.

Gillespie, M. (1995), *Television, Ethnicity and Cultural Change*, London: Routledge.

Gray, A. (1987), 'Behind Closed Doors: Video Recorders in the Home', in H. Baehr and G. Dyer (eds), *Boxed In: Women and Television*, London: Pandora.

Gray, A. (1992), *Video Playtime: The Gendering of a Leisure Technology*, London: Routledge.

Hobson, D. (1982), *'Crossroads': The Drama of a Soap Opera*, London: Methuen.

Lull, James (ed.) (1988), *World Families Watch Television*, Newbury Park and London: Sage.

Lull, James (1991), *Inside Family Viewing*, London: Routledge.

Mankekar, P. (1999), *Screening Culture, Viewing Politics: An Ethnography of Television, Womanhood, and Nation in Postcolonial India*, Durham and London: Duke University Press.

Moores, S. (1996), *Satellite Television and Everyday Life: Articulating Technology* (Academia Research Monography No. 18), Luton: John Libbey Media/University of Luton Press.

Moores, S. (2000), *Media and Everyday Life in Modern Society*, Edinburgh: Edinburgh University Press.

Morley, D. (1986), *Family Television: Cultural Power and Domestic Leisure*, London: Comedia.

Morley, D. and Silverstone, R. (1990), 'Domestic Communication – Technologies and Meanings', *Media, Culture and Society*, vol. 12, no. 1.

O'Sullivan, T. (1991), 'Television Memories and Cultures of Viewing, 1950–65', in J. Corner (ed.), *Popular Television in Britain: Studies in Cultural History*, London: BFI Publishing.

Paterson, R. (1980), 'Planning the Family: The Art of the Television Schedule', *Screen Education*, no. 35.

Spigel, Lynn (1992), *Make Room for TV: Television and the Family Ideal in Postwar America*, Chicago: University of Chicago Press.

Williams, R. (1974), *Television: Technology and Cultural Form*, London: Fontana.

OUT-OF-HOME TV NETWORKS

Ang, Ien (1991), *Desperately Seeking the Audience*, London/ New York: Routledge.

Berstell, Gerald (1992), 'Point-of-Sale Research Reveals Spontaneous Buying Decisions', *Marketing News*, 8 June.

Jackson, Cheryl (1997), 'Firms Can't Wait to Make Their Pitch', *The Tampa Tribune*, 4 January.

Jensen, Jeff (1997), 'Nickelodeon Channels into Retail with 3 Stores', *Advertising Age*, 24 November.

Layne, Barry (1993), 'NTA Study Finds 28 Million Viewers Out-of-Home', *The Hollywood Reporter*, March 11, p. 1.

Lemish, Dafna (1982), 'The Rules of Viewing Television in Public Places', *Journal of Broadcasting*, vol. 26, no. 4.

Lull, James (1990), *Inside Family Viewing: Ethnographic Research on Television Audiences*, New York: Routledge.

McCarthy, Anna (1999), '"Like an Earthquake": Theater Television, Boxing, and the Black Public Sphere', *Quarterly Review of Film and Video*, vol. 16, nos. 3/4.

McCarthy, Anna (2001), *Ambient Television: Visual Culture and Public Space*, Durham, NC: Duke University Press.

Mandese, Joe (1995), 'Place-Based Sports Network Skis onto the "Net"', *Advertising Age*, 6 March.

Moore, David J. (1990), *Just What the Doctor Ordered*, New York: Advertising Research Foundation.

Morley, David (1990), *Family Television: Cultural Power and Domestic Leisure*, New York: Routledge.

Rothenberg, Randall (1989), 'The Media Business', *The New York Times*, 11 December.

Sharkey, Joe (2000), 'Business Travel', *The New York Times*, 25 October.

Simpson, Robert S. (1997), *Videowalls: The Book of the Big Electronic Image*, 2nd edition, Oxford: Focal Press.

Spigel, Lynn (1992), *Make Room for TV: Television and the Family Ideal in Postwar America*, Chicago: University of Chicago Press.

Wenner, Lawrence A. (1998), 'In Search of the Sports Bar: Masculinity, Alcohol, Sports, and the Mediation of Public Space', in Genevieve Rail (ed.), *Sport and Postmodern Times*, Albany: State University of New York.

GENDER AND QUEERNESS

Bennett, Kathleen E. (1997), '*Xena: Warrior Princess*, Desire Between Women and Interpretive Response'. Available from: http://www.infogoddess.com/xena.

Brooker, Will (2000), *Batman Unmasked: Analyzing a Cultural Icon*, London and New York: Continuum.

D'Acci, Julie (1994), *Defining Women: Television and the Case of Cagney and Lacey*, Chapel Hill: University of North Carolina Press.

Doty, Alexander (1993), *Making Things Perfectly Queer: Interpreting Mass Culture*, Minneapolis and London: University of Minnesota Press.

Harding, Jenny (1994), 'Making a Drama out of Difference: *Portrait of a Marriage*', in Diane Hamer and Belinda Budge (eds), *The Good, the Bad and the Gorgeous: Popular Culture's Romance With Lesbianism*, London and San Francisco: Pandora.

Hinds, Hilary (1997), 'Fruitful Investigations: The Case of the Successful Lesbian Text', in Charlotte Brunsdon, Julie d'Acci and Lynn Spigel (eds), *Feminist Television Criticism: A Reader*, Oxford: Clarendon Press.

Hough, Fiona (1998), 'Why Subtext Should Never Become Maintext in *Xena: Warrior Princess*', *Whoosh: the Online Journal of the International Associaton of Xena Studies*, issue 27, December. Available from: www.whoosh.org/issue27/hough1.html.

Jenkins, Henry (1992), *Textual Poachers: Television Fans and Participatory Culture*, London and New York: Routledge.

Jones, Sara Gwenllian (2000a), 'Histories, Fictions and *Xena: Warrior Princess*', *Television and New Media*, vol. 1, no. 4.

Jones, Sara Gwenllian (2000b), 'Starring Lucy Lawless?', *Continuum*, vol 14, no. 1, April, pp. 9–22.

Marshment, Margaret and Hallam, Julia (1994), 'From String of Knots to Orange Box: Lesbianism on Prime Time', in Diane Hamer and Belinda Budge (eds), *The Good, the Bad and the Gorgeous: Popular Culture's Romance With Lesbianism*, London and San Francisco: Pandora.

TARGETING WOMEN

D'Acci, Julie (1994), *Defining Women: Television and the Case of Cagney and Lacey*, Chapel Hill, North Carolina: University of North Carolina Press.

Meehan, Eileen R. (2001), 'Gendering the Commodity Audience', in Eileen R. Meehan and Ellen Riordan (eds), *Sex and Money: Feminism, Political Economy, and Media Studies*, Minneapolis: University of Minnesota Press.

Race

TELEVISION AND RACE IN BRITAIN: COMEDY

Cohen, T. (2000), *Jokes: Philosophical Thoughts on Joking Matters*, Chicago: University of Chicago Press.

Gabriel, J. (1998), *Whitewash: Racialised Politics and the Media*, London: Routledge.

Gilroy, P. (1983), 'C4 Bridgehead or Bantustan?', *Screen*, vol. 24, no. 3.

Hall, S. (ed.) (1997), *Representation*, London: Sage and Open University.

Husband, C. (1988), 'Racist Humour and Racist Ideology in British Television or I Laughed Till You Cried', in C. Powell and G. Paton (eds), *Humour in Society: Resistance and Control*, London: Macmillan.

Medhurst, A. (1989), 'Laughing Matters', *The Colour Black: Black Images on British Television*, London: British Film Institute.

Naughton, J. (1985), 'Tandoori Nights', *The Listener*, 11 July.

Ross, K. (1996), *Black and White Media: Black Images in Popular Film and TV*, Cambridge: Polity Press.

RACE AND US TELEVISION

Boddy, William (1998), 'The Beginnings of American Television', in Anthony Smith (ed.), *Television: An International History*, New York: Oxford University Press.

Bogle, Donald (2001), *Primetime Blues: African Americans on Network Television*, New York: Farrar, Straus and Giroux.

'FCC Relaxes Dual-Network Ownership Rules' (2001), *Television Digest*, 23 April.

Gray, Herman (1995), *Watching Race: Television and the Struggle for 'Blackness'*, Minneapolis: University of Minnesota.

Hamamoto, Darrell Y. (1994), *Monitored Peril: Asian Americans and the Politics of TV Representation*, Minneapolis: University of Minnesota Press.

Havens, Timothy (2000), '"The Biggest Show in the World": Race and the Global Popularity of *The Cosby Show*', *Media, Culture and Society*, vol. 22, no. 4.

Jhally, Sut and Lewis, Justin (1992), *Enlightened Racism: The Cosby Show, Audiences, and the Myth of the American Dream*, San Francisco: Westview Press.

Montgomery, K. C. (1989), *Target Prime Time: Advocacy Groups and the Struggle Over Entertainment Television*, New York: Oxford University Press.

Navarrete, Lisa and Kamasaki, Charles (1994), *Out of the Picture: Hispanics in the Media*, Washington DC: National Council of La Raza.

'NBC, ABC, NAACP in Accords' (2000), *Television Digest*, 10 January.

Noriega, Chon A. (2000), *Shot in America: Television, the State, and the Rise of Chicano Cinema*, Minneapolis: University of Minnesota Press.

Ramano, Allison (2001), 'Checking the Census: Cable Recognizes the Growing Clout of Spanish Speaking Viewers', *Broadcasting and Cable*, 1 October, p. 32.

Steenland, Sally (1989), *Unequal Picture: Black, Hispanic, Asian and Native American Characters on Television*, Washington, DC: National Commission on Working Women.

Streeter, Thomas (1996), *Selling the Air: A Critique of the Policy of Commercial Broadcasting in the United States*, Chicago: University of Chicago Press.

Torres, Sasha (ed.) (1998), *Living Color: Race and Television in the United States*, Durham: Duke University Press.

Zook, Kristal Brent (1999), *Color By Fox: The Fox Network and the Revolution in Black Television*, New York: Oxford University Press.

TELEVISION AND ORIENTALISM

Barker, Chris (1999), *Television, Globalization and Cultural Identities*, Buckingham: Open University Press.

Carrier, James (ed.) (1995), *Occidentalism: Images of the West*, Oxford: Oxford University Press.

Graham, Allison (1996), '"Are You Now or Have You Ever Been?": Conspiracy Theory and *The X-Files*', in David Lavery et al. (eds), *'Deny All Knowledge': Reading The X-Files*, Syracuse: Syracuse University Press.

Hall, Stuart (1992), 'The West and the Rest: Discourse and Power', in Stuart Hall and Bram Gieben (eds), *Formation of Modernity*, Cambridge: Polity Press.

Liebes, Tamar and Katz, Elihu (1990), *The Export of Meaning: Cross-cultural Readings of Dallas*, Oxford: Oxford University Press.

Lodziak, Conrad (1986), *The Power of Television*, London: Frances Printer.

Ma, Eric K. W. (1999), *Culture, Politics and Television in Hong Kong*, London: Routledge.

Morley, David and Robins, Kevin (1995), 'Techno-Orientalism: Japan Panic', in *Spaces of Identity: Global Media, Electronic Landscapes and Cultural Boundaries*, London: Routledge.

Said, Edward (1995), *Orientalism: Western Conceptions of the Orient* (rev. edn), London: Penguin.

Sardar, Ziauddin (1999), *Orientalism*, Buckingham: Open University Press.

Suggested Video Clip

The X-Files

'Hell Money' (3rd series, 3X19)

The ending scene in which agents Mulder and Scully break into the Chinese underground society is a typical case for illustrating a wide range of Orientalist imageries. In this video clip, the 'orient is passionless and fanatic; disciplined in the arts of cruelty and licentious and effete; built on family and filial duty and lacking emotional warmth in intimate human relations' (Sardar, 1999, p. 114).

TARGETING MINORITIES

Ang, Ien (1991), *Desperately Seeking the Audience*, London: Routledge.

Astroff, Roberta J. (1988), 'Spanish Gold: Stereotypes, Ideology, and the Construction of a US Latino Market', *Howard Journal of Communication*, vol. 1, no. 4.

Barnouw, Erik (1975), *Tube of Plenty: The Evolution of American Television*, New York, Oxford: Oxford University Press.

Clark, Danae (2001), 'Commodity Lesbianism', in C. Lee Harrington and Denise D. Bielby (eds), *Popular Culture: Production and Consumption*, Malden, Massachusetts: Blackwell Publishers.

Dávila, Arlene (2000), 'Mapping Latinidad: Language and Culture in the Spanish TV Battlefront', *Television and New Media*, vol. 1, no. 1.

Gandy, Oscar H. (1998), *Communication and Race: A Structural Perspective*, Oxford: Oxford University Press.

Gray, Herman (1995), *Watching Race: Television and the Struggle for Blackness*, Minneapolis: University of Minnesota Press.

Jhally, Sut and Lewis, Justin (1992), *'Enlightened' Racism: The Cosby Show, Audiences, and the Myth of the American Dream*, Boulder: Westview Press.

MacDonald, J. Fred (1983), *Blacks on White TV: Afro-Americans in Television since 1948*, Chicago: Nelson-Hall Publishers.

Rodriguez, América (1999), *Making Latino News: Race, Language, Class*, Thousand Oaks, California: Sage.

Rodríguez, Clara E. (1997), *Latin Looks: Images of Latinas and Latinos in the US Media*, Boulder, CO: Westview Press.

Sinclair, John (1999), *Latin American Television: A Global View*, New York: Oxford University Press.

Valdivia, Angharad N. (2000), *A Latina in the Land of Hollywood and Other Essays on Media Culture*, Tucson: University of Arizona Press.

Videography

Riggs, Marlon (director) (1991), *Color Adjustment*, San Francisco, CA: California Newsreel (produced by Marlon Riggs and Vivian Kleiman).

Riggs, Marlon (director and producer) (1986), *Ethnic Notions*, San Francisco, CA: California Newsreel.

FIRST PEOPLES' TELEVISION

Alia, Valerie (1999), *Un/Covering the North: News, Media, and Aboriginal People*, Vancouver: UBC Press.

Browne, Donald R. (1996), *Electronic Media and Indigenous Peoples: A Voice of Our Own?*, Ames: Iowa State University Press.

Ginsburg, Faye (1991), 'Indigenous Media: Faustian Contract or Global Village?', *Cultural Anthropology*, vol. 6, no. 1.

Ginsburg, Faye (1993), 'Aboriginal Media and the Australian Imaginary', *Public Culture*, vol. 5, no. 3.

Ginsburg, Faye (2001), 'Screen Memories: Resignifying the Traditional in Indigenous Media', in Faye Ginsburg, Lila Abu-Lughod and Brian Larkin (eds), *The Social Practice of Media: Anthropological Interventions in an Age of Electronic Reproduction*, Berkeley: California.

Ginsburg, Faye, Lughod, Lila Abu and Larkin, Brian (eds) (2002), *Media Worlds: Anthropology on New Terrain*, Berkeley: University of California Press, pp. 39–57.

Hartley, John and McKee, Alan (2001), *The Indigenous Public Sphere: The Reporting and Reception of Indigenous Issues in the Australian Media, 1994–1997*, London: Oxford University Press.

King, J. C. H. and Lidchi, Henrietta (1998), *Imaging the Arctic*, Seattle: University of Washington Press.

Langton, Marcia (1993), *'Well, I Heard It on the Radio and I Saw It on the Television'*, North Sydney: Australian Film Commission.

Meadows, Michael (1994), 'Reclaiming A Cultural Identity: Indigenous Media Production in Australia and Canada', *Continuum: The Australian Journal of Media and Culture*, vol. 8, no. 2.

Michaels, Eric (1986), *The Aboriginal Invention of Television in Central Australia: 1982–1986*, Canberra: Australian Institute of Aboriginal Studies.

Michaels, Eric (1994), *Bad Aboriginal Art: Tradition, Media, and Technological Horizons*, Minneapolis: University of Minnesota Press.

Molnar, Helen (1990), 'The Broadcasting for Remote Areas Community Scheme: Small vs Big Media', *Media Information Australia*, no. 58.

Molnar, Helen and Meadows, Michael (2001), *Songlines to Satellites: Indigenous Communications in Australia, the South Pacific and Canada*, Leichhardt: Pluto Press.

O'Regan, Tom and Batty, Philip (1993), 'An Aboriginal Television Culture: Issues, Strategies, Politics', in *Australian Television Culture*, Sydney: Allen and Unwin.

Roth, Lorna (1994), *Northern Voices and Mediating Structures: The Emergence and Development of First Peoples' Television Broadcasting in the Canadian North* (PhD Thesis), Montreal: Concordia University.

Roth, Lorna (1998), 'Television Broadcasting North of 60', in Leen d'Haenens (ed.), *Images of Canadianness: Visions on Canada's Politics, Culture, Economics*, Ottawa: University of Ottawa Press International Canadian Studies Series.

Roth, Lorna (2000), 'The Crossing of Borders and the Building of Bridges: Steps in the Construction of the Aboriginal Peoples Television Network in Canada', Special Issue on Canadian Communications in *Gazette International Journal of Communication Studies*, vol. 62, nos. 3–4, London: Sage Publications.

Roth, Lorna (forthcoming), *Something New in the Air: Indigenous Television in Canada*, Montreal: McGill-Queens University Press.

Shinar, Dov (1996), '"Re-membering" and "Dis-membering" Europe: A Cultural Strategy for Studying the Role of Communication in the Transformation of Collective Identities', in Sandra Brahman and Annabelle Sreberny-Mohammadi (eds), *Globalization, Communication and Transnational Civil Society*, Greenskill, NJ: Hampton Press.

Suggested Videos

Starting Fire with Gunpowder (59 minutes, 1991).
Directors: William Hansen, David Poisey.
Producers: James Cullingham, William Hansen, Kent Martin, Peter Raymont.
Co-producers: Tamarack Productions.
The programme chronicles the origins and achievements of the Inuit Broadcasting Corporation (IBC), a model for aboriginal broadcasters the world over. Their story is told by Inuk film-maker Ann Meekitjuk Hanson who examines how Inuit television plays a critical role in the creation of a modern Inuit nation.

Satellite Dreaming (53 minutes, 1991).
Director: Ivo Burum.
Producers: Ivo Burum, Tony Downmunt, Central Australian Aboriginal Media Association (CAAMA).
This overview of the development of indigenous media during the crucial 1980s looks at the work of remote low-power television in traditional communities, the regional broadcaster Imparja in Alice Springs, and the development of indigenous production units on Australia's public service broadcaster, the ABC, and its multicultural counterpart, the SBS.

INDEX

Page numbers in **bold** type denote detailed treatment in a 'grey box' case study; page numbers in *italic* denote illustrations (may be textual material on same page).

LIST OF ILLUSTRATIONS

Whilst considerable effort has been made to correctly identify the copyright holders, this has not been possible in all cases. We apologise for any apparent negligence and any omissions or corrections brought to our attention will be remedied in any future editions.

Introduction: *Neighbours*, Grundy Organisation **Forms of Knowledge:** *Metropolis*, Ufa; *Hill Street Blues*, MTM Enterprises Inc./National Broadcasting Company (NBC); *Crossroads*, ATV/Central; *Al-Jazeera*, Al-Jazeera TV; *All in the Family*, Tandem Productions/CBS; *The Waltons*, Lorimar Television/CBS; *The Beverly Hillbillies*, CBS; *The Avengers*, Canal+; *Frasier*, Grub Street Productions/Paramount TV; *Home and Away*, ATN/Channel 7; *The Flying Doctors*, 9 Network/Crawford Productions **Audiences:** *Cathy Come Home*, BBC; *Dr Who*, BBC; *Jerry Springer*, Universal TV; *Star Trek*, Desilu Production Inc./Norway Corporation/ Paramount TV; *Medical Center*, MGM TV/CBS; *Sesame Street*, Children's Television Workshop (CTW), Jim Henson Productions, NET-TV, Public Broadcasting Service (PBS); *ER*, Warner Bros. TV/Amblin; *Rocky II*, Chartoff-Winkler Productions/UA **Gender:** *Dallas*, Lorimar Television; *The Mary Tyler Moore Show*, MTM Enterprises Inc./CBS; *Cagney and Lacey*, CBS TV/Filmways Pictures/Orion TV; *Inspector Morse*, Central TV/Zenith/Carlton TV; *Absolutely Fabulous*, BBC/French and Saunders Productions; *Queer as Folk*, Red Productions/Channel 4; *Xena: Warrior Princess*, Renaissance Pictures/MCA/Universal TV; *Good Morning America*, ABC **Race:** *Goodness Gracious Me*, BBC; *Amos 'n' Andy*, Hal Roach Studios/CBS TV; *Martial Law*, Carlton Cuse Productions/CBS; *The X-Files*, 20th Century Fox International Television Productions; *Kung Fu*, Warner Bros. Television; *Do the Right Thing*, 40 Acres & a Mule Filmworks; **Jacket:** *Buffy the Vampire Slayer*, 20th Century Fox Television/Sandollar TV.